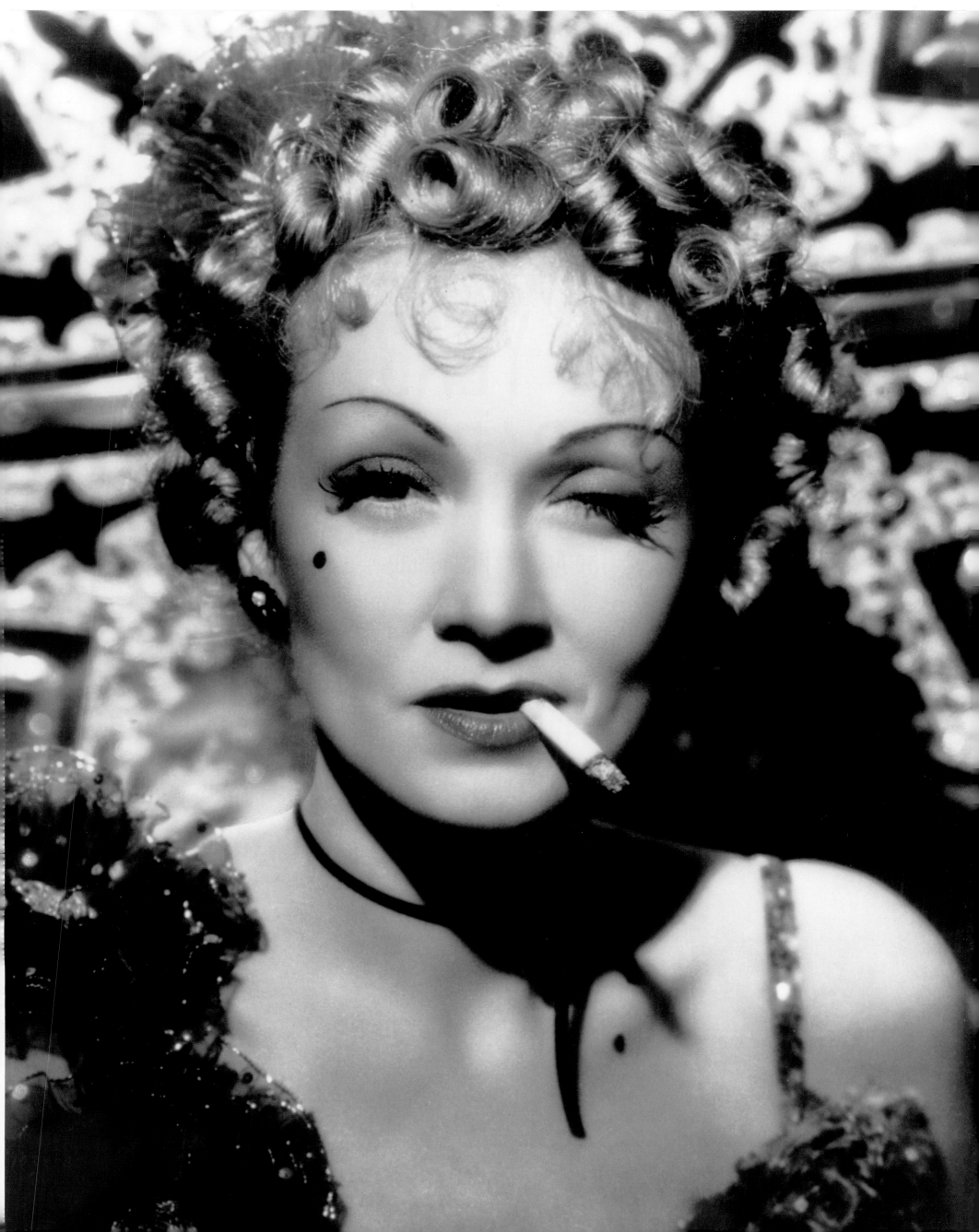

CONTENTS

It was a real thrill to work in the Babelsberg studios. I was really taken with the place. The studio lot was fantastic. And the tradition of Babelsberg is amazing. I'm a film expert, I'm a film scholar, so to be in a film studio where all the great films of the 1920s were made, a time which I consider to be one of the highpoints of cinema history…it's just magnificent!

Es war unglaublich aufregend, in den Babelsberger Studios zu arbeiten. Der Ort hat mich wirklich in seinen Bann gezogen. Das Studiogelände war fantastisch. Und die Tradition von Babelsberg ist beeindruckend. Ich bin ein Filmexperte, ein Filmgelehrter, weshalb es einfach überwältigend ist, in einem Filmstudio zu sein, in dem all die bedeutenden Filme der 20er Jahre gedreht wurden. Zu einer Zeit, die ich für einen der Höhepunkte der Filmgeschichte halte. Es ist einfach großartig!

– QUENTIN TARANTINO

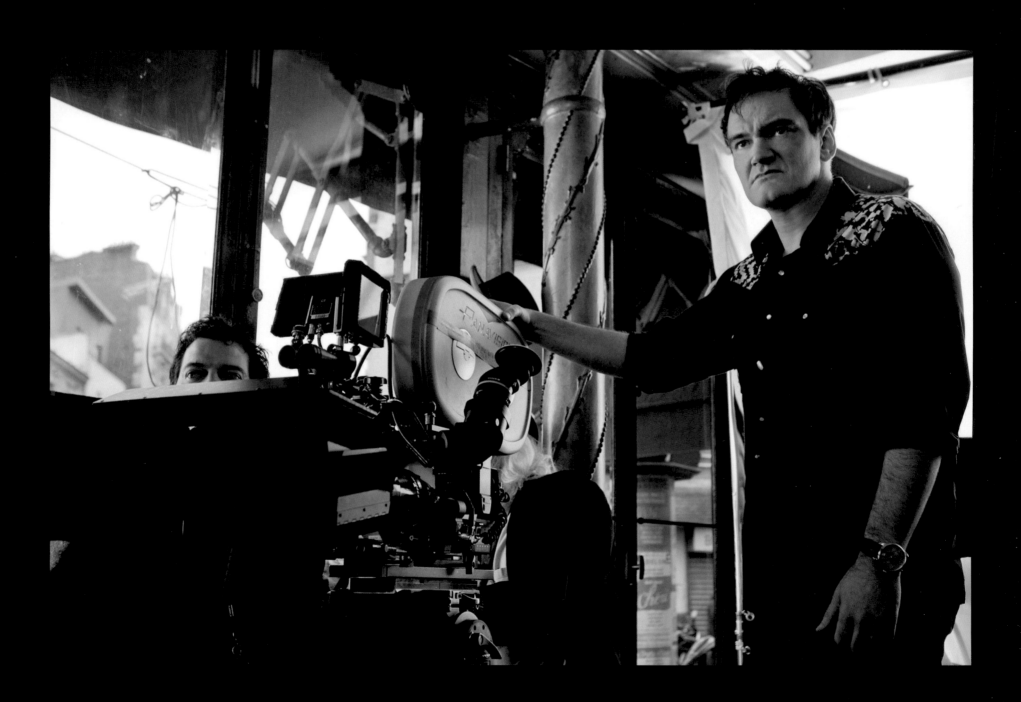

More than half a century ago, I shot my first film in Babelsberg. I experienced two regimes and was allowed to survive, while Babelsberg managed five. It's for survival artists of the highest order. During every regime, there were brave filmmakers in Babelsberg who swam against the current and filmed their stories. Congratulations on the 100th!

Vor mehr als einem halben Jahrhundert habe ich in Babelsberg meinen ersten Film gedreht. Ich habe zwei Systeme erlebt und überleben dürfen, Babelsberg fünf, für Überlebenskünstler ersten Ranges. In jedem System hat es in Babelsberg mutige Filmemacher gegeben, die gegen den Strom schwammen und ihre Geschichten verfilmt haben. Gratulation zum 100.!

- ARMIN MUELLER-STAHL

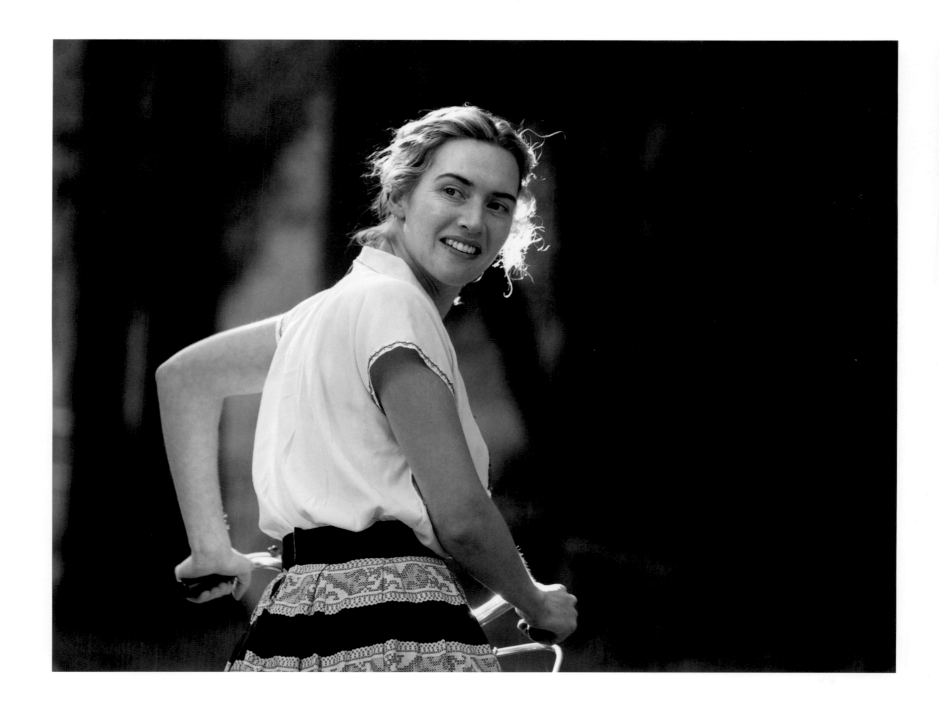

The tradition of this studio is amazing. I would love to work there again. I had a fantastic experience making *The Reader* there and working with the Babelsberg crew who were completely dedicated. It was great to work with such a team of committed filmmakers with a real passion for film. They provided a thoroughly supportive creative environment. Happy Birthday Studio Babelsberg and I wish you another hundred years of filmmaking magic!

Die Tradition dieses Studios ist beeindruckend. Ich würde sehr gerne wieder dort arbeiten, denn die Dreharbeiten zu *Der Vorleser* waren eine fantastische Erfahrung. Die Babelsberger Crew war unglaublich engagiert. Es war großartig, mit einem solchen Team begeisterter Filmemacher zusammenzuarbeiten, die eine wirkliche Leidenschaft für Film haben. Sie schufen ein durch und durch kreatives und unterstützendes Umfeld. Herzlichen Glückwunsch zum Geburtstag, Studio Babelsberg! Ich wünsche Dir weitere hundert Jahre großes Kino!

– KATE WINSLET

Germany has the greatest actors and the greatest crews and
Studio Babelsberg offers all possibilities. I cannot wait to come back.
Happy Birthday! Your biggest fan: Stephen Daldry.

Deutschland hat die besten Schauspieler und die besten Crews, und Studio Babelsberg
bietet alle Möglichkeiten. Ich kann es gar nicht erwarten, wieder hierher zu kommen.
Herzlichen Glückwunsch zum Geburtstag! Dein größter Fan: Stephen Daldry.

- STEPHEN DALDRY

Shooting *Anonymous* in Babelsberg was one of the most rewarding and fulfilling experiences of my professional career. Working in Germany again after nearly 20 years was an emotional reunion and the cast and crew of the project made me enjoy every moment of it. Germany's film community has exceptional talent, dedication, and creativity to offer that can compete with Hollywood any day and I look forward to return for another project in the future. Congratulations, Babelsberg, on your 100th anniversary!

Der *Anonymus*-Dreh in Babelsberg war eine der Erfahrungen meiner Karriere, die mich am meisten bereichert und erfüllt haben. Nach fast 20 Jahren wieder in Deutschland zu arbeiten, war ein emotionales Wiedersehen. Die Schauspieler und das Team sorgten dafür, dass ich jeden Moment genoss. Die deutsche Filmgemeinde verfügt über außergewöhnliches Talent, Hingabe und Kreativität, sodass sie es jederzeit mit Hollywood aufnehmen kann. Ich freue mich darauf, in der Zukunft für ein weiteres Projekt zurückzukehren. Herzlichen Glückwunsch, Babelsberg, zu Deinem 100. Jubiläum!

- ROLAND EMMERICH

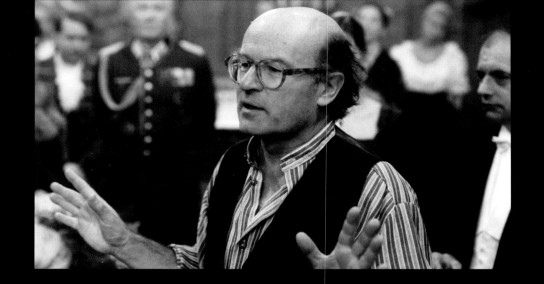

100 years of Babelsberg, to me, that means ten years of my life, lost or not, and as a director a disruption in my career. How powerful a myth must be to throw an otherwise reasonable man around 50 off course? My age might have something to do with it: for those of us grown up after the war, the cinema had an incredible pull. Travels to the Fiji Islands, to Hongkong, and to the Wild West, an elegant world beneath chandeliers, young hoods and gangsters on wet asphalt, this was only possible in motion pictures. The dream had a scene: Babelsberg. There stood the cradle of cinematic art. It is there, where the streets were named after Fritz Lang and Emil Jannings, there Friedrich Wilhelm Murnau was buried, and there Marlene Dietrich forever crossed her long legs. 1991, at the time I put my fingers into the wheelwork of privatization, this myth had faded. At least the old front gate, the Tonkreuz, and the great hall still bore traces of it. And it still lived in the self-confidence of the many technical crews whose abilities have lasted the times. Nobody believed then that their studio one day would shine again the way it does today.

100 Jahre Babelsberg, das sind für mich zehn Lebensjahre, verloren oder nicht, und ein Bruch in meiner Laufbahn als Regisseur. Wie stark muss ein Mythos sein, dass er einen ansonsten vernünftigen Mann um die Fünfzig aus der Bahn schmeißt? Mein Alter mag damit zu tun haben: Aufgewachsen nach dem Krieg, hatte Kino für uns einen unvorstellbaren Sog. Reisen zu den Fidschi-Inseln, nach Hongkong und in den Wilden Westen, elegante Welt unter Kronleuchtern, Halbstarke und Gangster auf nassem Asphalt, das gab es nur im Film. Der Traum hatte einen Ort: Babelsberg. Dort stand die Wiege der Filmkunst. Dort waren Straßen nach Fritz Lang und Emil Jannings benannt, dort war Friedrich Wilhelm Murnau begraben, dort kreuzte für immer Marlene Dietrich ihre langen Beine. 1991, als ich meine Finger ins Räderwerk der Privatisierung steckte, war dieser Mythos verblasst. Immerhin zeugten die alte Eingangspforte, das Tonkreuz und die Große Halle noch davon. Und er lebte noch im Selbstbewusstsein der vielen Gewerke, deren handwerkliche Fähigkeiten die Zeiten überdauert hatten. Keiner glaubte damals, dass ihr Studio einmal wieder so strahlen würde,

t was one of the great pleasures of my professional life to work at the Babelsberg studios,
for proficiency, courtesy, and the creative atmosphere that helped me artistically. I would like
to thank all those great figures from the past who've worked at the studio before me:
Fritz Lang, Marlene Dietrich, Ernst Lubitsch, Billy Wilder, for creating the myth which
gave us inspiration.

Es war eine der größten Freuden meiner Laufbahn, in den Babelsberger Studios zu arbeiten – aufgrund der dort
herrschenden Fähigkeiten, der Verbindlichkeit und der kreativen Atmosphäre, die mich künstlerisch unterstützt haben.
Ich möchte all jenen großen Persönlichkeiten der Vergangenheit danken, die vor mir in den Studios gearbeitet haben:
Fritz Lang, Marlene Dietrich, Ernst Lubitsch, Billy Wilder – dafür, dass sie den Mythos für unsere Inspiration geschaffen haben.

– ROMAN POLANSKI

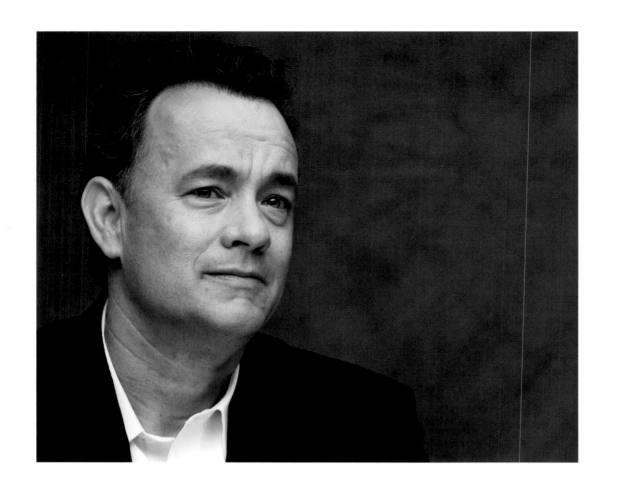

Babelsberg! I'd learned of you long ago and have been impressed and inspired by many films that were born here. Coming to shoot on your historic stages has been a fantasy of a student of cinema made into the work of a professional. From Fritz Lang to…*Cloud Atlas*!

Babelsberg! Vor langer Zeit schon habe ich von Dir gehört, war beeindruckt und inspiriert von den vielen Filmen, die hier geboren wurden. Hierher zu kommen, um in Deinen historischen Studios zu drehen, war die Fantasie eines Filmstudenten, die für den erfahrenen Filmemacher zur Wirklichkeit wurde. Von Fritz Lang zum … *Wolkenatlas*!

– TOM HANKS

Babelsberg—where else?!

Babelsberg – wo sonst?!

– TOM TYKWER

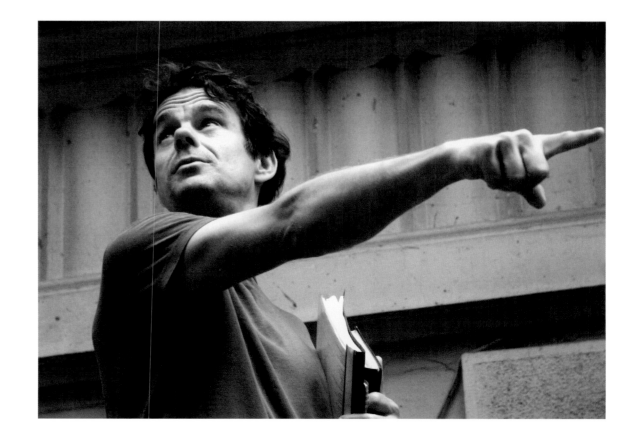

STUDIO BABELSBERG TODAY / HEUTE (1993–2012)

by Michael Wedel

TODAY (1993-2012)
HEUTE (1993-2012)

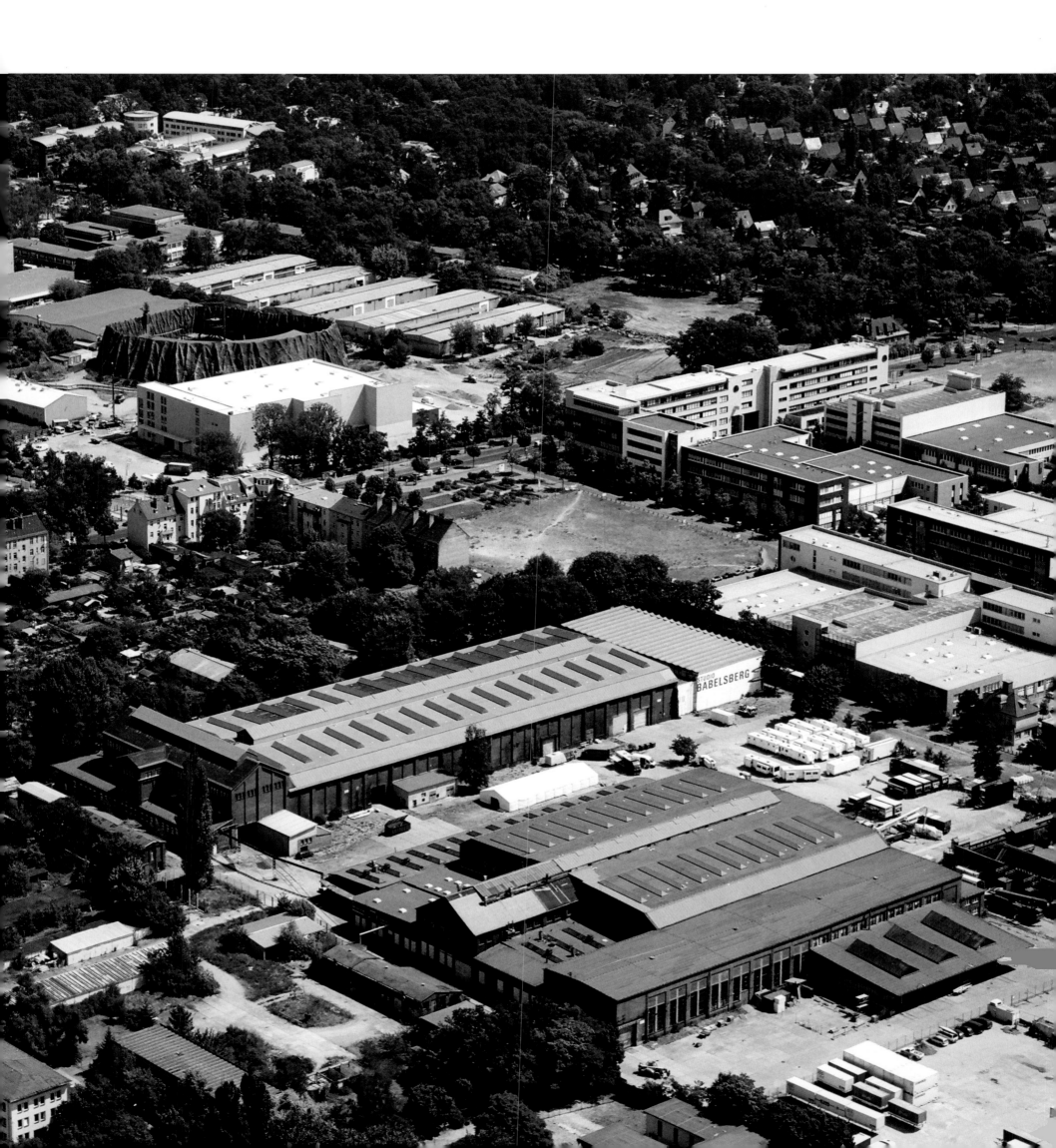

STUDIO BABELSBERG TODAY (1993-2012)

by Michael Wedel

Babelsberg at the end of 2011. A few yards after you enter the studio lot through the main gate, you will run into the street sign bearing the name of Quentin Tarantino. It was thus dedicated after the shooting of *Inglourious Basterds* wrapped in 2009. Quentin-Tarantino-Straße intersects the street named after G.W. Pabst (one of Weimar cinema's master directors before 1933), which you can follow a few steps to encounter another big name: the next cross street is dedicated to Josef von Sternberg, whose film *The Blue Angel* enabled Marlene Dietrich to leap into Hollywood in 1930.

And you do not have to look hard for the legendary diva: the largest sound stage on the lot bears her name, and even the elegantly arcing street that unevenly divides the lot in two commemorates the brightest star who conquered the world after starting out in Babelsberg. Marlene-Dietrich-Allee is dominated by a particular eye-catcher: the façades of the "Berliner Straße," the permanent exterior set where, eight years prior to Tarantino, Roman Polanski shot key scenes of his multiple-Oscar-winning Holocaust drama *The Pianist* (2002). Somewhat hidden across the street is the lovingly restored building that has been used as an administrative building in Babelsberg since its first resident production company, Deutsche Bioscop, in 1912. A few yards away, one finds the Guido Seeber Building, named after the gifted film technician and camera pioneer, who was the person who first discovered Babelsberg as a film site.

The street that extends Marlene-Dietrich-Allee, and which borders the rear of the studio, is named after Emil Jannings—the first actor from here to be awarded an Oscar, but who later became a Nazi cinema icon. That's where you'll find Caligari Hall, the front façade of which has been designed in the expressionist style of the silent film classic, and which is part of the Filmpark's adventure world. On the left-hand side, Metropolis Hall looms behind the old Ufa sound film studio, which recalls Fritz Lang's science-fiction epic from 1927.

The more than 40-year history of the GDR is also still present. For decades after World War II until Germany's reunification, the state-owned DEFA shot films here for cinema and television. The Sandman Building in the Filmpark is dedicated to the most popular puppet figure of GDR television: the Sandman, who remains a fixture in early evening programs to this day. The exotic gardens of Little Mook, through which visitors of the Filmpark can wander, is an homage to Wolfgang Staudte's enchanting children's film from 1953. And above the entrance of the glass building that houses the Film and Television University behind the Filmpark on Marlene-Dietrich-Allee is emblazoned the name of Konrad Wolf, one of the most exceptional DEFA directors.

Haus 62: administration building

Haus 62: Sitz der Verwaltung

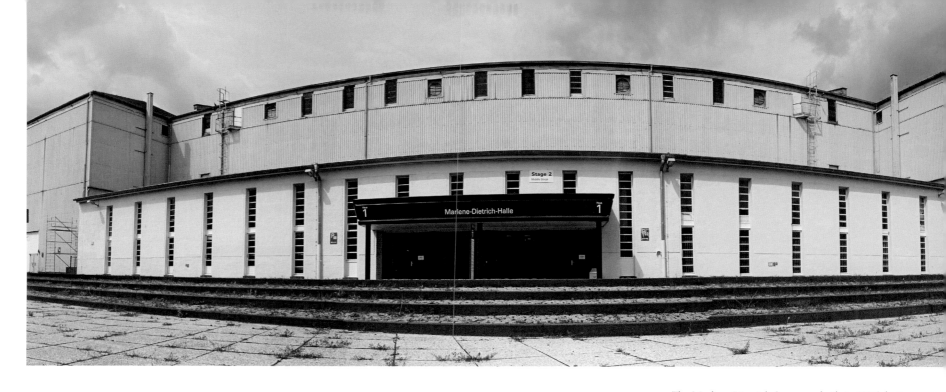

The Marlene Dietrich Stage was built in 1926 during the making of Fritz Lang's *Metropolis*.

Die Marlene-Dietrich-Halle wurde 1926 während der Dreharbeiten zu Fritz Langs *Metropolis* erbaut.

STUDIO BABELSBERG HEUTE (1993–2012)

Michael Wedel

Babelsberg, an der Jahreswende 2011/12. Betritt man das Studiogelände durch das Haupttor, stößt man nach wenigen Metern auf ein Straßenschild, das den Namen Quentin Tarantinos trägt. Es wurde 2009 zum Abschluss der Dreharbeiten zu *Inglourious Basterds* eingeweiht. Die Quentin-Tarantino-Straße kreuzt seitdem die nach G.W. Pabst, einem der Meisterregisseure des Weimarer Kinos vor 1933, benannte Straße, an der entlang man einige Schritte weiter auf einen anderen großen Namen trifft: Die nächste Querstraße ist Josef von Sternberg gewidmet, dessen Film *Der blaue Engel* Marlene Dietrich 1930 den Sprung nach Hollywood ermöglicht hat.

Auch nach der legendären Diva muss man nicht lange suchen: Die größte Studio-Halle auf dem Gelände trägt ihren Namen, und auch die Straße, die das Gelände im eleganten Schwung in zwei ungleiche Teile teilt, ist dem hellsten Stern, der von Babelsberg aus die Welt erobert hat, zugedacht. Dominiert wird die Marlene-Dietrich-Allee von einem besonderen Blickfang: den Häuserfassaden der „Berliner Straße", jener permanenten Außenkulisse, in der acht Jahre vor Tarantino schon Roman Polanski zentrale Szenen für sein gleich mehrfach Oscar-gekröntes Holocaust-Drama *Der Pianist* (2002) gedreht hat. Gegenüber ist, etwas versteckt, das liebevoll restaurierte Gebäude zu sehen, das ab 1912 schon von der ersten in Babelsberg ansässigen Produktionsfirma, der Deutschen Bioscop, genutzt wurde. Einige Meter entfernt befindet sich seit 2009 das Guido-Seeber-Haus, benannt nach dem begnadeten Filmtechniker und Kamera-Pionier, der 1911 Babelsberg als Filmgelände überhaupt erst entdeckte.

Nach Emil Jannings – dem ersten Schauspieler, der in Hollywood je mit einem Oscar ausgezeichnet wurde, später allerdings auch zu den Ikonen des NS-Films zählte – heißt die Straße, die in der Verlängerung der Marlene-Dietrich-Allee das Studiogelände an dessen Rückseite einfasst. Dort steht die zur Erlebniswelt des Filmparks gehörende Caligari-Halle, deren Frontfassade dem expressionistischen Stil des Stummfilmklassikers nachempfunden ist. Linker Hand erhebt sich hinter dem alten Ufa-Tonfilmstudio die Metropolis-Halle, mit der an Fritz Langs Science-Fiction-Epos von 1927 erinnert wird.

Auch die über 40-jährige DDR-Vergangenheit des Geländes ist präsent, die Jahrzehnte vom Ende des Zweiten Weltkriegs bis zur Wiedervereinigung Deutschlands, in denen die staatseigene DEFA hier ihre Filme für Kino und Fernsehen drehte. Das Sandmann-Haus im Filmpark ist der mit Abstand populärsten Puppentrickfigur des DDR-Fernsehens zugeeignet – sie hat sich bis

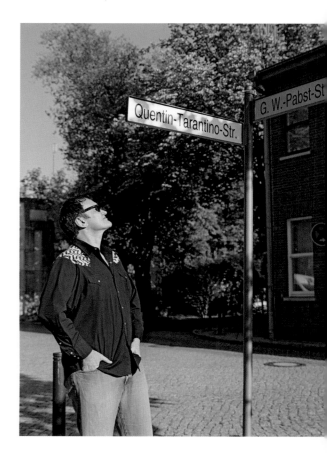

Quentin Tarantino with his street sign

Quentin Tarantino mit seinem Straßenschild

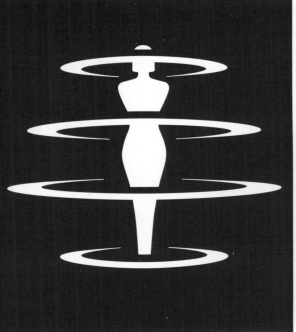 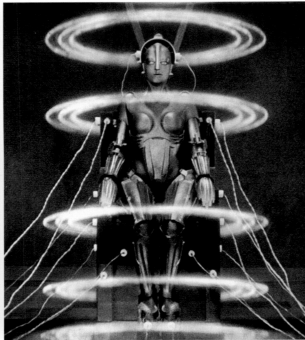

The Studio Babelsberg logo shows the silhouette of the artificial Maria from *Metropolis*. The similarity to the Oscar statue is unmistakable.

Das Studio Babelsberg-Logo zeigt die Silhouette der künstlichen Maria aus *Metropolis*. Die Ähnlichkeit mit der Oscar-Statue ist unverkennbar.

On another studio site, a bridge over the DEFA era has been built; the successor firm of Ufa, which still bears its name inside a rhombus as its company logo, has its headquarters across the street from the studio lot's main entrance. On its gates, the Studio Babelsberg company emblem recalls the silhouette of robot Maria from *Metropolis*: it is fixed at precisely the moment when robot Maria is brought to life, and her slim figure bears more than a passing resemblance to the Oscar statue. And another important name cannot be left out: kitty corner from the studio lot's entrance and somewhat concealed, immediately next to today's Ufa offices, is a research facility named after one of Ufa's historically most predominant producers—the Erich Pommer Institute.

Babelsberg today: to walk through it is to travel in time, a hundred years of film history in a quick rundown. The historical aura of the place is part of its capital. And it would remain unused capital that would merit the equivalent of a museum tour if it weren't also a globally competitive studio, embedded in the infrastructure of a complete media complex with celebrated Academy Award winners, worldwide box office hits, and also many well-regarded festival successes. The fact that Studio Babelsberg, in its 100th year as a film production location, enjoys an outstanding reputation is not least due to the films that came into being here over the last few years, and the names of those who made them: Tom Tykwer put Clive Owen and Naomi Watts under a hail of gunfire in the painstaking replica of the New York Guggenheim Museum rotunda for the spectacular finale of the 2007 thriller *The International* (2009), while Tom Cruise stood before the camera wearing a Wehrmacht uniform and eye-patch for Bryan Singer's *Valkyrie* (2008). Shortly after Quentin Tarantino shot his masterstroke *Inglourious Basterds* (2009)—which fulfilled his desire to have his own street sign—Roman Polanski came to Babelsberg in 2009, for the second time, to direct Ewan McGregor and Pierce Brosnan in *The Ghost Writer* (2010). At Studio Babelsberg in 2010, *Unknown* (2011) with Liam Neeson and Diane Kruger, *Hanna* (2011) with Cate Blanchett and Eric Bana, *Chicken with Plums* (2011) with Isabella Rossellini, as well as the revamped classic *The Three Musketeers* (2011), directed in digital 3D by Paul W.S. Anderson with the all-star cast of Milla Jovovich, Orlando Bloom, and Christoph Waltz, all came into being. After many years in Hollywood, Roland Emmerich returned to Germany—for his first time ever in Babelsberg—to shoot the Shakespeare drama *Anonymous* (2011). *Matrix* directors Andy and Lana Wachowski are currently working together with Tom Tykwer on the adaptation of the bestseller *Cloud Atlas*, with Halle Berry and Susan Sarandon in supporting parts and the lead played by none other than Tom Hanks. Industry experts write, that nowhere else in Germany have been "so many international feature films produced, or so many world stars have stood in front of the camera," and speak of a "Babelsberg secret": "Here the Oscars are forged, and Hollywood comes here."[1]

heute in den Vorabendprogrammen gehalten. Die exotischen Gärten des kleinen Muck, durch die man als Besucher des Filmparks wandeln kann, sind eine Hommage an Wolfgang Staudtes bezaubernden Kinderfilm von 1953. Und über dem Eingang des hinter dem Filmpark an der Marlene-Dietrich-Allee gelegenen Glasbaus der Filmhochschule prangt der Name von Konrad Wolf, einem der herausragenden Regisseure der DEFA.

An anderer Stelle des Geländes wird eine Brücke über die DEFA-Zeit hinweg geschlagen: Die Nachfolgefirma der Ufa, die noch heute diesen Namen im Rhombus des Firmen-Signets trägt, hat ihren Sitz gegenüber dem Haupteingang zum Studiogelände. An dessen Tor gemahnt das Firmenemblem von Studio Babelsberg an die Silhouette der künstlichen Maria aus *Metropolis*: Festgehalten ist genau jener Moment, in dem der Roboterfrau Leben eingehaucht wird, wobei ihre schlanke Linie wohl nicht von ungefähr eine gewisse Ähnlichkeit mit der Oscar-Statue aufweist. Und auch ein anderer wichtiger Name darf nicht fehlen: Etwas verborgen befindet sich schräg gegenüber dem Haupteingang zum Studiogelände und in unmittelbarer Nachbarschaft zur heutigen Ufa eine nach der prägenden Produzentenpersönlichkeit ihrer historischen Vorgängerin benannte Forschungseinrichtung – das Erich-Pommer-Institut.

Babelsberg heute: ein Spaziergang als Zeitreise, hundert Jahre Filmgeschichte im Schnell-durchlauf. Die historische Aura des Ortes ist Teil seines Kapitals. Es bliebe jedoch totes Kapital, seine Erkundung ein rein musealer Rundgang, wenn nicht auch heute noch ein wettbewerbsfähiges Studio, eingebettet in die Infrastruktur einer kompletten Medienstadt, gefeierte Oscarpreisträger, weltweite Kinohits und viel beachtete Festivalerfolge hervorbringen würde. Dass das Studio Babelsberg im 100. Jahr des Filmproduktionsstandorts in der internationalen Filmwelt einen hervorragenden Ruf genießt, belegen allein schon die Filme, die in den letzten Jahren hier entstanden sind, und die Namen derjenigen, die sie gemacht haben: Tom Tykwer jagt 2007 Clive Owen und Naomi Watts für das spektakuläre Finale seines Agenten-Thrillers *The International* (2009) auf einem maßstabsgetreuen Nachbau der Rotunde des New Yorker Guggenheim-Museums durch den Kugelhagel, Tom Cruise steht im gleichen Jahr für Bryan Singers *Operation Walküre – Das Stauffenberg-Attentat* (2008) in Wehrmachtsuniform

Entrance gate to the studio lot

Eingangstor zum Studiogelände

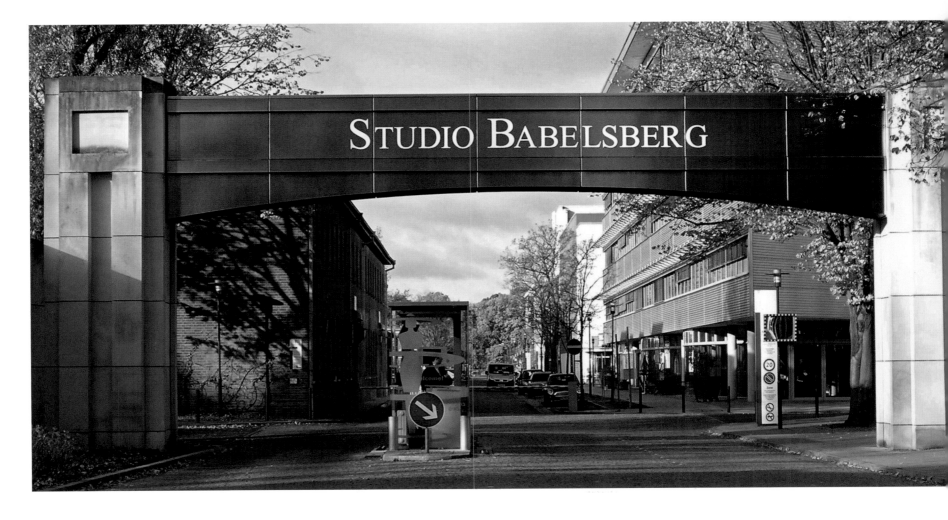

Isabella Rossellini in *Chicken with Plums*
(2011, Directors: Marjane Satrapi, Vincent Paronnaud)

Isabella Rossellini in *Huhn mit Pflaumen*
(2011, Regie: Marjane Satrapi, Vincent Paronnaud)

Studio set of *Chicken with Plums*

Studiokulisse *Huhn mit Pflaumen*

If it is even a secret at all, then it is one with many facets, an equation with many known variables. No magic tricks, rather "a combination of sly, risk-sensitive business management, high quality standards and specially tailored film subsidy politics."[2] Political frameworks play a part, as does a closely knit and stable network of global business relationships. Of high importance are the immediate environs of a "prototypical media complex"[3] and the regional concentration of over 130 media companies, whose profile and involvement in national and international processes of workflow and value chains comes very close to the "ideal of a serviceable production cluster."[4] One advantage it makes the most of is its proximity to suitable urban shooting locations in Berlin, historic buildings in Potsdam and the surrounding area, as well as diverse landscapes and scenery within a few 100 miles of Berlin. Its proximity to Berlin, in particular, with the city's convenient international air connections, over 50 first-class hotels, and wide-ranging cultural highlights and entertainment opportunities is also a vital factor in the planning and execution of major productions. Not only do the stars want to be able to arrive quickly and be comfortably boarded, a large crew must also be kept in a good mood over long periods of time.[5]

Crucial to the success of any studio is and will always be the quality of film work it is in the position to achieve. This in turn depends primarily on two factors: first, the size of the production facilities there and secondly the standard of technical equipment. These two factors ultimately determine a studio's scope and diversity of services, production volume and "blockbuster capacity." But it also has to do with the expertise of every single one of its employees.[6] Under the administration of producers and business partners Dr. Carl L. Woebcken and Christoph Fisser, Studio Babelsberg currently has 90 permanent employees, but it also employs up to 2,000 additional contractors for current productions on a project-by-project basis. There are 6.2 acres of total space available for all aspects of film production. Next to Marlene Dietrich Stage, which at 58,125 square feet is one of the largest sound stages in Europe, is the Tonkreuz with four smaller stages.

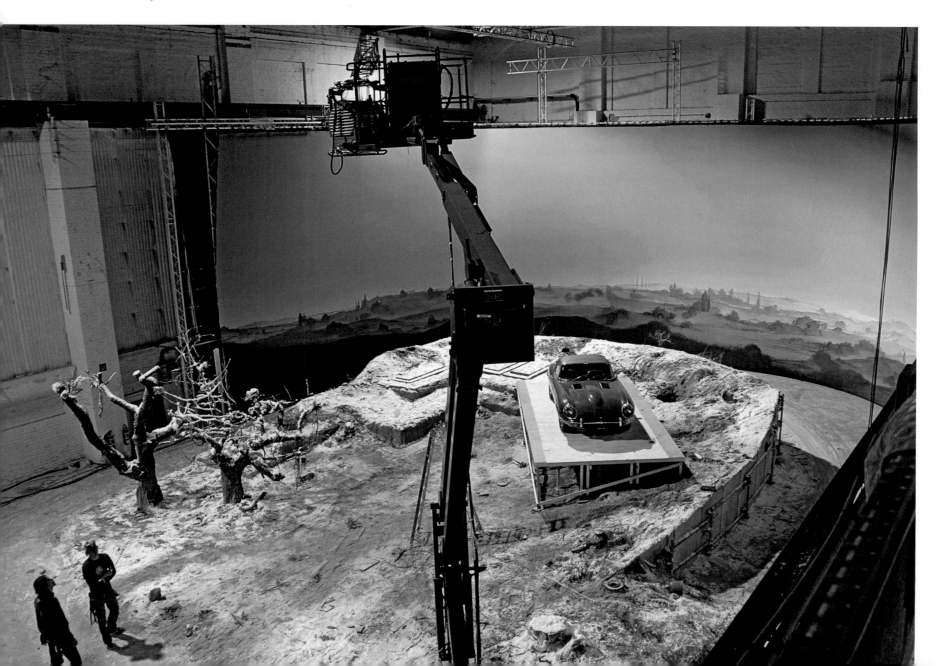

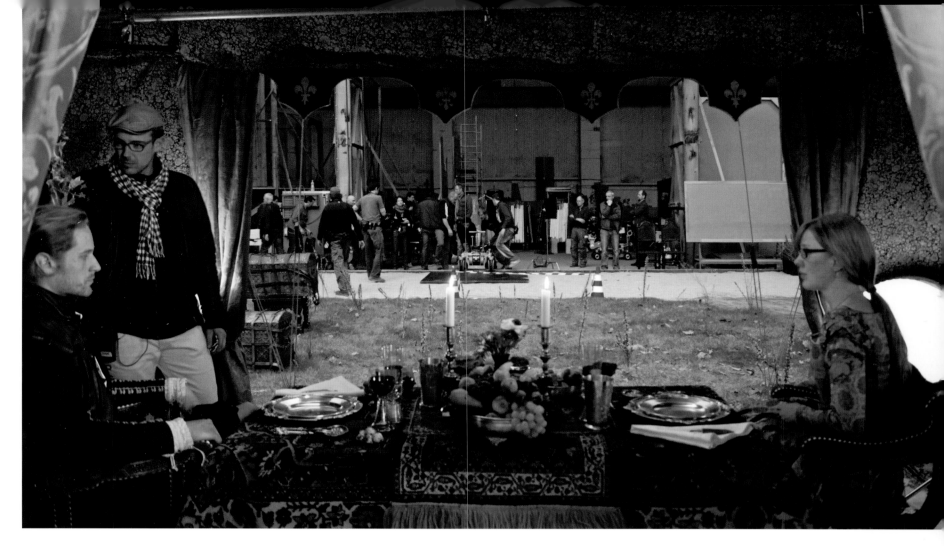

Set dressing for Roland Emmerich's *Anonymous* which was shot completely at Babelsberg in 2010.

Set-Dressing bei Roland Emmerichs *Anonymus*, der 2010 vollständig in Babelsberg gedreht wurde.

und mit Augenklappe vor der Kamera. Kurz nachdem Quentin Tarantino seinen Geniestreich *Inglourious Basterds* (2009) abgedreht hat, wofür ihm sogar der Wunsch nach einem eigenen Straßenschild erfüllt wird, kommt Roman Polanski 2009 ein zweites Mal nach Babelsberg, um Ewan McGregor und Pierce Brosnan in *Der Ghostwriter* (2010) zu inszenieren. 2010 entstehen in den Babelsberger Studios *Unknown Identity* (2011) mit Liam Neeson und Diane Kruger, *Wer ist Hanna?* (2011) mit Cate Blanchett und Eric Bana, *Huhn mit Pflaumen* (2011) mit Isabella Rossellini sowie – unter der Regie von Paul W.S. Anderson in 3D gedreht und mit Milla Jovovich, Orlando Bloom und Christoph Waltz hochkarätig besetzt – der zeitgemäß aufpolierte Klassiker *Die drei Musketiere* (2011). Roland Emmerich ist nach langen Jahren in Hollywood für das Shakespeare-Drama *Anonymus* (2011) nach Deutschland zurückgekehrt, um zum ersten Mal überhaupt in Babelsberg zu drehen. Aktuell arbeiten die *Matrix*-Regisseure Andy und Lana Wachowski gemeinsam mit Tom Tykwer an der Bestseller-Verfilmung *Der Wolkenatlas*, deren Hauptrolle – an der Seite von Halle Berry und Susan Sarandon – niemand Geringerer als Tom Hanks spielt. Nirgendwo sonst würden in Deutschland „so viele internationale Spielfilme produziert, stehen so viele Weltstars vor der Kamera", schreiben Branchenbeobachter und sprechen vom „Babelsberger Geheimnis": „Hier ist die Oscar-Schmiede, hierher kommt Hollywood."[1]

Es ist, wenn überhaupt, ein Geheimnis mit vielen Facetten, eine Gleichung mit vielen Bekannten. Keine Zauberei, sondern „eine Verbindung aus kluger, risikobewusster Unternehmensführung, höchsten Qualitätsansprüchen und einer maßgeschneiderten Förderpolitik".[2] Die politischen Rahmenbedingungen spielen eine Rolle, ebenso ein eng und tragfähig geknüpftes Netz an weltweiten Geschäftsbeziehungen. Von großer Bedeutung ist das unmittelbare Umfeld einer „proto-typischen Medienstadt",[3] die regionale Konzentration von über 130 Medienunternehmen, dessen Profil und Einbindung in nationale und internationale Arbeitsprozesse und Wertschöpfungs-ketten der „Idealvorstellung eines funktionsfähigen Produktionsclusters" sehr nahe kommt.[4] Ein Pfund, mit dem sich wuchern lässt, ist die Nähe zu geeigneten urbanen Drehorten in Berlin, historischen Bauwerken in Potsdam und Umgebung sowie einer vielfältigen landschaftlichen Szenerie im Umkreis von wenigen 100 Kilometern. Besonders die Nachbarschaft zur Weltstadt Berlin, mit einer bequemen internationalen Fluganbindung, über 50 First-Class-Hotels und einem vielfältigen Kultur- und Unterhaltungsangebot, ist bei der Planung und Durchführung von

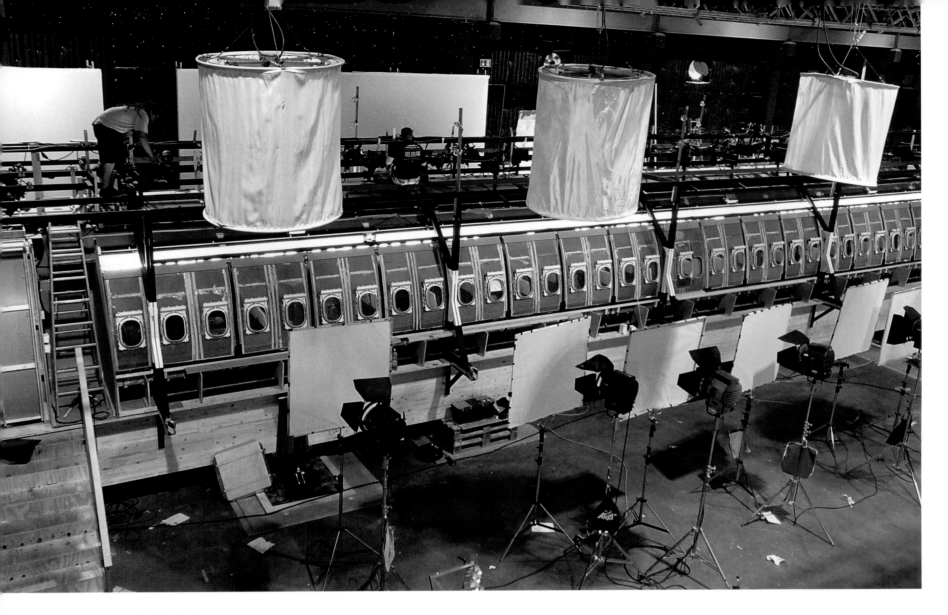

Germany's only completely hydraulic airplane set

Deutschlands einziges vollhydraulisches Flugzeug-Set

Other sound stages in the immediate vicinity can also be used; there is a backlot with a surface area of 4.2 acres, including the "Berliner Straße" exterior set. Since the shooting of *Unknown*, Germany's largest water tank for action and underwater shots is available in the studio area, as well as a complete hydraulic interior set of a modern passenger aircraft with flexible sidewalls and a detachable cockpit.

None of the larger film productions are now released without special effects and digital image processing. Babelsberg was quick to step into the digital age, and sustainably invested in the studio's "digital readiness."[7] In the fx.Center, smaller facilities specifically equipped to provide the necessary visual effects are available, and the resident VFX companies offer their services in the fields of computer-based recording technology and digital editing. Traditional special effects of all kinds—weapons and vehicles, explosions and fire, rain and flooding—are delivered by a studio subsidiary.

The creative heart of the studio is its art department, which relies on a craftsmanship tradition stretching back to *Metropolis* and *The Blue Angel*. Today, under the leadership of Michael Düwel, its areas of expertise cover not only film and television, but also exhibitions and theme parks, and special constructions for film premieres, trade shows, and conventions. During film productions, the art department is responsible for the production design, beginning with the concept, consulting and conception right up to the production, project management and realization. Painters and sculptors, architects and designers, carpenters and plasterers work on the production of storyboards, on drafting and building interior and exterior sets, on reproducing artworks or imitating surfaces, and preparing busts, sculptures, and statues. Here is where the sometimes historical, sometimes fantastic garb of films is created, the atmospheric depth and coherence of which often determine a film's success or failure.

The art department works hand in hand with the studio's very own prop warehouse, which provides historically authentic set dressing for feature and television films, as well as theater productions. It contains over a million items, from small props such as lamps, household appliances, and furnishings of all kind to large props such as furniture, cabinets, or built-in

Großproduktionen ein unverzichtbarer Faktor: Nicht nur die Stars wollen schnell anreisen und standesgemäß untergebracht sein, es muss auch dafür gesorgt werden, dass ein großer Stab über längere Zeit bei Laune bleibt.[5]

Entscheidend für den Erfolg eines Studios ist und bleibt jedoch die Qualität der Filmarbeit, die es zu leisten in der Lage ist. Sie hängt wiederum in erster Linie von zwei Faktoren ab: einmal von der Größe der Produktionsanlagen und dem Standard der technischen Ausrüstung, die über den Umfang und die Vielfalt der Leistungen, das Produktionsvolumen und die „Blockbusterfähigkeit" eines Studios entscheiden. Dann aber schlicht von der Expertise jedes einzelnen seiner Mitarbeiter.[6] Unter der Leitung der Produzenten und Geschäftspartner Dr. Carl L. Woebcken und Christoph Fisser beschäftigt Studio Babelsberg derzeit 90 fest angestellte Mitarbeiter, regelmäßig werden bis zu 2 000 zusätzliche Kräfte für laufende Produktionen projektbezogen angestellt. Es stehen insgesamt 25 000 m² Fläche für alle Belange der Filmproduktion zur Verfügung. Neben der Marlene-Dietrich-Halle, die mit 5 400 m² Arbeitsfläche zu den größten Studiohallen in Europa gehört, und dem Tonkreuz mit vier kleineren Stages können weitere Ateliers in unmittelbarer Nachbarschaft verwendet werden; außerdem ein Freigelände mit einer Fläche von 17 000 m², inklusive der Außenkulisse der „Berliner Straße". Im Atelierbereich gibt es – seit den Dreharbeiten zu *Unknown Identity* – Deutschlands größten Wassertank für Action- und Unterwasseraufnahmen sowie ein komplettes hydraulisches Innenset eines modernen Passagier-flugzeugs mit flexiblen Seitenwänden und abtrennbarem Cockpit.

Ohne Spezialeffekte und digitale Bildbearbeitungsmöglichkeiten kommt heute keine größere Filmproduktion mehr aus. Babelsberg hat frühzeitig den Schritt ins digitale Zeitalter des Films gewagt und nachhaltig in die „digital readiness"[7] des Studios investiert. Im fx.Center stehen kleinere, speziell für die Belange von Visual-Effects-Aufnahmen ausgerüstete Studiokapazitäten zur Verfügung, dort ansässige VFX-Firmen bieten ihre Dienstleistungen im Bereich der computergestützten Aufnahmetechnik und digitalen Nachbearbeitung an. Traditionelle Spezialeffekte aller Art – Waffen und Fahrzeuge, Explosionen und Feuer, Regen und Überschwemmungen – liefert eine Studio-Tochter.

Das kreative Herzstück des Studios ist sein Art Department, das sich auf eine handwerkliche Tradition beruft, die bis zu *Metropolis* und *Der blaue Engel* zurückreicht. Seine Geschäftsfelder erstrecken sich heute unter der Leitung von Michael Düwel über Film und Fernsehen hinaus auf Ausstellungen und Erlebniswelten bis hin zu Spezialbauten für Filmpremieren, Messen und Kongresse. Bei Filmproduktionen ist es für alle Bereiche des Production Designs von der Idee, Beratung und Konzeption bis hin zu Gestaltung, Projektsteuerung und Realisation zuständig: Kunstmaler und Bildhauer, Architekten und Gestalter, Tischler und Stuckateure arbeiten an der Herstellung von Storyboards, entwerfen und errichten Innen- und Außenkulissen, reproduzieren

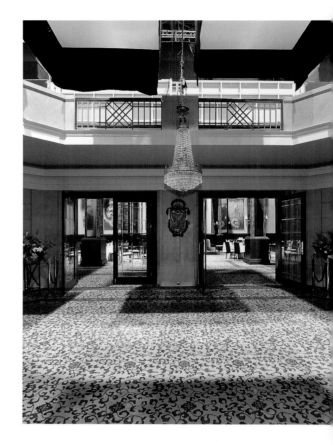

Original reconstruction of the Hotel Adlon lobby for
Unknown (2011, Director: Jaume Collet-Serra)

Original-Nachbau der Hotel Adlon-Lobby für
Unknown Identity (2011, Regie: Jaume Collet-Serra)

Logan Lerman and Mads Mikkelsen in action
during the making of *The Three Musketeers*
(2011, Director: Paul W.S. Anderson)

Logan Lerman und Mads Mikkelsen in Aktion
während der Dreharbeiten zu *Die drei Musketiere*
(2011, Regie: Paul W.S. Anderson)

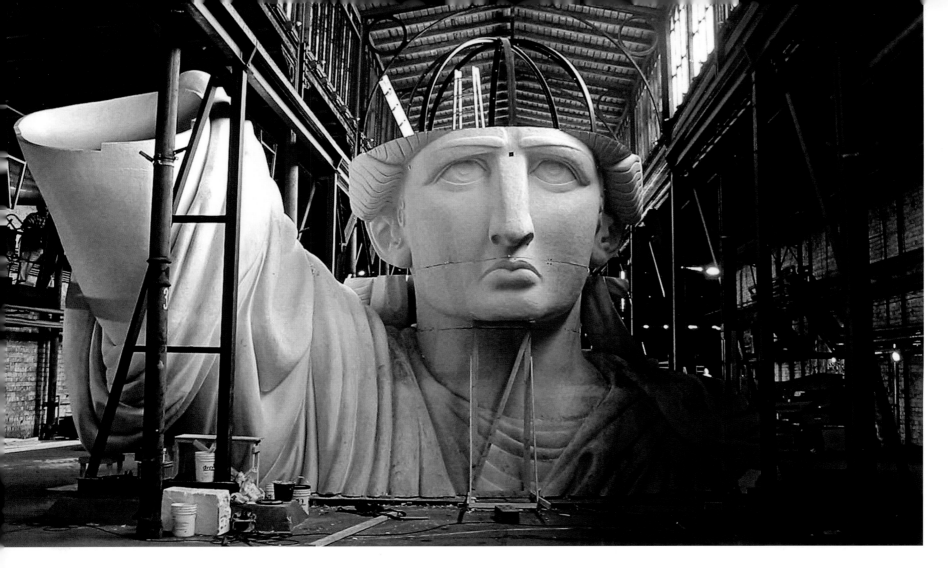

Set construction for *Around the World in 80 Days* (2004, Director: Frank Coraci)

Kulissenbau für *In 80 Tagen um die Welt* (2004, Regie: Frank Coraci)

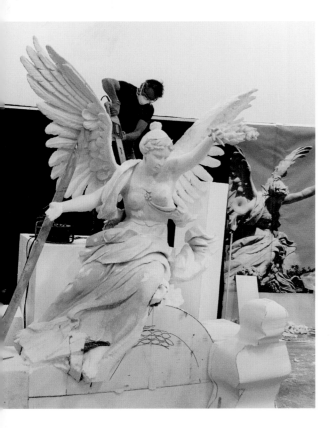

From painters to sculptors—arts and crafts professions have a long tradition in Babelsberg.

Vom Kunstmaler bis zum Bildhauer – Kunsthandwerksberufe haben in Babelsberg eine lange Tradition.

fixtures. Set designers and prop masters are able to construct complete generically or historically appropriate decorations from the warehouse. The costume studio also has a collection of over 250,000 costumes and uniforms from all eras of the 20th century. New dresses by the costume workshop have been custom-made for the stars and extras according to the demands of the production at hand, and complement the collection up to the present day. The stock of shoes, helmets, effects, embroidery, and other textiles is sorted based on size for children, women, and men and organized according to special clothing groups, for which even the appropriate reference works are kept in stock: stylized robes and modern costumes, professional and leisure clothing, judicial and ecclesiastical outfits, modern and historic uniforms. Numerous major productions from different historical eras such as *The Pianist*, *Around the World in 80 Days* (2004), *The Lives of Others* (2006), *Black Book* (2006), *The Counterfeiters* (2007), *The Reader* (2008), *The Baader Meinhof Complex* (2008), *Valkyrie*, *Anonymous*, and *The Three Musketeers* have been served by the Babelsberg costume and prop collections, and have made use of their employees' skills.

In all these core areas of film production, Studio Babelsberg has established itself in the national and international film landscape as an equal coproducer or as a service provider for foreign productions. Thus the list of services offered is longer than most of the other companies' in the European studio system. It encompasses the management of entire productions: the search for appropriate shooting locations and obtainment of the necessary shooting and work permits, the calculation of budgets and production schedules, the selection and employment of those in front of and behind the camera, the acquisition of insurance, the recommendation of appropriate coproducers and financiers, advising on contracts, legal and tax issues, and more. As one of the few European studio complexes, Babelsberg can provide "full service" on large productions, covering all necessary aspects of a film production that lie within the responsibility of the studio.[8]

The continued power to attract famous stars and directors, international box office and festival successes, and, of course, Oscar nominations and awards (for *The Counterfeiters* in 2008, *The Reader* in 2009, and *Inglourious Basterds* in 2010) give evidence to the high quality of the work accomplished over the last few years. It reinforces Babelsberg's leading position when it comes to the professional realization of high-budget film projects. But it is easy to forget that the way to this point has been hard, and it was by no means clear in the initial years after the studio's privatization.

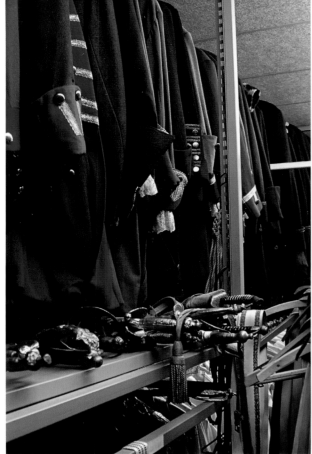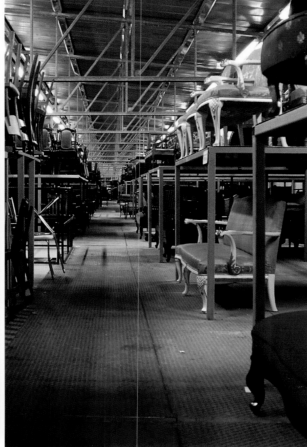

Kunstwerke oder imitieren Oberflächen, fertigen Büsten, Skulpturen und Plastiken an. Hier entsteht das mal historische, mal fantastische Gewand der Filme, dessen atmosphärische Dichte und Stimmigkeit nicht selten über Erfolg oder Misserfolg entscheiden.

Das Art Department arbeitet Hand in Hand mit dem studioeigenen Requisitenfundus, der historisch authentisches Kulissenmaterial für Spiel- und TV-Filme sowie Theaterproduktionen bietet. Er enthält über eine Million Einzelteile, von Kleinrequisiten wie Lampen, Haushalts- und Einrichtungsgegenständen aller Art bis hin zu Großrequisiten wie Möbeln, Schränken oder Einbauteilen. Szenenbildner und Requisiteure sind in der Lage, aus dem Fundus heraus themen- oder geschichtsbezogene Komplettdekorationen zu gestalten. Das Kostümstudio wiederum verfügt über einen Fundus von mehr als 250 000 Kostümen und Uniformen, die aus allen Epochen des 20. Jahrhunderts stammen. Neuanfertigungen, von der Kostümwerkstatt Stars und Statisten – den Ansprüchen der jeweiligen Produktion gemäß – auf den Leib geschnitten, ergänzen den Bestand bis in die unmittelbare Gegenwart. Der Vorrat an Schuhen, Helmen, Effekten, Stickereien und anderen Applikationen ist sortiert nach Größen für Kinder, Damen und Herren und geordnet nach speziellen Bekleidungsgruppen, zu denen sogar die entsprechenden Nachschlagewerke vorrätig gehalten werden: Stilgewänder und moderne Kostüme, Berufs- und Freizeitbekleidung, Justiz- und Kirchenmonturen, moderne und historische Uniformen. Zahlreiche Großproduktionen mit historischen Sujets aus so verschiedenen Epochen wie *Der Pianist*, *In 80 Tagen um die Welt* (2004), *Das Leben der Anderen* (2006), *Black Book* (2006), *Die Fälscher* (2007), *Der Vorleser* (2008), *Der Baader Meinhof Komplex* (2008), *Operation Walküre* oder zuletzt *Anonymus* und *Die drei Musketiere* haben sich aus dem Kostüm- und Requisitenfundus Babelsbergs bedient und das Können seiner Mitarbeiter in Anspruch genommen.

In allen diesen Kernbereichen der Filmherstellung hat sich das Studio Babelsberg in der nationalen und internationalen Filmlandschaft als gleichberechtigter Koproduzent oder als Dienstleister für Fremdproduktionen etabliert. Die Angebotsliste der Serviceleistungen ist dabei so lang wie kaum eine andere im europäischen Studiosystem. Sie umfasst das gesamte Produktionsmanagement: die Suche nach passenden Drehorten und das Einholen von Dreh- und Arbeitsgenehmigungen, die Kalkulation von Budgets und Drehplänen, die Auswahl und Anstellung von Mitarbeitern vor und hinter der Kamera, den Abschluss von Versicherungen, die Vermittlung geeigneter Koproduzenten und Finanziers, die Beratung bei Vertragsabschlüssen, Rechts- und Steuerfragen sowie anderes mehr. Als einer von wenigen europäischen Studio-komplexen kann Babelsberg großen Produktionen damit einen „full service" bieten, der sämtliche Aspekte der Filmarbeit unter der verantwortlichen Kontrolle des Studios abdeckt.[8]

The set dressing departments harbor over 250,000 costumes and more than a million props.

Über 250 000 Kostüme und mehr als eine Million Requisiten beherbergen die Ausstattungsbereiche.

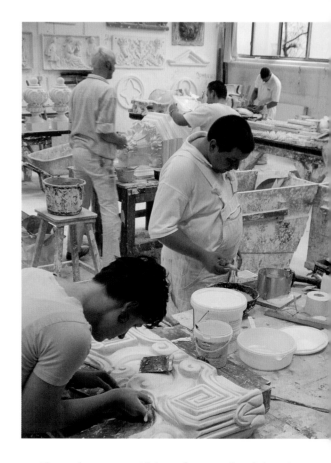

The art department with its craftsmen and workshops is counted among the best of the world.

Das Art Department zählt mit seinen Kunsthandwerkern und Werkstätten zu den besten der Welt.

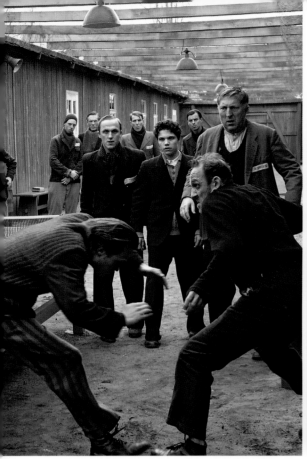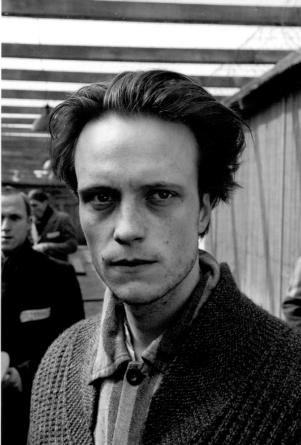

Scenes from *The Counterfeiters*
(Director: Stefan Ruzowitzky) starring
August Diehl (middle) and Karl Markovics (right).
The film was shot in 2006 at Babelsberg and
won the Oscar in the category
Best Foreign-Language Film in 2008.

Szenen aus *Die Fälscher* (Regie: Stefan Ruzowitzky)
mit August Diehl (Mitte) und Karl Markovics (rechts).
Der Film wurde 2006 in Babelsberg gedreht und
erhielt 2008 den Oscar in der Kategorie
„Bester nicht-englischsprachiger Film".

"When will Babelsberg once again write film history?"[9] The signal broadcast from the headline of the regional paper at the beginning of 1993 was unmistakable: public impatience was palpable. In the third year after the German reunification, two and a half years after DEFA-Spielfilm GmbH, which was "in liquidation," had transformed into "DEFA Studio Babelsberg GmbH" on July 1, 1990,[10] and a mere six months after the studio lot and inventory was bought by Compagnie Immobilière Phénix (CIP), part of the French conglomerate Compagnie Générale des Eaux (CGE, after 1998: Vivendi), the future usage of the 114-acre area remained completely open. Already in October 1991, the Ostdeutsche Rundfunk Brandenburg, a regional TV station, part of the pan-German television network ARD, had set up shop on the lot, and the CIP had founded "Studio Babelsberg GmbH" under the leadership of Oscar-winning director Volker Schlöndorff and industry manager Pierre Couveinhes. But their connection to Babelsberg's Golden Age, the sensitive synthesis of the Ufa mythos and DEFA tradition, was at this point in time not yet achieved.

Schlöndorff, who grew up in France, was a popular and well-connected director in the film scene. Along with Alexander Kluge, Edgar Reitz, Wim Wenders, Werner Herzog, and Rainer Werner Fassbinder, he belongs to a generation of filmmakers whose works in the 1960s and '70s forever changed the film landscape of the Federal Republic of Germany, and won international acclaim at festivals under the title of "New German Cinema." Under the impression of Schlöndorff films like *Young Törless* (1966) and the Oscar-winning adaptation of Günter Grass's *The Tin Drum* (1979), critics of the time spoke of a second Golden Age of German cinema, which would finally manage to connect with the artistic triumphs of the Ufa from the 1920s and early '30s. Therefore, Schlöndorff's first impressions of his encounter with the "historic site" of Babelsberg after his return from the U.S. resemble a symbolic homecoming:

> So this was the site of my dreams, the cradle of film art, the DEFA's studio lot privatized by the Treuhand. [...] It actually didn't remind me at all of the great films that once emerged from here. It had begun [...] with Asta Nielsen's *The Dance to Death*; in 1917, the Kaiser's generals, Ludendorff and the Deutsche Bank founded Ufa here, in order to mobilize the proletarian masses for the crown and for war; and then the artists came, Friedrich Wilhelm Murnau shot *Faust* and *The Last Laugh*, Fritz Lang *Metropolis*, *Dr. Mabuse*, *Die Nibelungen*, Greta Garbo performed in *The Joyless Street* and Marlene Dietrich in *The Blue Angel*. To emulate these role models was my lifelong ambition. But I knew, however, that Goebbels had ruled here and the Soviets and the SED after them.[11]

But what inspired Schlöndorff to swap the familiar director's chair of a film *auteur* for the executive chair of a studio mogul in 1992, was the historic aura of Babelsberg and the former DEFA employees active there whose creative traditions stretched back far into film history:

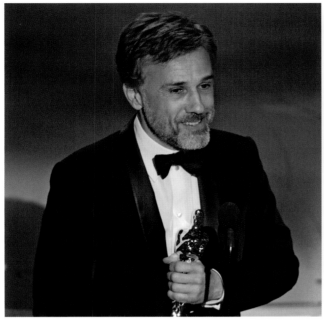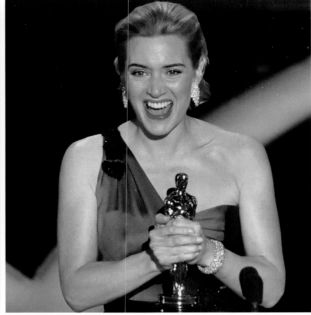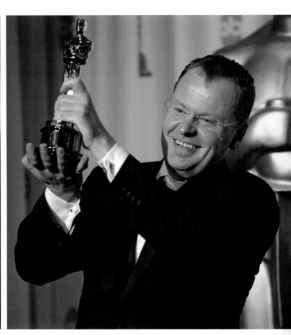

Die kontinuierlich starke Anziehungskraft auf berühmte Stars und bedeutende Regisseure, internationale Kassen- und Festivalerfolge und natürlich die Oscarnominierungen und -auszeichnungen 2008 für *Die Fälscher*, 2009 für *Der Vorleser* und 2010 für *Inglourious Basterds* zeugen von der handwerklichen Qualität der in den letzten Jahren geleisteten Arbeit. Sie untermauern die führende Stellung von Babelsberg, wenn es um die professionelle Realisierung hoch budgetierter Filmprojekte geht. Darüber lässt sich leicht vergessen, dass der Weg dorthin lang und in den ersten Jahren nach der Privatisierung des Studios auch nicht unbedingt vorgezeichnet war.

„Wann schreibt Babelsberg wieder Filmgeschichte?"[9] Das Signal, das von der Schlagzeile der Regionalpresse Anfang 1993 ausging, war unmissverständlich: In der Öffentlichkeit machte sich Ungeduld breit. Im dritten Jahr nach der deutschen Wiedervereinigung, zweieinhalb Jahre nachdem die „in Auflösung" befindliche DEFA-Spielfilm GmbH am 1. Juli 1990 in die „DEFA Studio Babelsberg GmbH" umgewandelt worden war,[10] ein knappes halbes Jahr nach der Übernahme von Gelände und Inventar durch die Compagnie Immobilière Phénix (CIP), Teil des französischen Konzerns Compagnie Générale des Eaux (CGE, ab 1998: Vivendi), war die zukünftige Nutzung des zu diesem Zeitpunkt 461 000 m² großen Areals weiterhin völlig offen. Zwar hatte sich bereits im Oktober 1991 der Ostdeutsche Rundfunk Brandenburg, ein Regionalsender der bundesweiten Fernsehanstalt ARD, auf dem Gelände angesiedelt und die CIP unter Führung des Regisseurs und Oscarpreisträgers Volker Schlöndorff sowie des Industriemanagers Pierre Couveinhes die „Studio Babelsberg GmbH" gegründet. Der Anschluss an die großen Zeiten Babelsbergs, die sensible Synthese aus Ufa-Mythos und DEFA-Tradition, war jedoch noch keineswegs gelungen.

Der in Frankreich aufgewachsene Schlöndorff war zu Beginn der 90er Jahre ein gefragter und in der Filmszene gut vernetzter Regisseur. Neben Alexander Kluge, Edgar Reitz, Wim Wenders, Werner Herzog und Rainer Werner Fassbinder gehört er einer Generation von Filmemachern an, deren Werke in den 60er und 70er Jahren die Filmlandschaft der Bundesrepublik Deutschland nachhaltig verändert und unter dem Begriff des „Neuen Deutschen Films" internationale Anerkennung auf Festivals errungen hatten. Unter dem Eindruck von Schlöndorff-Filmen wie *Der junge Törless* (1966) und der mit einem Oscar dekorierten Günter-Grass-Verfilmung. *Die Blechtrommel* (1979) sprachen Kritiker damals vom Anbruch eines zweiten Goldenen Zeitalters des deutschen Films, das endlich an die künstlerischen Triumphe der Ufa aus den 20er und frühen 30er Jahren anzuschließen vermochte. Schlöndorffs erste Eindrücke bei der Begegnung mit dem „geschichtsträchtigen Gelände" Babelsbergs nach seiner Anreise aus den USA gleichen daher nicht zufällig einer symbolischen Heimkehr:

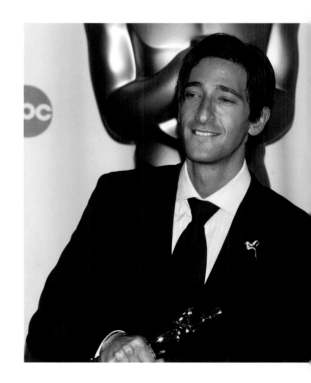

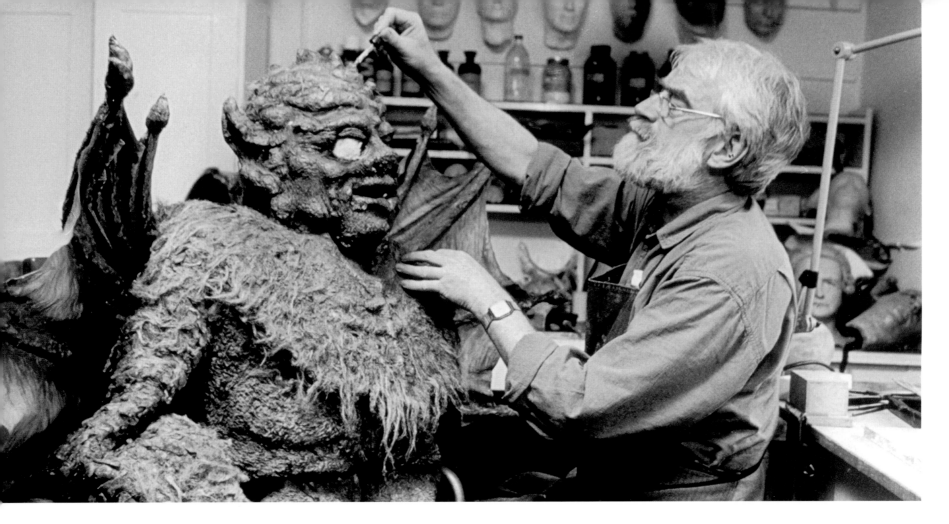

Attention to detail in the ateliers of Babelsberg

Detailarbeit in den Babelsberger Ateliers

Given the desolate conditions on the ground, I was initially inclined to withdraw from the entire emprise. But then I met the people on the lot: the drivers, the painters, the plasterers, the sound people, the milliners, the master carpenters, lighting technicians, and stage hands, most of them second- or third-generation film industry employees. In interacting with them, I immediately detected a kind of guild-like community. They were no different from their counterparts in Paris, London or Hollywood. I understood that, thanks to a historical accident, a classical film studio of the 1920s was being presented on a silver platter, complete with technicians, craftsmen, and an unbroken tradition that goes back to the origins of cinema.[12]

His vision of Babelsberg was of one of a European-transatlantic market place for concepts, materials, and projects, the creative combination of art and commerce, the entrenchment of a "transnational" film aesthetic, as he had done in his own films for a considerable time, on the historic lot:

My utopia looks quite simple: in one hall, Wim Wenders or Werner Herzog is shooting, and Louis Malle or Claude Chabrol in the next one, then Englishmen like Peter Greenaway, or Americans like Martin Scorsese. And in the canteen, they all meet, discuss, plan, sketch out new films. A place of constant meetings, I want to create a symbiosis of forces and fantasies—as it once was here at the Ufa before the Nazis destroyed it all.[13]

Four points defined the projects that Schlöndorff wanted to produce with his studio: they were to be shot in English, to be designed for the American market, to cost at least 10 million deutschmark, and to be able to cover at least half of these costs through the sale of international distribution rights.[14] It was a list of criteria that, from the outset, appeared to exclude from consideration many former DEFA directors.

In terms of infrastructure, the new studio owners took the necessary measures over the course of 1993. Under the leadership of Pierre Couveinhes' newly founded company "Euromedien GmbH," over 60 buildings were torn down, other facilities were renovated to be preserved out of historical reasons, and the studio was equipped with modern technology. In the first three years after the takeover of the studio lot, studio owner CIP had already invested around 500 million deutschmark. A development plan had been agreed upon earlier; this determined that predominantly companies from the media industry would establish themselves on the lot and its immediate vicinity, which would strengthen it as a production location. A corresponding architectural competition was announced and implemented quickly after the bid was accepted. The construction of the new Medienstadt Babelsberg (Media City Babelsberg) was in full swing.

Das war also der Ort meiner Träume, die Wiege der Filmkunst, das von der Treuhand zur Privatisierung ausgeschriebene Studiogelände der DEFA. [...] Tatsächlich erinnerte nichts an die großartigen Filme, die hier einmal entstanden waren. Begonnen hatte es [...] mit Asta Nielsens *Totentanz*; 1917 hatten des Kaisers Generäle, Ludendorff und die Deutsche Bank hier die Ufa gegründet, um durch das neue Medium die proletarischen Massen für die Krone und den Krieg zu mobilisieren; dann kamen die Künstler, Friedrich Wilhelm Murnau drehte *Faust* und *Der letzte Mann*, Fritz Lang *Metropolis*, *Dr. Mabuse*, *Die Nibelungen*, Greta Garbo trat in *Die freudlose Gasse* auf und Marlene Dietrich in *Der blaue Engel*. Diesen Vorbildern nachzueifern war mein lebenslanger Ehrgeiz gewesen. Allerdings wusste ich, dass Goebbels hier geherrscht hatte und nach ihm die Sowjets und die SED.[11]

Was Schlöndorff nach eigener Auskunft das Wagnis eingehen ließ, im August 1992 vom gewohnten Regiestuhl des Autorenfilmers in den Chefsessel eines Studiomoguls zu wechseln, waren neben der historischen Aura Babelsbergs vor allem die weit in die Filmgeschichte zurückreichenden kreativen Traditionen der an diesem Ort tätigen ehemaligen DEFA-Mitarbeiter:

Angesichts der desolaten Zustände vor Ort war ich zunächst geneigt, mich von dem ganzen Unternehmen zurückzuziehen. Aber dann traf ich die Menschen auf dem Gelände, die Fahrer, die Kunstmaler, die Stuckateure, die Tonleute, die Putzmacherinnen, die Tischlermeister, Beleuchter und Bühnenarbeiter – die meisten von ihnen in der zweiten oder dritten Generation beim Film. Im Umgang mit ihnen spürte ich sofort eine Art zunftmäßiger Gemeinsamkeit. Sie unterschieden sich in nichts von ihren Kollegen in Paris, London oder Hollywood. Ich begriff, dass uns hier durch einen Unfall der Geschichte ein klassisches Filmstudio der zwanziger Jahre auf dem Präsentierteller dargeboten wurde, komplett mit Technikern, Handwerkern und ungebrochenen Traditionen, die zurückreichten bis zu den Anfängen des Kinos.[12]

Seine Vision von Babelsberg war die eines europäisch-transatlantischen Umschlagplatzes für Ideen, Stoffe und Projekte, die kreative Verbindung von Kunst und Kommerz, die Verankerung einer „transnationalen" Filmästhetik auf historischem Gelände, wie er sie in seinen eigenen Filmen bereits seit geraumer Zeit praktiziert hatte:

Meine Utopie sieht ganz einfach aus: In der einen Halle dreht Wim Wenders oder Werner Herzog, in der daneben Louis Malle oder Claude Chabrol, da kommen Engländer wie Peter Greenaway oder Amerikaner wie Martin Scorsese. Und in der Kantine treffen sie sich alle, diskutieren, planen, hecken neue Filme aus. So einen Ort der ständigen Begegnungen, der Bündelung der Kräfte und Phantasien will ich schaffen – wie es hier bei der Ufa einmal war, bevor die Nazis alles zerstörten.[13]

Vier Punkte definierten die Projekte, die Schlöndorff mit seinem Studio produzieren wollte: Sie sollten in englischer Sprache gedreht sein, sich am US-amerikanischen Markt orientieren, über ein Produktionsvolumen von mindestens 10 Millionen DM verfügen und die Hälfte dieser

Workshop area in the art department at
Studio Babelsberg

Werkstattbereich im Art Department von
Studio Babelsberg

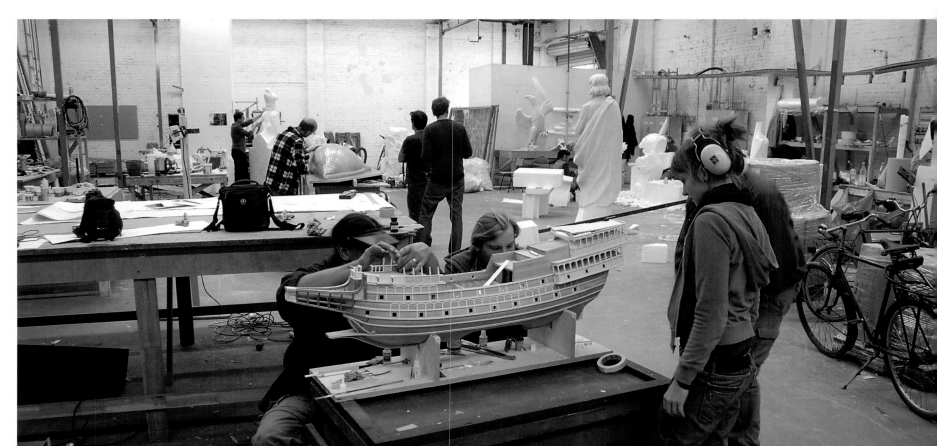

In support, well-known directors and actors came to visit Babelsberg: Billy Wilder, who had begun his career as a gag writer for the former Ufa, Francis Ford Coppola, and Anthony Hopkins. Schlöndorff had a very special relationship with Wilder. If Wilder had a slip of paper in his Hollywood office with the question "How would Lubitsch do it?", now, over Schlöndorff's desk in his Babelsberg office, a handwritten DIN-A-4 sheet hung with the words: "How would Billy do it? Would he do it?"

This form of reassurance was more than justified. During the first year of the implementation of Schlöndorff's ambitious vision, a series of obstacles were encountered. There were confrontations with the staff, who feared that the studio, as property of a French real estate company, might only serve as a fig leaf over the real goal of destroying the studio in order to sell the prime real estate on the edge of Berlin at a profit. Meanwhile, the employers lamented the inertia of the large apparatus of 740 inherited former DEFA employees, as it prevented the necessary flexibility of an internationally competitive studio. On top of that came a rather reticent subsidy policy and a cautious attitude by investors, not least because, shortly after the reunification, the high exchange rate for the deutschmark played a large role in halting the green lighting of major European projects and keeping Hollywood contracts at bay. The studio's continuing operation during the early years was largely maintained by contract work for German television.

The first feature film production of the studio after the privatization—shot in the fall of 1992—was consequently a purely German matter: *The Movie Teller* (1993), based on the eponymous novel by Gert Hofmann, which had been a surprise hit on the German book market two years earlier. The film tells the nostalgically inspired story of a pianist and narrator who accompanied and explained the silent films screened at a provincial theater in Saxony, and whose popularity increased over the years. At the beginning of the 1930s, this protagonist is inevitably a victim of the transition to talkies and, in the following years, increasingly comes into conflict with the Nazis. Armin Mueller-Stahl was cast in the starring role. The former DEFA actor had shot countless

Armin Mueller-Stahl in *The Movie Teller* (1993, Director: Bernhard Sinkel), the first feature film production of the studio after privatization

Armin Mueller-Stahl in *Der Kinoerzähler* (1993, Regie: Bernhard Sinkel), der ersten Kinoproduktion des Studios nach der Privatisierung

RAUCHEN VERBOTEN

In 1993, Billy Wilder visited Studio Babelsberg.

Billy Wilder besucht 1993 Studio Babelsberg.

Kosten über den Verkauf der internationalen Vertriebsrechte zu decken in der Lage sein.[14] Ein Kriterienkatalog, der viele ehemalige DEFA-Regisseure von vornherein aus den Erwägungen auszuschließen schien.

In Sachen Infrastruktur ergriff man im Laufe des Jahres 1993 die notwendigen Maßnahmen: Unter der Federführung der von Pierre Couveinhes neu gegründeten „Euromedien GmbH" wurden etwa 60 Gebäude abgerissen, die unter Denkmalschutz stehenden Häuser saniert und mit moderner Technik ausgestattet. Um die 500 Millionen DM investierte allein der Studio-Eigentümer CIP in den ersten drei Jahren nach der Übernahme des Geländes. Zuvor war ein Bebauungsplan beschlossen und festgelegt worden, der vorsah, dass sich auf dem Gelände und seiner unmittelbaren Umgebung überwiegend Firmen aus dem Medienbereich ansiedeln und auf diese Weise den Produktionsstandort stärken sollten. Ein entsprechender Architektenwettbewerb wurde ausgeschrieben, nach dem Zuschlag zügig umgesetzt. Die Errichtung der neuen Medienstadt Babelsberg war in vollem Gange.

Als Begleitmaßnahme kamen namhafte Regisseure und Schauspieler zu Besuch nach Babelsberg: Billy Wilder, der seine Karriere einst als Gagschreiber für die Ufa begonnen hatte, Francis Ford Coppola und Anthony Hopkins. Mit Wilder verband Schlöndorff eine ganz besondere Beziehung: Hatte Wilder in seinem Arbeitszimmer in Hollywood einen Zettel mit der Frage angebracht: „How would Lubitsch do it?", so hing nun über dem Schreibtisch von Schlöndorffs Babelsberger Büro ein handbeschriebenes DIN-A-4-Blatt mit den Worten: „How would Billy do it? Would he do it?"

Die ideelle Rückversicherung war durchaus berechtigt. Im ersten Jahr standen der Umsetzung von Schlöndorffs ambitionierter Vision eine Reihe von Hindernissen entgegen: Es gab Auseinandersetzungen mit der Belegschaft, die befürchtete, das Studio, Tochter einer französischen Immobilienfirma, könne lediglich als Feigenblatt dienen, um den lukrativen Standort am Rande Berlins zu zerschlagen und mit Gewinn wieder zu veräußern. Von Arbeitgeberseite wurde die Unbeweglichkeit des großen Apparats von 740 übernommenen ehemaligen DEFA-Mitarbeitern beklagt, der die notwendige Flexibilität eines im internationalen Wettbewerb stehenden Studios nicht aufbrächte. Hinzu kamen eine eher zögerliche Subventionspolitik und eine abwartende Haltung von Investoren; nicht zuletzt hatte auch der – kurz nach der Wiedervereinigung – hohe Wechselkurs der Deutschen Mark seinen Anteil daran, dass die Akquisition europäischer Großprojekte und auch Aufträge aus Hollywood zunächst ausblieben. Der laufende Studiobetrieb wurde in den Anfangsjahren weitgehend von Auftragsarbeiten fürs deutsche Fernsehen aufrechterhalten.

Die erste Kinoproduktion des Studios nach der Privatisierung – im Herbst 1992 gedreht – war folglich eine rein deutsche Angelegenheit: *Der Kinoerzähler* (1993) nach dem gleichnamigen Roman von Gert Hofmann, zwei Jahre zuvor ein Überraschungserfolg auf dem deutschen Buchmarkt.

The period film *Mesmer*
(1994, Director: Roger Spottiswoode) starring
Alan Rickman was the first international
coproduction after the "Change."

Der Historienfilm *Mesmer*
(1994, Regie: Roger Spottiswoode) mit
Alan Rickman war die erste internationale
Koproduktion nach der „Wende".

films in Babelsberg between 1959 and 1980, when he left the GDR and became an international star in the West. For the role of the movie teller Karl Hofmann, Mueller-Stahl returned to his old stomping grounds. But even Schlöndorff gave himself a telling role: "The new studio boss played, armed with monocle and cigar, a gruff general director from the old Ufa."[15]

Other productions from the early days of the studio also establish equally personal and thematic relations with DEFA.[16] *The Blue One* (1994) places two former DEFA stars at the center: Manfred Krug plays an ex-Stasi spy who is now a Bundestag official in the reunited Germany, but who is then haunted by his past in the form of the former friend of his daughter, played by Ulrich Mühe. In the spring of 1996, Armin Mueller-Stahl started working in Babelsberg again. He shot the bizarre drama *Conversation with the Beast* (1996) in the sound stage "Large South," and was not only the main actor, but also writer and director. The shooting of this "What if?" parable happened under the strictest of secrecy: no one was to get a glimpse of Mueller-Stahl playing a fictitious Hitler who sent a doppelgänger to his death and survived World War II.

Other projects guaranteed the regular influx of money. Among them was the TV mini-series *Catherine the Great* (1994), an Ufa and CBS coproduction made for U.S. network television, which shows young Catherine Zeta-Jones in the role of the Russian queen. Already in the fall of 1993, the first Studio Babelsberg international coproduction *Mesmer* (1994) came into being. In the Marlene Dietrich Stage, Canadian director Roger Spottiswoode shot the story of the legendary miracle healer of Vienna based on a script by Dennis Potter with Alan Rickman in the title role. The music to the film was written by Michael Nyman, who that same year had also composed the soundtrack to the much-celebrated film *The Piano*. The next big step was *The Neverending Story III: Escape from Fantasia* (USA/Germany 1994), the continuation of the fantasy epic that began a decade earlier with Wolfgang Petersen's adaptation of Michael Ende's bestseller, which was a worldwide box office hit. Studio Babelsberg served as an equal coproducer on the multi-million dollar project. The service provider revenue for the studio utilized by this project in the second half of 1993 was over 3 million deutschmark per month and required three quarters of its capacity.[17] Producer Dieter Geissler stresses that "with productions of this magnitude, [...] it makes no sense to talk about 'German' films":

> The team was primarily composed of Germans and Englishmen. The actors had to come from America again [...] to make it in the American market. [...] For the studio administration, it was certainly a positive experience that the native employees got along very well with the international team. [...] The Babelsberg people have their own traditions and techniques. And then, suddenly, some international filmmakers came through who needed things done differently and faster, for whom time really meant money. But the Babelsberg staff noticed very quickly that such major productions had to be implemented with a completely different level of pressure.[18]

Der Film erzählt die nostalgisch angehauchte Geschichte eines Klavierspielers und Filmerklärers, der in einem sächsischen Provinzkino für sein Publikum über Jahre hinweg mit wachsender Beliebtheit die gezeigten Stummfilme begleitet und erläutert hatte. Zu Beginn der 30er Jahre wird er unweigerlich ein Opfer der Umstellung auf Tonfilm und gerät in den Folgejahren zunehmend mit den Nazis in Konflikt. Für die Hauptrolle konnte Armin Mueller-Stahl verpflichtet werden. Der ehemalige DEFA-Schauspieler hatte seit 1959 unzählige Male in Babelsberg gedreht, bevor er, 1980 aus der DDR ausgereist, im Westen zum internationalen Star aufgestiegen war. Für die Rolle des Kinoerzählers Karl Hofmann kehrte Mueller-Stahl erstmals an seine alte Wirkungsstätte zurück. Aber auch Schlöndorff gönnte sich einen vielsagenden Auftritt: „Der neue Studiochef spielte, mit Monokel und Zigarre bewehrt, einen knarzigen Generaldirektor der alten Ufa."[15]

Andere Produktionen aus der Anfangszeit des Studios stellen ebenfalls personelle und thematische Bezüge zur DEFA her.[16] *Der Blaue* (1994) rückt gleich zwei ehemalige DEFA-Schauspieler ins Zentrum: Manfred Krug verkörpert einen Ex-Stasispitzel, der es im wiedervereinigten Deutschland zum Bundestagsabgeordneten bringt, dann jedoch von seiner Vergangenheit – in Gestalt des von Ulrich Mühe gespielten früheren Freundes der Tochter – eingeholt wird. Im Frühjahr 1996 arbeitet Armin Mueller-Stahl erneut in Babelsberg. Im Atelier „Große Süd" dreht er, dieses Mal nicht nur als Hauptdarsteller, sondern auch als Autor und Regie-Debütant, das bizarre Kammerspiel *Gespräch mit dem Biest* (1996). Die Aufnahmen zu dieser Was-wäre-wenn-Parabel finden unter strengster Geheimhaltung statt: Niemand soll vorab Einblick erhalten, wie Mueller-Stahl die Rolle eines fiktiven Hitler spielt, der einen Doppelgänger in den Tod schickt und den Zweiten Weltkrieg überlebt.

Der regelmäßige Geldeingang wird unterdessen von anderen Projekten sichergestellt. Etwa mit dem TV-Mehrteiler *Katharina die Große* (1995), der, von der Ufa und dem US-Sender CBS kofinanziert, die junge Catherine Zeta-Jones in der Rolle der russischen Kaiserin zeigt. Schon im Herbst 1993 war mit *Mesmer* (1994) die erste internationale Koproduktion von Studio Babelsberg entstanden. Der kanadische Regisseur Roger Spottiswoode drehte in der Marlene-Dietrich-Halle die Geschichte des sagenumwobenen Wunderheilers aus Wien nach

A scene from *The Blue One*
(1994, Director: Lienhard Wawrzyn) starring
Ulrich Mühe (left) and Manfred Krug

Szene aus *Der Blaue* (1994, Regie: Lienhard Wawrzyn)
mit Ulrich Mühe (links) und Manfred Krug

In the cost- and technology-intensive realm of the fantasy film, the signals echoed by *The Neverending Story III* did not fall on deaf ears; in the following years, Babelsberg became more attractive to cinema and television productions of this genre segment. In the end, Bernd Eichinger's Constantin Film, which shot the first film of *The Neverending Story* in the Bavaria studios in Munich back in the days, sets up the interior shots for Eichinger's British-German coproduction *Prince Valiant* (1997) under the direction of action and horror specialist Anthony Hickox in the spring of 1996, thus utilizing the studio's full capacity for multiple weeks. The provision of services for this film had a noticeable breadth and depth: based on models by production designer Crispian Sallis (*Twelve Monkeys*), the art department manufactured extensive backdrop sets for this adaptation of Hal Foster's famous fantasy comic from the 1930s.

In light of the substantially improved situation of the studio, thanks to *Neverending Story III* and other major projects, in the summer of 1994, Volker Schlöndorff saw that the time had come for him to return to his own directorial projects. He wanted to devote only ten percent of his work to his role as the "general overseer of the enterprise" in the coming year: "The urban planning, modernization and especially the hiring of personnel has now been completed," he reported to the industry press.[19] Once again, it seemed, he was taking the advice of his mentor Billy Wilder to heart. Apparently, Wilder reminded him, during his visit in Babelsberg, that he was a director and was not to be concerned with holes in the roof, but rather the holes in the scripts.[20] In 1994, together with Wolfgang Kohlhaase, writer of some of the most important DEFA films, Schlöndorff began work on *The Legend of Rita* (2000), the story of an RAF terrorist who has gone underground in the GDR, which, however, would not be realized in Babelsberg until 1999.

The first directorial work that Schlöndorff carried out during his time as business manager for the studio was in 1995: *The Ogre* (1996), the life story of a French loner who becomes a German prisoner of war in World War II and is made the stooge of the National Socialists. He is selected as Göring's hunting assistant and a violent collector of adolescent males who are to be prepared for Wehrmacht service in the elite Napola boarding school. The conditions of the film's production throw an equally sharp light on the complicated strategic contexts in which the studio was involved en route to internationalization, as well as the uncertainties with which one must always deal. The idea to make French writer Michel Tournier's novel into a film originated from former

Director Peter MacDonald during the making of
The Neverending Story III (1994) in the
Marlene Dietrich Stage

Regisseur Peter MacDonald während der Dreharbeiten zu
Die unendliche Geschichte III (1994) in der
Marlene-Dietrich-Halle

einem Buch des Briten Dennis Potter mit Alan Rickman in der Titelrolle. Die Musik zum Film stammte von Michael Nyman, der auch den Soundtrack zum im gleichen Jahr gefeierten Film *Das Piano* (1993) komponiert hatte. Die größte Signalwirkung ging dann jedoch von *Die unendliche Geschichte III – Rettung aus Phantasien* (USA/D 1994) aus, der Fortsetzung des Fantasy-Epos, das zehn Jahre zuvor mit Wolfgang Petersens Verfilmung des Bestsellers von Michael Ende begonnen hatte und zu einem weltweiten Kinoerfolg geworden war. Studio Babelsberg fungierte bei dem viele Millionen schweren Projekt als gleichberechtigter Koproduzent; der reine Dienstleistungsumsatz für das Studio, das durch dieses Projekt im zweiten Halbjahr 1993 zu drei Vierteln ausgelastet war, betrug knapp 3 Millionen DM pro Monat.[17] Produzent Dieter Geissler unterstreicht, dass es bei „Produktionen dieser Größenordnung [...] keinen Sinn mehr" habe, „von ,deutschen' Filmen zu sprechen":

> Das Team bestand vor allem aus Deutschen und Engländern. Die Schauspieler mußten allerdings wieder aus Amerika sein [...], um in den amerikanischen Markt zu gelangen. [...] Für die Studioleitung war es sicher auch eine positive Erfahrung, daß die angestammten Mitarbeiter sich schließlich sehr gut mit unserem internationalen Team verstanden haben. [...] Die Babelsberger haben ihre eigenen Traditionen und Techniken. Und da kamen plötzlich irgendwelche internationalen Filmemacher, die die Dinge anders und viel zügiger brauchten, für die Zeit wirklich Geld bedeutete. Aber die Babelsberger haben das sehr schnell gemerkt, daß solche Großproduktionen mit einem ganz anderen Druck durchgezogen werden müssen.[18]

Falkor the luckdragon at Babelsberg

Glücksdrache Fuchur in Babelsberg

Im kosten- und technikintensiven Bereich des Fantasy Films verhallte das von *Die unendliche Geschichte III* ausgehende Signal nicht ungehört, sodass Babelsberg in den Folgejahren immer wieder Kino- und TV-Produktionen aus diesem Genre-Segment anziehen wird. Schließlich lässt auch Bernd Eichingers Constantin Film, die den ersten Teil der *Unendlichen Geschichte* seinerzeit in den Münchner Bavaria-Studios gedreht hatte, unter der Regie des Action- und Horror-Spezialisten Anthony Hickox im Frühjahr 1996 Innenaufnahmen für ihre britisch-deutsche Koproduktion *Prinz Eisenherz* (1997) in Babelsberg herstellen und lastet damit die Studiokapazitäten für mehrere Wochen aus. Die Dienstleistungen für diesen Film haben einen beträchtlichen Umfang: Nach Vorlagen des Produktionsdesigners Crispian Sallis (*Twelve Monkeys*) stellt das Art Department aufwendige Kulissenbauten für die Verfilmung des berühmten Fantasy-Comics von Hal Foster aus den 30er Jahren her.

Angesichts der durch *Die unendliche Geschichte III* und andere Großprojekte nachhaltig verbesserten Situation des Studios sieht Volker Schlöndorff im Sommer 1994 die Zeit gekommen, sich wieder verstärkt eigenen Regiearbeiten zuzuwenden. Nur zehn Prozent seiner Arbeit will er in den kommenden Jahren noch seiner Rolle als „Generalüberwacher des Unternehmens" widmen: „Die städtebauliche Planung, die Modernisierung und vor allem das Anheuern von Mitarbeitern ist jetzt durchgezogen", gibt er der Fachpresse zu Protokoll.[19] Einmal mehr scheint er damit einen Rat seines Mentors Billy Wilder zu beherzigen. Wilder soll ihn bei seinem Besuch in Babelsberg daran erinnert haben, dass er Regisseur sei und sich nicht um die Löcher im Dach, sondern um die Löcher in Drehbüchern zu kümmern habe.[20] Gemeinsam mit Wolfgang Kohlhaase, Autor einiger der bedeutendsten DEFA-Filme, arbeitet Schlöndorff ab 1994 am Buch zu *Die Stille nach dem Schuss* (2000), der Geschichte einer in der DDR untergetauchten RAF-Terroristin, die allerdings erst 1999 in den Babelsberger Studios realisiert wird.

Die erste Regie-Arbeit, die Schlöndorff während seiner Zeit als Geschäftsführer für das Studio ausführt, ist 1995 *Der Unhold* (1996), die Lebensgeschichte eines französischen Einzelgängers, der im Zweiten Weltkrieg in deutsche Kriegsgefangenschaft gerät und sich zum Handlanger der Nationalsozialisten macht: als Jagdhelfer Görings und gewaltsamer Eintreiber von halbwüchsigen Männern, die im Elite-Internat „Napola" auf den Dienst in der Wehrmacht vorbereitet werden. Die Entstehungsumstände des Films werfen ein gleichermaßen scharfes Licht auf die komplizierten strategischen Zusammenhänge, in die das Studio auf dem Weg zu seiner Internationalisierung eingebunden war, wie auch auf die Unwägbarkeiten, mit denen

DEFA director Rainer Simon. But Schlöndorff took the project out of his hands. The studio head wanted to use it to get Gérard Depardieu, the celebrated actor from *Cyrano de Bergerac* (1990) who was in front of the Babelsberg cameras for the French-German coproduction sci-fi thriller *The Machine* (1994) at this time, to play another monster with a human face. Together with Jean-Claude Carrière, Schlöndorff wrote the screenplay in French, the intended language of the production. But then everything changed:

> When the preparations were as good as finished, Depardieu suddenly had a crisis, called off all his projects and then disappeared in America. [...] John Malkovich was ready to jump in. [...] His name was as good as Depardieu's for the financing, but he wasn't French. Just like with *Homo Faber* (1991), they now had to shoot in English. So the German-French language mixture was lost. Victors and prisoners spoke more or less accent-free English, and all authenticity was lost, grounded in nothing except the already somewhat straightforward tale [...] The finished film—full of bravura performances (Volker Spengler's Göring), a murderous hunt in Mazury [...] with a sonorous brass orchestra (Michael Nyman) and all the otherwise serviceable ingredients—was an indigestible brew which was received with shaking heads.[21]

There was also some discomfort about the eclectic mix of styles in *The Ogre*: it combined an homage to French director Louis Malle—who died in November 1995 and to whom the film is dedicated, since the black-and-white opening scenes of Schlöndorff's film are reminiscent of *Au revoir les enfants* (1987)—with set pieces of a visual language borrowed from the aesthetic of Leni Riefenstahl's Nazi Party Congress films.[22] The skepticism after the film premiered intensified when it became apparent that in 1994 Schlöndorff had been negotiating with the then 91-year-old Riefenstahl about collaboration on a film about the Mercedes "Silver Arrow" and the car racing sports of the 1930s, because Riefenstahl—according to Schlöndorff—had so perfectly captured the visual style of that time in her own films.[23]

Gérard Depardieu in the French-German coproduction *The Machine* (1994, Director: François Dupeyron)

Gérard Depardieu in der französisch-deutschen Koproduktion *Die Maschine* (1994, Regie: François Dupeyron)

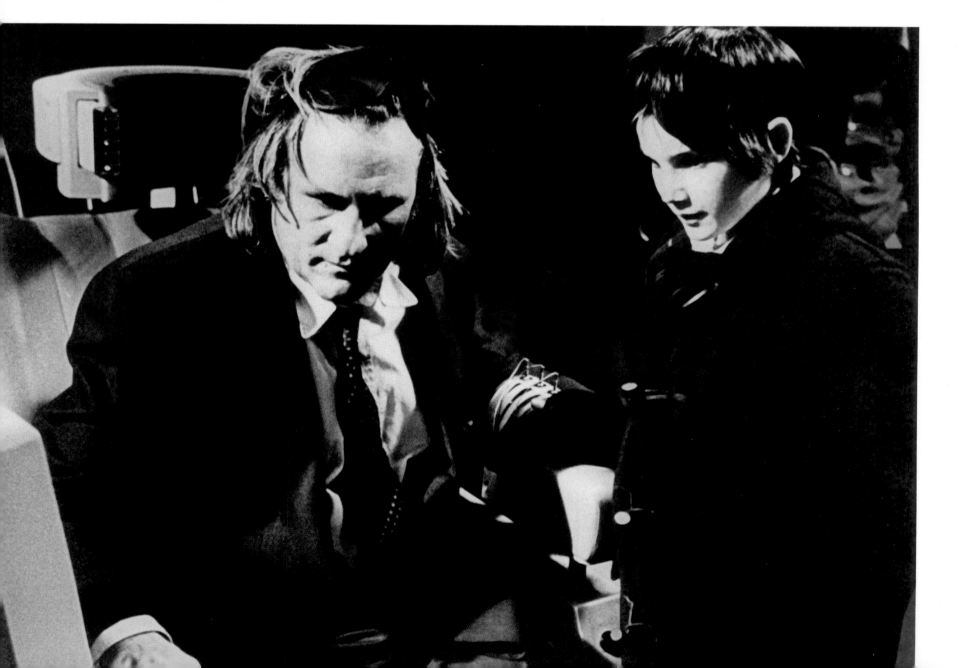

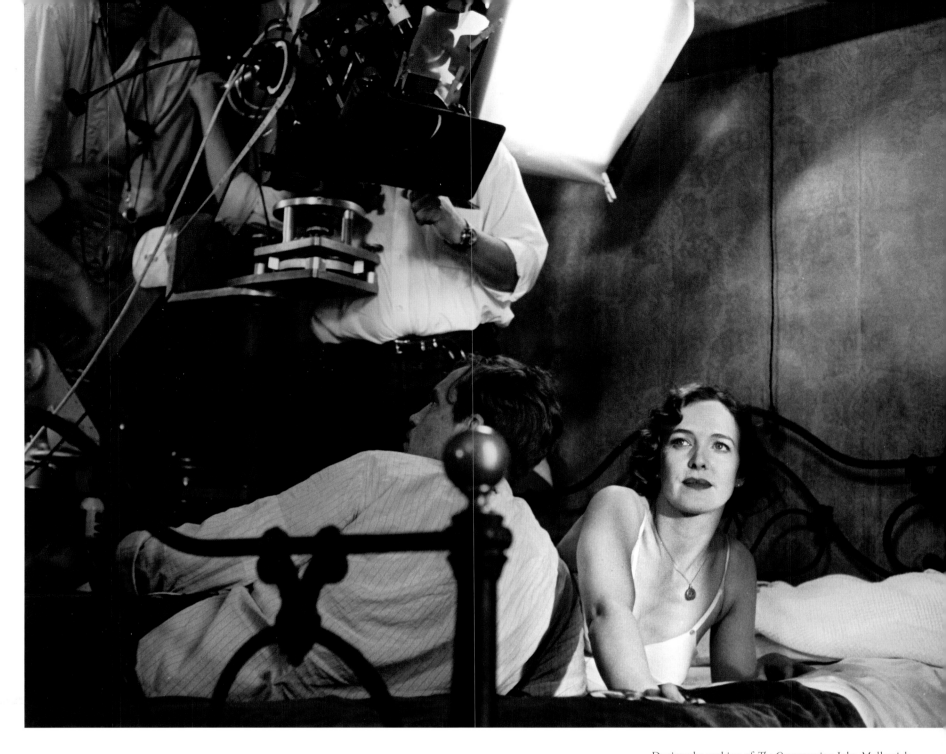

During the making of *The Ogre* starring John Malkovich and Agnès Soral (1996, Director: Volker Schlöndorff)

Während der Dreharbeiten zu *Der Unhold* mit John Malkovich und Agnès Soral (1996, Regie: Volker Schlöndorff)

man immer rechnen musste. Die Idee, den Roman des französischen Autors Michel Tournier zu einem Film zu machen, stammte ursprünglich vom ehemaligen DEFA-Regisseur Rainer Simon. Das Projekt wurde ihm jedoch von Schlöndorff aus der Hand genommen. Der Studiochef wollte es sich zunutze machen, dass Gérard Depardieu im Frühjahr 1994 gerade in Babelsberg für eine französisch-deutsche Koproduktion, den Science-Fiction-Thriller *Die Maschine* (1994), vor der Kamera stand, um dem gefeierten Darsteller aus *Cyrano de Bergerac* (1990) die Rolle eines weiteren Monsters mit menschlichen Zügen anzubieten. Zusammen mit Jean-Claude Carrière schrieb Schlöndorff das Drehbuch in französischer Sprache, in welcher auch gedreht werden sollte. Dann kam jedoch alles anders:

> Als die Vorbereitungen so gut wie abgeschlossen waren, geriet Depardieu plötzlich in eine Krise, sagte alle Projekte ab und verschwand in Amerika. [...] John Malkovich war bereit einzuspringen. [...] Sein Name war für die Finanzierung so gut wie der Depardieus, aber er war kein Franzose. Wie schon bei *Homo Faber* [1991] musste nun auf Englisch gedreht werden. Dadurch ging das deutsch-französische Sprachgemisch verloren, Sieger und Gefangene sprachen mehr oder weniger akzentfreies Englisch, alles Authentische fehlte, nichts erdete mehr die ohnehin ziemlich ausgedachte Fabel. [...] Der fertige Film – gespickt mit Bravourleistungen der Schauspielerei (Volker Spenglers Göring), einer mörderischen Treibjagd in Masuren [...], mit klangvollem Bläserorchester (Michael Nyman) und was es sonst noch an guten Zutaten gab – war ein unverdaulicher Aufguss, der mit Kopfschütteln aufgenommen wurde.[21]

Unbehagen löste auch der eklektische Stilmix von *Der Unhold* aus: Verband er doch eine Hommage an den im November 1995 verstorbenen französischen Regisseur Louis Malle – dem der Film gewidmet ist und an dessen *Auf Wiedersehen, Kinder* (1987) die Schwarz-Weiß-Szenen

In the summer of 1997, Schlöndorff's five-year contract terminates. He switches to the supervisory board, and Pierre Couveinhes becomes (until early 1999) the business manager of the Babelsberg Medienstadt Holding. Now standing as the new business management at the head of the studio are Friedrich-Carl Wachs, Gerhard Bergfried, Rainer Schaper, and Arthur Hofer, who came to Babelsberg from the Bavaria studios in Munich. As the head of Vivendi Germany, Thierry Potok is entrusted with the studio's activities. Among the first changes in 1998 is the construction of their own television branch Babelsberg TV, the business goals of which mirror the high share of television productions utilizing the studio's capacity. Under the administration of Michael Bütow, game and talk shows, reports and documentaries are to be developed over the short term, series, TV movies, and sitcoms over the long term. However, the work of Babelsberg TV is abandoned in early 2001. The second new business branch is the label Studio Babelsberg Independents, which is to build up and cultivate the talent pool of younger German producers and directors as a coproducer and financier of their films. In the first year of its existence, the label collaborates with ten cinema and TV productions, but until late 2003 only about 20 projects are realized in total. One of the best known is Andreas Dresen's much-acclaimed episodic film *Night Shapes* (1999).

Over the course of the year 2000, rumors begin to spread that Vivendi wants to sell the studio. They are fueled by a rigorous program of austerity, retrenchment, and turmoil among the management. At the beginning of the year, they distance themselves from Friedrich-Carl Wachs, and Arthur Hofer also leaves the studio. At the same time, a great coup is carried out. Through the negotiations of Rainer Schaper, who in the past has worked as a film architect with director Jean-Jacques Annaud on *The Name of the Rose* (1986), the most expensive film (90 million dollars) ever made in Europe at the time is brought to Babelsberg. Paramount's Stalingrad epic *Enemy at the Gates* with Jude Law, Ed Harris, Rachel Weisz, and Joseph Fiennes in the lead roles, as well as 5,000 extras on the set, brings the studio 20 million deutschmark in revenue and finally promotes it "into the international league," as Schaper tells the press: "Old Stalingrad is coming together at a breakneck speed. With a 150-man crew, we will build a set like no other. In the Rüdersdorf cement factory, Stalingrad tank factory 'Red October' will be resurrected and the central plaza of the hotly embattled city will be located in Krampnitz [ed. former Soviet army barracks]."[24] Annaud had initially wanted to shoot at original locations in Russia. But when this proves impossible, Babelsberg is the next most attractive option for the perfectionist French

Director Jean-Jacques Annaud talks over a scene with Joseph Fiennes for *Enemy at the Gates* (2001)

Regisseur Jean-Jacques Annaud in Szenenbesprechung mit Joseph Fiennes für *Duell – Enemy at the Gates* (2001)

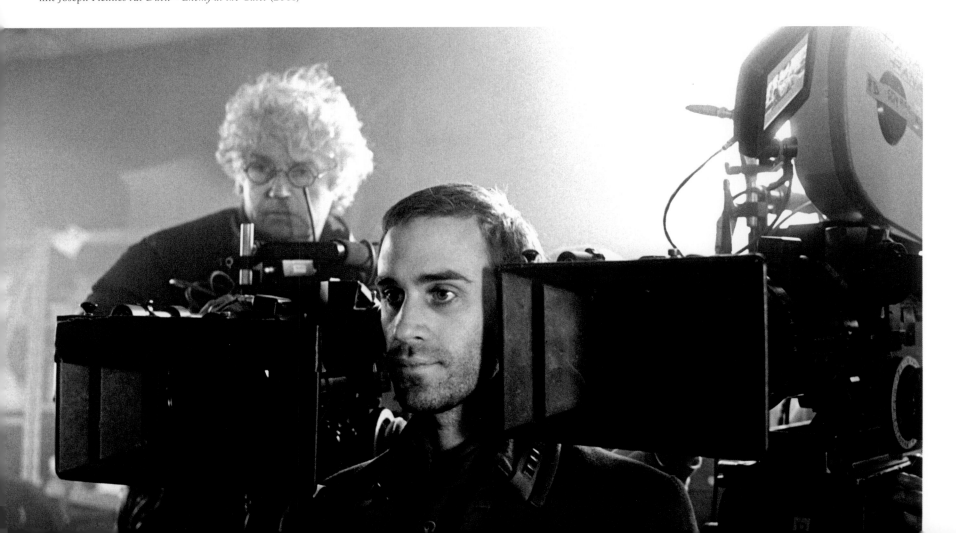

Joseph Fiennes and Jude Law in
Enemy at the Gates

Joseph Fiennes und Jude Law in
Duell – Enemy at the Gates

zu Beginn erinnern – mit Versatzstücken einer Bildsprache, die Anleihen bei der Ästhetik der NS-Parteitagsfilme Leni Riefenstahls nahm.[22] Die Skepsis war nach der Premiere des Films umso stärker, als Schlöndorff noch 1994 mit der damals 91-jährigen Riefenstahl verhandelt hatte: Es ging um die Zusammenarbeit an einem Film über die Mercedes-„Silberpfeile" und den Autorennsport der 30er Jahre – eben weil Riefenstahl, so Schlöndorff, die Optik der damaligen Zeit perfekt beherrsche.[23]

Im Sommer 1997 läuft Schlöndorffs Fünf-Jahres-Vertrag aus. Er wechselt in den Aufsichtsrat, Pierre Couveinhes wird (bis Anfang 1999) Geschäftsführer der Babelsberg Medienstadt Holding. An der Spitze des Studios stehen nun als neue Geschäftsführung Friedrich-Carl Wachs, Gerhard Bergfried, Rainer Schaper und Arthur Hofer, der von der Bavaria aus München nach Babelsberg wechselt. Als Chef von Vivendi Deutschland verantwortet Thierry Potok die Aktivitäten des Studios. Zu den ersten Veränderungen gehört 1998 der Aufbau eines eigenen Fernsehbereichs Babelsberg TV, dessen Geschäftsziele den immer noch hohen Anteil von Fernsehproduktionen an der Auslastung des Studios widerspiegeln: Unter der Leitung von Michael Bütow sollen kurzfristig Game- und Talk-Shows, Reportagen und Dokumentationen, mittelfristig auch Serien, TV-Movies und Sitcoms entwickelt werden. Im Frühjahr 2001 wird die Arbeit von Babelsberg TV jedoch schon wieder eingestellt. Der zweite neue Geschäftsbereich ist das Label Studio Babelsberg Independents, das als Koproduzent und Finanzier von Filmen jüngerer deutscher Produzenten und Regisseure einen Talentpool aufbauen und pflegen soll. Im ersten Jahr seines Bestehens ist das Label an zehn Kino- und TV-Produktionen beteiligt, bis Ende 2003 sind insgesamt aber nur etwas über 20 Projekte realisiert worden. Zu den bekanntesten gehört Andreas Dresens viel beachteter Episodenfilm *Nachtgestalten* (1999).

Im Laufe des Jahres 2000 mehren sich die Gerüchte, Vivendi wolle das Studio verkaufen. Sie werden angeheizt von einem konsequenten Sparkurs, Personalabbau und Turbulenzen in der Geschäftsführung: Anfang des Jahres trennt man sich von Friedrich-Carl Wachs, auch Arthur Hofer verlässt das Studio. Gleichzeitig gelingt ein großer Coup: Durch die Vermittlung von Rainer Schaper, der als Filmarchitekt mit dem Regisseur Jean-Jacques Annaud schon an *Der Name der Rose* (1985) zusammengearbeitet hat, gelingt es, den mit knapp 90 Millionen Dollar bis dahin teuersten Film, der je in Europa gedreht wurde, nach Babelsberg zu holen: Paramounts Stalingrad-Epos *Duell – Enemy at the Gates* (2001) mit Jude Law, Ed Harris, Rachel Weisz und Joseph Fiennes in den Hauptrollen sowie fast 5 000 Komparsen am Set bringt dem Studio 20 Millionen Mark Umsatz und befördert es endgültig „in eine internationale Liga", wie Schaper der Presse mitteilt: „Nun entsteht in einem Höllentempo das alte Stalingrad. Wir werden mit einer 150 Mann starken Crew eine Kulisse bauen, die ihresgleichen sucht. Im Rüdersdorfer Zementwerk wird die Stalingrader Panzerfabrik ‚Roter Oktober' wiederauferstehen und in Krampnitz [Anm.: eine ehemalige Sowjetarmee-Kaserne] entsteht der zentrale Platz der heißumkämpften Stadt."[24] Ursprünglich hatte Annaud an Originalschauplätzen in Russland drehen wollen.

director: "Studio Babelsberg made the decision easy for me. They put unbelievable effort into this project. And I like to work in Germany. I like the people here. [...] As far as filming goes, Germany is very expensive, but you know what you can expect."[25]

The studio's performance finally convinces not only Hollywood but also other European directors: at the end of 2000, Oscar winner István Szabó (*Mephisto*) shoots *Taking Sides* (2001) with Stellan Skarsgård and Harvey Keitel, a thoughtful portrait of the political entanglements of celebrated conductor Wilhelm Furtwängler during the National Socialist era. In early 2001, Roman Polanski is the next living-legend director to come to Babelsberg to make *The Pianist*, the film which he comes to consider his greatest work to date and which at long last grants him his first Oscar for directing. The film is awarded an Oscar for Best Actor (Adrien Brody) and Best Screenplay, serving as a milestone in the studio's history. Following that are either sub-contracted or coproduced Hollywood films, spectacularly directed star vehicles that become international box office hits: *Beyond the Sea* (2004) with Kevin Spacey as director and main actor, *Around the World in 80 Days* (2004) with Jackie Chan, and *The Bourne Supremacy* (2004) with Matt Damon. Unlike previous productions, the labor in all the different areas is now autonomously implemented, coordinated by Henning Molfenter, the business manager of Studio Babelsberg Motion Pictures, the daughter firm of Studio Babelsberg. It is a high prestige victory overall for the employees there. On the fringes of the sensational shooting of the spy thriller *The Bourne Supremacy* in Berlin, which employed a 350-person crew from the region, it was noted in the press: "Up until now, the directors from Hollywood brought their own cinematographers, lighting technicians, decorators, and set designers with them. The Babelsberg staff, many of whom learned their trade at DEFA during the GDR era, were only allowed to collaborate under the administration of an American or British 'supervisor'. But word's apparently gotten around that Babelsberg filmmakers can make good films."[26] Producer Frank Marshall adds: "Berlin is an excellent shooting location. Most of our crew are Germans, the city has great locations, and the rest is taken care of in the Babelsberg studios. You've got all you need there."[27]

Since 2001, the post-production department has benefited from the most modern sound studio in Europe, which has a fully digital mixing console that is exclusively reserved for feature

Director and Oscar winner István Szabó during a shooting break for *Taking Sides* (2001)

Regisseur und Oscar-Preisträger István Szabó während einer Drehpause bei *Taking Sides – Der Fall Furtwängler* (2001)

Harvey Keitel in *Taking Sides*

Harvey Keitel in
Taking Sides – Der Fall Furtwängler

Als sich dies als unmöglich erwies, war Babelsberg für den perfektionistischen französischen Regisseur die attraktivste Option: „Studio Babelsberg hat mir die Entscheidung leicht gemacht, sie haben sich unglaublich um dieses Projekt bemüht. Und ich arbeite sehr gerne in Deutschland, ich mag die Leute hier. [...] Was das Filmen angeht ist Deutschland zwar sehr teuer, aber man weiß, was man erwarten kann."[25]

Das Leistungsvermögen des Studios überzeugt endlich nicht nur Hollywood, sondern auch andere europäische Regisseure: Oscargewinner István Szabó (*Mephisto*) dreht Ende 2000 mit Stellan Skarsgård und Harvey Keitel *Taking Sides – Der Fall Furtwängler* (2001), ein nachdenkliches Porträt der politischen Verstrickung des gefeierten Dirigenten Wilhelm Furtwängler in der Zeit des Nationalsozialismus. Anfang 2001 kommt mit Roman Polanski die nächste Regie-Legende nach Babelsberg, um mit *Der Pianist* jenen Film zu machen, der ihm endlich den ersten Regie-Oscar beschert und den der Regisseur selbst für den bedeutendsten Film seines bisherigen Schaffens hält. Der Film wird zudem mit Oscars für den Besten Hauptdarsteller (Adrien Brody) und das Beste Drehbuch ausgezeichnet und gilt damit als Meilenstein in der Studiogeschichte. Es folgen im Auftrag von oder in Koproduktion mit Hollywood hergestellte, spektakulär inszenierte Star-Vehikel, die zu internationalen Kassenerfolgen werden: *Beyond the Sea – Musik war sein Leben* (2004) mit Kevin Spacey als Regisseur und Hauptdarsteller, *In 80 Tagen um die Welt* (2004) mit Jackie Chan und *Die Bourne Verschwörung* (2004) mit Matt Damon. Im Unterschied zu früheren Produktionen können die Arbeiten in allen Bereichen nun auch eigenverantwortlich umgesetzt werden, koordiniert von Henning Molfenter, dem Geschäftsführer von Studio Babelsberg Motion Pictures, der Produktionstochter von Studio Babelsberg. Ein hoher Prestigegewinn für die Mitarbeiter insgesamt. Am Rande der aufsehenerregenden Dreharbeiten für den Spionagethriller *Die Bourne Verschwörung* in Berlin, die eine 350-köpfige Crew aus der Region beschäftigen, wird entsprechend vermerkt: „Bisher haben die Regisseure aus Hollywood ihre Kameraleute, Beleuchter, Dekorateure und Kulissenbauer selbst mitgebracht. Die Babelsberger, die oftmals ihr Handwerk zu DDR-Zeiten bei der DEFA gelernt haben, durften nur unter der Leitung eines amerikanischen oder britischen ‚Supervisor‘ mitarbeiten. Aber offenbar hat sich herumgesprochen, dass die Babelsberger gute Filme machen können."[26] Produzent Frank Marshall fügt hinzu: „Berlin ist ein hervorragender Drehort. Die meisten aus der Crew sind Deutsche, die Stadt bietet tolle Drehorte, der Rest wird in den Babelsberger Studios erledigt. Da hat man alles, was man braucht."[27]

Seit 2001 profitiert die Postproduktion zudem vom modernsten Tonstudio Europas, dessen voll digitalisiertes Mischpult exklusiv für Kinofilme reserviert ist. Um höchsten Ansprüchen genügen zu können, wurden in den Umbau 3 Millionen DM investiert. Viele Filme machen sich auch ein anderes Studio-Unikum zunutze: Das Außenset der „Berliner Straße", errichtet im Herbst 1998 auf einer Fläche von 7 000 m² für Leander Haußmanns DDR-Komödie

films. In order to meet the highest possible standards, 3 million deutschmark were invested in the modification. Many films make good use of another unique asset of the studio: the "Berliner Straße" backlot, which was built in the fall of 1998 over a 1.72-acre area for Leander Haußmann's GDR comedy *Sun Alley* (1999). The exterior set's unique flexibility in the European studio landscape provides the possibility for film teams to use the street for scenes not even set in Berlin. Thus time-consuming and cost-intensive shooting on original locations can be bypassed—a considerable financial and logistical advantage in the production of already high-budget films. Façades can be reconstructed and newly painted, windows lit, stairwells and apartments enabled to be entered, street signs swapped upon request. If necessary, a real tram can be run on tracks across the screen. Depending on the camera position, different places can be portrayed with this set inside a single film. The illusion is perfected through the use of digital effects, which help to seamlessly bring in the streetcar from a suitable horizon, along with the filling in of other details. To date, a number of in-house productions by Studio Babelsberg, as well as national and international foreign and coproduced films, have made use of this advantage.[28]

Despite its nickname, "Berliner Straße" is by no means restricted to be a substitute only for the streets of Berlin. In Polanski's *The Pianist*, it portrays the Warsaw Ghetto, where the Jewish pianist Władysław Szpilman, played by Adrien Brody, has to experience the Nazi occupation and persecution. Although Szpilman is supposed to be looking onto the streets of Warsaw out of two different apartments, both places were staged in the "Berliner Straße"—shot once from the south side, and once from the north.

To the uninitiated eye of the viewer, no one recognizes this trick. One also does not suspect that many of the action scenes in the German-Danish coproduction *Flame & Citron* (2008), a film about two underground resistance fighters who rebel against the Nazi occupation in Copenhagen during World War II, were actually shot in the backlot of Studio Babelsberg. For *Inglourious Basterds*, Quentin Tarantino transformed the "Berliner Straße" into a cineaste's version of a Parisian street corner. The complete façade of a Parisian cinema was specifically erected to set the scene for the American director's alternative end to World War II, with stars like Brad Pitt and Christoph Waltz, whose artistic achievement was awarded an Oscar. The "Berliner Straße" has even portrayed non-European streets in other productions. *Around the World in 80 Days* is set at the end of the 19th century and used many locations in Berlin and Brandenburg to simulate various locations around the globe. The "Berliner Straße" was given the role of San Francisco. And when Oscar winner Kevin Spacey shot the biography of singer Bobby Darin, *Beyond the Sea*, in Babelsberg and the surrounding area, locations in New York and other American cities grew out of the "Berliner Straße."

Mads Mikkelsen in *Flame & Citron*
(2008, Director: Ole Christian Madsen)

Mads Mikkelsen in *Tage des Zorns*
(2008, Regie: Ole Christian Madsen)

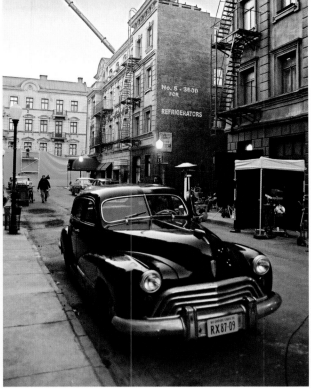

Sonnenallee (1999). Die in der europäischen Studiolandschaft einzigartige Flexibilität der Außenkulisse bietet Filmteams die Möglichkeit, die Straße auch für Szenen zu verwenden, die nicht in Berlin angesiedelt sind. So können zeitaufwendige und kostenintensive Dreharbeiten an Originalschauplätzen umgangen werden – ein nicht unerheblicher finanzieller und logistischer Vorteil bei der Herstellung zumeist ohnehin schon hoch budgetierter Filme. Auf Wunsch werden Fassaden umgebaut und neu gestrichen, Fenster beleuchtet, Treppenhäuser und Wohnungen begehbar gemacht, Straßenschilder ausgetauscht. Bei Bedarf fährt sogar eine echte Straßenbahn auf Schienen durchs Bild. Je nach Kameraposition können mit dem Set innerhalb eines Films auch unterschiedliche Orte dargestellt werden. Perfektioniert wird die Illusion durch den Einsatz digitaler Effekte, mit deren Hilfe der Straßenzug in der Nachbearbeitung problemlos um einen passenden Horizont und andere Details ergänzt werden kann. Bis heute haben eine ganze Reihe von Eigenproduktionen des Studios Babelsberg, aber auch national wie international fremd- und koproduzierte Filme von diesem Vorteil Gebrauch gemacht.[28]

Trotz ihres Spitznamens ist die „Berliner Straße" nämlich keinesfalls darauf beschränkt, nur als Ersatz für Straßenzüge Berlins verwendet zu werden. In Polanskis *Der Pianist* stellt sie das Warschauer Ghetto dar, in dem der von Adrien Brody gespielte jüdische Pianist Władysław Szpilman den Horror von NS-Besatzung und -Verfolgung miterleben muss. Obwohl Szpilman im Film eigentlich aus zwei verschiedenen Wohnungen auf die Straßen von Warschau blickt, wurden beide Orte in der „Berliner Straße" inszeniert – einmal von der Südseite, einmal von Norden her aufgenommen.

Für das uneingeweihte Auge des Zuschauers ist dieser Trick nicht zu erkennen. Genauso wenig ahnt man, dass viele der Actionszenen aus *Tage des Zorns* (2008) – einer deutsch-dänischen Koproduktion über zwei Untergrundkämpfer, die während des Zweiten Weltkriegs in Kopenhagen gegen die Okkupation der Nazis vorgehen – auf dem Backlot des Studios Babelsberg entstanden sind. Für *Inglourious Basterds* verwandelte Quentin Tarantino die „Berliner Straße" in eine cineastisch verklärte Straßenecke von Paris. Dazu wurde eigens die komplette Fassade eines Pariser Kinos errichtet, um die herum der amerikanische Regisseur mit Stars wie Brad Pitt und Christoph Waltz, dessen schauspielerische Leistung mit einem Oscar belohnt wurde, sein alternatives Ende des Zweiten Weltkriegs in Szene setzte. In anderen Produktionen stellt die „Berliner Straße" auch außereuropäische Städte dar. Frank Coracis Actionkomödie *In 80 Tagen um die Welt* spielt Ende des 19. Jahrhunderts und nutzte viele Drehorte in Berlin und Brandenburg, um die unterschiedlichsten Schauplätze rund um den Globus zu simulieren. Der „Berliner Straße" wird dabei die Rolle von San Francisco zuteil. Und als Oscarpreisträger Kevin Spacey seine Filmbiographie des Sängers Bobby Darin, *Beyond the Sea – Musik war sein Leben*, in Babelsberg und Umgebung drehte, erwuchsen aus der „Berliner Straße" Schauplätze in New York und anderen amerikanischen Städten.

Action scenes for *Flame & Citron* in the "Berliner Straße"

Actionszenen für *Tage des Zorns* in der „Berliner Straße"

Doubling the studio capacities in the year 2005:
four further sound stages and an additional backlot

Verdoppelung der Studiokapazitäten im Jahr 2005:
Vier weitere Studios und ein Gelände für Außenkulissen

In the middle of 2001, Gerhard Bergfried takes over the administration of the studio fortunes after Rainer Schaper suddenly died due to complications from a stroke on March 7. The new management lets it be known that, in the future, emphasis will be placed more on service-providing than on their own productions as well as coproductions. Over the course of 2003, Babelsberg Independents is dismantled, and Vivendi separates itself from the studio tour and gives notice to more employees. At the beginning of 2004, the company offers the studio up for sale. The bid is won in the middle of the year by producers Dr. Carl L. Woebcken and Christoph Fisser's Filmbetriebe Berlin-Brandenburg (FBB). As Studio Babelsberg AG, the business is put on the stock exchange the following year. Once again, the new administration invests in the studio's capacity: two listed landmark factory halls across from the studio lot are leased and, under the names of "Neue Film 1" and "Neue Film 2," are upgraded to fully functioning sound stages. In the fall of 2006, the internationalization of the production service provision is propelled forward by the establishment of the daughter firm Central Scope Productions in Prague. The new business management creates the conditions for implementing an ambitious target, which Dr. Woebcken formulates as follows after the studio's takeover:

> Studio Babelsberg is not just a business venture for us. [...] It's overwhelmingly an affair of the heart. Babelsberg is a legend, but it's also a business. If the legend is to survive, it has to stand on solid legs. [...] That's our mission: We want to make Babelsberg fit for the future, so that in 10, 20, or 50 years there will still be a living legend and not just a dead myth.[29]

In 2004, work begins on Fernando Meirelles' *The Constant Gardener* (2005), a German-British coproduction for which Rachel Weisz—starring next to Ralph Fiennes—is awarded an Oscar. Another Oscar winner, Charlize Theron, shoots *Aeon Flux* in 2005, a futuristic mixture of "spectacular design concepts (where the Potsdam palace gardens are even allowed to play a role), meticulously choreographed action scenes, stylish costumes, and an array of motifs like cyberspace, genetics, a totalitarian regime, and artificial paradise."[30] The comic book adaptation *V for Vendetta (2006)*—based on a script by the Wachowski siblings, who are said to have also directed some scenes—comes out in the same year. Three quarters of it is shot in Berlin and Babelsberg, and it becomes a double success for the studio:

> This film is not just an advertising vehicle for the region. Producer Joel Silver was so impressed by the work conditions there that he recently announced at the Berlinale: "We will shoot here again." [...] Production designer Owen Paterson had the Babelsberg art department build 89 sets, including the London television tower, the completely destroyed "Victoria Station," and part of an underground line. The most elaborate set was the labyrinthine Shadow Gallery of the freedom fighter and avenger "V."[31]

Mitte 2001 übernimmt Gerhard Bergfried die Leitung der Studio-Geschicke, nachdem Rainer Schaper am 7. März des Jahres völlig überraschend an den Folgen eines Hirnschlags verstorben war. Die neue Geschäftsführung lässt verlauten, in Zukunft weniger auf Eigen- und Koproduktionen, sondern mehr auf den Servicebetrieb zu setzen. Im Laufe des Jahres 2003 wird die Arbeit von Babelsberg Independents eingestellt, Vivendi trennt sich von der Studiotour und entlässt weitere Mitarbeiter. Anfang 2004 bietet der Konzern schließlich auch das Studio zum Verkauf an. Den Zuschlag erhalten Mitte des Jahres die von den Produzenten Dr. Carl L. Woebcken und Christoph Fisser geführten Filmbetriebe Berlin-Brandenburg (FBB). Als Studio Babelsberg AG wird das Unternehmen im darauffolgenden Jahr an die Börse gebracht. Die neue Leitung investiert abermals in die Studio-Kapazitäten: Zwei denkmalgeschützte Fabrikhallen gegenüber dem Studiogelände werden angemietet und als „Neue Film 1" und „Neue Film 2" zu voll funktionstüchtigen Ateliers ausgebaut. Im Herbst 2006 wird die Internationalisierung der Produktionsdienstleistungen durch die Gründung der Tochtergesellschaft Central Scope Productions in Prag vorangetrieben. Die neue Geschäftsführung schafft damit die Bedingungen für die Umsetzung einer ambitionierten Zielvorgabe, die Dr. Woebcken nach der Übernahme des Studios wie folgt formuliert hatte:

> Studio Babelsberg ist für uns nicht nur ein geschäftliches Unternehmen. [...] Es ist vor allem eine Herzensangelegenheit. Babelsberg ist eine Legende, aber es ist eben auch ein Geschäft. Wenn die Legende überleben soll, muss sie auf sicheren Beinen stehen. Das ist unsere Mission: Wir wollen Babelsberg fit machen für die Zukunft, sodass es in zehn, 20 oder 30 Jahren noch immer eine lebende Legende ist und nicht nur ein toter Mythos.[29]

Noch 2004 beginnen die Arbeiten an Fernando Meirelles' *Der ewige Gärtner* (2005), eine deutsch-britische Koproduktion, für die Rachel Weisz – an der Seite von Ralph Fiennes zu sehen – mit einem Oscar ausgezeichnet wird. Eine andere Oscargewinnerin, Charlize Theron, dreht 2005 *Aeon Flux*, eine futuristische Mischung aus „spektakulären Ausstattungsideen (wobei auch die Potsdamer Schlossgärten eine Rolle spielen durften), akribisch choreografierten Action-Szenen, schicken Kostümen und der Anordnung von Motiven wie Cyberspace, Genetik, totalitäres Regime und künstliches Paradies".[30] Die Comic-Verfilmung *V wie Vendetta* (2006) – nach einem Drehbuch der Wachowski-Geschwister, die auch einige Szenen eigenhändig inszeniert haben sollen – entsteht im gleichen Jahr zu drei Vierteln in Berlin und Babelsberg und wird für das Studio zu einem doppelten Erfolg:

> Der Film ist nicht nur ein Werbeträger für die Region. Produzent Joel Silver war so angetan von den Arbeitsbedingungen, dass er kürzlich auf der Berlinale ankündigte: „Wir werden wieder hier drehen." [...] Vom Babelsberger Art Department ließ Produktionsdesigner Owen Paterson 89 Sets bauen, darunter den Londoner Fernsehturm, die völlig zerstörte U-Bahnstation „Victoria Station" und den Teil einer U-Bahnlinie. Die aufwändigste Kulisse war die labyrinthische Schattengalerie des Freiheitskämpfers und Rächers „V".[31]

Charlie Woebcken (left) and Christoph Fisser, film producers and owners of Studio Babelsberg

Charlie Woebcken (links) und Christoph Fisser, Filmproduzenten und Eigentümer von Studio Babelsberg

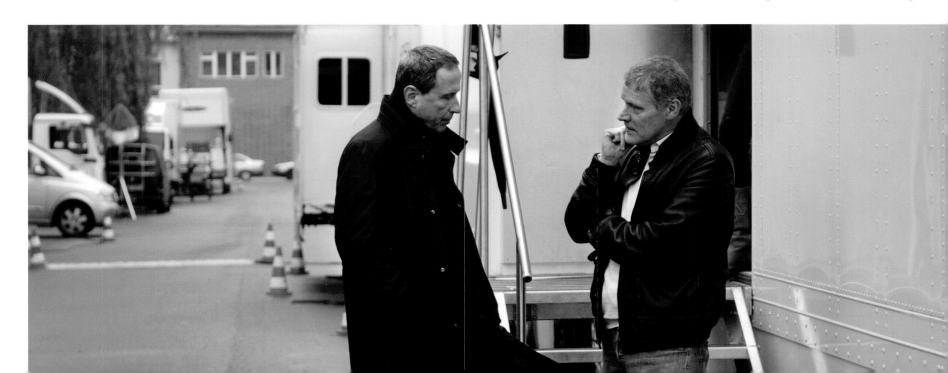

Director James McTeigue talking over a
scene with South Korean actor Rain for
Ninja Assassin (2009)

Regisseur James McTeigue in
Szenenbesprechung mit dem
südkoreanischen Schauspieler Rain für
Ninja Assassin (2009)

At the end of the year, Hollywood director Paul Verhoeven (*Basic Instinct*) is in residence to shoot his German-Dutch World War II drama *Black Book*, coproduced by Studio Babelsberg. Despite the increasingly strained international economic situation, they also succeed, in the following years, to bring out several audience favorites that receive awards at festivals, and feature films praised in Hollywood, such as the last part of the Bourne trilogy *The Bourne Ultimatum* and Academy Award winner *The Counterfeiters*. The introduction of the German Federal Film Fund in 2007 helps to further attract major international productions: *Speed Racer* (2008, Andy and Lana Wachowski), Tykwer's *The International*, *Valkyrie* with Tom Cruise, *Ninja Assassin* (2009) and Stephen Daldry's *The Reader*, a Babelsberg coproduction for which Kate Winslet receives her first Oscar. Each of the films mentioned is almost completely produced in Germany and Babelsberg, as the studio also acts as the sole executive production company. In 2007 alone, twelve feature films are created in Babelsberg for cinema release; with annual sales of 87.1 million euros and a net profit of 6 million euros, the year becomes the most successful since the studio's privatization in 1992.[32] And now Joel Silver makes good on his promise. At the end of 2008, a strategic alliance between the *Matrix* producer and Studio Babelsberg is sealed.

Babelsberg has not only kept pace with the demands of the times to incline away from a nationally defined toward an internationally oriented film studio.[33] It also has future developments firmly in view. Between the past Ufa mythos and DEFA tradition on the one hand, and the future of an ever more globalized and digital media world on the other, the present takes place on a very practical level: in the daily work on the film at hand, which still constitutes a power center in the network, the main artery that supplies all the connected media areas in Babelsberg with energy—which in itself is remarkable. And this is by no means self-evident almost a quarter of a century after the German reunification and the end of DEFA. On the contrary, a look at the more recent history of Babelsberg as a film production location illustrates that its persistence—and with it the preservation of a now 100-year tradition—has had to be fought for against obstacles and changes. And day after day, it must be prepared and asserted anew.

Most importantly: even after 100 years, Babelsberg is still writing film history. Therefore what Volker Schlöndorff said at the beginning of his time as studio boss seems to have come true: whoever invests in the future will receive the support he needs in the end...because the Babelsberg project fulfills a general longing.[34]

Speed Racer (2008, Directors: Andy and Lana Wachowski)
starring Susan Sarandon and John Goodman

Speed Racer (2008, Regie: Andy und Lana Wachowski)
mit Susan Sarandon und John Goodman

Ende des Jahres ist Hollywood-Regisseur Paul Verhoeven (*Basic Instinct*) zu Dreharbeiten an seinem deutsch-holländischen Weltkriegsdrama *Black Book*, das von Studio Babelsberg koproduziert wird, zu Gast. Trotz der international zunehmend angespannten wirtschaftlichen Lage gelingt es auch in den folgenden Jahren, beim Publikum erfolgreiche und mit Preisen auf Festivals und in Hollywood gewürdigte Kinofilme hervorzubringen, so den letzten Teil der Bourne-Trilogie, *Das Bourne Ultimatum* (2007), und den Oscargewinner *Die Fälscher*. Die Einführung des Deutschen Filmförderfonds kommt ab 2007 der Umsetzung des Vorhabens, regelmäßig große internationale Produktionen anzulocken, zugute: *Speed Racer* (2008, Andy und Lana Wachowski), Tykwers *The International*, *Operation Walküre* mit Tom Cruise, *Ninja Assassin* (2009) und Stephen Daldrys *Der Vorleser*, eine Babelsberg Koproduktion, für die Kate Winslet ihren ersten Oscar erhält. Die genannten Filme sind nahezu komplett in Deutschland und Babelsberg produziert, das Studio agiert dabei als alleinige ausführende Produktionsfirma. Allein 2007 entstehen in Babelsberg zwölf Spielfilme fürs Kino; mit einem Jahresumsatz von 87,1 Millionen Euro und einem Reinerlös aus der Geschäftstätigkeit von 6 Millionen Euro wird das Jahr zum erfolgreichsten seit der Privatisierung des Studios 1992.[32] Und auch Joel Silver macht sein Versprechen wahr: Es wird Ende 2008 mit einer strategischen Allianz zwischen dem *Matrix*-Produzenten und dem Studio Babelsberg besiegelt.

Auf diese Weise hält Babelsberg nicht nur mit den Forderungen der Zeit Schritt, der Tendenz vom national definierten zum international ausgerichteten Filmstudio.[33] Es hat auch zukünftige Entwicklungen fest im Blick. Zwischen Ufa-Mythos und DEFA-Tradition auf der einen, der Zukunft einer noch stärker globalisierten und digitalisierten Medienwelt auf der anderen Seite, findet die Gegenwart jeden Tag ganz praktisch statt: in der Arbeit am Film, der – und das ist bemerkenswert genug – noch immer das Kraftzentrum des Netzwerks darstellt, die Hauptschlagader, die alle angeschlossenen Medienbereiche in Babelsberg mit Energie versorgt. Dass dem so ist, fast ein Vierteljahrhundert nach der deutschen Wiedervereinigung und dem Ende der DEFA, ist dabei keineswegs selbstverständlich. Ganz im Gegenteil verdeutlicht ein Blick auf die jüngere Geschichte Babelsbergs als Filmproduktionsstandort, dass sein Erhalt – und damit auch die Bewahrung einer nunmehr 100-jährigen Tradition – über Hindernisse und Umbrüche hinweg erkämpft werden musste. Und Tag für Tag aufs Neue erarbeitet und sichergestellt werden muss.

Das Wichtigste aber ist: Auch nach 100 Jahren schreibt Babelsberg weiter Filmgeschichte. Es scheint sich also doch noch zu bestätigen, was Volker Schlöndorff zu Beginn seiner Zeit als Studiochef einmal gesagt hat: Wer auf die Zukunft setzt, wird am Ende die Unterstützung erhalten, die er braucht – eben weil das Projekt Babelsberg eine allgemeine Sehnsucht erfüllt.[34]

Director Paul Verhoeven (right) with Carice van Houten and Sebastian Koch during the making of *Black Book* (2006)

Regisseur Paul Verhoeven (rechts) mit Carice van Houten und Sebastian Koch während der Dreharbeiten zu *Black Book* (2006)

Director Tom Tykwer with Naomi Watts while shooting *The International* (2009)

Regisseur Tom Tykwer mit Naomi Watts während der Dreharbeiten zu *The International* (2009)

Exterior set for Roland Emmerich's
Anonymous on the Studio Babelsberg lot

Außenkulisse zu Roland Emmerichs
Anonymus auf dem Gelände von
Studio Babelsberg

1 Sabine Schicketanz: Das Babelsberger Geheimnis. In: *Der Tagesspiegel*, 20 March 2009.
2 Ibid.
3 Ben Goldsmith / Tom O'Regan: *The Film Studio. Film Production in the Global Economy*. Lanham, MD: Rowman & Littlefield 2005, p. 38.
4 Stefan Krätke: *Medienstadt. Urbane Cluster und globale Zentren der Kulturproduktion*. Opladen: Leske & Budrich 2002, p. 136.
5 Goldsmith / O'Regan: *The Film Studio*, p. 32.
6 Ibid., p. 26: "The size of a studio, particularly the number of stages it contains and their dimensions [...] is an important determinant of the kind and variety of work it is capable of hosting."
7 Ibid., p. 31.
8 Ibid., p. 28: "Studio Babelsberg and Cinecittà offer what is called 'full service' because they have sole or substantial control over the on-site service providers and are therefore able to offer some or all of these services as a package to reduce production costs as an incentive to producers."
9 Frank Kober: Von Investoren, Strategen und Enthusiasten – Wann schreibt Babelsberg wieder Filmgeschichte? In: *Märkische Allgemeine Zeitung*, 21 January 1993.
10 On December 12, 1993, the DEFA was finally struck from the business registry.
11 Volker Schlöndorff: *Licht, Schatten und Bewegung. Mein Leben und meine Filme*. München: Hanser 2008, p. 431.
12 Ibid., p. 432.
13 Cited in Gundolf S. Freyermuth: *Der Übernehmer. Volker Schlöndorff in Babelsberg*. Berlin: Ch. Links Verlag 1993, p. 15.
14 Helga Einecke: Wie Schlöndorff Geld für Babelsberg auftreibt. Der renommierte Filmemacher will den traditionsreichen Studios zu altem Glanz verhelfen. In: *Süddeutsche Zeitung*, 13 August 1993.
15 Freyermuth: *Der Übernehmer*, p. 102.
16 In the first fiscal year, *Novalis—The Blue Flower* (Herwig Kipping) and *The Far Away Country of Pa-Isch* (Rainer Simon) were produced by former DEFA directors in the studio.
17 Cf. „Der Haupterfolg ist, daß wir überlebt haben". Volker Schlöndorff über das Studio Babelsberg. In: *Blickpunkt: Kino*, 8 August 1994, p. 11.
18 „Ein Film muß gleich funktionieren oder er ist weg". Dieter Geissler hat die *Unendliche Geschichte* produziert. Ein Gespräch über die Amerikaner und das europäische Kino. In: *Berliner Zeitung*, 28 October 1994.
19 „Der Haupterfolg ist, daß wir überlebt haben", p. 12.
20 Cf. Ralf Schenk: Poker in Babelsberg. In: *Privatisierte – Was aus ihnen wird*. Berlin: Die Wirtschaft 1994, p. 925.
21 Schlöndorff: *Licht, Schatten und Bewegung*, p. 439.
22 Cf. Randall Halle: The Transnational Aesthetic. Volker Schlöndorff, Studio Babelsberg, and Vivendi Universal. In: *German Film after Germany. Toward a Transnational Aesthetic*. Urbana / Chicago: University of Illinois Press 2008, p. 76.
23 Cf. Andreas Conrad: Duell in der Nordkurve. Stromliniengeschoß: Für seinen Film über die „Silberpfeile" will Volker Schlöndorff auch Leni Riefenstahl verpflichten. In: *Der Tagesspiegel*, 15 August 1994.
24 Chance für Studio Babelsberg. In: *Medienstadt Babelsberg*, No. 5, 1999, p. 3.
25 Ungeliftet. In: *Süddeutsche Zeitung*, 16 February 2000.
26 Sabine Schicketanz / Volker Eckert: Babelsberg dreht durch. In: *Der Tagesspiegel*, 25 November 2003.
27 Ibid.
28 Cf. Michael Wedel / Andreas Meissner: Filmkulisse zwischen Realität und Fantasie. Die „Berliner Straße". In: Kulturland Brandenburg (Hg.): *LichtSpielHaus. Film, Kunst und Baukultur*. Berlin: Koehler & Amelang 2011, pp. 74–79.
29 Cited in Goldsmith / O'Regan: *The Film Studio*, p. 124.
30 Wolfgang Fuhrmann: Hart wie Kruppstahl. In: *Berliner Zeitung*, 16 February 2006.
31 Sabine Schicketanz / Lars von Törne: Nächster Halt Gendarmenmarkt. In: *Der Tagesspiegel*, 16 March 2006.
32 Studio Babelsberg AG: *Geschäftsbericht / Annual Report 2007*. Potsdam-Babelsberg: Studio Babelsberg 2008, p. 40. See also Ed Meza: Babelsberg's Profits Tower. In: *Variety*, 29 April 2008.
33 Cf. Goldsmith / O'Regan: *The Film Studio*, p. 109.
34 Cf. Freyermuth: *Der Übernehmer*, p. 10.

1 Sabine Schicketanz: Das Babelsberger Geheimnis. In: *Der Tagesspiegel*, 20.3.2009.

2 Ebd.

3 Ben Goldsmith / Tom O'Regan: *The Film Studio. Film Production in the Global Economy*. Lanham u. a.: Rowman & Littlefield 2005, S. 38.

4 Stefan Krätke: *Medienstadt. Urbane Cluster und globale Zentren der Kulturproduktion*. Opladen: Leske & Budrich 2002, S. 136.

5 Goldsmith / O'Regan: *The Film Studio*, S. 32.

6 Ebd., S. 26: „The size of a studio, particularly the number of stages it contains and their dimensions [...] is an important determinant of the kind and variety of work it is capable of hosting."

7 Ebd., S. 31.

8 Ebd., S. 28: „Studio Babelsberg and Cinecittà offer what is called ‚full service' because they have sole or substantial control over the on-site service providers and are therefore able to offer some or all of these services as a package to reduce production costs as an incentive to producers."

9 Frank Kober: Von Investoren, Strategen und Enthusiasten – Wann schreibt Babelsberg wieder Filmgeschichte? In: *Märkische Allgemeine Zeitung*, 21.1.1993.

10 Am 12. Dezember 1993 wurde die DEFA schließlich aus dem Handelsregister gestrichen.

11 Volker Schlöndorff: *Licht, Schatten und Bewegung. Mein Leben und meine Filme*. München: Hanser 2008, S. 431.

12 Ebd., S. 432.

13 Zitiert nach Gundolf S. Freyermuth: *Der Übernehmer. Volker Schlöndorff in Babelsberg*. Berlin: Ch. Links Verlag 1993, S. 15f.

14 Helga Einecke: Wie Schlöndorff Geld für Babelsberg auftreibt. Der renommierte Filmemacher will den traditionsreichen Studios zu altem Glanz verhelfen. In: *Süddeutsche Zeitung*, 13.8.1993.

15 Freyermuth: *Der Übernehmer*, S. 102.

16 Im ersten Geschäftsjahr wurden außerdem noch *Novalis – Die blaue Blume* (Herwig Kipping) und *Fernes Land Pa-isch* (Rainer Simon) von ehemaligen DEFA-Regisseuren im Studio produziert.

17 Vgl. „Der Haupterfolg ist, daß wir überlebt haben". Volker Schlöndorff über das Studio Babelsberg. In: *Blickpunkt: Kino*, 8.8.1994, S. 11.

18 „Ein Film muß gleich funktionieren oder er ist weg". Dieter Geissler hat die *Unendliche Geschichte* produziert. Ein Gespräch über die Amerikaner und das europäische Kino. In: *Berliner Zeitung*, 28.10.1994.

19 „Der Haupterfolg ist, daß wir überlebt haben", S. 12.

20 Vgl. Ralf Schenk: Poker in Babelsberg. In: *Privatisierte – Was aus ihnen wird*. Berlin: Die Wirtschaft 1994, S. 925.

21 Schlöndorff: *Licht, Schatten und Bewegung*, S. 439f.

22 Vgl. Randall Halle: The Transnational Aesthetic. Volker Schlöndorff, Studio Babelsberg, and Vivendi Universal. In: *German Film after Germany. Toward a Transnational Aesthetic*. Urbana / Chicago: University of Illinois Press 2008, S. 76.

23 Vgl. Andreas Conrad: Duell in der Nordkurve. Stromliniengeschoß: Für seinen Film über die „Silberpfeile" will Volker Schlöndorff auch Leni Riefenstahl verpflichten. In: *Der Tagesspiegel*, 15.8.1994.

24 Chance für Studio Babelsberg. In: *Medienstadt Babelsberg*, Nr. 5, 1999, S. 3.

25 Ungeliftet. In: *Süddeutsche Zeitung*, 16.2.2000.

26 Sabine Schicketanz / Volker Eckert: Babelsberg dreht durch. In: *Der Tagesspiegel*, 25.11.2003.

27 Ebd.

28 Vgl. Michael Wedel / Andreas Meissner: Filmkulisse zwischen Realität und Fantasie. Die „Berliner Straße". In: Kulturland Brandenburg (Hg.): *LichtSpielHaus. Film, Kunst und Baukultur*. Berlin: Koehler & Amelang 2011, S. 74–79.

29 Zitiert nach Goldsmith / O'Regan: *The Film Studio*, S. 124f.

30 Wolfgang Fuhrmann: Hart wie Kruppstahl. In: *Berliner Zeitung*, 16.2.2006.

31 Sabine Schicketanz / Lars von Törne: Nächster Halt Gendarmenmarkt. In: *Der Tagesspiegel*, 16.3.2006.

32 Studio Babelsberg AG: *Geschäftsbericht / Annual Report 2007*. Potsdam-Babelsberg: Studio Babelsberg 2008, S. 40. Vgl. auch Ed Meza: Babelsberg's Profits Tower. In: *Variety*, 29.4.2008.

33 Vgl. Goldsmith / O'Regan: *The Film Studio*, S. 109f.

34 Vgl. Freyermuth: *Der Übernehmer*, S. 10.

1993
–
2012

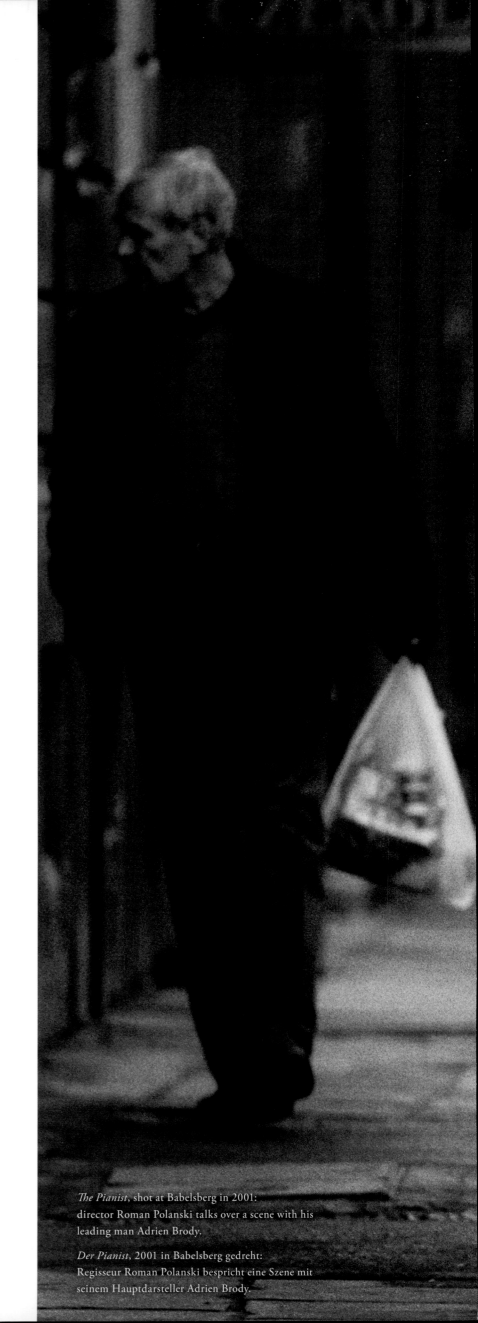

The Pianist, shot at Babelsberg in 2001:
director Roman Polanski talks over a scene with his
leading man Adrien Brody.

Der Pianist, 2001 in Babelsberg gedreht:
Regisseur Roman Polanski bespricht eine Szene mit
seinem Hauptdarsteller Adrien Brody.

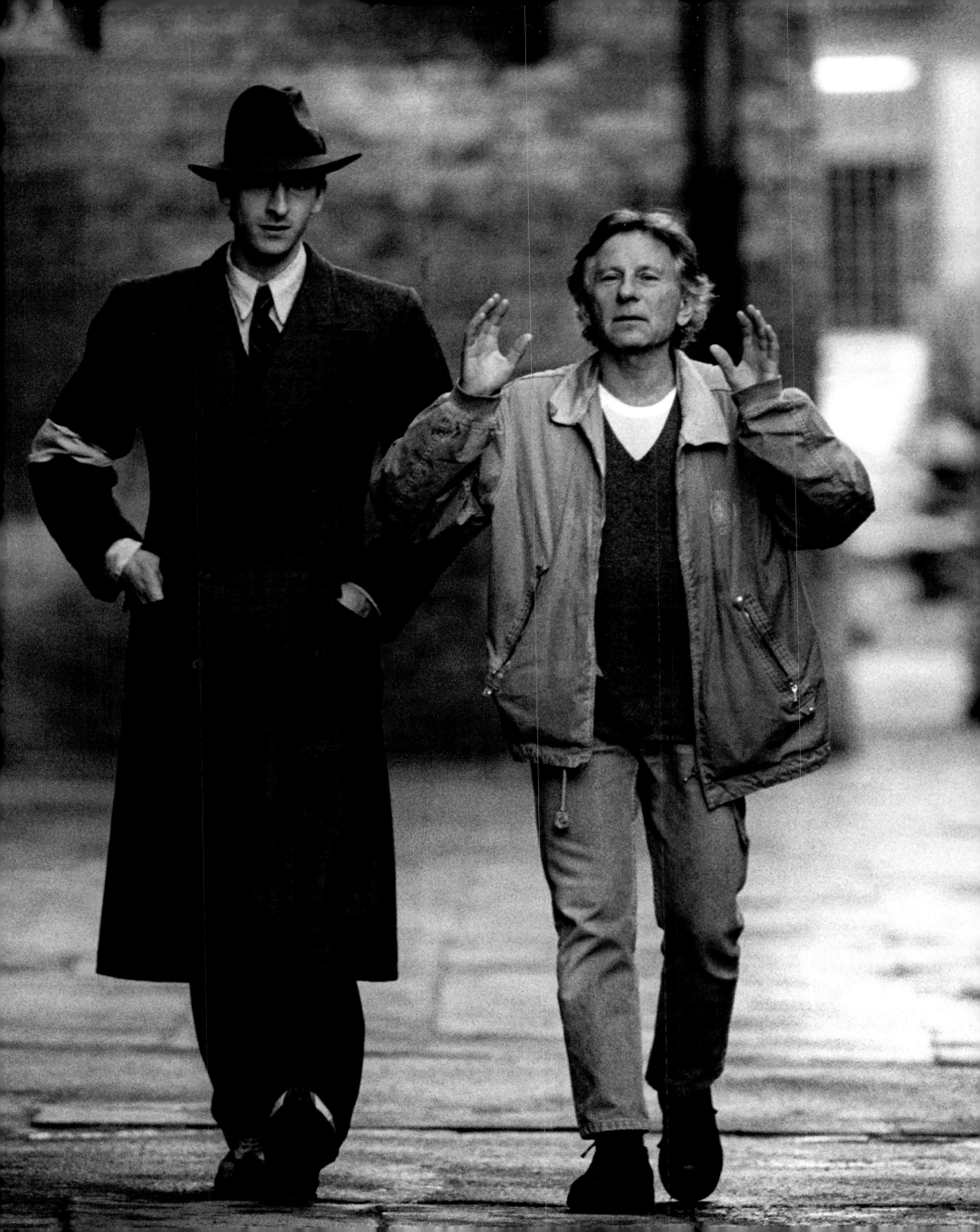

In 1998, based on blueprints by production designer Lothar Holler, the outside set "Berliner Straße" was built at Babelsberg for Leander Haußmann's film *Sun Alley*. The comedy is set in East Berlin during the '70s and depicts the life of adolescents in the shadow of the Berlin Wall.

Für Leander Haußmanns Film *Sonnenallee* wird 1998 in Studio Babelsberg nach Entwürfen des Szenenbildners Lothar Holler die Außenkulisse „Berliner Straße" gebaut. Die Komödie ist im Ost-Berlin der 70er Jahre angesiedelt und wirft einen Blick auf das Leben von Jugendlichen im Schatten der Berliner Mauer.

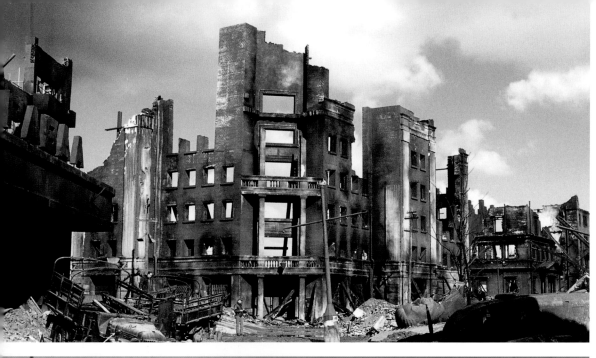

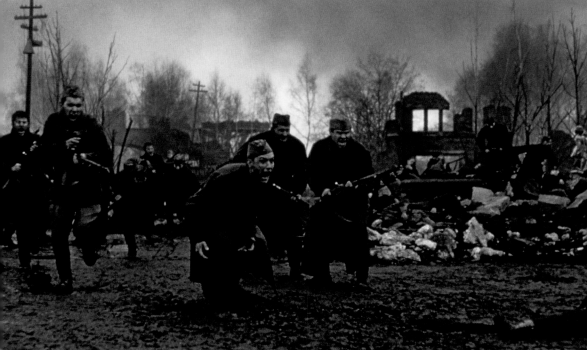

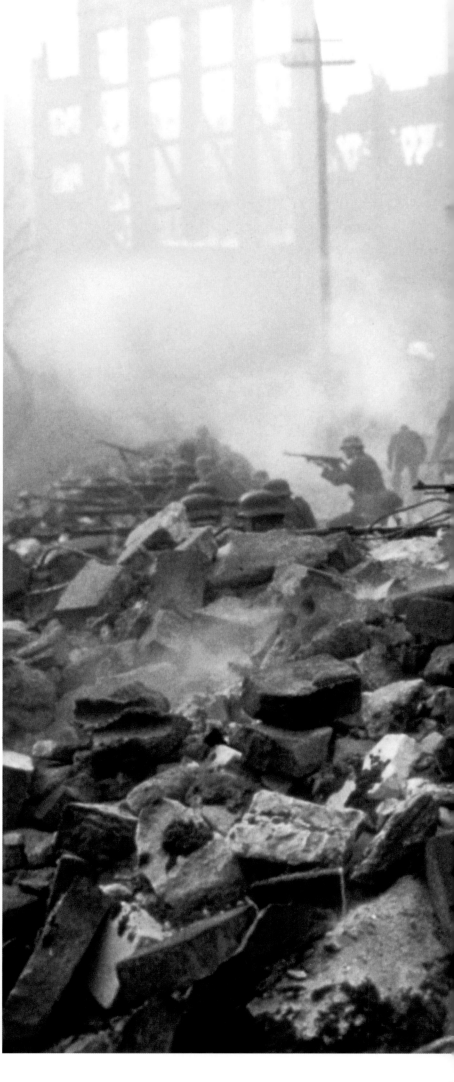

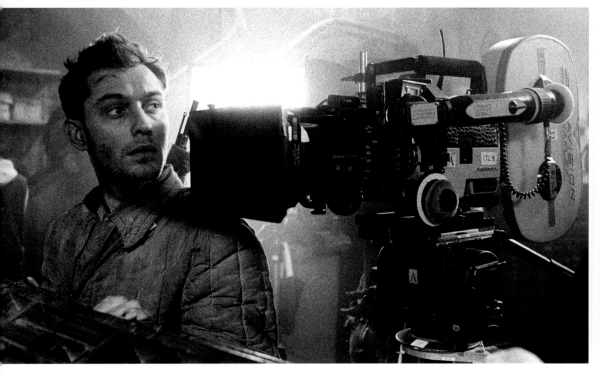

In 2000, Jean-Jacques Annaud made *Enemy at the Gates*, starring Jude Law, Joseph Fiennes, Ed Harris, Rachel Weisz, and Ron Perlman. A duel between two snipers during the battle of Stalingrad is at the center of the war film. The film was shot at Studio Babelsberg as well as on many locations in Brandenburg.

Im Jahr 2000 dreht Jean-Jacques Annaud *Duell – Enemy at the Gates* mit Jude Law, Joseph Fiennes, Ed Harris, Rachel Weisz und Ron Perlman. Im Mittelpunkt des Kriegsfilms steht das Duell von zwei Scharfschützen während der Schlacht von Stalingrad. Gedreht wird der Film in Studio Babelsberg sowie an zahlreichen Drehorten in Brandenburg.

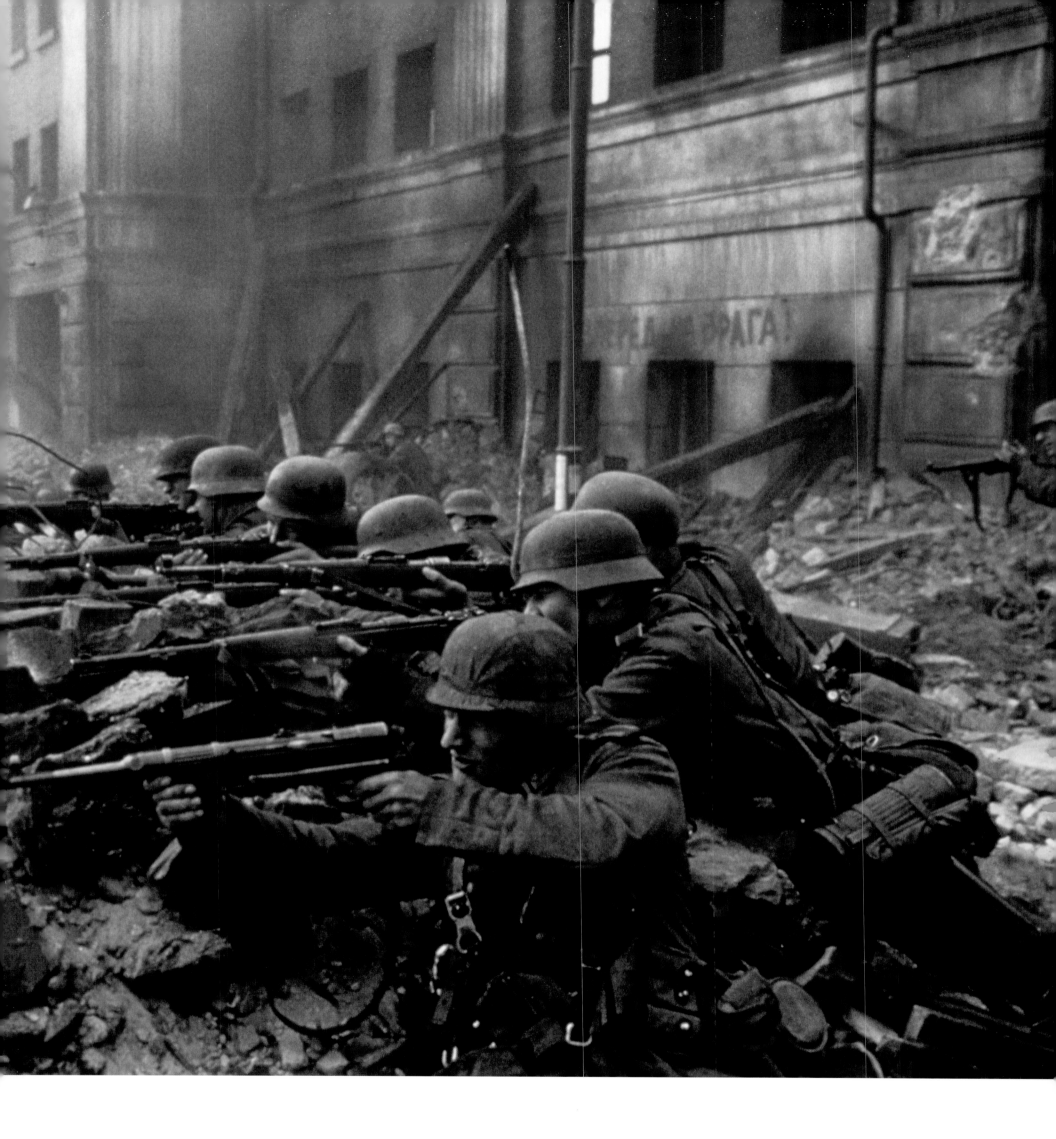

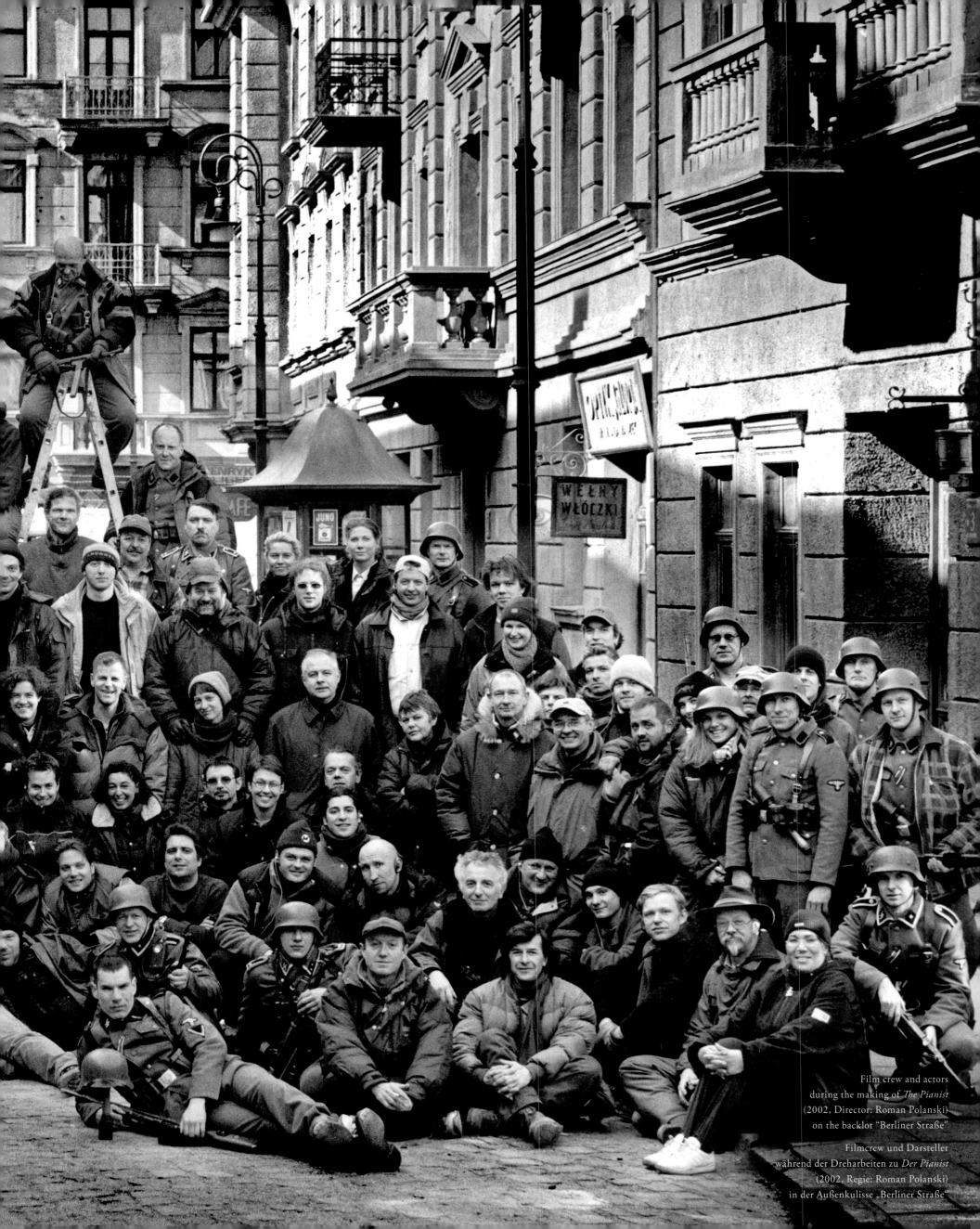

Film crew and actors
during the making of *The Pianist*
(2002, Director: Roman Polanski)
on the backlot "Berliner Straße"

Filmcrew und Darsteller
während der Dreharbeiten zu *Der Pianist*
(2002, Regie: Roman Polanski)
in der Außenkulisse „Berliner Straße"

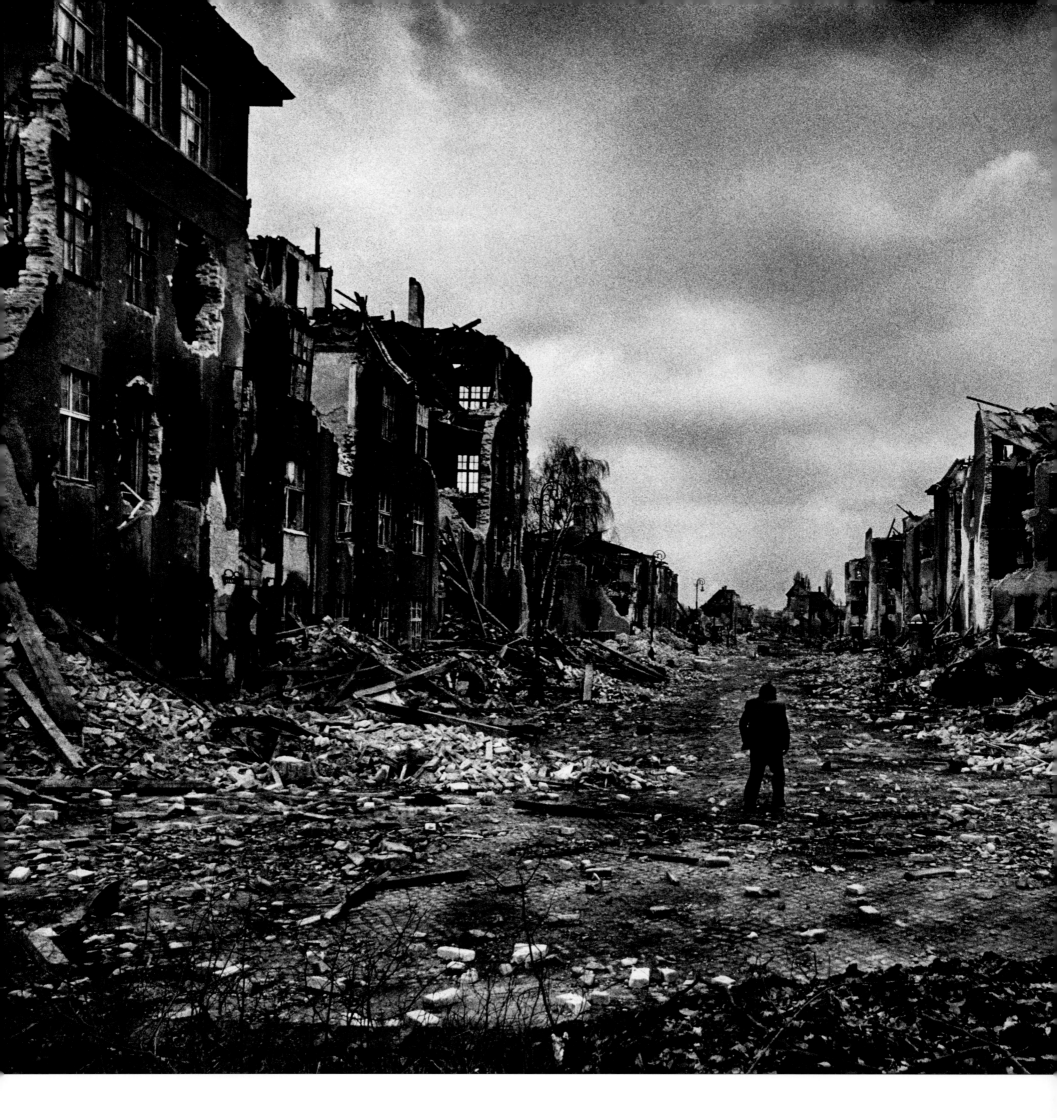

Roman Polanski (right) shot the holocaust drama *The Pianist* at Babelsberg in 2001. Adrien Brody and Thomas Kretschmann play the leads. The film is counted among the most personal ones in the career of Roman Polanski, one of the survivors of the Kraków Ghetto. *The Pianist* would go on to win the Golden Palm at the Cannes International Film Festival as well as three Oscars at the Academy Awards.

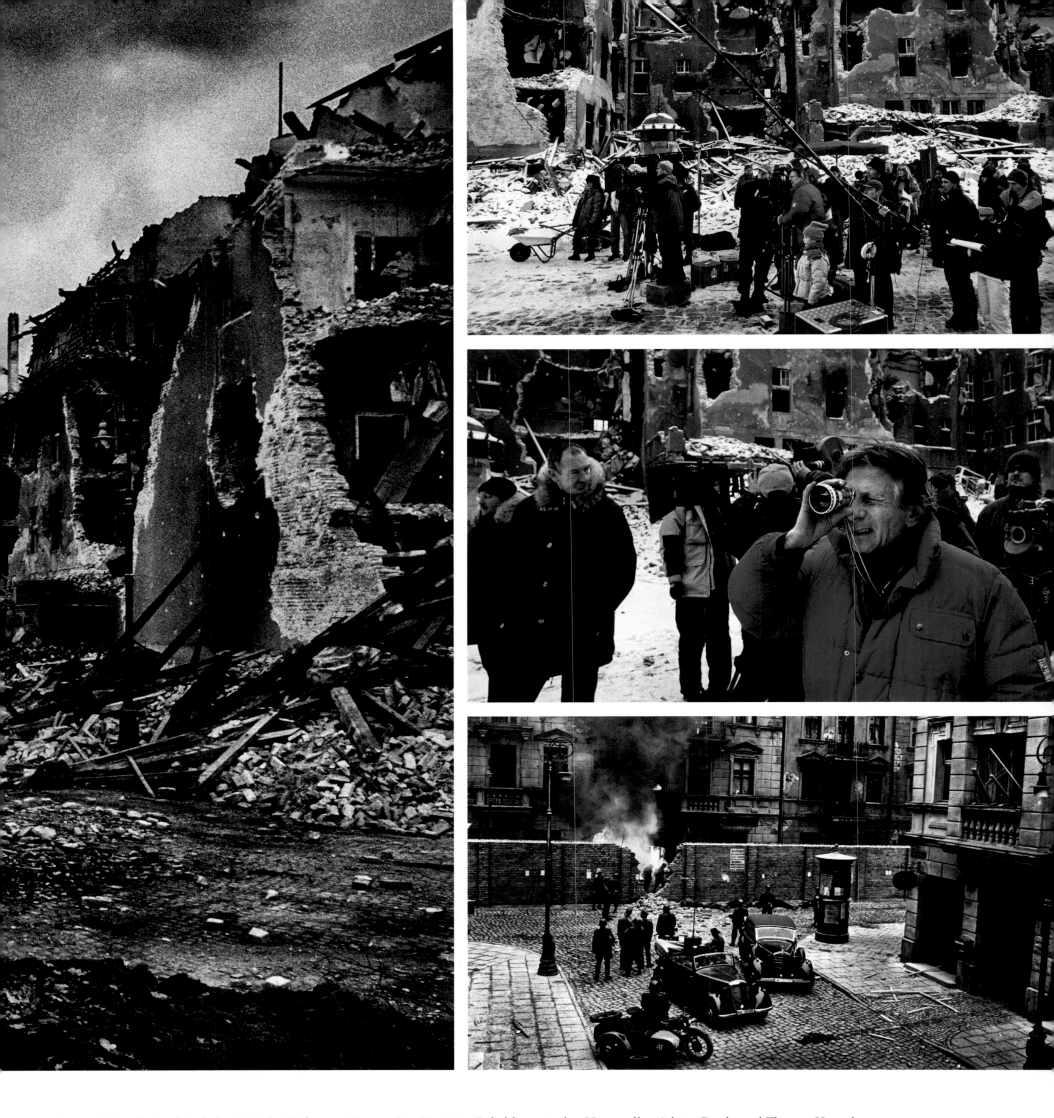

Roman Polanski (rechts) dreht 2001 das Holocaust-Drama *Der Pianist* in Babelsberg, in den Hauptrollen Adrien Brody und Thomas Kretschmann. Der Film zählt zu den persönlichsten in der Karriere von Roman Polanski, der zu den Überlebenden des Ghettos von Krakau gehört. *Der Pianist* gewinnt die Goldene Palme bei den Internationalen Filmfestspielen in Cannes sowie drei Oscars bei den Academy Awards.

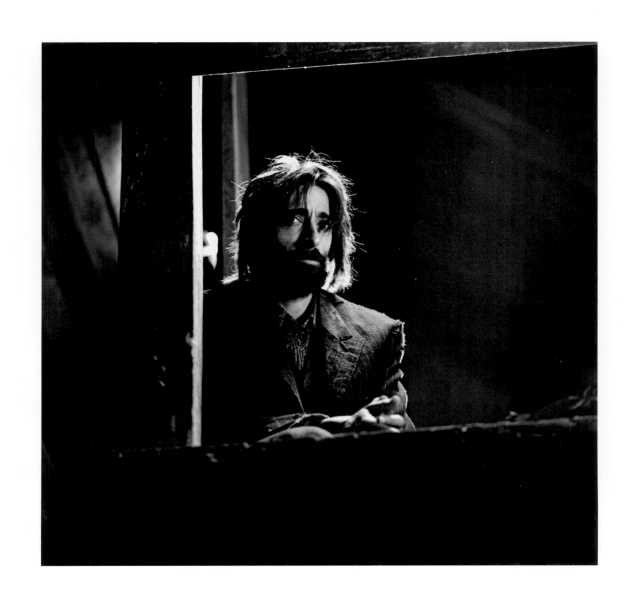

SPIELMANN? THAT IS A GOOD NAME FOR A PIANIST.

The Pianist

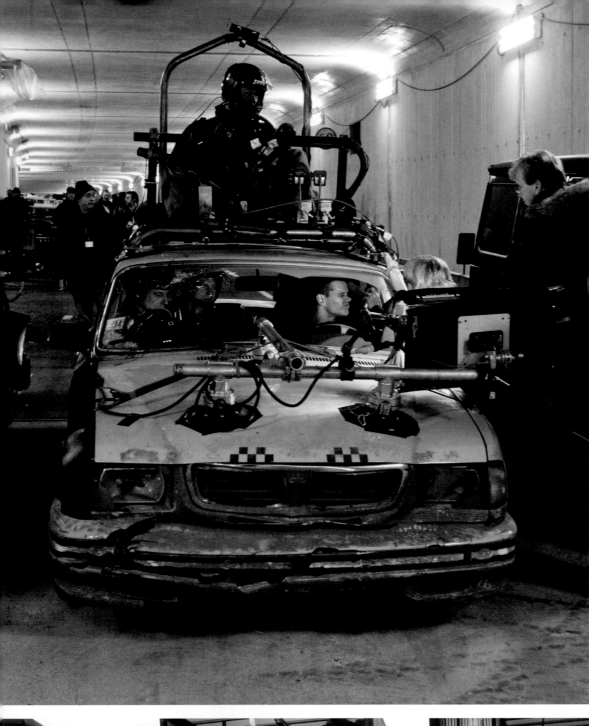

During the making of an action scene for *The Bourne Supremacy* with leading man Matt Damon. The spy thriller from director Paul Greengrass (bottom left, 2.f.l.) has been shot at countless Berlin locations in 2003. Scenes meant to take place in Moscow were shot in the eastern part of Berlin.

Beim Dreh einer Actionszene für *Die Bourne Verschwörung* mit Hauptdarsteller Matt Damon. Der Agenten-Thriller von Regisseur Paul Greengrass (links unten, 2.v.l.) wird 2003 an zahlreichen Drehorten in Berlin gedreht. Szenen, die in Moskau spielen, werden im Ostteil Berlins gefilmt.

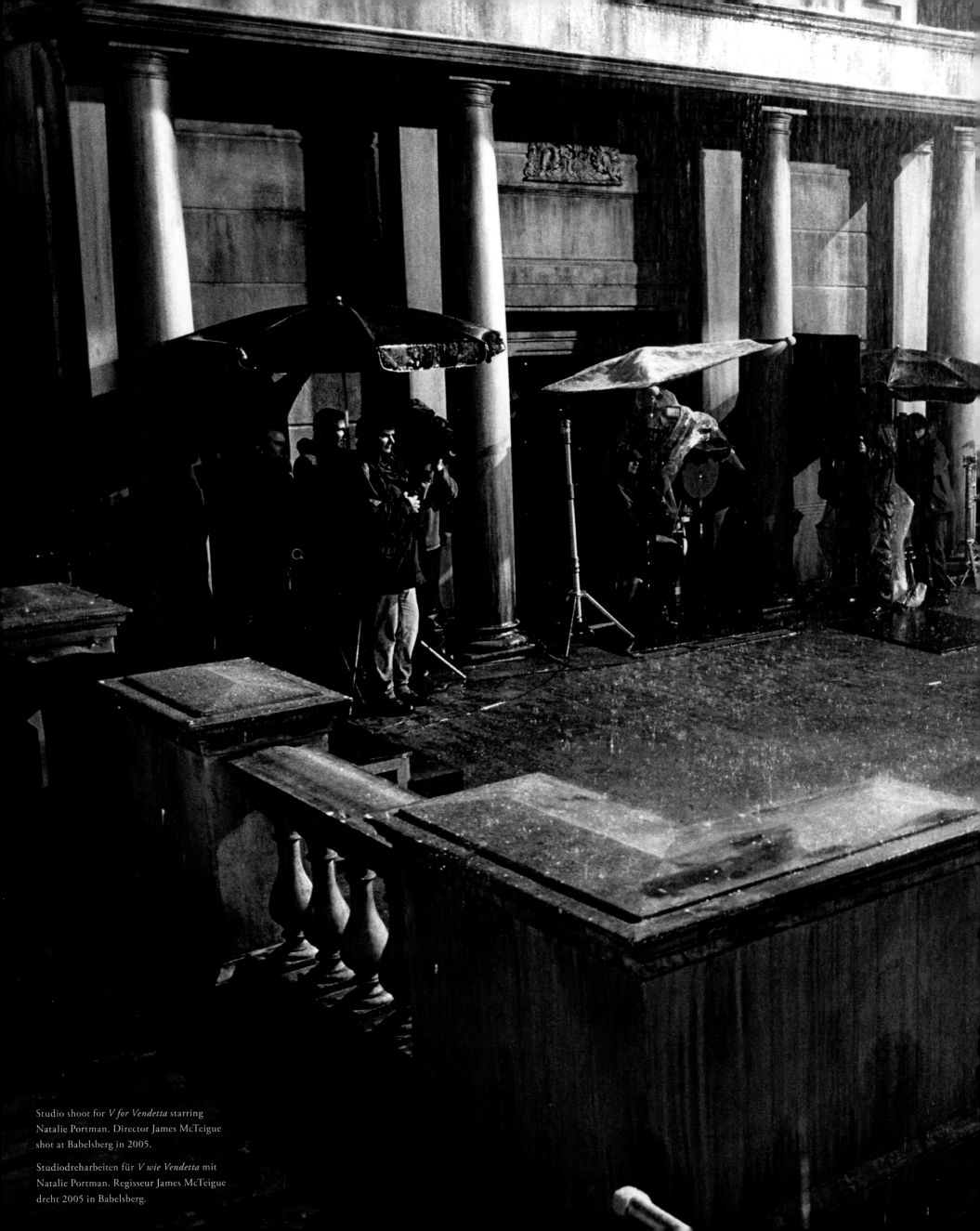

Studio shoot for *V for Vendetta* starring
Natalie Portman. Director James McTeigue
shot at Babelsberg in 2005.

Studiodreharbeiten für *V wie Vendetta* mit
Natalie Portman. Regisseur James McTeigue
dreht 2005 in Babelsberg.

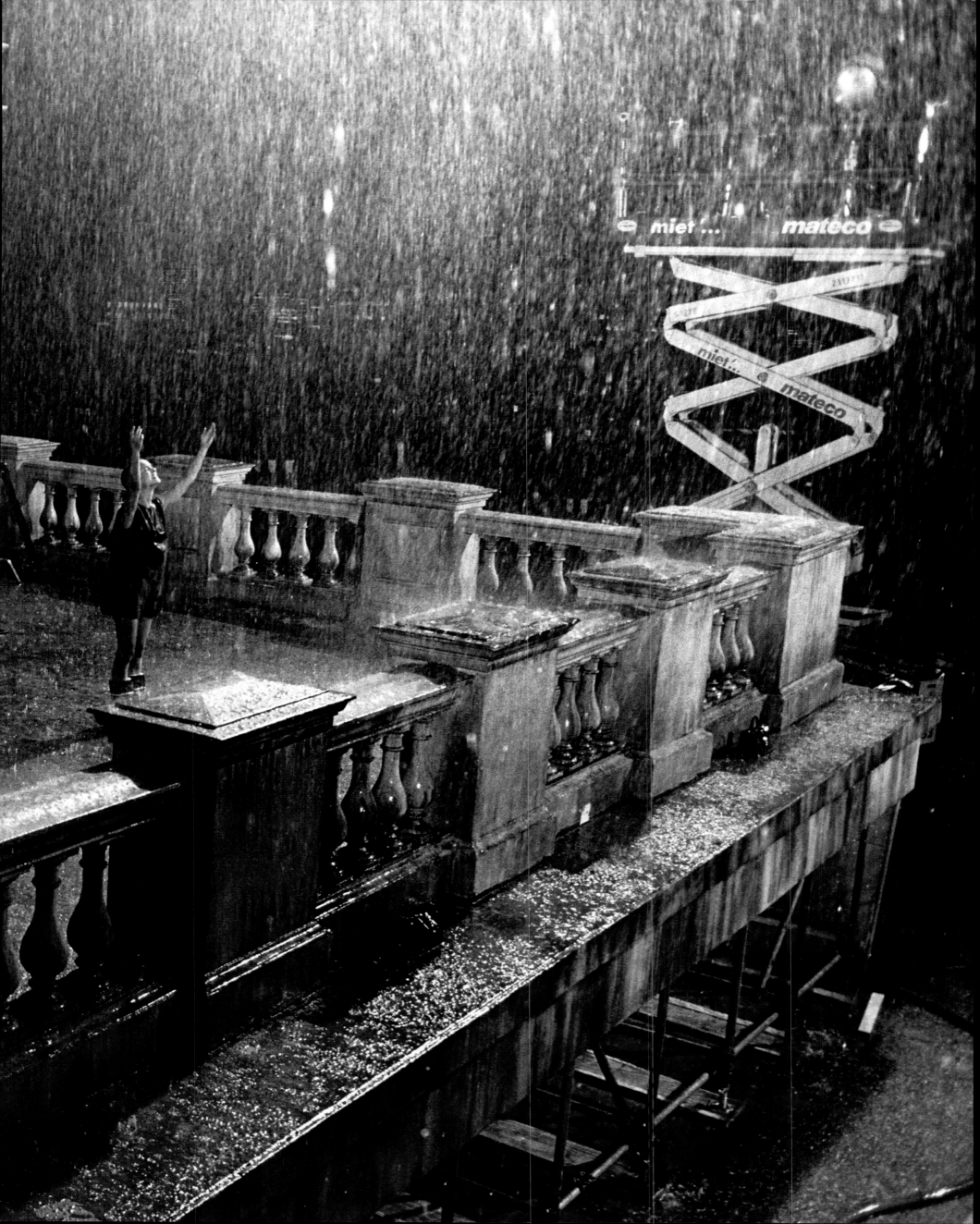

REMEMBER, REMEMBER THE 5th OF NOVEMBER.

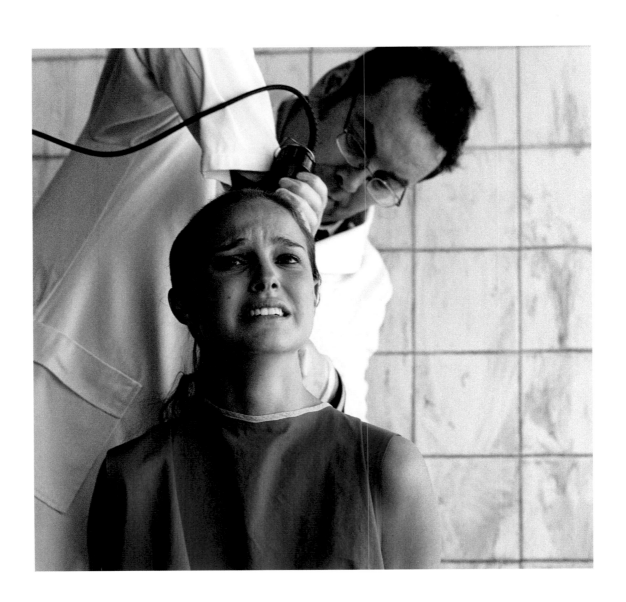

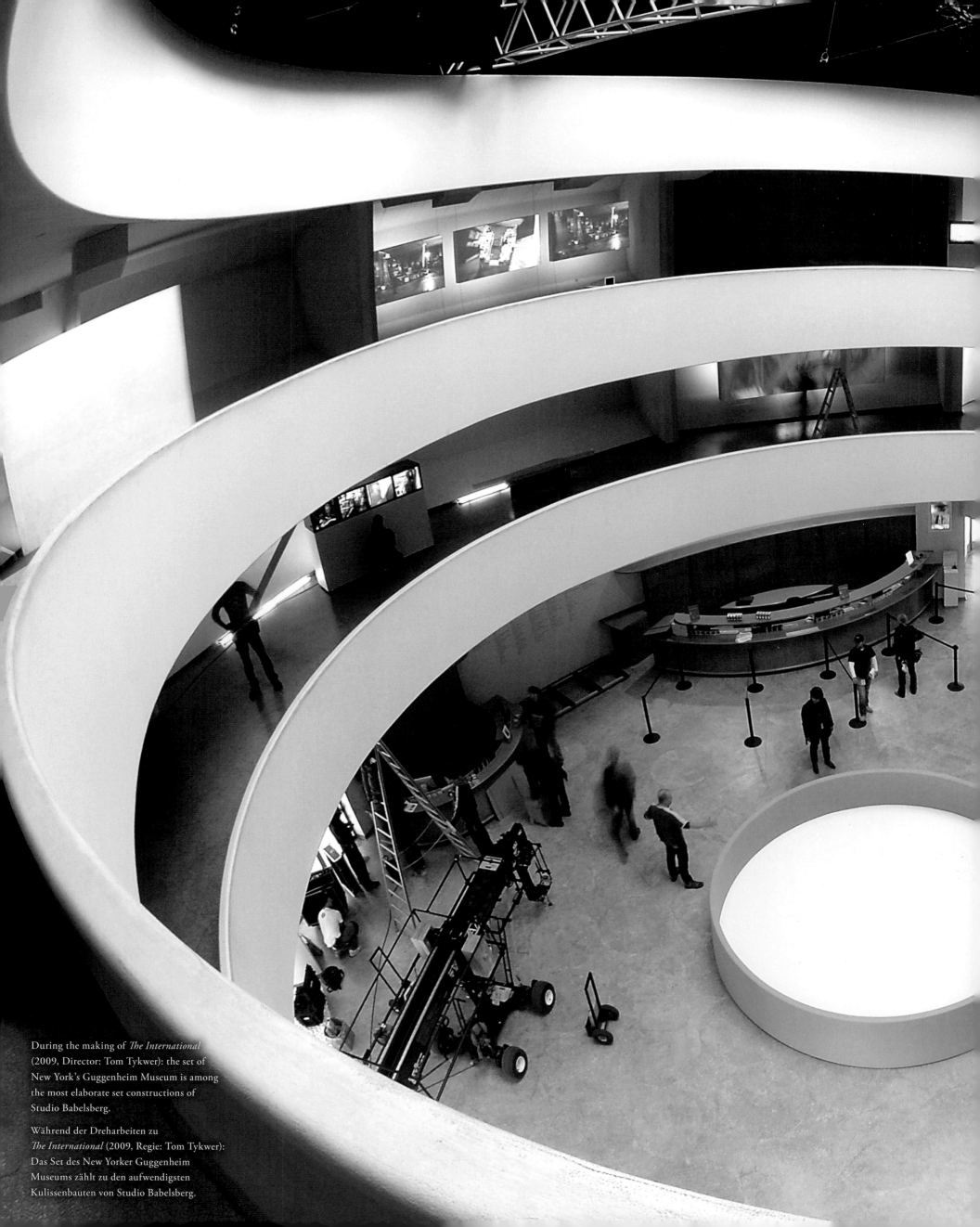

During the making of *The International*
(2009, Director: Tom Tykwer): the set of
New York's Guggenheim Museum is among
the most elaborate set constructions of
Studio Babelsberg.

Während der Dreharbeiten zu
The International (2009, Regie: Tom Tykwer):
Das Set des New Yorker Guggenheim
Museums zählt zu den aufwendigsten
Kulissenbauten von Studio Babelsberg.

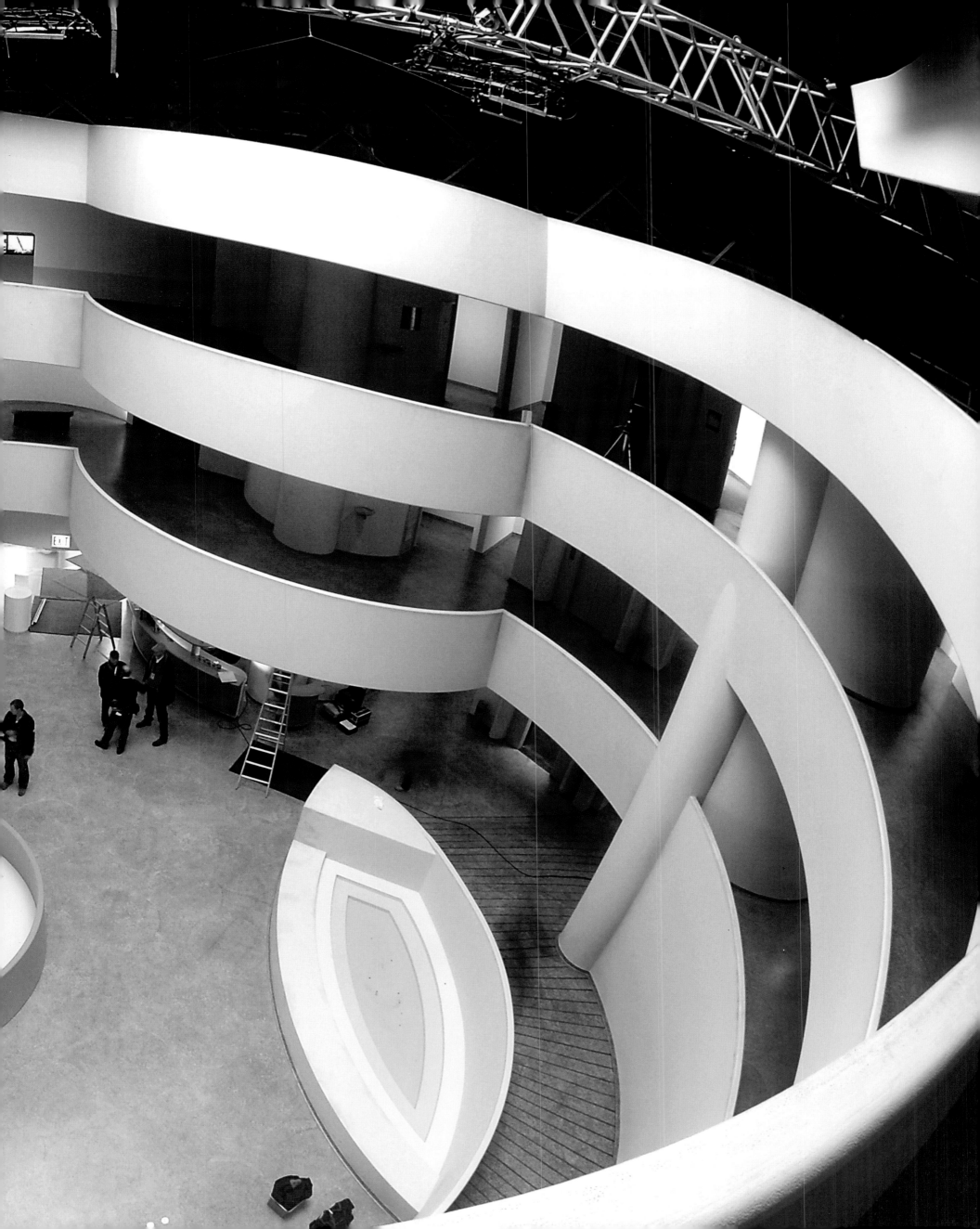

left: While making *The International* in 2007, Tom Tykwer directs Clive Owen (on the floor).
right: Clive Owen as Interpol agent Louis Salinger during a chase in the Guggenheim set.

links: Während der Dreharbeiten zu *The International* im Jahr 2007. Tom Tykwer gibt Clive Owen (liegend) Regieanweisungen.
rechts: Clive Owen als Interpol-Agent Louis Salinger bei einer Verfolgungsjagd im Guggenheim-Set.

In 2008, Studio Babelsberg produced the film *The Reader* with Kate Winslet and David Kross in the leading roles. The drama directed by Stephen Daldry (right) is based on the literary bestseller by Bernhard Schlink. Kate Winslet's acting performance is honored by countless film prizes, among them an Academy Award and a Golden Globe.

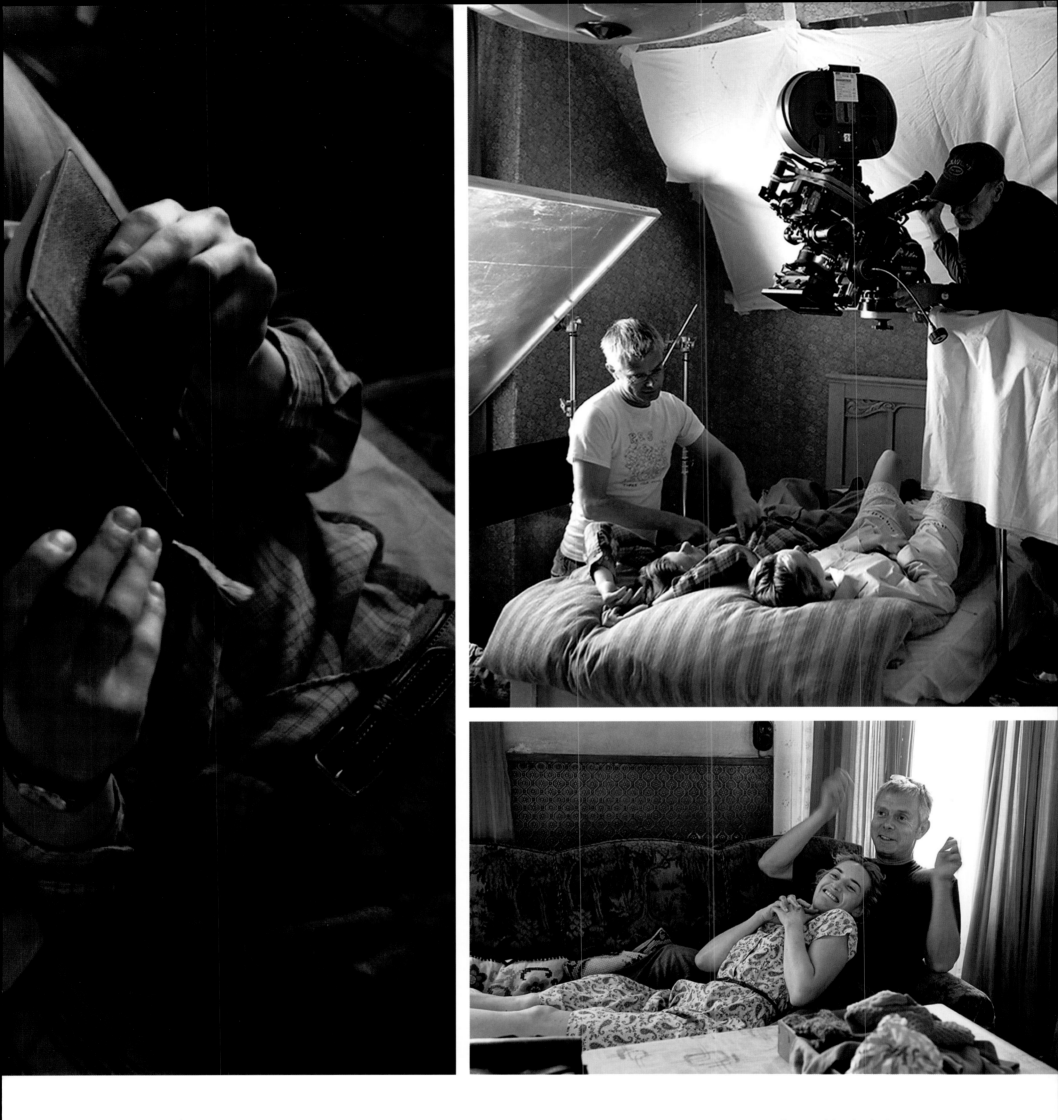

2008 produziert Studio Babelsberg den Film *Der Vorleser* mit Kate Winslet und David Kross in den Hauptrollen. Das von Stephen Daldry (rechts) inszenierte Drama basiert auf dem Bestseller-Roman von Bernhard Schlink. Kate Winslet wird für ihre schauspielerische Leistung mit zahlreichen Filmpreisen geehrt, darunter ein Oscar und ein Golden Globe.

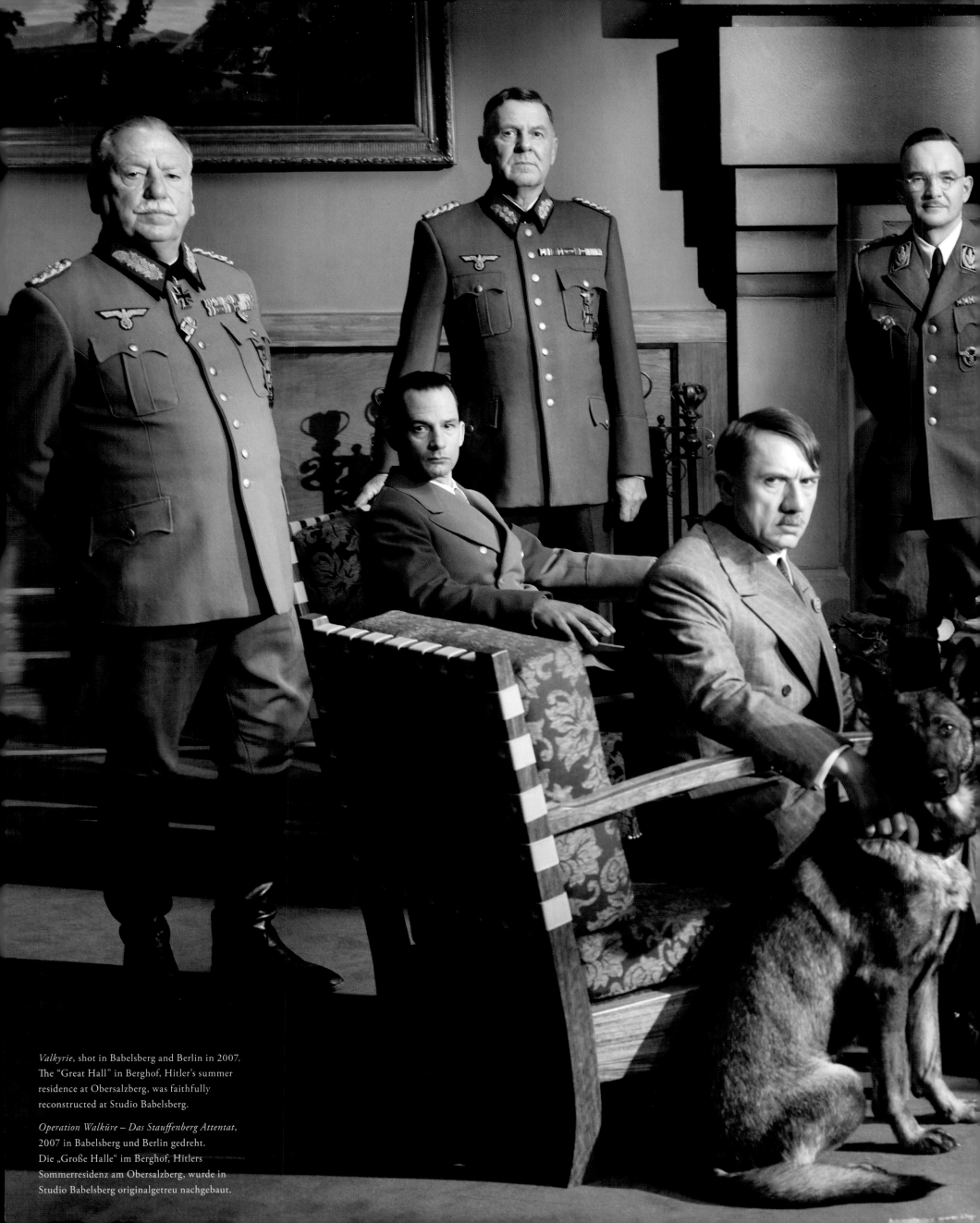

Valkyrie, shot in Babelsberg and Berlin in 2007.
The "Great Hall" in Berghof, Hitler's summer
residence at Obersalzberg, was faithfully
reconstructed at Studio Babelsberg.

Operation Walküre – Das Stauffenberg Attentat,
2007 in Babelsberg und Berlin gedreht.
Die „Große Halle" im Berghof, Hitlers
Sommerresidenz am Obersalzberg, wurde in
Studio Babelsberg originalgetreu nachgebaut.

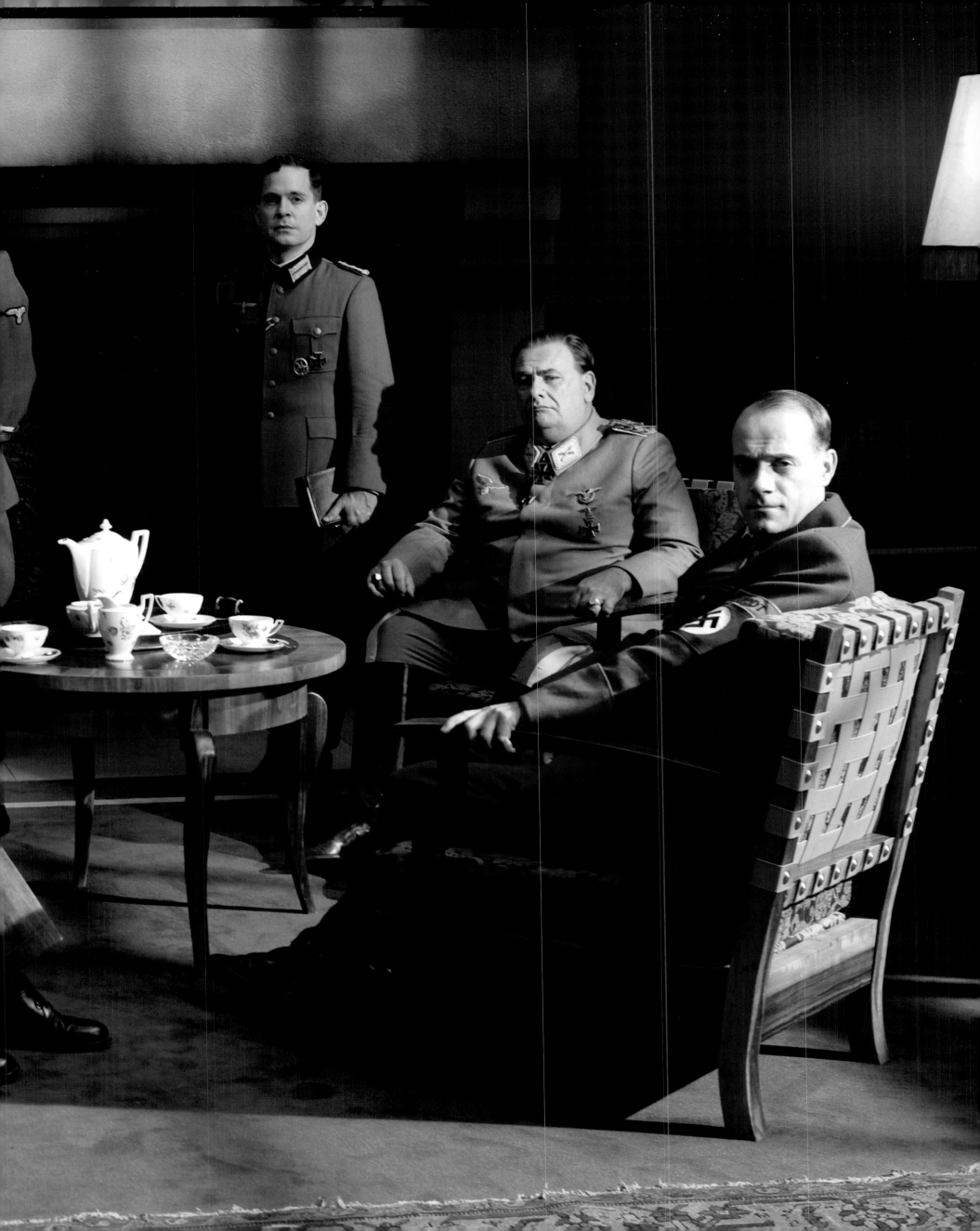

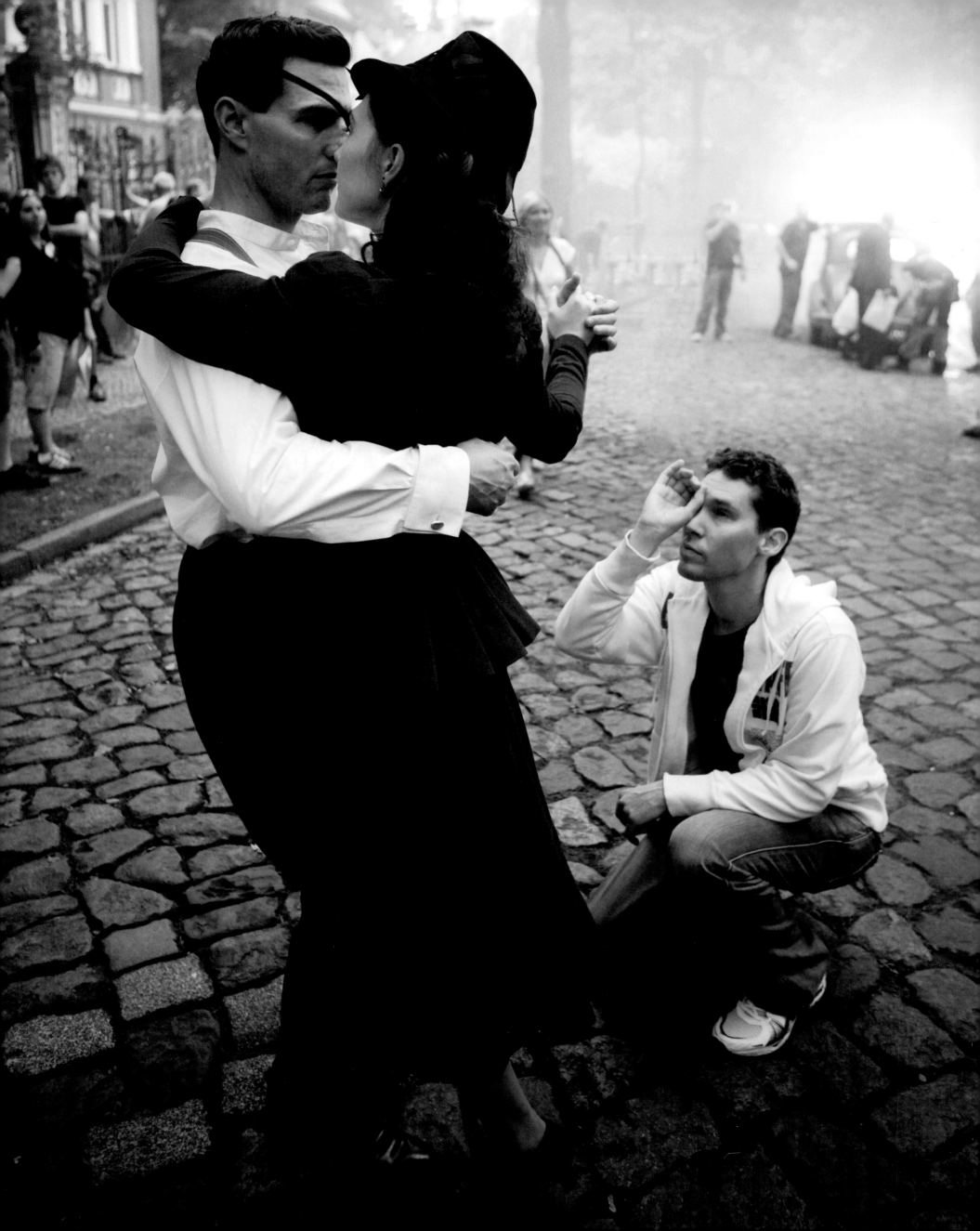

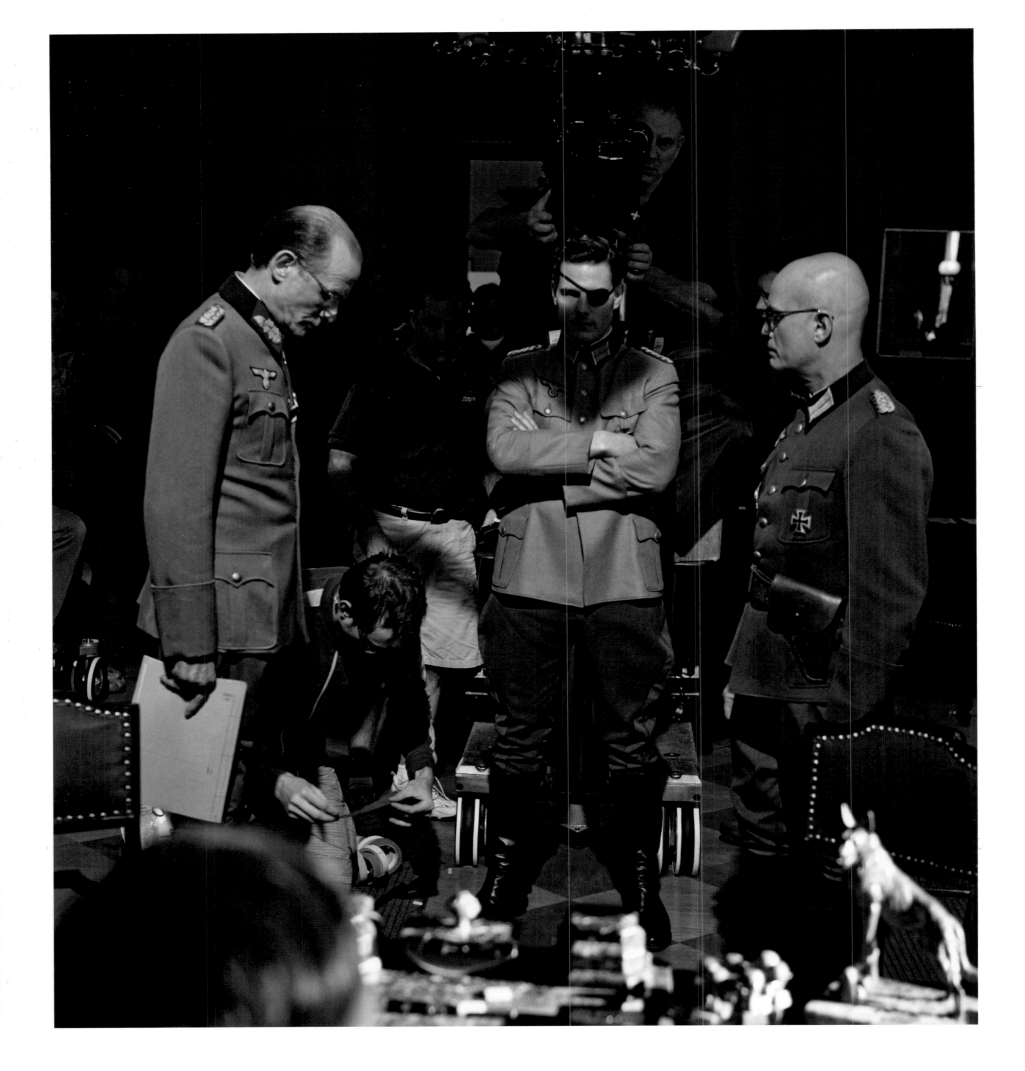

During the making of *Valkyrie* in 2007.

left: Director Bryan Singer checks a camera setup with leads Carice van Houten and Tom Cruise.

right: Billy Nighy (left), Tom Cruise (middle), and Christian Berkel (right) in preparation for a dialogue scene.

Während der Dreharbeiten zu *Operation Walküre – Das Stauffenberg Attentat*, 2007.

links: Regisseur Bryan Singer prüft eine Kameraeinstellung mit den Hauptdarstellern Carice van Houten und Tom Cruise.

rechts: Bill Nighy (links), Tom Cruise (Mitte) und Christian Berkel (rechts) bereiten sich auf eine Dialogszene vor.

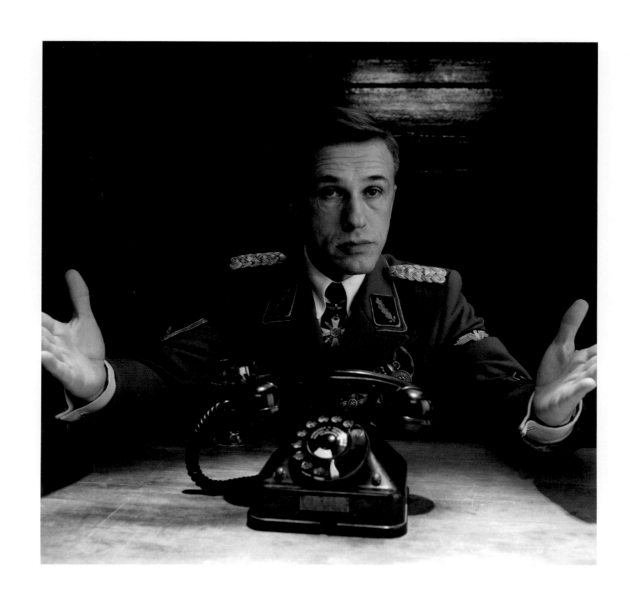

OOOH, THAT'S A BINGO!

Inglourious Basterds

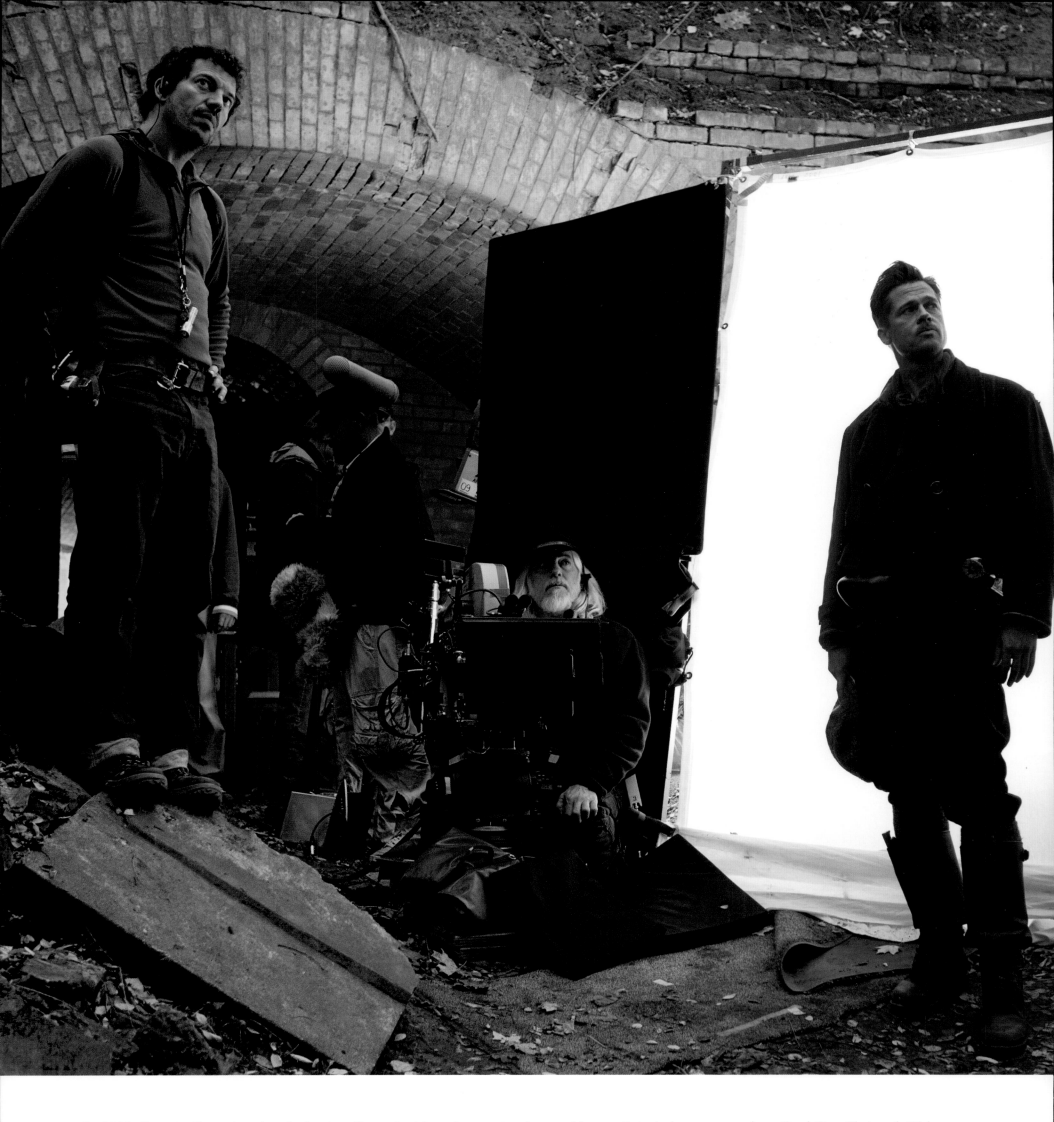

In 2009, Quentin Tarantino shot *Inglourious Basterds* with an international ensemble cast. It includes, among others, Brad Pitt, Christoph Waltz, Diane Kruger, Mélanie Laurent, Michael Fassbender, Mike Myers, Eli Roth, August Diehl, Daniel Brühl, Til Schweiger, Christian Berkel, Martin Wuttke, Sylvester Groth, and Gedeon Burkhard. In the large picture, sitting next to Brad Pitt: cinematographer and two-time Academy Award winner Robert Richardson.

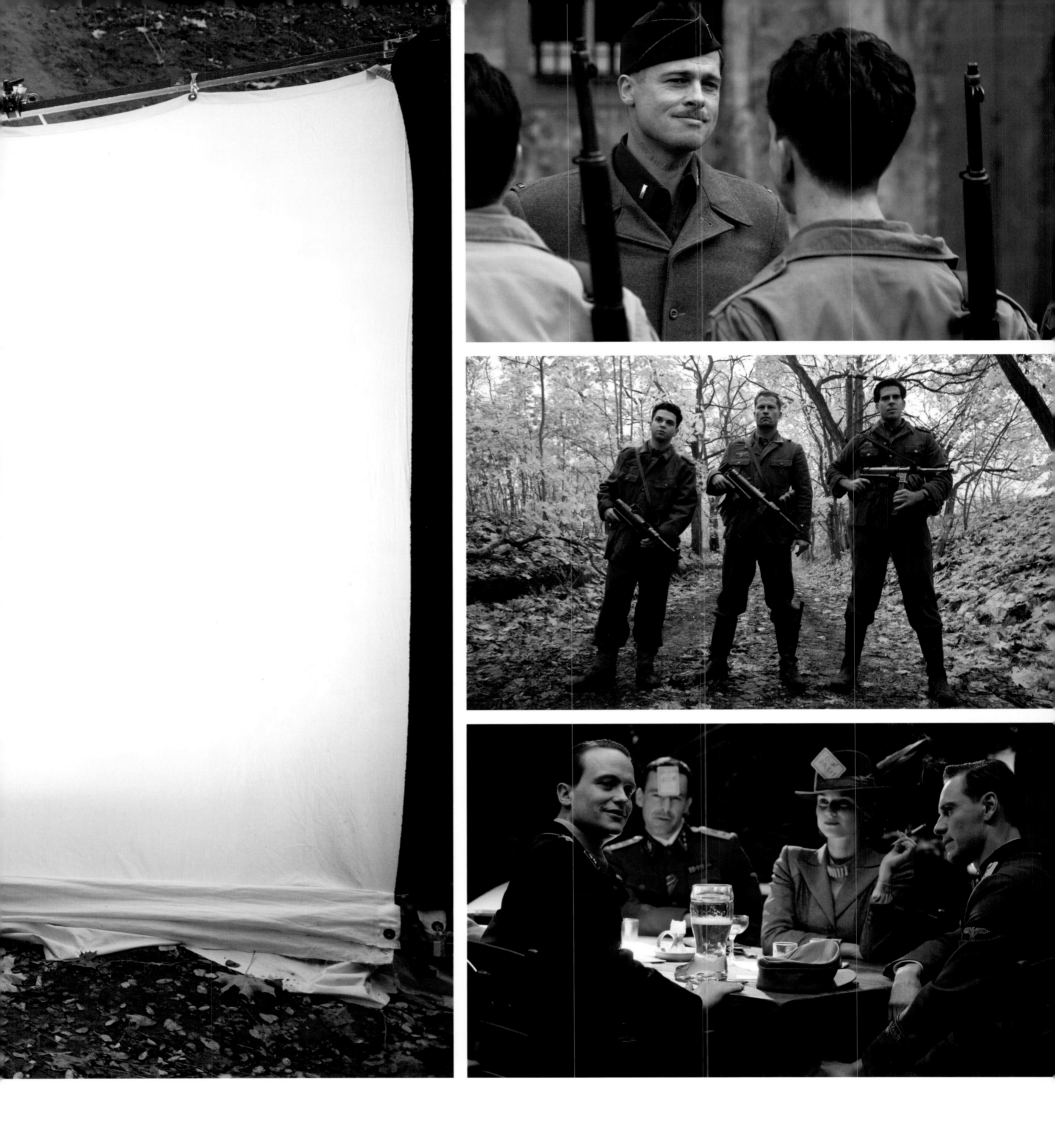

2009 dreht Quentin Tarantino *Inglourious Basterds* mit einem internationalen Schauspieler-Ensemble. Zum Cast gehören unter anderem Brad Pitt, Christoph Waltz, Diane Kruger, Mélanie Laurent, Michael Fassbender, Mike Myers, Eli Roth, August Diehl, Daniel Brühl, Til Schweiger, Christian Berkel, Martin Wuttke, Sylvester Groth und Gedeon Burkhard. Im großen Bild neben Brad Pitt sitzend: Kameramann und zweifacher Oscar-Preisträger Robert Richardson.

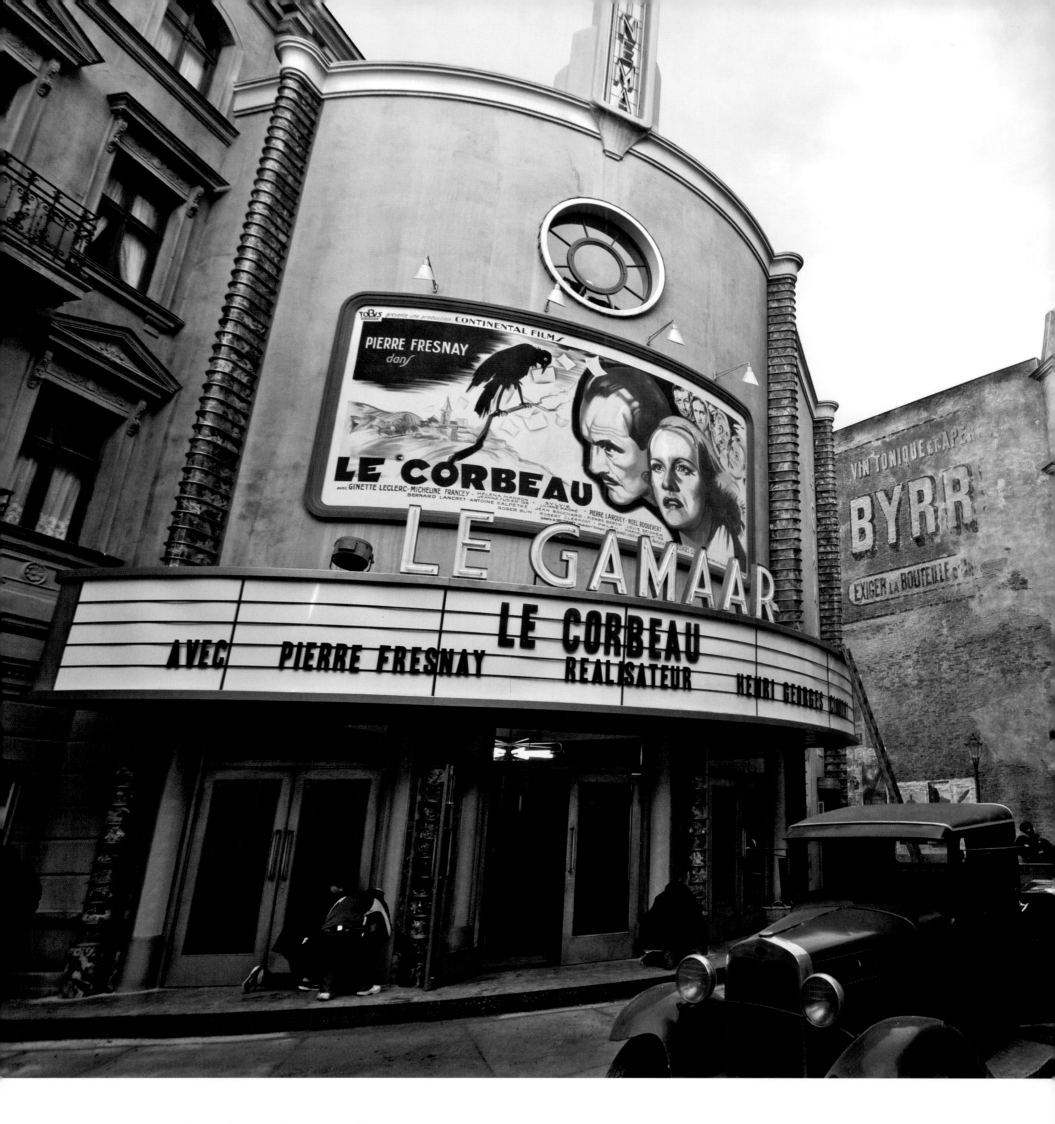

In 2009, the backlot "Berliner Straße" was transformed into a Parisian street for *Inglourious Basterds*. One of the main locations was the cinema "Le Gamaar" (top). The foyer (right) and the auditorium were built under the guidance of production designers David Wasco and Sebastian Krawinkel.

Die Außenkulisse „Berliner Straße" wird 2009 für *Inglourious Basterds* in einen Pariser Straßenzug umgewandelt. Einer der Hauptschauplätze ist das Kino „Le Gamaar" (oben). In der Marlene-Dietrich-Halle werden das Foyer (rechts) sowie der Kinosaal unter Anleitung der Production Designer David Wasco und Sebastian Krawinkel gebaut.

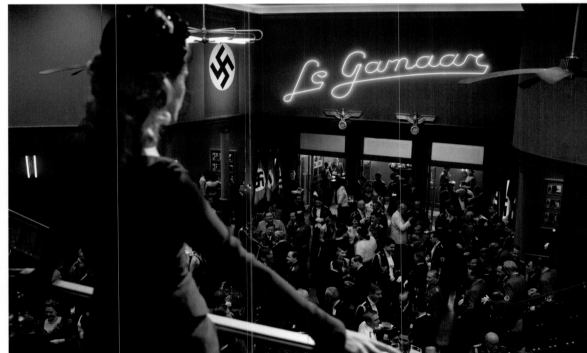

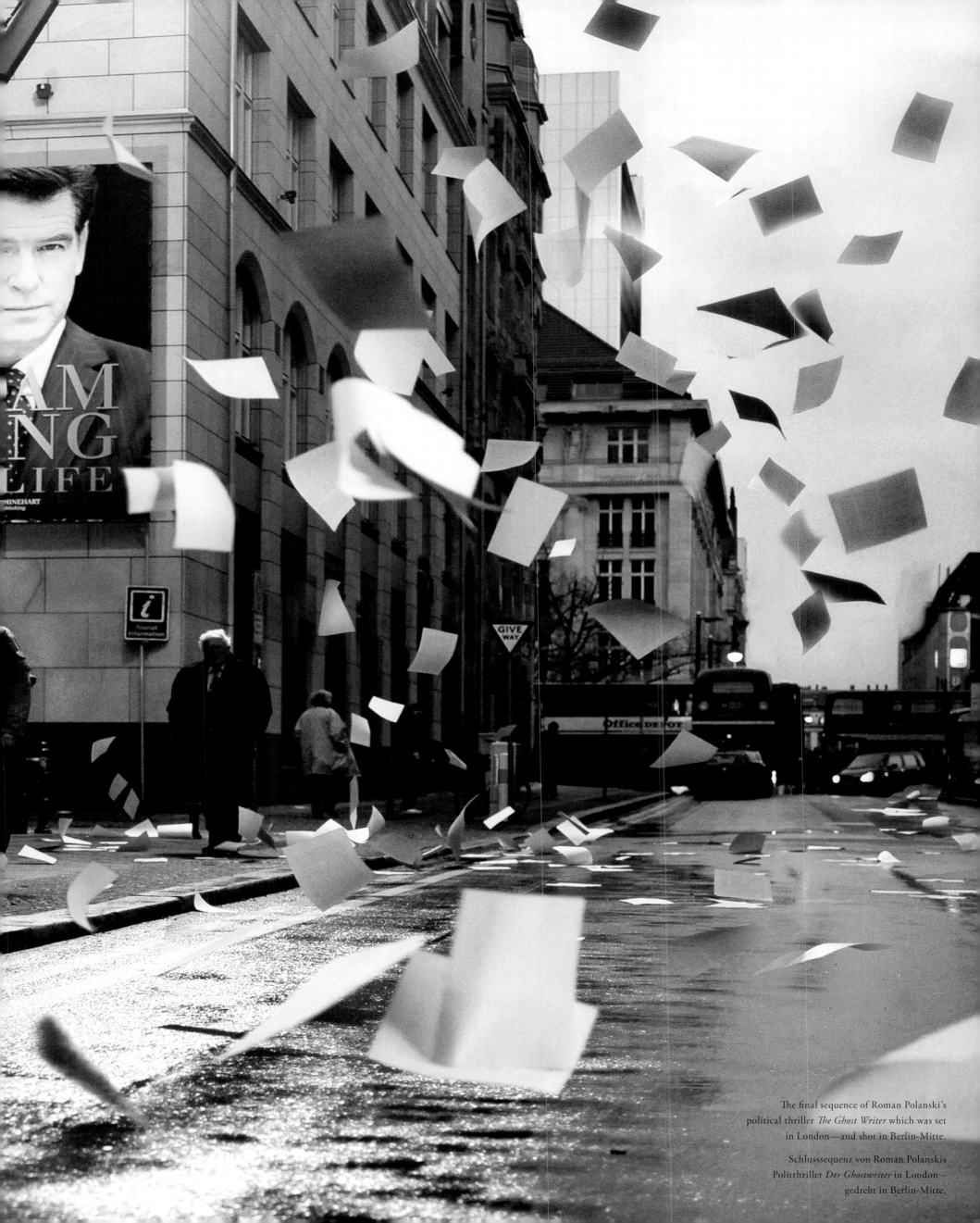

The final sequence of Roman Polanski's political thriller *The Ghost Writer* which was set in London—and shot in Berlin-Mitte.

Schlusssequenz von Roman Polanskis Politthriller *Der Ghostwriter* in London – gedreht in Berlin-Mitte.

A scene featuring Pierce Brosnan and Olivia Williams from *The Ghost Writer*. The official residence of the English Prime Minister, 10 Downing Street, was reconstructed as a façade on the studio lot.

Szene mit Pierce Brosnan und Olivia Williams aus *Der Ghostwriter*. Die offizielle Residenz des englischen Premierministers, 10 Downing Street, wurde als Fassade auf dem Studiogelände in Babelsberg nachgebaut.

Exterior and interior set from
The Ghost Writer: in the film,
the villa is located on Martha's
Vineyard on the American east coast.
It was actually shot in Germany at
Usedom and at Studio Babelsberg.

right: A film still featuring
Ewan McGregor. The dune landscape
was added by visual effects.

Außen- und Innenset-Fotos von
Der Ghostwriter: Im Film steht die
Villa auf Martha's Vineyard, an der
Ostküste der USA. Tatsächlich wurde
in Deutschland auf Usedom und in
Studio Babelsberg gedreht.

rechts: Filmstill mit Ewan McGregor.
Die Dünenlandschaft wurde mithilfe
von Visual Effects hinzugefügt.

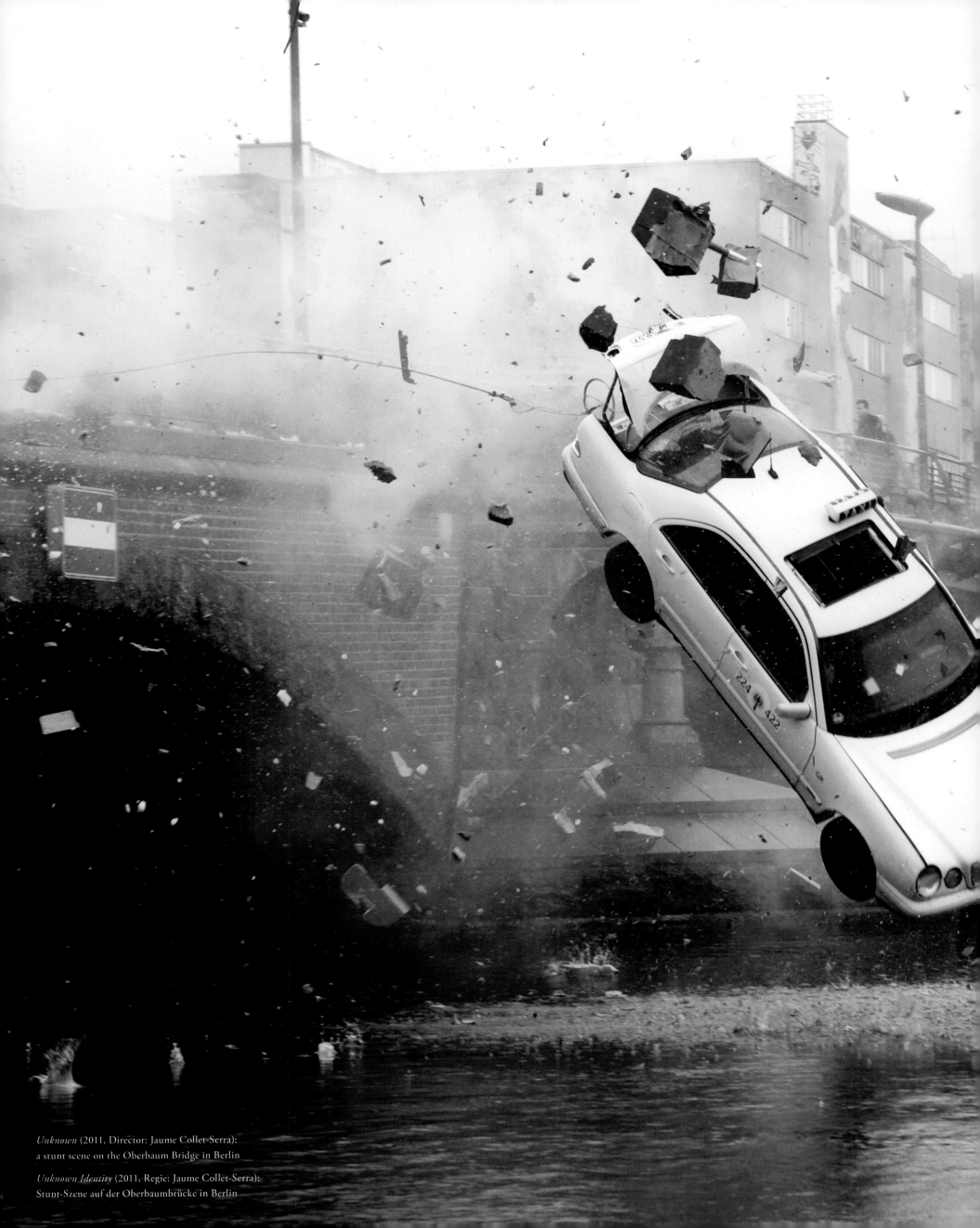

Unknown (2011, Director: Jaume Collet-Serra):
a stunt scene on the Oberbaum Bridge in Berlin

Unknown Identity (2011, Regie: Jaume Collet-Serra):
Stunt-Szene auf der Oberbaumbrücke in Berlin

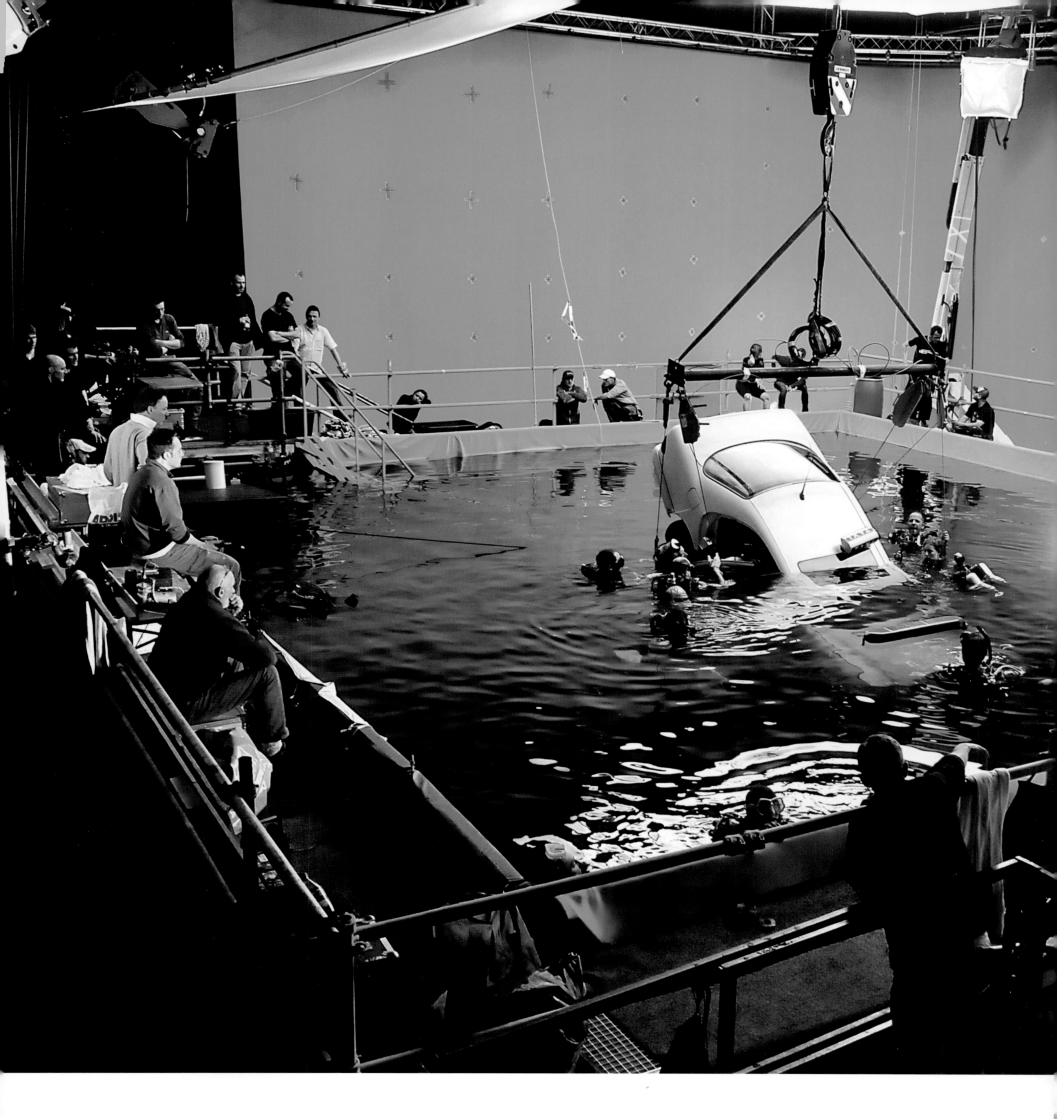

Studio Babelsberg owns Germany's largest water tank for action shoots under and above water.
top: Studio shoot for the scene in *Unknown*, in which Gina (Diane Kruger) rescues unconscious Martin Harris (Liam Neeson).

Studio Babelsberg besitzt Deutschlands größten Wassertank für Action-Aufnahmen unter und über Wasser.
oben: Studioaufnahmen für die Szene in *Unknown Identity*, in der Gina (Diane Kruger) den bewusstlosen Martin Harris (Liam Neeson) rettet.

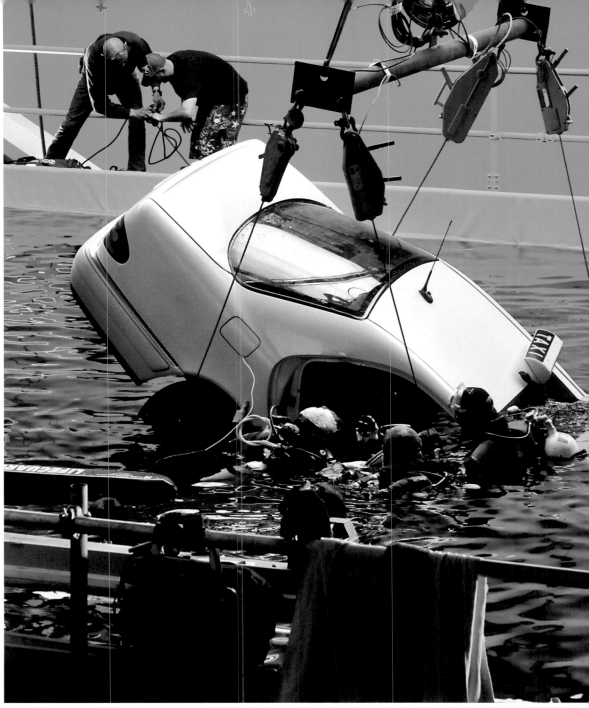

PAPA, I'M READY

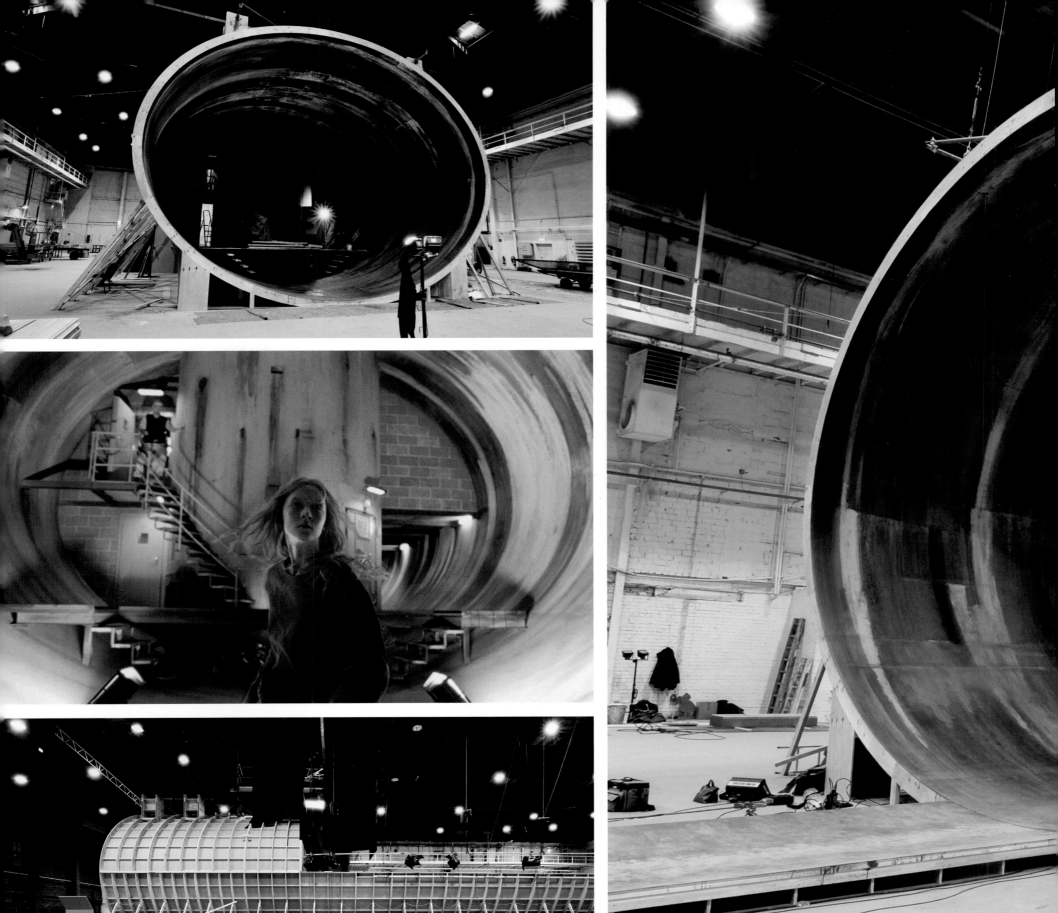

Action scenes were shot in a tunnel system in the Marlene Dietrich Stage for the thriller *Hanna* (2011, Director: Joe Wright) starring Saoirse Ronan (top), Cate Blanchett, and Eric Bana.

Für den Thriller *Wer ist Hanna?* (2011, Regie: Joe Wright) mit Saoirse Ronan (oben), Cate Blanchett und Eric Bana wurden Actionszenen in einem Tunnelsystem in der Marlene-Dietrich-Halle gedreht.

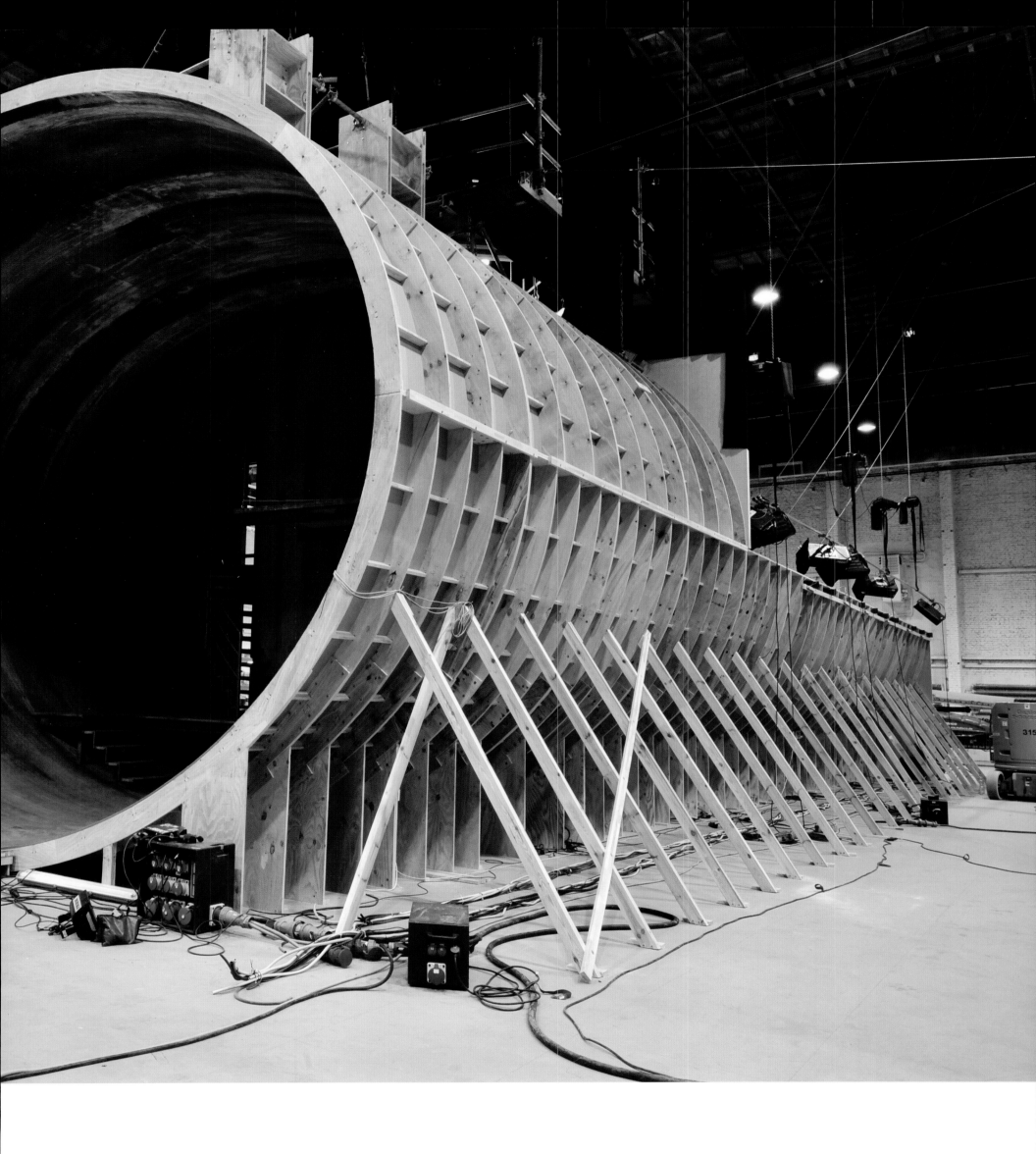

STUDIO BABELSBERG TODAY / HEUTE (1993-2012) 97

Roland Emmerich

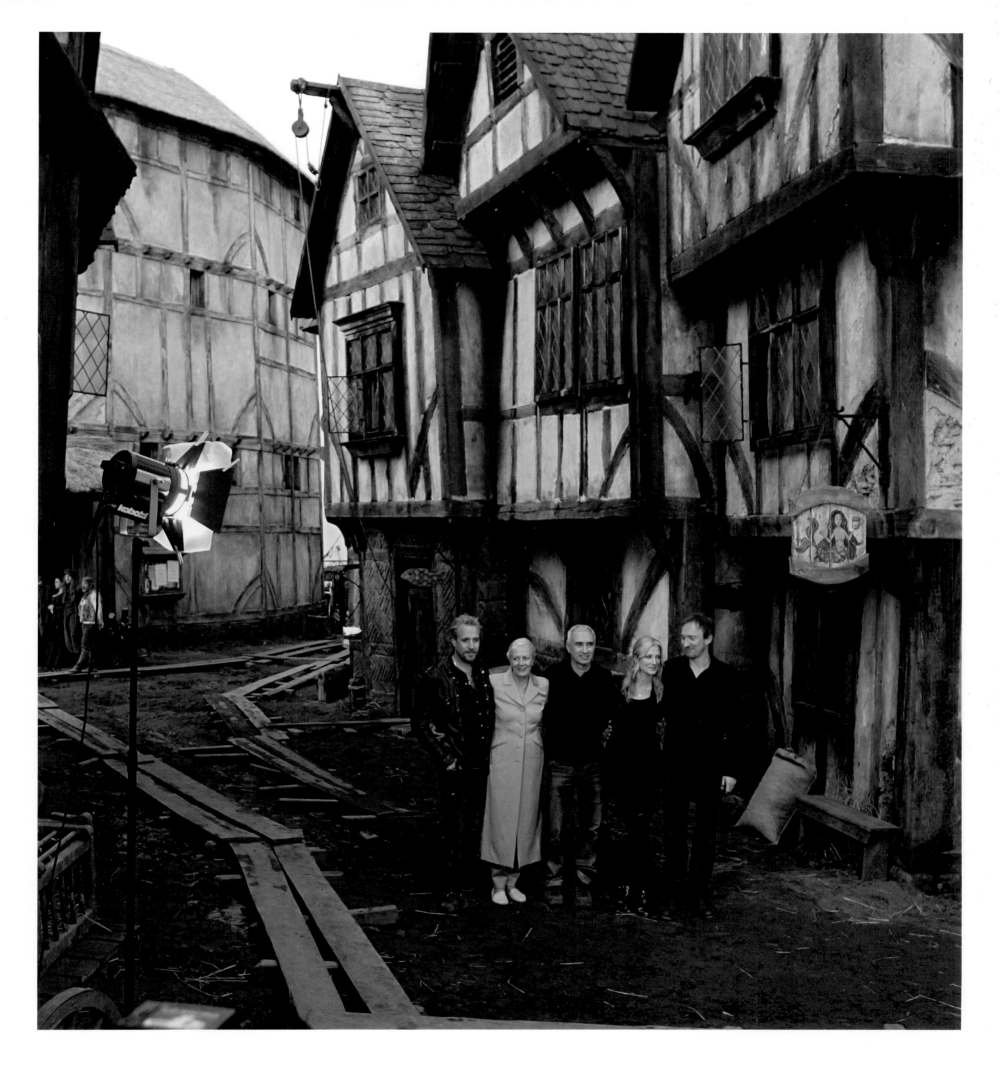

top: Roland Emmerich shot his Shakespeare drama *Anonymous* completely at Babelsberg. F.l.t.r.: Rhys Ifans, Vanessa Redgrave, Roland Emmerich, Joely Richardson, and David Thewlis. Right: The art department had over 80 sets of different size built. Highlights are the faithful reconstructions of London's Rose and Globe Theatre with a London street scene from the 16th century.

oben: Roland Emmerich filmt sein Shakespeare-Drama *Anonymus* vollständig in Babelsberg. V.l.n.r.: Rhys Ifans, Vanessa Redgrave, Roland Emmerich, Joely Richardson und David Thewlis. Rechts: Das Art Department baut über 80 Sets unterschiedlicher Größe. Highlights sind die originalgetreuen Nachbauten des Londoner Rose und Globe Theatre mit einem Straßenzug Londons im 16. Jahrhundert.

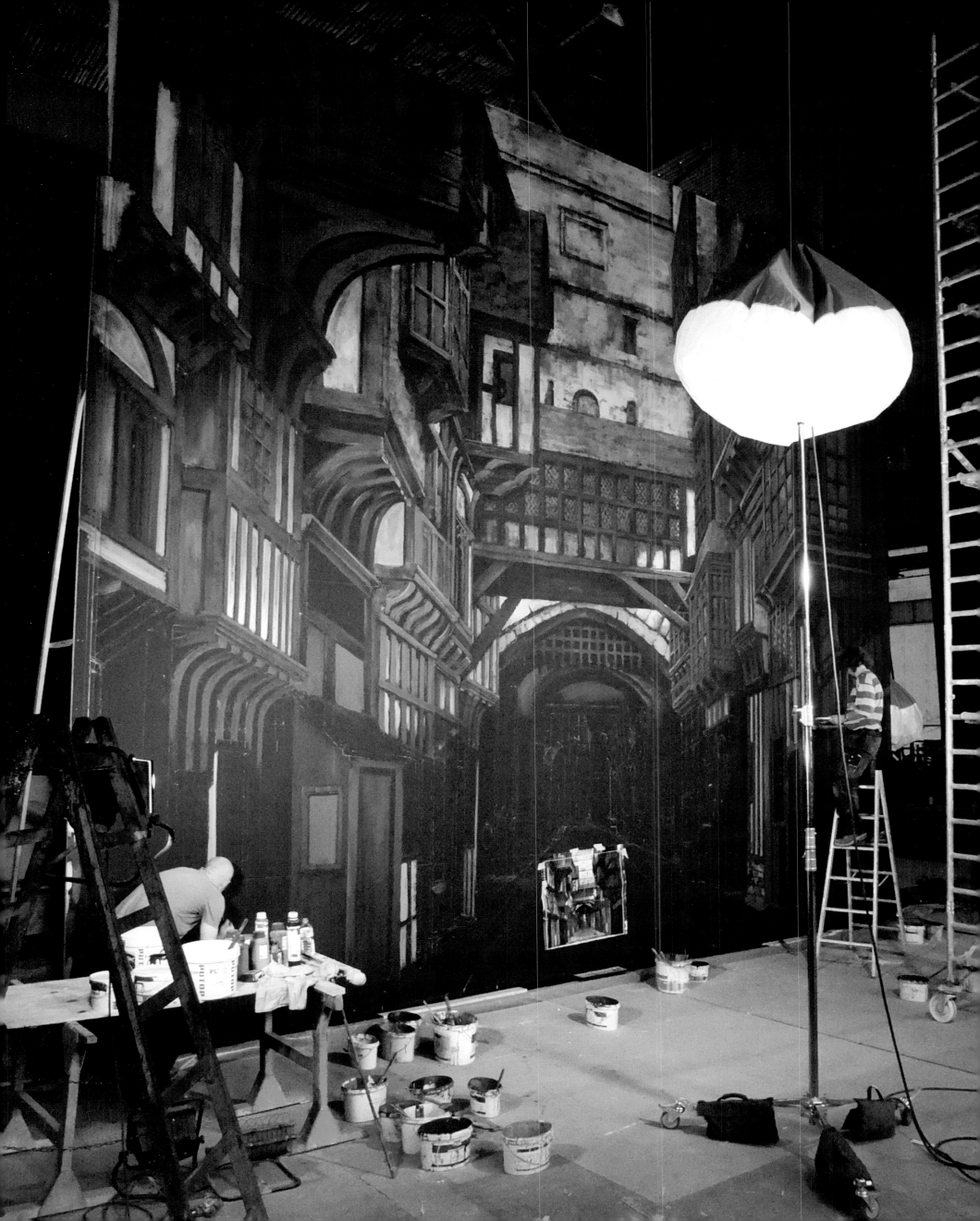

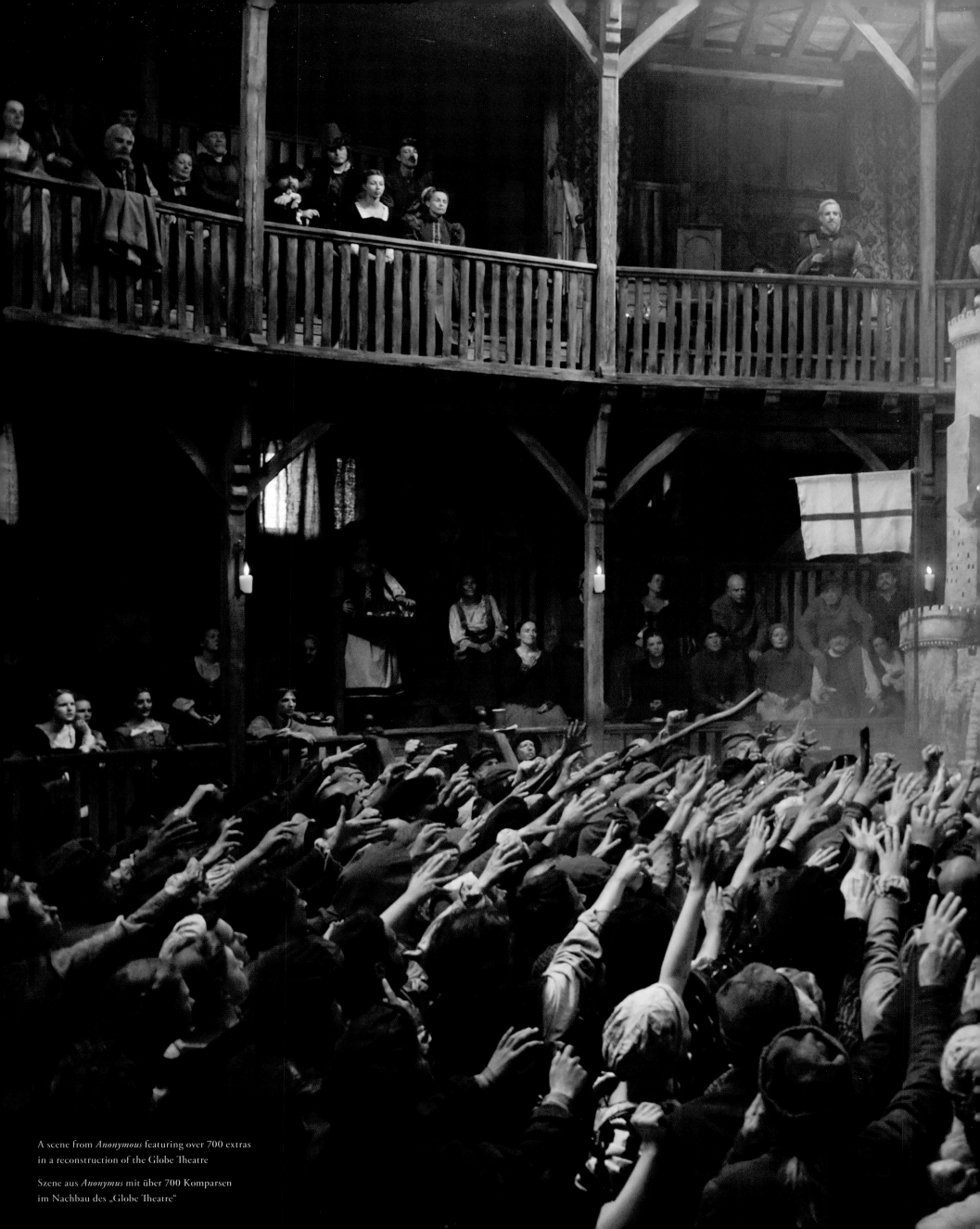

A scene from *Anonymous* featuring over 700 extras
in a reconstruction of the Globe Theatre

Szene aus *Anonymus* mit über 700 Komparsen
im Nachbau des „Globe Theatre"

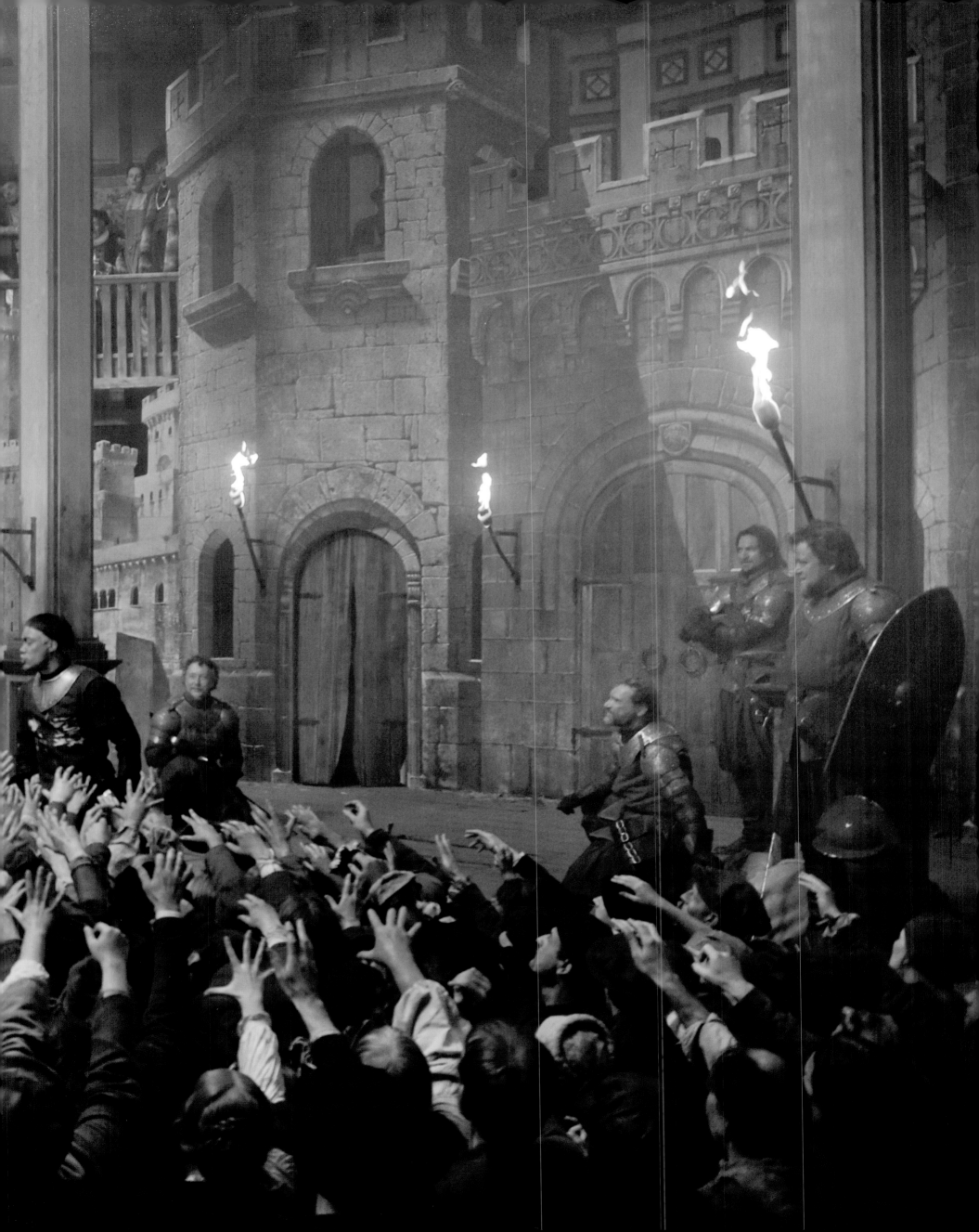

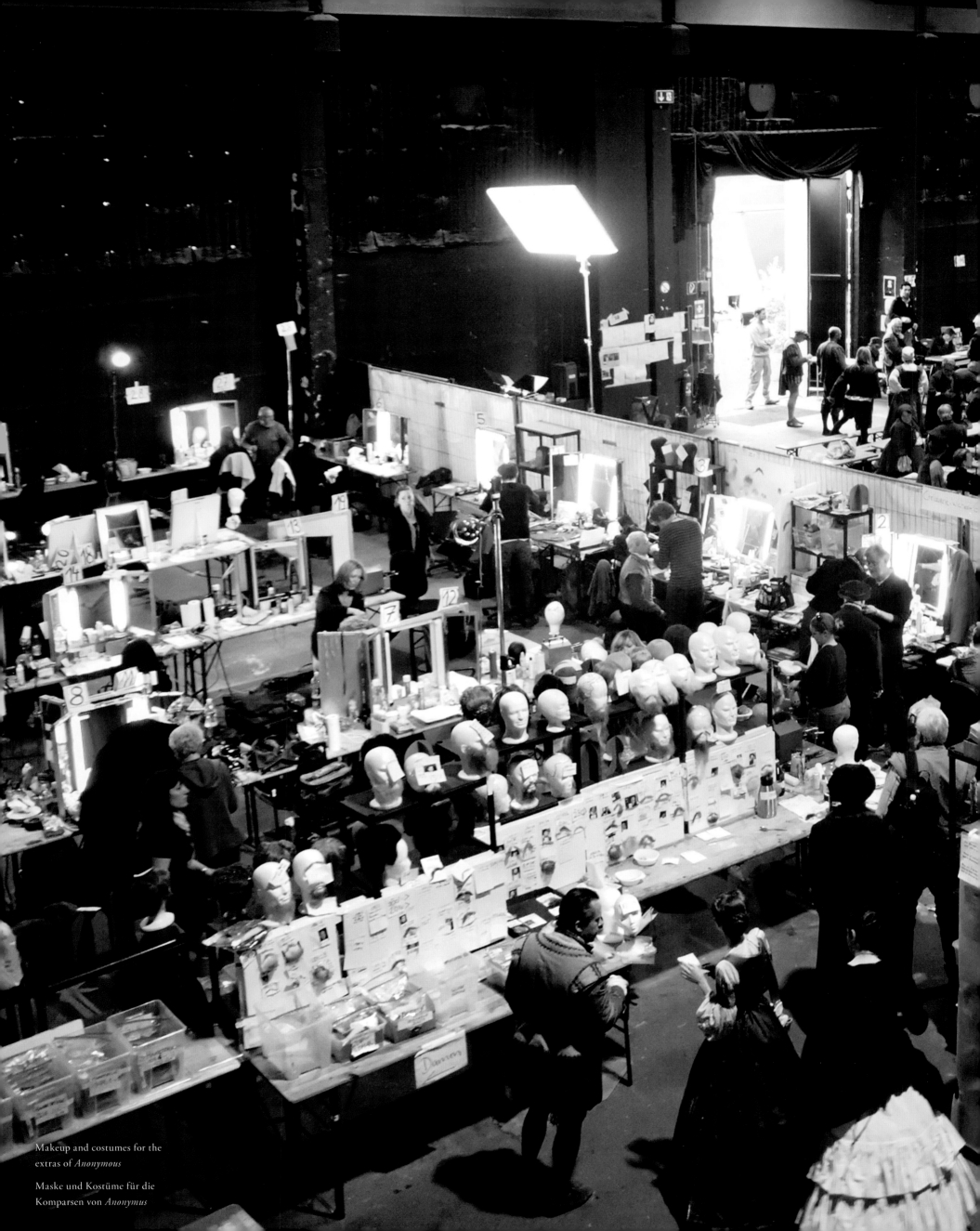

Makeup and costumes for the
extras of *Anonymous*

Maske und Kostüme für die
Komparsen von *Anonymus*

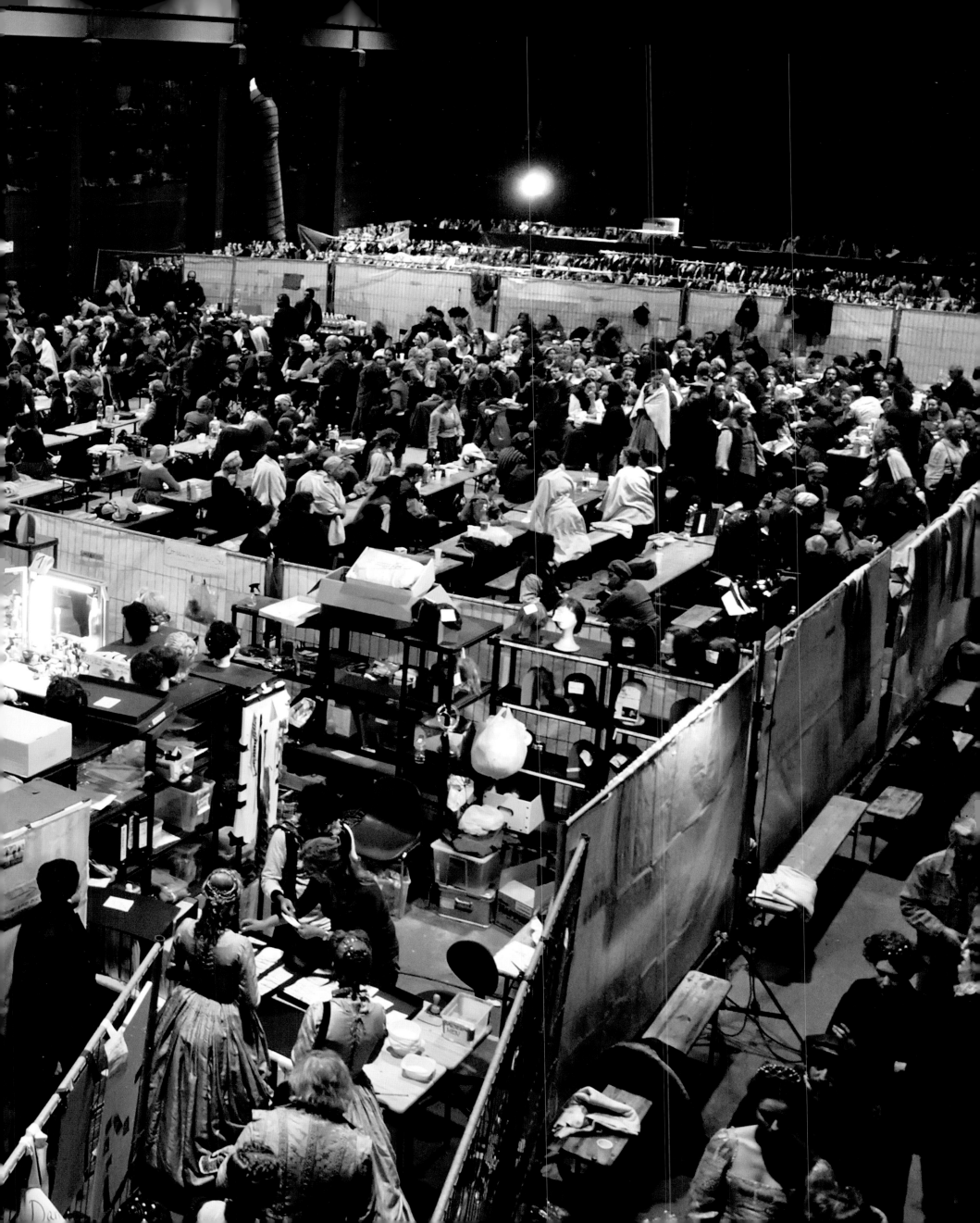

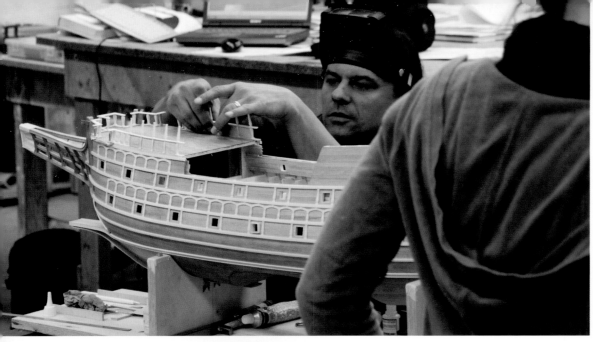

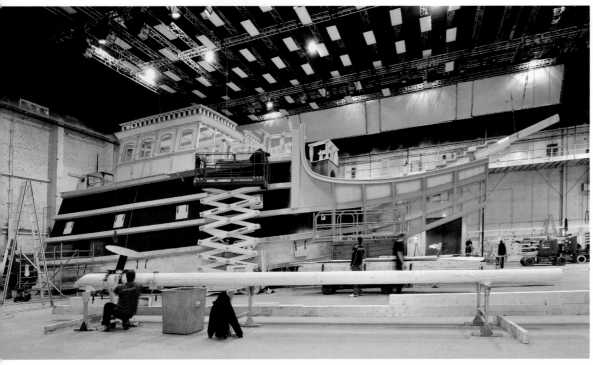

In 2010, Constantin Film produced the adventure film *The Three Musketeers* in 3D under the direction of Paul W.S. Anderson at Babelsberg. Logan Lerman, Milla Jovovich, Matthew Macfadyen, Ray Stevenson, Luke Evans, Christoph Waltz, and Orlando Bloom are the leads. The elaborate set constructions consisted of a Venetian waterway as well as an airship over 164 feet long and 40 feet high.

Constantin Film produziert 2010 unter der Regie von Paul W.S. Anderson den Abenteuerfilm *Die drei Musketiere* in 3D in Babelsberg. In den Hauptrollen sind Logan Lerman, Milla Jovovich, Matthew Macfadyen, Ray Stevenson, Luke Evans, Christoph Waltz und Orlando Bloom. Zu den aufwendigen Setbauten zählen ein venezianischer Wasserstraßenzug sowie ein über 50 Meter langes und zwölf Meter hohes Luftschiff.

Shooting *The Three Musketeers* in the Marlene Dietrich Stage. Orlando Bloom (right) as Duke of Buckingham in the wake of a cannonball impact. The film is the first 3D cinema production at Babelsberg.

Dreharbeiten in der Marlene-Dietrich-Halle für *Die drei Musketiere*. Orlando Bloom (rechts) als Herzog von Buckingham nach einem Kanonenkugeleinschlag. Der Film ist die erste 3D-Kinofilmproduktion in Babelsberg.

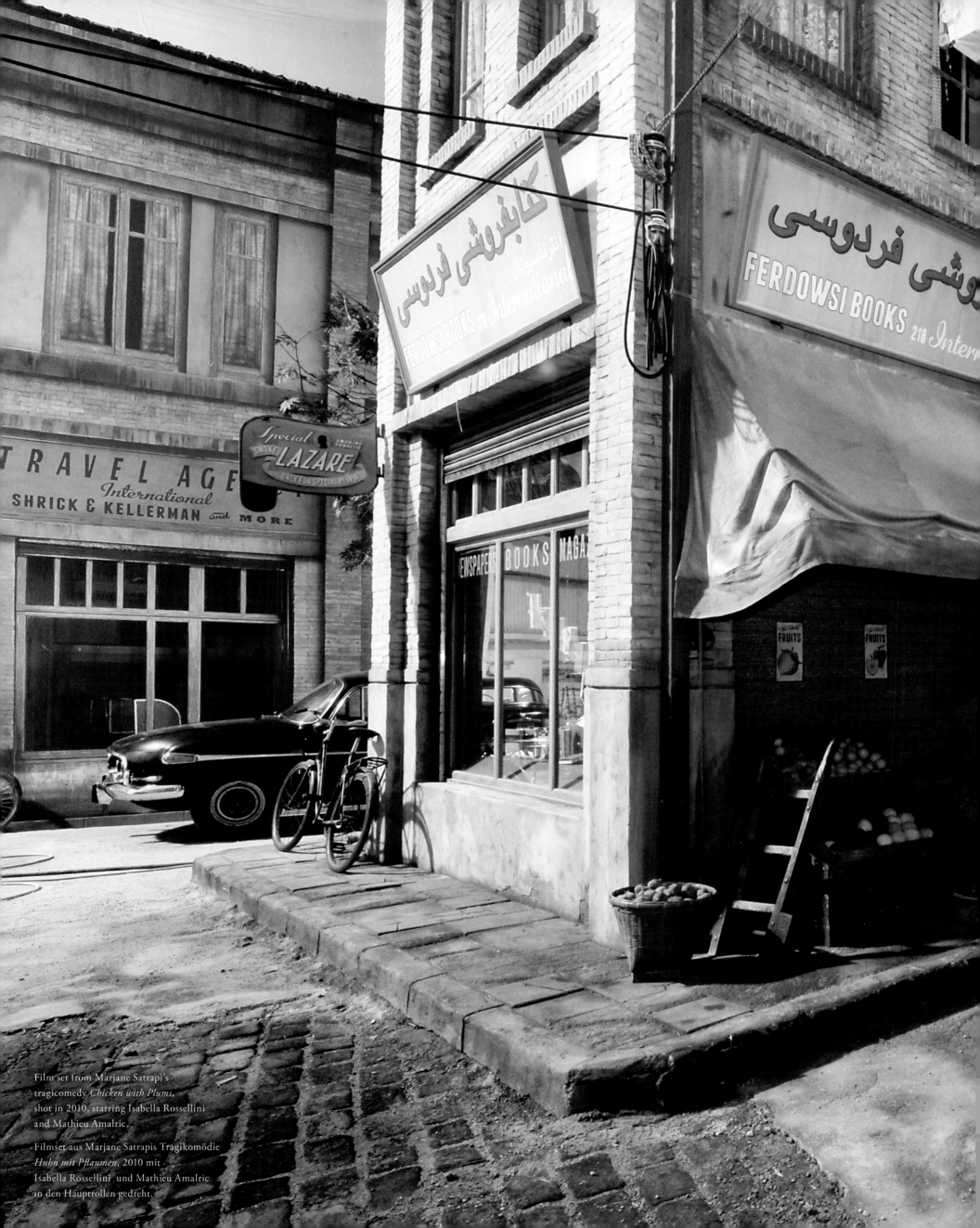

كتابفروشى فردوسى
انترناسيونال
FERDOWSI BOOKS n International

كتابفروشى فردوسى
FERDOWSI BOOKS 218 Inter

TRAVEL AGE
International
SHRICK & KELLERMAN and MORE

Special
SAUKE
LAZARE
SMOKING TUBAK CO
ONLY FOR SPECIAL PEOPLE

NEWSPAPERS BOOKS MAGA

FRUITS

FRUITS

Film set from Marjane Satrapi's
tragicomedy *Chicken with Plums*,
shot in 2010, starring Isabella Rossellini
and Mathieu Amalric.

Filmset aus Marjane Satrapis Tragikomödie
Huhn mit Pflaumen, 2010 mit
Isabella Rossellini und Mathieu Amalric
in den Hauptrollen gedreht.

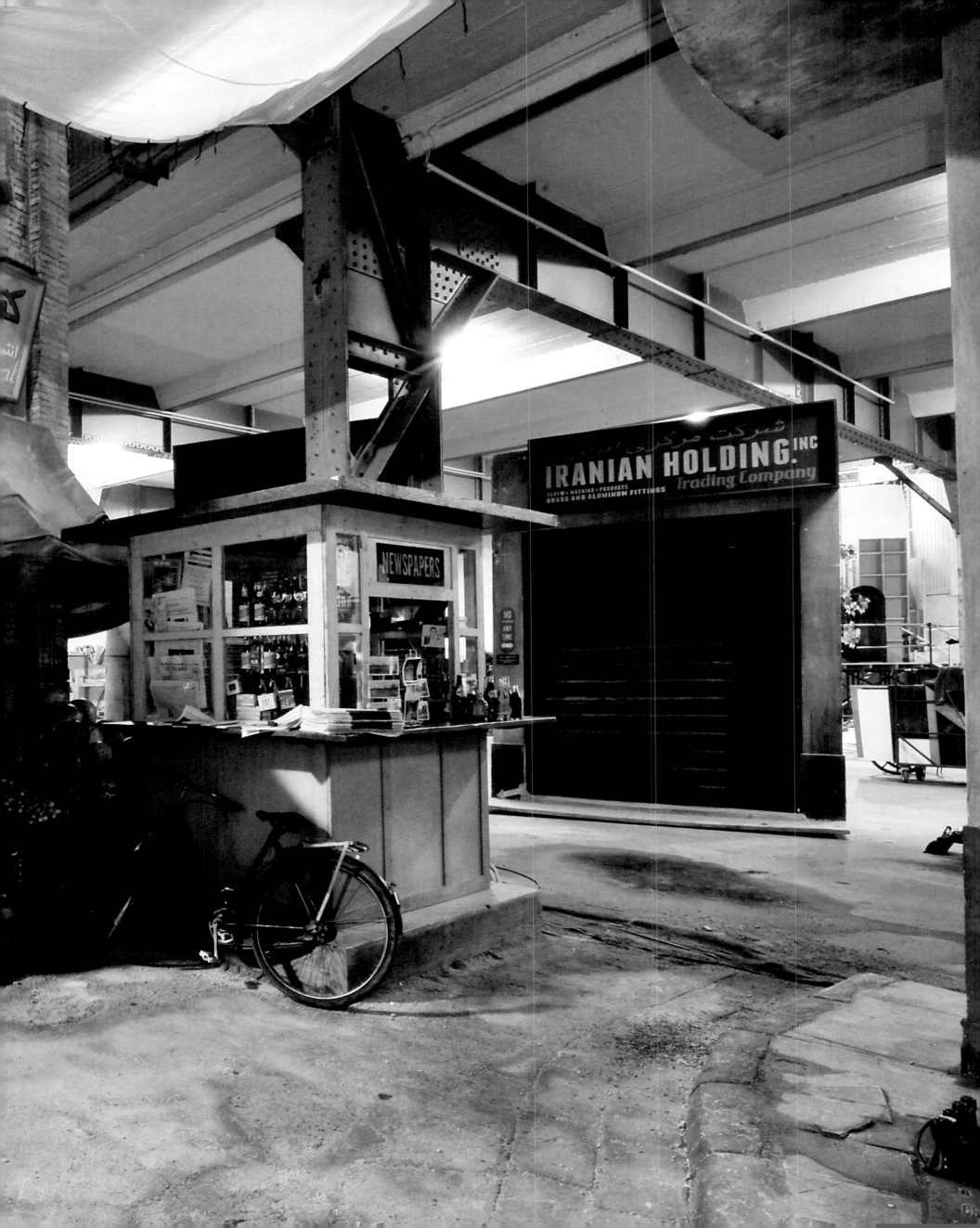

DEFA (1946–1992)
by Ralf Schenk

"DRITTES REICH" (1933–1945)
by Chris Wahl

UFA (1921–1933)
by Chris Wahl

THE BEGINNINGS / DIE ANFÄNGE (1912–1921)
by Michael Wedel

HISTORY
GESCHICHTE

DEFA (1946–1992)

DEFA Studio for Feature Films Potsdam-Babelsberg,
street in front of the canteen, May 1987

DEFA-Studio für Spielfilme Potsdam-Babelsberg,
Straße vor der Kantine, Mai 1987

DEFA (1946-1992)

by Ralf Schenk

Kurt Maetzig, director and cofounder of the DEFA

Kurt Maetzig, Regisseur und Mitbegründer der DEFA

Designing the DEFA signet

Entwurf des DEFA-Signets

After the end of World War II, the Western Allies initially saw no reason to churn out new film productions on German soil. According to their logic, many writers, directors, and actors were too deeply entrenched within Nazi Minister of Propaganda Goebbels' former empire to immediately let them have a second chance. In addition, there were plenty of American, English, and French films at their disposal for the Germans' re-education and entertainment.

Different plans, however, were forged in the zone of influence of the Soviet Military Administration (SMAD). Even here, the decision of the Allied Control Council concerning the confiscation of all film assets from the Third Reich, including the Ufi company with its studios in Potsdam-Babelsberg, was in effect. Yet already in the fall of 1945, the Central Department of People's Education, established at the behest of SMAD, put out a call to all filmmakers to report to them in order to take part in the resumption of film production. On October 29, 1945, the Soviet dictator Joseph Stalin granted Marshal Zhukov, the head of SMAD and commander-in-chief of Soviet occupation forces, the permission to found a German-Soviet company to produce films. A working group of the People's Education Department named "Film-Aktiv" convened at the Hotel Adlon in Berlin on November 22. Among the participants were Film-Aktiv's driving forces, including directors like Gerhard Lamprecht, Wolfgang Staudte, Peter Pewas, and Werner Hochbaum, and writers such as Friedrich Wolf and Hans Fallada, as well as Dr. Kurt Maetzig.

In the following months, numerous activities were to emerge from Film-Aktiv. An artistic-dramaturgical department, a technical department, a cultural film department, and a newsreel department came into being, among others. DEFA (Deutsche Film-A.G.) emerged as the name for the newly founded film company. By February 19, 1946, the first DEFA newsreel "Der Augenzeuge" appeared on Berlin screens. On April 1, the DEFA start-up signed a lease agreement regarding the use of the Althoff studios in Potsdam-Alt Nowawes. At that time, the

DEFA (1946–1992)

Ralf Schenk

Nach dem Ende des Zweiten Weltkriegs sahen die westlichen Alliierten zunächst keinen Grund, eine neue Filmproduktion auf deutschem Boden zu forcieren: Viele Autoren, Regisseure und Schauspieler, so ihre Argumentation, seien zu tief im Imperium von NS-Propagandaminister Goebbels verankert gewesen, als dass ihnen sogleich wieder eine Chance ermöglicht werden sollte. Zudem stünden für die Umerziehung, aber auch für die Unterhaltung der Deutschen genügend US-amerikanische, englische und französische Filme zur Verfügung.

Im Machtbereich der Sowjetischen Militäradministration (SMAD) wurden indes andere Pläne geschmiedet. Zwar galt auch hier jener Beschluss des Alliierten Kontrollrats, nach dem das Filmvermögen des Dritten Reiches beschlagnahmt worden war, darunter der Ufi-Konzern mit seinen Studios in Potsdam-Babelsberg. Doch die Zentralverwaltung für Volksbildung, die Ende August 1945 auf Befehl der SMAD etabliert wurde, startete schon im Herbst 1945 einen Aufruf an deutsche Filmschaffende, sich bei ihr zu melden, um an der Wiederaufnahme der Filmproduktion teilzunehmen. Am 29. Oktober 1945 erteilte der sowjetische Machthaber Josef Stalin dem Chef der SMAD und Oberbefehlshaber der sowjetischen Besatzungstruppen, Marschall Shukow, die Erlaubnis, eine deutsch-sowjetische Aktiengesellschaft zur Herstellung von Filmen zu gründen. Eine Arbeitsgruppe der Zentralverwaltung für Volksbildung, genannt „Film-Aktiv", berief am 22. November eine Zusammenkunft im Berliner Hotel Adlon ein. Zu den Teilnehmern des Treffens gehörten Regisseure wie Gerhard Lamprecht, Wolfgang Staudte, Peter Pewas und Werner Hochbaum, Autoren wie Friedrich Wolf und Hans Fallada sowie Dr. Kurt Maetzig als treibende Kraft des „Film-Aktivs".

In den folgenden Monaten gingen vom „Film-Aktiv" zahlreiche Aktivitäten aus. Unter anderem entstanden eine künstlerisch-dramaturgische Abteilung, eine technische Abteilung, eine Kulturfilm- und eine Wochenschau-Abteilung. Als Name für die neu zu gründende Filmfirma kristallisierte sich die Bezeichnung DEFA (Deutsche Film-A.G.) heraus. Schon am 19. Februar 1946

Director Wolfgang Staudte (right) and leading actress
Hildegard Knef (middle) during the making of
The Murderers Are Among Us (1946)

Regisseur Wolfgang Staudte (rechts) und
Hauptdarstellerin Hildegard Knef (Mitte) während der
Dreharbeiten zu *Die Mörder sind unter uns* (1946)

Ufa studios in Babelsberg were not yet available. On May 4, Wolfgang Staudte began shooting
the first German postwar film *The Murderers Are Among Us* (1946).

The official foundation of the DEFA occurred on May 17, 1946, in the large hall of the Althoff
studio. Among the speakers was the president of the Central Department of People's Education,
Paul Wandel, who had returned to Germany from Soviet exile. He encouraged artists to take
a stand on the "great and vital questions of our people:"

> It is essential to recognize the follies of the past and step onto the new path of honest cooperation
> with all peace-loving people. [...] Film [...] can no longer be the opium that makes one forget,
> but should give power, courage, the will to live, and vitality to broad segments of the population.
> But above all, filmmaking itself has to be borne by an inner honesty that seeks the truth, proclaims
> the truth, and shakes consciences awake.[1]

Cultural officer Sergei Tulpanov gave off similar signals: film, so he proclaimed, has to "become a
sharp and powerful weapon against the reactionaries and for a deep-seated, growing democracy."[2]

In the first year of its existence, DEFA released three films into the cinemas that dealt with the
German present and the immediate past in three stylistically very different ways. *The Murderers
Are Among Us*, which is about the participation of Wehrmacht soldiers in war crimes, harked back
to the expressionist films of the Weimar Republic with its canted camera angles and emphasis
on light and shadow. Milo Harbich's *A Free Country* (1946), a didactic report on land reform
that delves into societal processes, connects fictional scenes with documentary footage. With
Somewhere in Berlin (1946), Gerhard Lamprecht recalled the realistic style of his children's film
Emil and the Detectives (1931) and imbued his images of Berlin with melodramatic pathos. In
1947, Kurt Maetzig directed the first German film about the persecution of the Jews under the
Nazis with *Marriage in the Shadows*; it premiered in all four sectors of Berlin simultaneously.
The DEFA provided technical support to Italian director Roberto Rossellini during the filming
of *Germany Year Zero* (1948). Erich Engel pursued the virulent anti-semitism in the Weimar
Republic with the crime film *The Blum Affair* (1948). And Georg C. Klaren adapted Georg
Büchner's drama fragment "Woyzeck" under the title *Wozzeck* (1947) as a feverishly nightmarish
denunciation of militarism.

erschien die erste DEFA-Wochenschau „Der Augenzeuge" auf den Berliner Leinwänden. Am 1. April schloss die „DEFA in Gründung" einen Pachtvertrag über die Nutzung der Althoff-Ateliers in Potsdam-Alt Nowawes. Die Ufa-Studios in Babelsberg standen zu diesem Zeitpunkt noch nicht zur Verfügung. Am 4. Mai begann Wolfgang Staudte mit den Dreharbeiten zum ersten deutschen Nachkriegsspielfilm *Die Mörder sind unter uns* (1946).

Der offizielle Akt der DEFA-Gründung fand am 17. Mai 1946 in der Großen Halle des Althoff-Ateliers statt. Zu den Rednern gehörte der Präsident der Zentralverwaltung für Volksbildung, Paul Wandel, der aus sowjetischem Exil nach Deutschland zurückgekehrt war. Er forderte die Künstler auf, Stellung zu den „großen Schicksalsfragen unseres Volkes" zu nehmen:

> Es gilt, den Irrweg der Vergangenheit zu erkennen und den neuen Weg der ehrlichen Zusammenarbeit mit allen friedliebenden Völkern zu beschreiten. [...] Der Film [...] darf nicht mehr Opium des Vergessens sein, sondern soll den breiten Schichten unseres Volkes Kraft, Mut, Lebenswillen und Lebensfreude spenden. Vor allem aber muss das Filmschaffen getragen sein von innerer Ehrlichkeit, die die Wahrheit sucht, die Wahrheit verkündet und das Gewissen wachrüttelt.[1]

Ähnliche Signale gingen von dem sowjetischen Kulturoffizier Sergej Tulpanow aus: Film, so proklamierte er, müsse „eine scharfe und mächtige Waffe werden gegen die Reaktion und für in der Tiefe wachsende Demokratie."[2]

Im ersten Jahr ihres Bestehens brachte die DEFA drei Filme in die Kinos, die sich auf stilistisch unterschiedliche Weise mit der deutschen Gegenwart und der unmittelbaren Vergangenheit befassten. *Die Mörder sind unter uns*, über die Mitwirkung von Wehrmachtsangehörigen an Verbrechen des Krieges, griff mit seinen schrägen Kameraperspektiven und der Betonung von Licht und Schatten auf Elemente des expressionistischen Films der Weimarer Republik zurück. Milo Harbichs *Freies Land* (1946), ein didaktischer, in die gesellschaftlichen Vorgänge eingreifender Report über die Bodenreform, verknüpfte dokumentarische und Spielszenen. Gerhard Lamprecht erinnerte mit *Irgendwo in Berlin* (1946) an den realistischen Stil seines Kinderfilms

Handing over the license to the DEFA, 17th of May, 1946, f.l.t.r.:
Col. Sergej Tulpanow, Hans Klering, Alfred Lindemann,
Willy Schiller, Karl Hans Bergmann, Kurt Maetzig

Lizenzübergabe an die DEFA, 17. Mai 1946, v.l.n.r.:
Oberst Sergej Tulpanow, Hans Klering, Alfred Lindemann,
Willy Schiller, Karl Hans Bergmann, Kurt Maetzig

Hildegard Knef and Ernst Wilhelm Borchert in
The Murderers Are Among Us

Hildegard Knef und Ernst Wilhelm Borchert in
Die Mörder sind unter uns

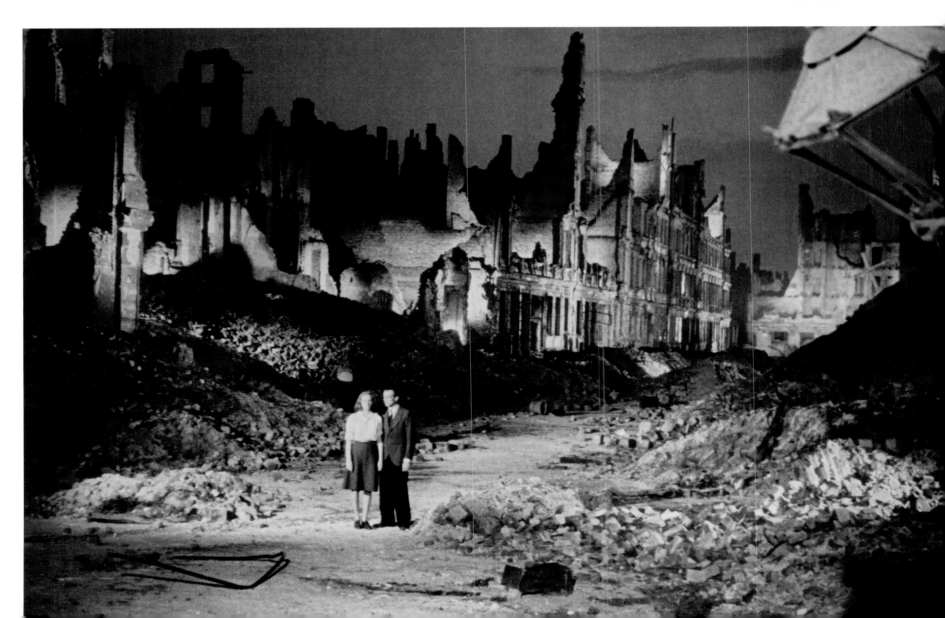

Director Konrad Wolf and leading man Kurt Böwe during the making of *The Naked Man in the Stadium* (1974)

Regisseur Konrad Wolf und Hauptdarsteller Kurt Böwe während der Dreharbeiten zu *Der nackte Mann auf dem Sportplatz* (1974)

Director Rainer Simon and leading man Jörg Gudzuhn during the making of *The Airship* (1983)

Regisseur Rainer Simon und Hauptdarsteller Jörg Gudzuhn während der Dreharbeiten zu *Das Luftschiff* (1983)

It was *Wozzeck* that stirred up the first ideological controversies. Klaren's expressive motifs, which are reminiscent of the German silent film classics, were not particularly well-received by DEFA's Soviet advisors. They detected "formalism," a notion often used in the Stalinist era of Soviet cultural politics to criticize or even completely forbid formal experiments that did not knuckle down under the canon of so-called socialist realism. To these gatekeepers of the pure doctrine, formalism meant something strange, threatening, or intellectual: something that did not correspond with the "cultural-political interests of the working class." Even after this concept was no longer used in the GDR, its effects remained noticeable in the film industry. Until the end of the GDR, formal experiments aroused suspicion among cultural policy makers; in their eyes, a DEFA film—each of which cost the state over a million East German mark—had to be easy, unambiguous and comprehensible to everyone, and in no way marked by surrealist or other "elitist" artistic tendencies. This explains why DEFA experiments remained a rarity, and the best of them shine today like beacons of the avant-garde from the film landscape of divided Germany at the time, amongst them: *The Gleiwitz Case* (1961, Gerhard Klein) about the Nazis' staged attack on the Gleiwitz transmitter, an event that unleashed World War II; *The Keys* (1974, Egon Günther) about the tragic journey of a young couple to Kraków, and German-Polish relations; *The Naked Man on the Athletic Field* (1974, Konrad Wolf) about the everyday life of a sculptor and the relation between artists and society; *Your Unknown Brother* (1982, Ulrich Weiß) about fear and betrayal in the anti-fascist resistance; and *The Airship* (1983, Rainer Simon) about an inventor and his disastrous involvement with his historical moment.

In the first two years of its existence, both the Althoff studios in Potsdam-Alt Nowawes and the Tobis studios in Berlin-Johannisthal stood at DEFA's disposal. Yet already by February 1948, the ongoing film production grew to such an extent that those spaces were no longer sufficient. And so the Soviet Military Administration permitted the Ufa studios at Babelsberg to be used once again: director Hans Müller shot parts of his circus film *1-2-3 Corona* (1948) in Building 3 of

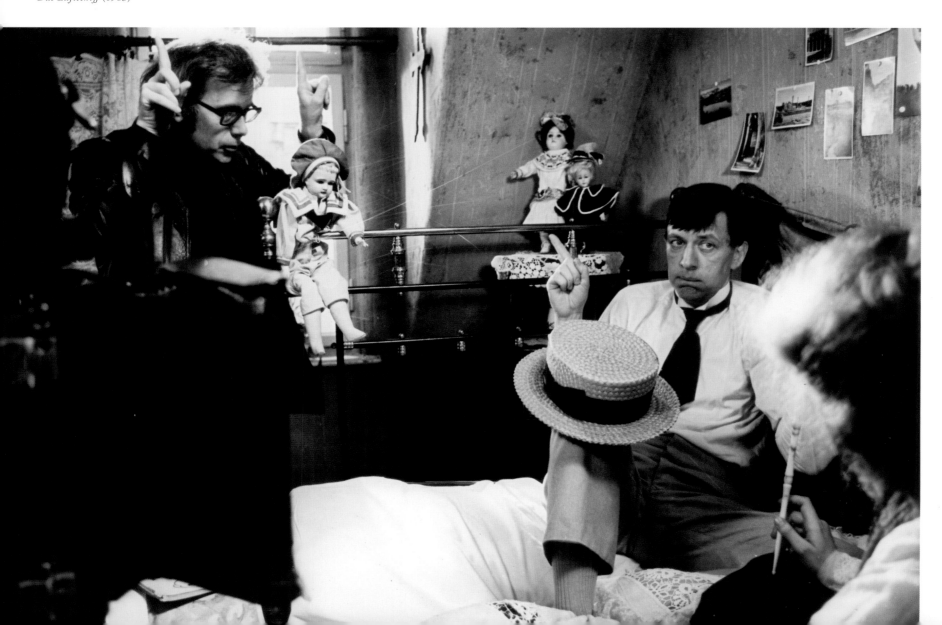

Emil und die Detektive (1931) und unterfütterte die Berlin-Bilder mit melodramatischem Pathos. 1947 inszenierte Kurt Maetzig mit *Ehe im Schatten* den ersten deutschen Film über Juden-verfolgungen in der NS-Zeit; er wurde in allen vier Sektoren Berlins gleichzeitig uraufgeführt. Die DEFA leistete dem italienischen Regisseur Roberto Rossellini technische Hilfe bei den Dreh-arbeiten zu *Deutschland im Jahre Null* (1948). Erich Engel ging in dem Kriminalfilm *Affaire Blum* (1948) dem virulenten Antisemitismus in der Weimarer Republik nach. Und Georg C. Klaren adaptierte Georg Büchners Dramenfragment „Woyzeck" unter dem Titel *Wozzeck* (1947) als albtraumhaft-fiebrige Anklage des Militarismus.

Anlässlich von *Wozzeck* kam es zu ersten ideologischen Kontroversen. Klarens expressive Motive, die an deutsche Stummfilmklassiker denken ließen, kamen bei sowjetischen DEFA-Beratern nicht sonderlich gut an. Sie witterten „Formalismus", ein Begriff, der in der sowjetischen Kulturpolitik der Stalinzeit häufig dafür benutzt wurde, um Formexperimente, die sich nicht dem Kanon des sogenannten Sozialistischen Realismus beugten, zu kritisieren oder gleich ganz zu verbieten. Formalismus bedeutete den Gralshütern der reinen Lehre etwas Fremdes, Bedroh-liches, Intellektualistisches, etwas, das den kulturpolitischen Interessen der Arbeiterklasse nicht entsprach. Auch als dieser Begriff in der DDR längst nicht mehr benutzt wurde, blieben seine Folgen im Filmbereich spürbar. Bis zum Ende der DDR erregten Formexperimente bei kulturpolitischen Entscheidungsträgern oft Misstrauen: Ein DEFA-Film, für den jeweils mehr als eine Million Mark aus der Staatskasse ausgegeben wurde, hatte in ihren Augen leicht und für jedermann verständlich, klar und eindeutig zu sein, keinesfalls von surrealistischen oder sonstigen „elitären" Kunsttendenzen geprägt. So ist es zu erklären, dass DEFA-Experimente eine Seltenheit blieben, wobei die besten von ihnen heute wie avantgardistische Leuchttürme aus der – gesamt-deutschen – Filmlandschaft ihrer Zeit herausragen: *Der Fall Gleiwitz* (1961, Gerhard Klein) über den fingierten Überfall der Nazis auf den Sender Gleiwitz, ein Vorgang, der den Zweiten Welt-krieg auslöste; *Die Schlüssel* (1974, Egon Günther) über die tragische Reise eines Liebespaares nach Krakau und das Verhältnis zwischen Polen und Deutschen; *Der nackte Mann auf dem Sportplatz* (1974, Konrad Wolf) über den Alltag eines Bildhauers, das Verhältnis von Künstler und Gesellschaft; *Dein unbekannter Bruder* (1982, Ulrich Weiß) über Verrat und Angst im antifaschistischen Widerstand; *Das Luftschiff* (1983, Rainer Simon) über einen Erfinder und seine unheilvollen Verstrickungen in die Zeitgeschichte, und einige andere mehr.

In den ersten beiden Jahren ihrer Existenz standen der DEFA sowohl die Althoff-Ateliers in Potsdam-Alt Nowawes als auch die Tobis-Ateliers in Berlin-Johannisthal zur Verfügung. Doch bereits im Februar 1948 war die laufende Produktion derart angewachsen, dass diese

1-2-3 Corona (1948, Director: Hans Müller)

1-2-3 Corona (1948, Regie: Hans Müller)

Dubbing sessions, among others with
Willi Domgraf-Fassbaender (4.f.l.), Erna Berger (6.f.l.),
Mathieu Ahlersmeyer (4.f.r.), Tiana Lemnitz (3.f.r.)

Synchronaufnahmen, u. a. mit Willi Domgraf-Fassbaender
(4.v.l.), Erna Berger (6.v.l.), Mathieu Ahlersmeyer (4.v.r.),
Tiana Lemnitz (3.v.r.)

the former young talent studio there. From then on, feature film production gradually relocated back to the former Ufa complex. On January 1, 1953, it received the official designation "VEB DEFA-Studio für Spielfilme" and remained the exclusive site of feature cinema production in the GDR until 1990: a monopoly.

This feature film studio, which became one of the largest employers in the region with about 2,500 employees, initially had to rely on colleagues who had already been working in film before 1945. They all knew each other: the directors and their cinematographers, the producers, production and unit managers, set designers, gaffers, and editors. Many of them lived in West Berlin. Until the borders were closed in August 1961, it was not difficult to get from there to the Babelsberg film metropolis by car or S-Bahn. The DEFA had to cope with the first exodus of artistic personnel, especially directors and cinematographers, when the three western powers' currency reform in 1948 brought about different currencies for West and East. Individual artists such as opera film director Georg Wildhagen (*The Marriage of Figaro*, 1949) succeeded in negotiating a contract with DEFA to guarantee an honorarium paid in West German currency, but it was not allowed to become precedent: throughout its existence, the DEFA suffered from a notorious lack of foreign currency. Those who were employed here had to settle for the East German mark, the "weaker" currency.

But the Cold War that set in between the western powers and the Soviet Union in 1947–48 had an undeniable effect on the work of DEFA. Already by November 1947, the proprietors of the Soviet-German company had signed a supplementary contract that granted a special committee of the SED Central Secretariat the ability to intervene in both the DEFA's production planning and its personnel politics. Over the course of the following months, founding DEFA activists such as Alfred Lindemann or Karl Hans Bergmann, who favored open and democratic film politics and tried to implement their vision of DEFA as a pan-German operation, fell under suspicion as cosmopolitans, and were suppressed and replaced by Communist Party functionaries like Sepp Schwab. Liberal Soviet cultural officers, mostly professors of literature and Germanists, had guided the first DEFA years with intelligence and talent, but now they either were ordered back to Moscow or died, as with Ilja Trauberg's sudden death under mysterious circumstances. The DEFA's production program, which until 1949 had enough leeway for entertainment films like those of former Ufa directors Hans Deppe, Werner Klingler or Arthur Maria Rabenalt alongside political education, was increasingly brought into the Party line. A fairytale film such as Paul Verhoeven's *The Cold Heart* (1950), DEFA's first color film and a masterwork of animation, now seemed mystic and symbolistic—exactly the sort of work that would not be permitted according to the rules of the socialist realism adopted from the Soviet Union.

Räumlichkeiten nicht mehr ausreichten. So erlaubte es die Sowjetische Militäradministration zum ersten Mal, nun auch die Babelsberger Ufa-Ateliers wieder zu nutzen: Regisseur Hans Müller drehte Teile seines Zirkusfilms *1-2-3 Corona* (1948) im dortigen früheren Nachwuchsstudio im Haus 3. Von nun an verlagerte sich die Spielfilmproduktion schrittweise in die ehemalige Ufa-Stadt zurück. Ab 1. Januar 1953 erhielt sie die offizielle Bezeichnung „VEB DEFA-Studio für Spielfilme" und blieb bis 1990 der exklusive Ort für die Kinospielfilmproduktion in der DDR: ein Monopol.

Dieses Spielfilmstudio, das bald mit rund 2 500 Angestellten zu einem der größten Arbeitgeber der Region avancierte, musste zunächst vor allem auf Mitarbeiter zurückgreifen, die schon vor 1945 beim Film tätig gewesen waren. Sie kannten sich alle: die Regisseure und ihre Kameramänner, die Produktions- und Aufnahmeleiter, Szenenbildner, Oberbeleuchter, Cutterinnen. Viele von ihnen wohnten in West-Berlin. Bis August 1961, als die Grenzen geschlossen wurden, war es keine Schwierigkeit, von dort mit Auto oder S-Bahn in die Babelsberger Filmstadt zu gelangen. Einen ersten Exodus von künstlerischem Personal, vor allem von Regisseuren und Kameramännern, musste die DEFA verkraften, als 1948 die von den drei Westmächten beschlossene Währungsreform verschiedene Währungen für West und Ost mit sich brachte. Einzelnen Künstlern, zum Beispiel dem Opernfilmregisseur Georg Wildhagen (*Figaros Hochzeit*, 1949), gelang es zwar, mit der DEFA einen Vertrag auszuhandeln, der ihm ein Honorar in westdeutscher Währung garantierte, aber zum Präzedenzfall sollte und durfte das nicht werden: Die DEFA litt Zeit ihres Bestehens unter notorischem Devisenmangel. Wer hier tätig war, hatte sich im Grunde mit Ost-Mark, der „schwächeren" Währung, abzufinden.

Aber nicht nur pekuniär, auch ideologisch wirkte sich der Kalte Krieg, der 1947/48 zwischen den Westmächten und der Sowjetunion einsetzte, unmittelbar auf die Arbeit der DEFA aus. Die Gesellschafter der sowjetisch-deutschen AG verabschiedeten schon im November 1947 einen Zusatzvertrag, der es einem Sonderausschuss des Zentralsekretariates der SED zubilligte, sowohl in die Produktionsplanung als auch in die Personalpolitik der DEFA einzugreifen. Im Laufe der folgenden Monate wurden DEFA-Aktivisten der ersten Stunde wie Alfred Lindemann oder Karl Hans Bergmann, die eine offene, demokratische Filmpolitik favorisierten und ihre Vision von der DEFA als einem gesamtdeutschen Unternehmen umzusetzen versuchten, als Kosmopoliten verdächtigt, verdrängt und durch eher dogmatische, kommunistische Parteifunktionäre wie Sepp Schwab ersetzt. Liberale sowjetische Kulturoffiziere, meist Literaturwissenschaftler und Germanisten, die die ersten DEFA-Jahre mit Klugheit und Geschick begleitet hatten, wurden

 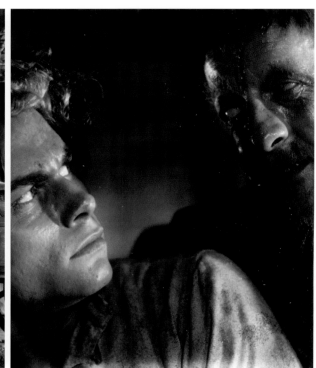

Scenes from *Heart of Stone* with Erwin Geschonneck and
Lutz Moik (1950, Director: Paul Verhoeven)

Szenen aus Das kalte Herz *mit Erwin Geschonneck und
Lutz Moik (1950, Regie: Paul Verhoeven)*

From 1949 on, many DEFA scripts were subjected to a lengthy review process by the SED
Film Commission. Ideological traps lay everywhere, and whomever they captured had to fear
being held politically accountable. The rigid control mechanisms shrank the annual output of
feature films: if ten DEFA films were released in 1950, only eight appeared in 1951, and a mere
six in 1952. A masterpiece such as Wolfgang Staudte's *The Kaiser's Lackey* (1951), a remorselessly
satirical study of the German petty *bourgeois* subject and his obsessions, was accompanied by a
number of films that looked more like the visualization of newspaper editorials and which almost
always ended with mass marches for peace and socialism. In 1951, the first film was banned:
The Axe of Wandsbek (1951), the film debut of former DEFA artistic director Falk Harnack, was
withdrawn a few weeks after its premiere. Soviet advisors thought the movie elicited audience
sympathy for a Nazi executioner.

Given the situation, the party felt compelled to take a public stand. In July 1952, the
Politburo of the SED Central Committee passed a resolution by the name of "For the Revival
of Progressive German Film Art," which established standards for DEFA's work. A Berlin SED
film conference followed in September 1952. But where might the Babelsberg practitioners have
begun with suggestions such as overcoming the "typical objects of our time" or "critical realism,"
and increasing the "portrayals of positive heroes"? Instead, the party called for films that would
serve to "educate the working masses in the spirit of socialism" with role models from the past
and present. Richard Groschopp, one of the DEFA directors affected by this, said much later that
"many creative sparks" were snuffed out at that time: "There were no ideas and, as a consequence,
no scripts."[3] It was a fiasco for the DEFA employees in Babelsberg and Berlin. The studios were
abandoned. The discontinuous production process and the regulation from outside bred unrest.

On March 5, 1953, Joseph Stalin died. In the years that followed, a tentative political
thaw began to spread from Moscow, which could also be felt at DEFA. Instead of the Film
Commission, a Department of Film (HV) was created within the Ministry of Culture that
had specific administrative contacts and smaller administrative hurdles. In 1956, the HV even
allowed the Babelsberg studio administration itself to greenlight feature films for a few months.
Only when the film was to be accepted was the Berlin-based department to be involved. Work
returned to the studios. Until the beginning of the 1960s, production climbed to 20 or even
30 feature films a year.

Well-known genres were increasingly treated—sometimes more, sometimes less—and
often accompanied by harsh public criticism, which did not make it easy on the filmmakers to

nach Moskau zurückbeordert oder starben, wie Ilja Trauberg, unter ungeklärten Umständen eines plötzlichen Todes. Das Produktionsprogramm der DEFA, das bis 1949 neben politischer Aufklärung noch genügend Spielraum für Unterhaltungsfilme, so von einstigen Ufa-Regisseuren wie Hans Deppe, Werner Klingler oder Arthur Maria Rabenalt gelassen hatte, wurde immer mehr auf Parteilinie gebracht. Ein Märchenfilm wie Paul Verhoevens *Das kalte Herz* (1950), der erste Farbfilm der DEFA und ein Meisterwerk der Tricktechnik, galt nun als mystisch und symbolistisch – genau das, was er nach den Regeln des aus der Sowjetunion übernommenen Sozialistischen Realismus nicht hätte sein dürfen.

Ab 1949 wurden sämtliche DEFA-Stoffe einem langwierigen Prüfungsverfahren durch die SED-Filmkommission unterworfen. Überall lauerten ideologische Fallen, und wer sich in ihnen verfing, musste fürchten, politisch zur Verantwortung gezogen zu werden. Die rigiden Kontroll-mechanismen ließen die Spielfilmproduktion von Jahr zu Jahr schrumpfen: Waren 1950 noch zehn DEFA-Filme in die Kinos gekommen, so erschienen 1951 nur acht und 1952 gar nur sechs. Ein Meisterwerk wie Wolfgang Staudtes *Der Untertan* (1951), eine erbarmungslos satirische Studie des deutschen Kleinbürgers und seiner Obsessionen, war von einer Menge von Filmen umgeben, die eher wie die Bebilderung von Leitartikeln aussahen und fast alle mit Massen-aufmärschen für Frieden und Sozialismus endeten. 1951 kam es zum ersten Filmverbot: *Das Beil von Wandsbek* (1951), das Debüt des vormaligen Künstlerischen Direktors der DEFA, Falk Harnack, wurde wenige Wochen nach seiner Premiere aus den Kinos zurückgezogen. Sowjetische Berater glaubten zu erkennen, dass der Film beim Publikum Mitleid mit einem Nazi-Henker hervorrufe.

Angesichts der Lage sah sich die Partei gezwungen, auch öffentlich Stellung zu beziehen. Im Juli 1952 legte das Politbüro des Zentralkomitees (ZK) der SED eine Resolution unter dem Titel „Für den Aufschwung der fortschrittlichen deutschen Filmkunst" vor, die die Maßstäbe für die Arbeit der DEFA festlegte. Im September 1952 folgte eine Filmkonferenz der SED in Berlin. Was aber sollten die Praktiker in Babelsberg mit Ratschlägen anfangen wie jenen, dass es auf das „Typische unserer Zeit", die „Darstellung des positiven Helden" ankomme und der „kritische Realismus" zu überwinden sei? Stattdessen rief die Partei nach Filmen, die der „Erziehung

Director Wolfgang Staudte and cinematographer Robert Baberske on the camera crane (middle, right) during the making of *The Kaiser's Lackey* (1951)

Regisseur Wolfgang Staudte und Kameramann Robert Baberske auf dem Kamerakran (Mitte, rechts) während der Dreharbeiten zu *Der Untertan* (1951)

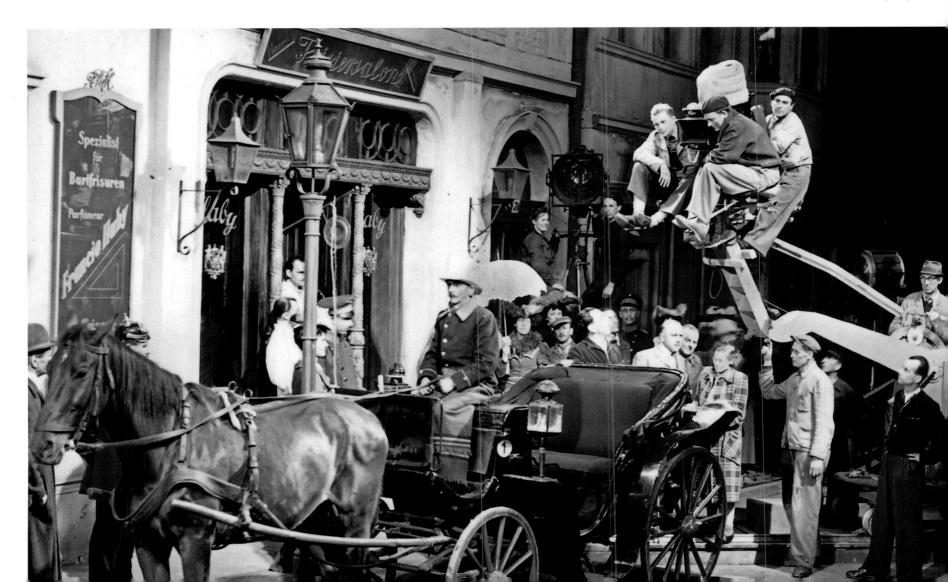

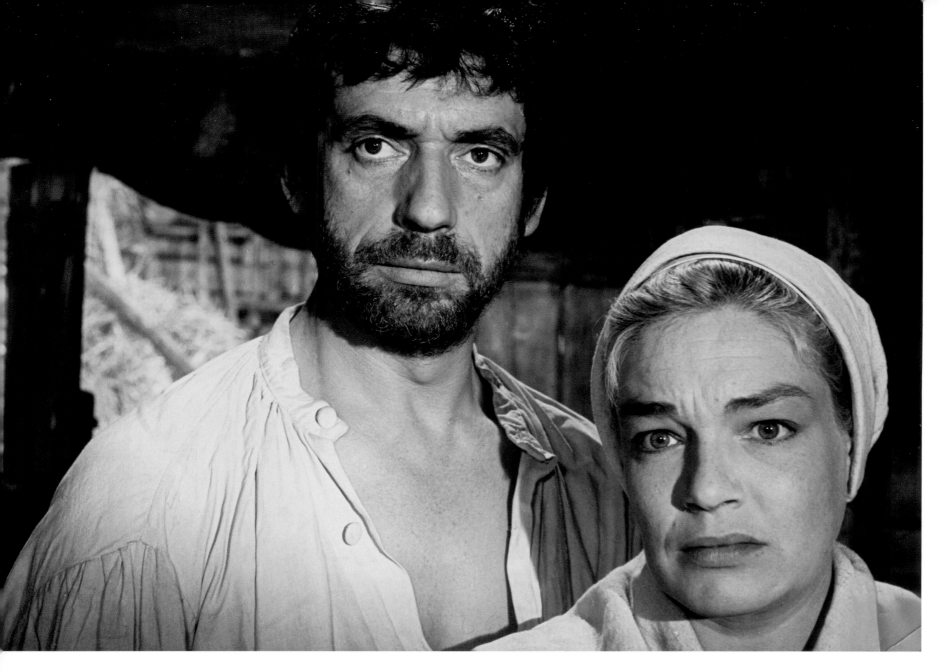

Yves Montand and Simone Signoret in *The Crucible*
(1957, Director: Raymond Rouleau)

Yves Montand und Simone Signoret in *Die Hexen von Salem*
(1957, Regie: Raymond Rouleau)

make their next, perhaps better attempts: comedies and satires, mystery and spy films, opera adaptations and revue films. The dramaturgs were now regularly preoccupied with children's films, including fairytale adaptations of Hans Christian Andersen and the Brothers Grimm. The children's film became one of the internationally regarded flagships for the DEFA. With *The Story of Little Mook* (1953), Wolfgang Staudte succeeded at creating a long-running audience favorite. In addition, the studio filmed *Bold Adventure* (1956, Gérard Philipe), *The Crucible* (1957, Raymond Rouleau), or *Les Miserables* (1958, Jean-Paul Le Chanois) with French production partners. For these films, guest stars like Simone Signoret, Yves Montand, Bernard Blier, and Jean Gabin came to Babelsberg.

As long as it was financially feasible, the GDR feature film studio began to employ directors and actors from the Federal Republic of Germany again in 1953. With the circus film *Carola Lamberti—eine vom Zirkus (Carola Lamberti—One from the Circus,[4]* 1954, Hans Müller) and the E.T.A. Hoffmann adaptation *Mademoiselle de Scuderi* (1955, Eugen York), silent film star Henny Porten was given a late comeback. Young Götz George appeared in a boatman comedy, *Old Barge, Young Love* (1957, Hans Heinrich). Leny Marenbach guest-starred at DEFA, as did Rudolf Forster, Gisela Trowe, Gisela Uhlen, and Evelyn Künneke. Because German-German coproductions were shot down by West German government offices, the West Berlin film distributor and producer Erich Mehl served as a middleman and, with the help of his Stockholm company Pandora, put up foreign currency for the West German actors' wages. After a six-year delay, Mehl succeeded at bringing Staudte's *The Kaiser's Lackey* into West German cinemas. And he also financially supported the director in his adaptation of Brecht's *Mother Courage and Her Children* (1955). Along with Helene Weigel, Simone Signoret played one of the main roles. Yet after a few days of shooting, the film had to be stopped due to artistic differences with the author himself. Staudte left DEFA and never again returned to Babelsberg.

der arbeitenden Massen im Geiste des Sozialismus" dienen sollten, mit Vorbildfiguren aus Gegenwart und Vergangenheit. Sehr viel später sprach Richard Groschopp, einer der betroffenen DEFA-Regisseure, davon, dass „viele schöpferische Funken" gelöscht worden seien: „Es gab kaum noch Einfälle und demzufolge keine Drehbücher."[3] Für die DEFA-Mitarbeiter in Babelsberg und Berlin war das ein Fiasko. Die Ateliers verwaisten. Der diskontinuierliche Produktionsablauf und die Reglementierungen von außen sorgten für Unmut.

Am 5. März 1953 verstarb Josef Stalin. In den Jahren danach begann, von Moskau ausgehend, ein zaghaftes politisches Tauwetter, das auch die DEFA zu spüren bekam. Anstelle der Filmkommission wurde eine Hauptverwaltung (HV) Film beim Ministerium für Kultur installiert, mit konkreten Ansprechpartnern und kürzeren administrativen Wegen. 1956 erlaubte es die HV sogar für wenige Monate, dass die Babelsberger Studiodirektion selbst über den Drehbeginn von Spielfilmen entscheiden konnte. Erst die Abnahme des fertigen Films sollte der Berliner Verwaltung vorbehalten sein. In die Ateliers kehrte die Arbeit zurück. Bis Anfang der 60er Jahre stieg die Produktion auf 20, bald sogar mehr als 30 Kinofilme jährlich. Verstärkt wurden tradierte Genres bedient, manche mehr, manche weniger, und oft von harscher öffentlicher Kritik begleitet, die es den Filmschaffenden nicht immer leicht machte, nun auch den nächsten, vielleicht besseren Versuch zu wagen: Lustspiele und Satiren, Kriminal- und Agentenfilme, Opernadaptionen, Revuefilme. Die Dramaturgie kümmerte sich von nun an regelmäßig um Kinderfilme, darunter Märchenadaptionen nach Hans Christian Andersen und den Brüdern Grimm. Der Kinderfilm wurde zu einem international viel beachteten Aushängeschild der DEFA. Wolfgang Staudte gelingt mit *Die Geschichte vom kleinen Muck* (1953) ein bleibender Publikumserfolg. Daneben verfilmte das Studio gemeinsam mit französischen Produktionspartnern *Die Abenteuer des Till Ulenspiegel* (1956, Gérard Philipe), *Die Hexen von Salem* (1957, Raymond Rouleau) oder *Die Elenden* (1958, Jean-Paul Le Chanois). Dafür kamen Gaststars wie Simone Signoret, Yves Montand, Bernard Blier und Jean Gabin nach Babelsberg.

Soweit es finanziell möglich war, engagierte das DDR-Spielfilmstudio ab 1953 auch wieder Regisseure und Darsteller aus der Bundesrepublik. Mit dem Zirkusfilm *Carola Lamberti – eine vom Zirkus* (1954, Hans Müller) und der E.T.A. Hoffmann-Adaption *Das Fräulein von Scuderi* (1955, Eugen York) ermöglichte man dem Stummfilmstar Henny Porten ein spätes Comeback. Der junge Götz George trat in einem Lustspiel aus dem Milieu der Binnenschiffer auf, *Alter Kahn und junge Liebe* (1957, Hans Heinrich). Leny Marenbach gastierte ebenso bei der DEFA wie Rudolf Forster, Gisela Trowe, Gisela Uhlen und Evelyn Künneke. Weil deutsch-deutsche

Henny Porten in Carola Lamberti—eine vom Zirkus (Carola Lamberti—One From the Circus, 1954, Director: Hans Müller)

Henny Porten in Carola Lamberti – eine vom Zirkus (1954, Regie: Hans Müller)

f.l.t.r.: Robert Baberske, director Wolfgang Staudte and Simone Signoret during the making of *Mother Courage and Her Children* (1955)

v.l.n.r.: Robert Baberske, Regisseur Wolfgang Staudte und Simone Signoret während der Dreharbeiten zu *Mutter Courage und ihre Kinder* (1955)

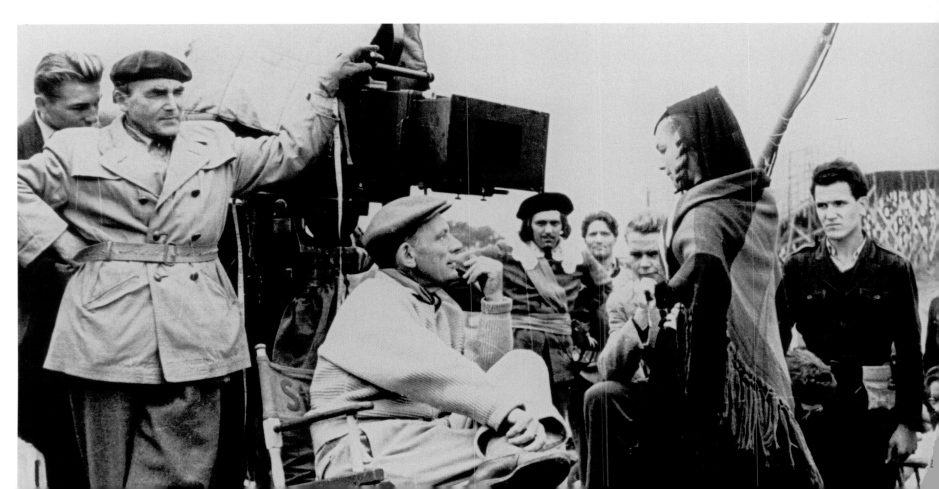

First Spaceship on Venus was the first DEFA
science fiction movie (1960, Director: Kurt Maetzig)

Der schweigende Stern war der erste Science-Fiction-Film
der DEFA (1960, Regie: Kurt Maetzig)

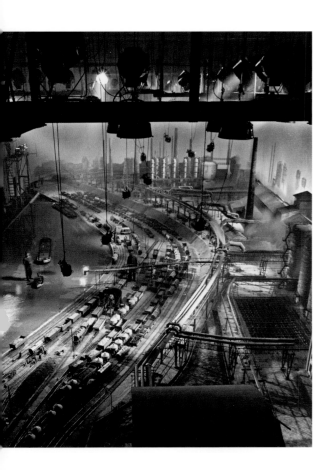

Film set of *The Council of Gods* (1950, Director: Kurt Maetzig)

Filmset von *Der Rat der Götter* (1950, Regie: Kurt Maetzig)

Thus the director triumvirate of Kurt Maetzig, Slatan Dudow, and Martin Hellberg went down in 1950s DEFA history. With *Council of the Gods* (1950), Maetzig dared to capture filmically the entanglement of German capital in the crimes of the Nazi regime: an enlightening panorama of society that, in a canonical finale for the time, concludes in a peace demonstration. In 1954–55, Maetzig directed the excessively legendary cult of personality films for the state *Ernst Thälmann—Son of His Class* and *Ernst Thälmann—Leader of His Class*, big-budget color productions about the leader of the German Communist Party who was murdered by the Nazis in 1944. Maetzig can also be credited with a great contemporary film, *Castles and Cottages* (1957), which is about post-1945 agricultural developments, and is one of the few DEFA films in which June 17, 1953 is thematized. In 1959, at considerable expense, Maetzig shot the first DEFA utopian feature film, *First Spaceship on Venus* (1960), a Polish coproduction.

Until he retired from the feature film studio in 1976, Kurt Maetzig proved to be the DEFA director whose oeuvre most directly reflected the political tumult to which film in the GDR was subjected. In the times that were favorable to film art—like the early DEFA years between 1946 and 1948, around 1956, and in 1964–65—he created exceptional critical realist works. But when the screws of dogma were twisted, then his films dropped in aesthetic quality, and in the worst cases were little more than mere agitprop extensions. Maetzig, who served as the founding rector of the Babelsberg Film Academy in 1954, was smart enough to recognize this himself, and yet also so weak as to make him a political apologist, stumbling into the traps of politically accepted cinema when given the opportunity. This is what makes his story both so great and so tragic.

Theater director Martin Hellberg shot two propagandistic films about the re-militarization of the Federal Republic of Germany, *The Condemned Village* (1952) and *The Ox of Kulm* (1955). Later, he shifted primarily to adaptations of classic literature, directing works such as *Emilia Galotti* (1958), *Intrigue and Love* (1959), and *Minna von Barnhelm* (1962). There were years in which he celebrated three film premieres: he was a workaholic whose artistic output was variable, but whose voice was nevertheless heard at DEFA. Even more important was director Slatan Dudow, who returned to East Berlin from Swiss exile and, next to Gustav von Wangenheim, was one of the only remigrants among the DEFA directors.[5] Most of his works, which he realized in comparatively long intervals and for which he required long shooting periods, stood as erratic blocks of a

Koproduktionen von westdeutschen Regierungsstellen torpediert wurden, fungierte der West-Berliner Filmhändler und -produzent Erich Mehl als Mittelsmann und stellte mithilfe seiner Stockholmer Firma Pandora Devisen für die Gagen westdeutscher Darsteller zur Verfügung. Mit sechsjähriger Verspätung war es Mehl gelungen, Staudtes *Der Untertan* in westdeutsche Kinos zu bringen. Und er unterstützte den Regisseur auch bei der Finanzierung seiner Verfilmung von Brechts Stück *Mutter Courage und ihre Kinder* (1955). Neben Helene Weigel spielte Simone Signoret eine der Hauptrollen. Doch nach wenigen Drehtagen musste der Film wegen künstlerischer Meinungsverschiedenheiten mit dem Dichter abgebrochen werden. Staudte verließ die DEFA und kehrte nie mehr nach Babelsberg zurück.

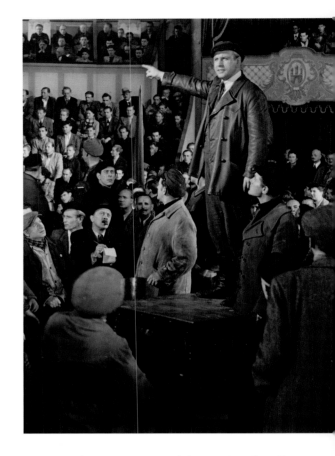

Als Regie-Triumvirat der 50er Jahre gingen dann Kurt Maetzig, Slatan Dudow und Martin Hellberg in die DEFA-Geschichte ein. Mit *Der Rat der Götter* (1950) hatte Maetzig den Versuch gewagt, die Verfilzung des deutschen Großkapitals mit den Verbrechen des NS-Regimes filmisch zu fassen: ein aufklärerisches Gesellschaftspanorama, das in seinem Finale, dem Kanon der Zeit entsprechend, in eine Friedensdemonstration mündete. 1954/55 inszenierte er die personenkultischen, legendenhaft überhöhten Haupt- und Staatsfilme *Ernst Thälmann – Sohn seiner Klasse* und *Ernst Thälmann – Führer seiner Klasse*, farbige Großproduktionen über den 1944 von den Nazis ermordeten Führer der Kommunistischen Partei Deutschlands. Zum großen Zeitbild geriet ihm *Schlösser und Katen* (1957) über Prozesse in der Landwirtschaft nach 1945, einer der wenigen DEFA-Filme, in denen der 17. Juni 1953 thematisiert wurde. 1959 drehte Maetzig mit erheblichem Aufwand den ersten utopischen Spielfilm der DEFA, *Der schweigende Stern* (1960), eine Koproduktion mit Polen.

Bis zu seinem Ausscheiden aus dem Spielfilmstudio 1976 sollte sich Kurt Maetzig als derjenige DEFA-Regisseur erweisen, dessen Œuvre die politischen Wellenbewegungen, denen der Film in der DDR unterworfen war, am deutlichsten spiegelte. In Zeiten, die für die Filmkunst günstig waren – so in den frühen DEFA-Jahren 1946–48, um 1956 und um 1964/65 –, gelangen ihm herausragende kritisch-realistische Arbeiten. Wurden die Schrauben des Dogmas wieder angezogen, fielen seine Filme ästhetisch ab, erwiesen sich im schlimmsten Fall als verlängerte Arme der Agitation. Maetzig, der ab 1954 auch als Gründungsrektor der Babelsberger Filmhochschule fungierte, war klug genug, um dies selbst zu erkennen, und doch immer wieder auch so

Günther Simon in *Ernst Thälmann—Son of His Class* (1954, Director: Kurt Maetzig)

Günther Simon in *Ernst Thälmann – Sohn seiner Klasse* (1954, Regie: Kurt Maetzig)

Castles and Cottages (1957, Director: Kurt Maetzig)

Schlösser und Katen (1957, Regie: Kurt Maetzig)

Rolf Ludwig in *The Captain from Cologne*
(1956, Director: Slatan Dudow)

Rolf Ludwig in *Der Hauptmann von Köln*
(1956, Regie: Slatan Dudow)

Film set of *Emilia Galotti*
(1958, Director: Martin Hellberg)

Filmset von *Emilia Galotti*
(1958, Regie: Martin Hellberg)

political visionary within the Babelsberg landscape. Many Dudow films allow utopia to blur into reality such as, for example, his DEFA debut *Our Daily Bread* (1949), which is an object lesson in socialist realism. This is the story of a family that chafes against the social conditions following World War II, the "better" half of which chooses the socialist experiment. *Destinies of Women* (1952) wonders about the maturity behind female emancipation, while *Stronger than the Night* (1954) creates a film monument of an anti-fascist worker couple, and *The Captain from Cologne* (1956) caricatures the return of the old Nazi elite to key positions in the Federal Republic of Germany. With *Love's Confusion* (1959), Dudow shot an optimistic genre picture about the GDR youth. His last film *Christine* (1963), left incomplete due to his early death, portrays a young woman from the countryside looking for her own personal happiness which he always felt inseparable from society. Thanks to his uncompromising disposition and the integrity with which he defended film as art, Dudow became a role model for many young directors.

The stylistics of many DEFA films over the years were predominantly influenced by obsolete Ufa traditions. This had to do with the fact that many film technicians and craftsmen came from that particular "school." But Gerhard Klein and Wolfgang Kohlhaase dared to break this tradition. With their Berlin films *Alarm at the Circus* (1954), *A Berlin Romance* (1956), and *Berlin—Schönhauser Corner* (1957), they no longer turned to the immediate German film past but to the principles of Italian neo-realism. They departed the sound stages for the streets and plazas, employed non-actors, and worked with grainy newsreel stock, in order to give their feature films a documentary-style, "authentic" look. The young Heiner Carow employed similar techniques in his debut film *Sheriff Teddy* (1957), also a story about life with the open border between East and West Berlin. In the middle of the 1950s, together with Konrad Wolf, Günter Reisch, Frank Vogel, and Frank Beyer, Klein and Carow let fresh aesthetic winds blow through the studio. This second generation of DEFA directors, who were urgently needed in Babelsberg, turned toward the contemporary cinema of USSR or Poland, borrowed material from British Free Cinema and French *cinéma vérité*, and used relatively open narrative structures instead of conventional dramaturgy. Trained in the DEFA Studio for Young Filmmakers or in the internationally renowned film schools in Moscow or Prague, they were primarily preoccupied with a filmic portrayal of life in the GDR, though they also put out remarkable anti-fascist films such as Konrad Wolf's *Lissy* (1957), *Stars* (1959), and *Professor Mamlock* (1961), Frank Beyer's *Five Cartridges* (1959), *Star-Crossed Lovers* (1962), and *Naked Among Wolves* (1963), or Heiner Carow's *They Called Him Amigo* (1959) and *The Russians Are Coming* (1968), the last of which was banned for nearly 20 years on account of its surreal imagery.

schwach, dass er sich bei nächster Gelegenheit erneut zum Apologeten der Politik machte und in die Fallen des bloßen Bestätigungskinos stolperte. Das macht seine Größe und seine Tragik aus.

Der Theaterregisseur Martin Hellberg drehte mit *Das verurteilte Dorf* (1952) und *Der Ochse von Kulm* (1955) zwei propagandistisch aufgeladene Filme über die Remilitarisierung in der Bundesrepublik. Später verlegte er sich vorwiegend auf Klassikeradaptionen und inszenierte Arbeiten wie *Emilia Galotti* (1958), *Kabale und Liebe* (1959) und *Minna von Barnhelm* (1962). Es gab Jahre, in denen er drei Filmpremieren feierte: ein Vielarbeiter, dessen künstlerische Ausbeute wechselhaft war, dessen Stimme in der DEFA aber gehört wurde. Noch mehr Gewicht besaß Slatan Dudow, der aus dem Schweizer Exil nach Ost-Berlin zurückgekehrt und neben dem aus Moskau gekommenen Gustav von Wangenheim der einzige Remigrant unter den DEFA-Regisseuren war.[4] Die meisten seiner Arbeiten, die er in vergleichsweise großen Abständen realisierte und für die er lange Drehzeiten benötigte, standen wie erratische Blöcke eines politischen Visionärs in der Babelsberger Landschaft. Viele Dudow-Filme ließen die Utopie bereits zur Realität gerinnen: So galt sein DEFA-Debüt *Unser täglich Brot* (1949) als Musterbeispiel des Sozialistischen Realismus. Es war die Geschichte einer Familie, die sich an den gesellschaftlichen Verhältnissen nach dem Zweiten Weltkrieg reibt, wobei sich der „bessere" Teil für das sozialistische Experiment entscheidet. *Frauenschicksale* (1952) fragte nach dem Reifegrad der Emanzipation, *Stärker als die Nacht* (1954) setzte einem antifaschistischen Arbeiterpaar ein filmisches Denkmal, *Der Hauptmann von Köln* (1956) karikierte die Rückkehr alter Nazi-Eliten auf Schlüsselpositionen in der Bundesrepublik. Mit *Verwirrung der Liebe* (1959) zeichnete Dudow ein optimistisches Sittenbild der DDR-Jugend. In seinem letzten, durch den frühen Tod des Regisseurs unvollendet gebliebenen Film *Christine* (1963) porträtierte er eine junge Landarbeiterin auf ihrer Suche nach dem privaten Glück, das für ihn stets gesellschaftlich determiniert war. Durch seine integre, kompromisslose Haltung, mit der er den Film als Kunst verteidigte, wirkte Dudow für viele jüngere Regisseure als Vorbild.

Die Stilistik vieler DEFA-Filme war über Jahre hinweg von überkommenen Ufa-Traditionen geprägt. Das hatte auch damit zu tun, dass viele Filmtechniker und -handwerker aus dieser „Schule" kamen. Einen entscheidenden Bruch wagten Gerhard Klein und Wolfgang Kohlhaase, die sich für ihre Berlin-Filme *Alarm im Zirkus* (1954), *Eine Berliner Romanze* (1956) und

Director Frank Beyer
Regisseur Frank Beyer

Armin Mueller-Stahl and Manfred Krug in
Five Cartridges (1959, Director: Frank Beyer)

Armin Mueller-Stahl und Manfred Krug in
Fünf Patronenhülsen (1959, Regie: Frank Beyer)

In the middle of the time when the second generation of directors was establishing itself, however, the second SED film conference took place. In July 1958, the short political thaw after the XX. Congress of the Communist Party of the Soviet Union[6] was already over in the GDR, and the party administration once again began to intervene in DEFA's affairs. This time, the films that were pilloried were the "noncommittal" films such as the revue film *My Wife Wants to Sing* (1958, Hans Heinrich) or *The Casino Affair* (1957, Arthur Pohl). Fairytale films like *The Singing, Ringing Tree* (1957, Francesco Stefani) were reprimanded for their *bourgeois* idealist conceptions of reality. A domestic comedy about the outer appearance and inner hollowness of a West Berlin factory-owning family (*The Most Beautiful One*, 1958, Ernesto Remani) was immediately forbidden. That didn't bother the young directors: they also thought these films were passé and stuffy. But they became all ears, however, when Konrad Wolf's *Sun Seekers* (1958) also disappeared into the censorship vault as a result of the conference. That film about the lives of workers in a GDR uranium mine was left unscreened until 1971 due to pressure from Soviet officials. Hard-liners in GDR cultural politics were all too correct in recognizing criticism of the dogmatic SED leadership style within Wolf's differentiated, honest, and thoughtful work.

Having DEFA feature film production put on a leash by the Party was a process that repeated itself multiple times in over 40 years of DEFA, and was consistently based on a similar pattern. The first and second film conferences in 1952 and 1958, respectively, were followed by the disastrous 11th Plenum of the SED Central Committee, which resulted in the banning of twelve DEFA films. Even in 1973, DEFA was scolded at a Plenum, and again in November 1981, this time by a faked letter-to-the-editor by a worker from Erfurt, printed in the commentary column of the SED paper "Neues Deutschland" in order to halt certain societal tendencies in the Babelsberg feature production, that actually turned out to be Erich Honecker's brainchild. Under the title "What I Would Like to See from Our Filmmakers," paragraphs such as these were published:

I sense too little pride in those great works which the working class and its Party, together with all the workers of our country, have brought about. Where are the works of art that make us aware of the—as I see it—titanic level of achievement that, through their construction, can be found in the growing and becoming of our stable and blossoming worker-and-farmer state?[7]

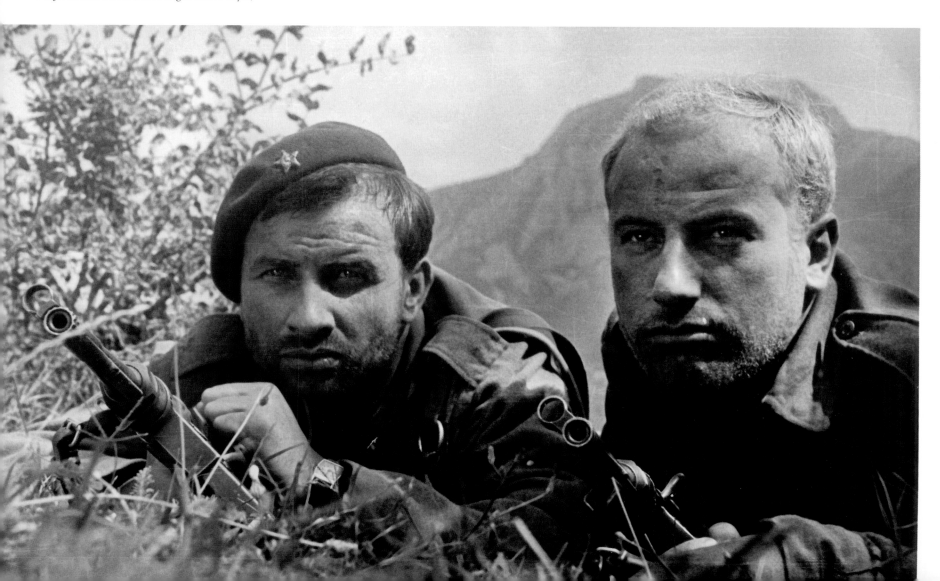

Berlin – Ecke Schönhauser... (1957) nicht mehr an der unmittelbaren deutschen Filmvergangenheit, sondern an den Prinzipien des italienischen Neorealismus orientierten: Sie gingen aus den Ateliers auf die Straßen und Plätze, engagierten Laiendarsteller und arbeiteten mit grobkörnigem Wochenschau-Material, um ihren Spielfilmen einen dokumentarischen und authentischen Look zu geben. Der junge Heiner Carow nutzte ähnliche Prinzipien für sein Debüt *Sheriff Teddy* (1957), ebenfalls eine Geschichte über das Leben mit der offenen Grenze zwischen Ost- und West-Berlin. Klein und Carow brachten Mitte der 50er Jahre gemeinsam mit Konrad Wolf, Günter Reisch, Frank Vogel und Frank Beyer ästhetisch frischen Wind ins Studio. Diese Regisseure der zweiten DEFA-Generation, die in Babelsberg dringend gebraucht wurden, orientierten sich am modernen Kino in der UdSSR oder in Polen, wagten Anleihen beim britischen Free Cinema und dem französischen Cinéma vérité, nutzten bisweilen offene Erzählstrukturen anstelle herkömmlicher Dramaturgien. Ausgebildet im DEFA-Nachwuchsstudio oder an international renommierten Filmschulen in Moskau oder Prag, kümmerten sie sich vor allem um eine filmische Gestaltung des Lebens in der DDR, legten aber auch bemerkenswerte antifaschistische Filme vor – so wie Konrad Wolfs *Lissy* (1957), *Sterne* (1959) und *Professor Mamlock* (1961), Frank Beyers *Fünf Patronenhülsen* (1959), *Königskinder* (1962) und *Nackt unter Wölfen* (1963) oder Heiner Carows *Sie nannten ihn Amigo* (1959) und *Die Russen kommen* (1968), der nicht zuletzt aufgrund seiner surrealistischen Bilder fast 20 Jahre lang verboten blieb.

Mitten in jene Zeit, in der sich die zweite Regie-Generation etablierte, fiel allerdings auch die Zweite Filmkonferenz der SED. Im Juli 1958 – das kurze politische Tauwetter nach dem XX. Parteitag der KPdSU[5] war in der DDR schon wieder vorbei – las die Parteiführung der DEFA erneut die Leviten. Diesmal standen „unverbindliche" Filme wie die Revue *Meine Frau macht Musik* (1958, Hans Heinrich) oder *Spielbank-Affäre* (1957, Arthur Pohl) am Pranger. Märchenfilmen wie *Das singende, klingende Bäumchen* (1957, Francesco Stefani) wurden bürgerlich-idealistische Konzeptionen vorgeworfen. Eine Salonkomödie über den äußeren Glanz und die innere Hohlheit einer West-Berliner Industriellenfamilie (*Die Schönste*, 1958, Ernesto Remani) wurde gleich ganz verboten. Das störte die jungen Regisseure nicht: Auch sie hielten diese Filme für fade und spießig. Hellhörig mussten sie jedoch werden, als im Umfeld der Filmkonferenz auch Konrad Wolfs *Sonnensucher* (1958) im Tresor der Zensur verschwand. Dieser Film über Lebensschicksale von Arbeitern im Uranbergbau der DDR blieb auf Druck sowjetischer Behörden bis 1971 unaufgeführt. Hardlinern in der DDR-Kulturpolitik war das nur recht, erkannten sie in Wolfs differenzierter, ehrlicher und nachdenklicher Arbeit doch auch eine Kritik am dogmatischen Führungsstil der SED.

Director Konrad Wolf

Regisseur Konrad Wolf

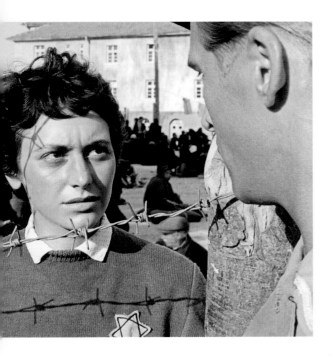

Sascha Kruscharska and Jürgen Frohriep in *Stars*
(1959, Director: Konrad Wolf)

Sascha Kruscharska und Jürgen Frohriep in *Sterne*
(1959, Regie: Konrad Wolf)

Renate Blume and Eberhard Esche in *Divided Heaven*
(1964, Director: Konrad Wolf)

Renate Blume und Eberhard Esche in *Der geteilte Himmel*
(1964, Regie: Konrad Wolf)

Such rhetoric proved that powerful forces inside the SED leadership, as always, saw film less as an art form and more as a means of political agitation and propaganda. But it would be wrong to conclude that standing on one side of the barricades were the dogmatic SED functionaries, and on the other side, the more-or-less brave, resistant, and subversive filmmakers. The truth was much more complicated: those who conformed and those who resisted actually stood on both sides; even within any given individual, two souls raged. Only that fact can explain why the DEFA and Department of Film administrations helped pave the way for works that were—moderately—socially critical or formally daring until the end of the GDR. Those DEFA films which were banned in 1965–66, for example, were created in a social climate that was dominated by the open, critical engagement with their country's past and present, extending even to the highest ranks of the SED. The fact that old GDR Stalinists and their protégés were ever successful at suppressing overtures of a "democratic socialism with a human face" in connection with global political developments is part of the tragedy of DEFA, as well as the GDR itself.

After the construction of the Berlin Wall and the at least partial containment of Western influences, the view prevailed among the DEFA artists, as with the writers in the GDR, that now they could reflect somewhat more openly on the country itself. Thanks to a young and constructive DEFA administration, to which director Jochen Mückenberger and chief dramaturg Klaus Wischnewski belonged, scripts were encouraged that dealt with political developments in the GDR with increasing sovereignty. Having fundamentally agreed on the socialist way, filmmakers now placed emphasis on exposing details deserving criticism: *It Happened One Summer* (1963, Ralf Kirsten) discussed the Party's influence on the private lives of its members, while *Divided Heaven* (1964, Konrad Wolf) reflected on the reasons why young people left the GDR in droves until the Wall was built. *The Rabbit Is Me* (1965) is a scathing critique of the opportunism of judges and lawyers who let their opinions be swayed by the prevailing political

Dass die DEFA-Spielfilmproduktion ans Gängelband der Partei genommen wurde, wiederholte sich in über 40 DEFA-Jahren mehrfach und stets nach ähnlichem Muster. Der Ersten und Zweiten Filmkonferenz 1952 bzw. 1958 folgte im Dezember 1965 das verhängnisvolle 11. Plenum des ZK der SED, in dessen Folge insgesamt zwölf DEFA-Filme verboten wurden. Auch 1973 wurde die DEFA auf einem Plenum getadelt, und im November 1981 reichte der fingierte Leserbrief eines Erfurter Arbeiters, der in Wirklichkeit von Erich Honecker inspiriert war und in der Kommentarspalte des SED-Blattes „Neues Deutschland" abgedruckt wurde, um gesellschafts-kritische Tendenzen in der Babelsberger Spielfilmproduktion zu bremsen. Unter der Überschrift „Was ich mir mehr von unseren Filmemachern wünsche" war dort unter anderem zu lesen:

> Ich spüre zu wenig Stolz auf das, was die Arbeiterklasse und ihre Partei im Bunde mit allen Werktätigen unseres Landes an Großem vollbracht hat. Wo sind die Kunstwerke, die das – ich nenne es so – Titanische der Leistung bewusst machen, die in der Errichtung, im Werden und Wachsen unseres stabilen und blühenden Arbeiter-und-Bauern-Staates besteht?[6]

Ilse Voigt and Angelika Waller in *The Rabbit Is Me*
(1965/1990, Director: Kurt Maetzig)

Ilse Voigt und Angelika Waller in *Das Kaninchen bin ich*
(1965/1990, Regie: Kurt Maetzig)

Solche Formeln belegten, dass starke Kräfte innerhalb der SED-Parteiführung den Film nach wie vor weniger als Kunst denn als Mittel der parteipolitischen Agitation und Propaganda ansahen. Es wäre jedoch falsch zu schlussfolgern, dass auf der einen Seite der Barrikade dogmatische SED-Funktionäre, auf der anderen Seite aber mehr oder weniger mutige, widerständige, gar subversive Filmemacher gestanden hätten. Es war viel komplizierter: Angepasste und Mutige gab es stets auf beiden Seiten; selbst in der Brust des Einzelnen tobten bisweilen zwei Seelen. Nur so ist zu erklären, dass die Leitungen der DEFA und der Hauptverwaltung Film bis zum Ende der DDR mitunter Arbeiten den Weg bahnten, die – in Maßen – gesellschaftskritisch oder formal wagemutig waren. Jene DEFA-Filme, die 1965/66 verboten wurden, entstanden beispielsweise in einem gesellschaftlichen Klima, das bis in höchste Ränge der SED von einer offeneren, kritischeren Auseinandersetzung mit der eigenen Vergangenheit und Gegenwart geprägt war. Dass es den DDR-Alt-Stalinisten und ihren Adepten im Zusammenhang mit weltpolitischen Entwicklungen immer wieder gelang, Ansätze eines „demokratischen Sozialismus mit menschlichem Antlitz" zu unterdrücken, gehört zur Tragik der DDR wie der DEFA.

Christel Bodenstein and Manfred Krug in
It Happened One Summer (1963, Director: Ralf Kirsten)

Christel Bodenstein und Manfred Krug in
Beschreibung eines Sommers (1963, Regie: Ralf Kirsten)

Nach dem Bau der Berliner Mauer und der zumindest partiellen Abschottung von Einflüssen aus dem Westen überwog bei DEFA-Künstlern, ähnlich wie bei Schriftstellern der DDR, die

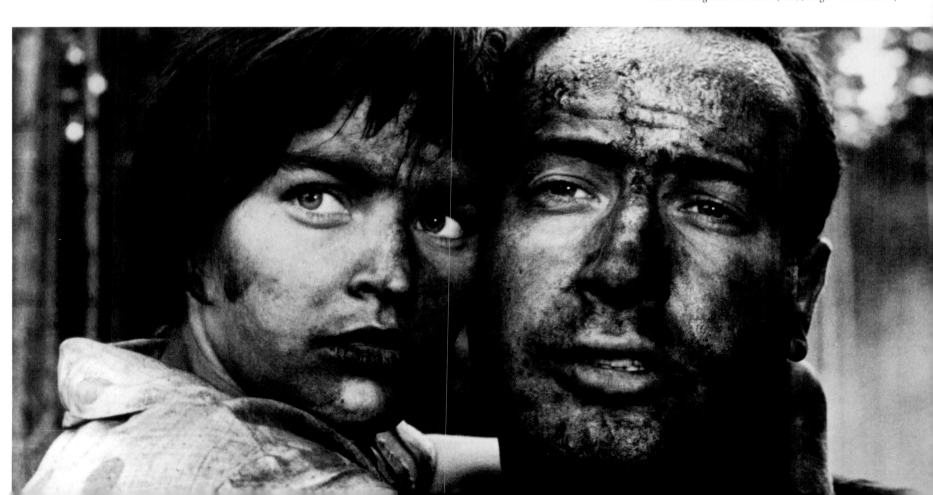

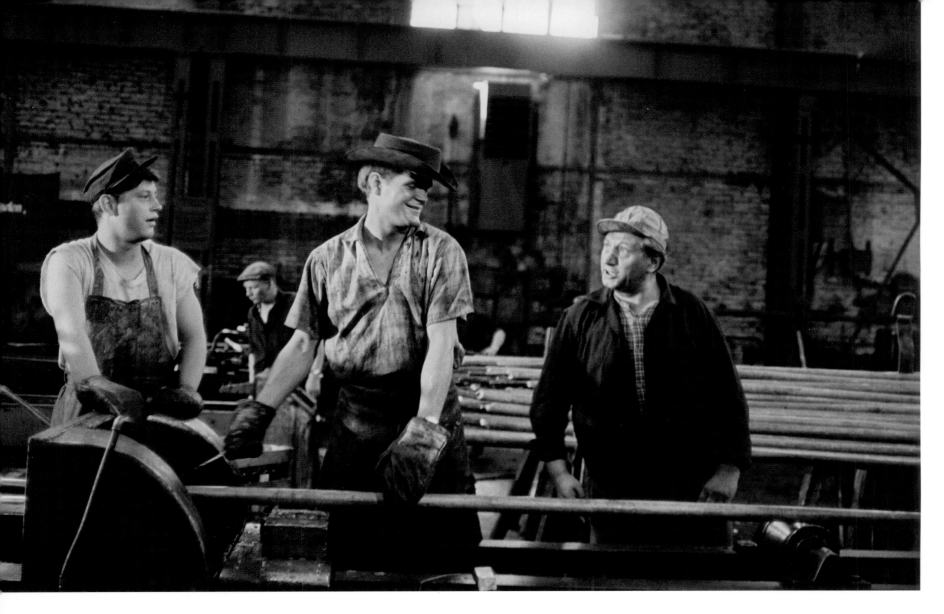

f.l.t.r.: Kaspar Eichel, Dieter Mann,
and Rudolf Ulrich in *Berlin Around the Corner*
(1965/1990, Director: Gerhard Klein)

v.l.n.r.: Kaspar Eichel, Dieter Mann
und Rudolf Ulrich in *Berlin um die Ecke*
(1965/1990, Regie: Gerhard Klein)

winds. With this particular film, DEFA dared to adapt a book by Manfred Bieler that was not even approved for print. Along with Frank Vogel's *Just Don't Think I'll Cry* (1965), a film about a high-school graduate who dejectedly confronts the GDR, *The Rabbit Is Me* was screened for the delegates of the 11th Plenum of the Central Committee and immediately banned. The films that were also banned over the next few months were works by Herrmann Zschoche (*Carla*), Egon Günther (*When You Grow Up, Dear Adam*), Gerhard Klein (*Berlin Around the Corner*), Jürgen Böttcher (*Born in '45*), and Frank Beyer (*Trace of Stones*), the latter being dismissed from the studio along with Günter Stahnke (*Spring Takes Its Time*).

As with every other such assault, for a while afterward, DEFA was deeply unsettled. The incriminated films from 1965–66 remained banned until 1989 and were made taboo. No one publicly mentioned them. Even for their creators, only under special circumstances were the films permitted to be retrieved from the archive and given one-time internal screenings. From then on in terms of content, DEFA leaned toward smaller, intimate stories about the present, realized by the directors of the "third generation" via semi-documentary means. These films were concerned with moral and ethical questions of living together, such as Herrmann Zschoche's *Leben zu Zweit* (*Living As a Pair,* 1968) and *Weite Straßen—stille Liebe* (*Wide Streets—Quiet Love,* 1969), Ingrid Reschke's *We Are Getting Divorced* (1968) and *Do You Know Urban?* (1971), Roland Gräf's *My Dear Robinson* (1970) and *P.S.* (1979), Lothar Warneke's *It's An Old Story...* (1972) and *Living With Uwe* (1974), Siegfried Kühn's *Time of the Storks* (1971) or Rainer Simon's *Men Without Beards* (1971). *Ordinary People*, the title of Simon's half-hour film included in the omnibus film made for the 20th Anniversary of the GDR, *Aus unserer Zeit* (*From Our Age,* 1969), reveals to a certain degree the tenor of these films.

Of course, this third generation also sought opportunities to break out of this canon. Rainer Simon, whose debut films were modern fairytale adaptations, laid out an enigmatic parable about the relationship between power, subversion, and violence with *Till Eulenspiegel* (1975). His film about the present, *Jadup and Boel* (1981), which revolves around the veracity of memory and interrogates the smugness of the administrative caste, was then banned. After that point, he

Ansicht, man könne jetzt vergleichsweise offen über sich selbst reflektieren. Von einer jungen und konstruktiven DEFA-Leitung, zu der unter anderem Direktor Jochen Mückenberger und Chefdramaturg Klaus Wischnewski gehörten, wurden Stoffe gefördert, die sich zunehmend souveräner mit politischen Entwicklungen in der DDR befassten. Bei grundsätzlicher Zustimmung zum sozialistischen Weg legten die Filmemacher Wert auf die Aufdeckung kritikwürdiger Details: *Beschreibung eines Sommers* (1963, Ralf Kirsten) diskutierte die Einflussnahme der Partei aufs Privatleben ihrer Mitglieder; *Der geteilte Himmel* (1964, Konrad Wolf) reflektierte die Gründe dafür, dass junge Leute die DDR bis zum Mauerbau in Scharen verlassen hatten. In *Das Kaninchen bin ich* (1965) prangerte Kurt Maetzig den Opportunismus von Richtern und Staatsanwälten an, die ihr Fähnchen in den jeweiligen politischen Wind hängen. Die DEFA wagte es mit diesem Film sogar, ein zur Drucklegung nicht zugelassenes Buch von Manfred Bieler zu adaptieren. Gemeinsam mit Frank Vogels *Denk bloß nicht, ich heule* (1965) über einen Abiturienten, der der DDR ablehnend begegnet, wurde *Das Kaninchen bin ich* den Delegierten des 11. ZK-Plenums vorgeführt und sofort verboten. Zu den Filmen, die in den darauf folgenden Monaten ebenfalls verboten wurden, zählten Arbeiten von Herrmann Zschoche (*Karla*), Egon Günther (*Wenn du groß bist, lieber Adam*), Gerhard Klein (*Berlin um die Ecke*), Jürgen Böttcher (*Jahrgang 45*) und Frank Beyer (*Spur der Steine*), der zusammen mit Günter Stahnke (*Der Frühling braucht Zeit*) aus dem Studio entlassen wurde.

Wie jedes Mal nach einer solchen Attacke war die DEFA für eine Zeit lang zutiefst verunsichert. Die inkriminierten Filme von 1965/66 blieben bis 1989 verboten und wurden tabuisiert. Niemand erwähnte sie öffentlich. Selbst den Mitwirkenden war es nur in Ausnahmefällen gestattet, sie aus dem Archiv für einmalige interne Vorführungen herauszuholen. Inhaltlich tendierte die DEFA von nun an zu kleineren, intimeren Gegenwartsgeschichten, die von Regisseuren der „dritten Generation" mit semidokumentarischen Mitteln realisiert wurden. Diese Filme kümmerten sich um moralisch-ethische Fragen des Zusammenlebens, so wie Herrmann Zschoches *Leben zu zweit* (1968) und *Weite Straßen – stille Liebe* (1969), Ingrid Reschkes *Wir lassen uns scheiden* (1968) und *Kennen Sie Urban?* (1971), Roland Gräfs *Mein lieber Robinson* (1970) und *P.S.* (1979), Lothar Warnekes *Es ist eine alte Geschichte...* (1972) und *Leben mit Uwe* (1974), Siegfried Kühns *Zeit der Störche* (1971) oder Rainer Simons *Männer ohne Bart* (1971). Der Titel von Simons halbstündigem Film *Gewöhnliche Leute*, einem Teil des Episodenfilms zum 20. Jahrestag der DDR, *Aus unserer Zeit* (1969), gab gewissermaßen den Tenor vor.

f.l.t.r.: Karl Brenk, Erik Veldre, Fred Ludwig, Manfred Krug, Helmut Schreiber, Hans-Peter Reinecke, and Detlev Eisner in *Trace of Stones* (1966/1990, Director: Frank Beyer)

v.l.n.r.: Karl Brenk, Erik Veldre, Fred Ludwig, Manfred Krug, Helmut Schreiber, Hans-Peter Reinecke und Detlev Eisner in *Spur der Steine* (1966/1990, Regie: Frank Beyer)

Vivian Hanjohr in *Presence Required*
(1984, Director: Helmut Dziuba)

Vivian Hanjohr in *Erscheinen Pflicht*
(1984, Regie: Helmut Dziuba)

shot multi-layered historical allegories about the relationship between individual and society with films like *The Woman and the Stranger* (1984), *Wengler and Sons, A Legend* (1987), and *The Ascent of the Chimborazo* (1989). Roland Gräf directed the satire *Exploring the Brandenburg Marches* (1982) and then, encountering much resistance, turned his attentions toward the ambivalent biography of poet Hans Fallada (*Fallada: The Last Chapter*). Siegfried Kühn shot the biting grotesque *The Second Life of Friedrich Wilhelm Georg Platow* (1973), which was then only permitted to be screened in smaller GDR studio cinemas and was forbidden for export, or *The Actress* (1988) about the Jewish theater in Berlin during the Nazi era. Meanwhile, Lothar Warneke's clever work *Bear Ye One Another's Burdens (1987)*, in which two representatives of different worldviews enter into a peaceful dispute, became a hit with audiences.

Along with such narratively and aesthetically ambitious works which found their audiences in the GDR, while some even received international awards, e.g., at the Berlinale film festival in West Berlin, between 1965 and 1985, DEFA also shot over a dozen westerns (Indianerfilme), often in coproduction with other Eastern European film studios, continued to try out comedies, primarily under the direction of Günter Reisch, Jo Hasler, and Roland Oehme, and brought respectable artist biopics and literature adaptations into cinemas. Horst Seemann, for example, was always associated with affirmative, overly melodramatic dramas about the present à la *Time to Live* (1969). Yet with *Beethoven: Days in a Life* (1977), and *Levin's Mill* (1980), Seemann made two important historical films, each with their own unique relationship to the present. Günter Reisch and Günther Rücker set *The Fianceé* (1980) in a prison for political offenders during the Nazi era, receiving the grand prize at the film festival in Karlovy Vary. But along with such successes, in the 1980s, DEFA once again came under repeated political pressure. This was the case for youth films such as *Island of the Swans* (1983, Herrmann Zschoche) and *Presence Required* (1984, Helmut Dziuba), which remind one to exhibit greater honesty in dealings between the generations, and which allow their young heroes to follow their own unique lifepaths, diverging from the prescribed tracks. In light of these experiences, important DEFA *auteurs* and directors clad their critical views in the robes of history, as with Michael Gwisdek in his directing debut *Treffen in Travers* (*Meeting in Travers*, 1989), a film about a revolution that stagnates under lethargy and cowardice.

Diese dritte Generation suchte allerdings auch nach Ausbruchsmöglichkeiten aus diesem Kanon. Rainer Simon, der mit modernen Märchenadaptionen debütiert hatte, legte mit *Till Eulenspiegel* (1975) eine hintergründige Parabel auf das Verhältnis von Macht, Subversion und Gewalt vor. Nach dem Verbot seines Gegenwartsfilms *Jadup und Boel* (1981), der um die Wahrhaftigkeit des Erinnerns kreiste und die Selbstgenügsamkeit der Funktionärskaste infrage stellte, drehte er mit Filmen wie *Die Frau und der Fremde* (1984), *Wengler & Söhne. Eine Legende* (1987) und *Die Besteigung des Chimborazo* (1989) vielschichtige historische Gleichnisse über das Verhältnis von Individuum und Gesellschaft. Roland Gräf inszenierte die Satire *Märkische Forschungen* (1982) und wandte sich dann, gegen viele Widerstände, der ambivalenten Biografie des Dichters Hans Fallada zu (*Fallada – letztes Kapitel*, 1988). Siegfried Kühn drehte die freche Groteske *Das zweite Leben des Friedrich Wilhelm Georg Platow* (1973), die allerdings nur in kleineren DDR-Studiokinos aufgeführt werden durfte und Exportverbot erhielt, oder *Die Schauspielerin* (1988) über das jüdische Theater in Berlin zur NS-Zeit. Zum größten Publikumserfolg Lothar Warnekes avancierte *Einer trage des anderen Last* (1987), in dem Vertreter unterschiedlicher Weltanschauungen in einen friedvollen Disput treten.

Neben solchen inhaltlich und ästhetisch anspruchsvollen Arbeiten, die in der DDR ihr Publikum fanden und bisweilen auch international Preise erhielten, so auf dem West-Berliner Filmfestival, drehte die DEFA zwischen 1966 und 1985, oft in Koproduktion mit anderen osteuropäischen Filmstudios, ein rundes Dutzend Indianerfilme, probierte sich, vor allem unter der Regie von Günter Reisch, Jo Hasler und Roland Oehme, weiterhin an Lustspielen und Komödien aus und brachte respektable Künstlerbiografien und Literaturverfilmungen ins Kino. Horst Seemann beispielsweise, der lange Zeit durch affirmative, bis zur Schwülstigkeit überladene Gegenwarts-Melodramen à la *Zeit zu leben* (1969) aufgefallen war, drehte mit *Beethoven – Tage aus einem Leben* (1977) und *Levins Mühle* (1980) zwei bedeutende historische Filme mit jeweils ganz eigenem Gegenwartsbezug. Günter Reisch und Günther Rücker siedelten *Die Verlobte* (1980) in einem Gefängnis für politische Häftlinge der NS-Zeit an – und erhielten dafür den Großen Preis der Filmfestspiele in Karlovy Vary. Neben solchen Erfolgen geriet die DEFA in den 80er Jahren aber auch wiederholt unter politischen Druck: so mit den Jugendfilmen *Insel der Schwäne* (1983, Herrmann Zschoche) und *Erscheinen Pflicht* (1984, Helmut Dziuba), die eine größere Ehrlichkeit im Umgang der Generationen miteinander anmahnten und ihren jugendlichen Helden einen eigenen Weg ins Leben zubilligten, der abseits vorgeschriebener Gleise verlief. Angesichts dieser Erfahrungen kleideten wichtige DEFA-Autoren und -Regisseure ihre

Hermann Beyer in *Exploring the Brandenburg Marches*
(1982, Director: Roland Gräf)

Hermann Beyer in *Märkische Forschungen*
(1982, Regie: Roland Gräf)

Jörg Pose and Manfred Möck in *Bear Ye One Another's Burden*
(1987, Director: Lothar Warneke)

Jörg Pose und Manfred Möck in *Einer trage des anderen Last*
(1987, Regie: Lothar Warneke)

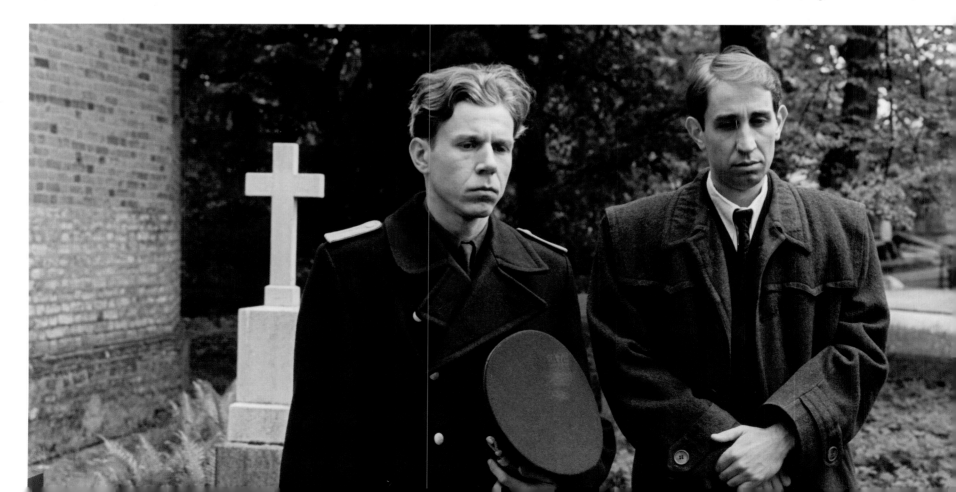

Matthias Freihof in *Coming Out*
(1989, Director: Heiner Carow)

Matthias Freihof in *Coming Out*
(1989, Regie: Heiner Carow)

As with Slatan Dudow's work earlier, his student Heiner Carow's productions stood out from the rank-and-file DEFA films during the 1970s and '80s. *The Legend of Paul and Paula* (1973), his equally poetic and anarchistic film, became a cult hit in the GDR. Other films of his included *Icarus* (1975) and, notably, *Coming Out* (1989), the first and only DEFA film that dealt with homosexuality. All advocated self-determination in one's life, which may only conditionally be subordinated to societal forces—a topic that also marked successful women's films such as *The Third* (1972, Egon Günther), *Solo Sunny* (1980, Konrad Wolf), or *On Probation* (1981, Herrmann Zschoche). Two of Heiner Carow's larger projects that were nearly ready for production remained unrealized due to financial or ideological reasons: *Die Nibelungen* and *Simplicissimus*, both based on treatments written by author Franz Fühmann. Even Kurt Maetzig's 20-year-long plan to adapt Heinrich Mann's "Henri Quatre" remained unexecuted.

Seeing as it had all the divisions needed to produce a film, the DEFA studio at Babelsberg could bring the whole of its strength to bear in order to implement such grand-scale projects. In fact, the studio had proven on multiple occasions during the 1960s and '70s that independent, big-budget 70mm productions were not impossible to implement. The GDR was the only country besides the U.S. and USSR with access to that technology. A total of eight feature films were shot with DEFA's own 70mm technology, each of which cost up to 5 million East German mark. Among the films were the colorful adventure spectacle *Captain Florian of the Mill* (1968, Werner W. Wallroth), the artist biography *Goya* (1970, Konrad Wolf), the utopian films *Signals: A Space Adventure* (1969, Gottfried Kolditz), and *Eolomea* (1972, Herrmann Zschoche), as well as the operetta *Orpheus in the Underworld* (1974, Horst Bonnet). These films were intended to increase the attractiveness of the cinema—in particular because many earlier cinema-goers had deserted in favor of their home television sets. Even the DEFA studios themselves could not avoid the presence of television: since the early 1960s, fifteen to twenty television films were realized per year as contract productions in order to utilize the studio space and take in revenue. These films included Walter Felsenstein's important opera adaptations *Tales of Hoffmann* (1970) and *Knight Bluebeard* (1973), which also played in GDR cinemas. Now and again, the studio also opened its doors to contract productions from the Federal Republic of Germany to bring in foreign currency: following *The Heathens of Kummerow* (1966, Werner Jacobs) were, among others, *Spring Symphony* (1983, Peter Schamoni) and *Die Grünstein-Variante* (*The Grünstein Version*, 1985, Bernhard Wicki), which were made at Babelsberg.

kritische Haltung zur Gegenwart in historisches Gewand, so Michael Gwisdek bei seinem Regie-debüt *Treffen in Travers* (1989) über eine Revolution, die in Lethargie und Mutlosigkeit erstarrt.

Wie früher die Arbeiten Slatan Dudows, so ragten in den 70er und 80er Jahren die Werke seines Schülers Heiner Carow aus dem Gros der DEFA-Produktion heraus. Seine ebenso poetische wie anarchistische *Legende von Paul und Paula* (1973), die in der DDR zum Kultfilm avancierte, aber auch *Ikarus* (1975) und vor allem *Coming out* (1989), der erste und einzige Film der DEFA, der sich mit der Problematik von Homosexuellen befasste, plädierten für ein selbstbestimmtes Leben, das sich nur bedingt den Zwängen der Gesellschaft unterordnet – ein Thema, das auch so erfolgreiche Frauenporträts wie *Der Dritte* (1972, Egon Günther), *Solo Sunny* (1980, Konrad Wolf) oder *Bürgschaft für ein Jahr* (1981, Herrmann Zschoche) prägte. Zwei Großprojekte Heiner Carows, die teilweise nahezu drehreif waren, wurden aus finanziellen oder ideologischen Gründen dann doch nicht realisiert: „Die Nibelungen" und „Simplicissimus", beide Male nach Drehbuch-entwürfen des Dichters Franz Fühmann. Auch Kurt Maetzigs über fast 20 Jahre lang verfolgter Plan, Heinrich Manns „Henri Quatre" für die DEFA zu adaptieren, blieb unausgeführt.

Natürlich hätte das Babelsberger DEFA-Studio, in dem alle Gewerke vorhanden waren, die für die Filmherstellung benötigt wurden, all seine Kraft aufbringen müssen, um solche Groß-projekte in die Tat umzusetzen. Dass so etwas nicht unmöglich war, hatte es mehrfach bewiesen, zum Beispiel, als es Mitte der 60er Jahre gelang, eine eigene, vom Ausland unabhängige 70-mm-Produktion auf die Beine zu stellen. Damit war die DDR das einzige Land neben den USA und der UdSSR, das über eine solche Technologie verfügte. Insgesamt wurden mit der DEFA-eigenen 70-mm-Technik acht Spielfilme gedreht, die jeweils bis zu 5 Millionen Mark kosteten, darunter das farbenprächtige Abenteuerspektakel *Hauptmann Florian von der Mühle* (1968, Werner W. Wallroth), die Künstlerbiografie *Goya* (1970, Konrad Wolf), die utopischen Filme *Signale – ein Weltraumabenteuer* (1969, Gottfried Kolditz) und *Eolomea* (1972, Herrmann Zschoche) sowie die Operette *Orpheus in der Unterwelt* (1974, Horst Bonnet). Diese Filme sollten die Attraktivität des

Jutta Hoffmann in *The Third*
(1972, Director: Egon Günther)

Jutta Hoffmann in *Der Dritte*
(1972, Regie: Egon Günther)

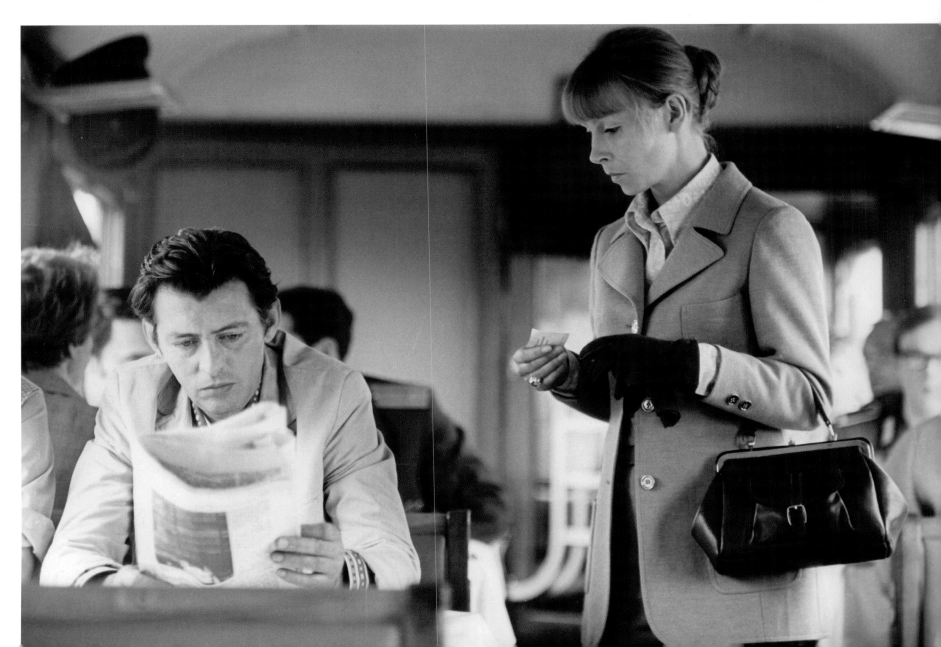

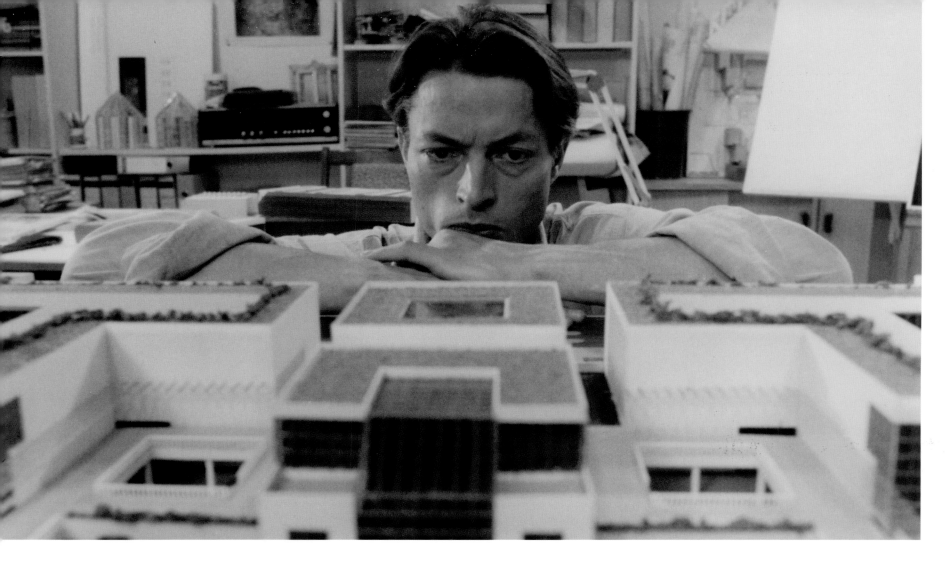

Kurt Naumann in *The Architects*
(1990, Director: Peter Kahane)

Kurt Naumann in *Die Architekten*
(1990, Regie: Peter Kahane)

At the end of 1989, after the Wall fell, the DEFA studios' technical and economic personnel revolted for the first time in its forty-year history against film projects that no longer fit the times. Stagehands, set designers, and carpenters demanded an "independent commission whose members would be democratically elected from members of the staff" and which would determine the films planned. There was increasing talk of assessing projects based on commercial value: in light of the West German competition from open borders, many personnel members justifiably feared becoming unemployed. In the spring of 1990, it became clear that the state-level alimentation of the studios would no longer be an option. One of the last GDR films premiered, *The Architects* (1990, Peter Kahane), is the 40-year-olds' relentless attack on the country in which they were born, in which they never had a real chance to realize their full potential. Written by Thomas Knauf, this was the key film of the fourth and last generation of DEFA directors who, after they had finished their studies, had the aim to "splash some acid on the polished image of 'real existing socialism',"[8] but who rarely got to do so.

With the beginning of the economic and currency union, the Treuhandanstalt, installed by the East German government, received the task of transitioning the DEFA Feature Studio from a state-owned enterprise into one of the market economy. DEFA GmbH, a capital company since July 1, 1990, first laid off large numbers of artistic personnel, including forty permanently employed directors and numerous dramaturgs and writers. At the same time, the company received 18 million deutschmark from the last GDR Ministry of Culture budget to help multiple film projects, and thus prepare it for the market economy. The new DEFA administration, with the ex-head dramaturg Rudolf Jürschik as its artistic director, decided to support a few projects by young directors, including Jörg Foth's clown cabaret *Latest from the Da-Da-R* (1990) and Herwig Kipping's bitter farce *The Land Beyond the Rainbow* (1992). A few of the older filmmakers the DEFA felt morally obligated to were also given support. Egon Günther, who directed two veritable literature adaptations, *Lotte in Weimar* (1975, starring Lilli Palmer) and *The Sorrows of Young Werther* (1976), and who left the GDR at the end of the 1970s, returned to the studio with his tragicomedy *Stone* (1991). Ulrich Weiß, who had not received work in years, was now able to shoot his apocalyptic parable *Miraculi* (1992). Frank Beyer (*The Suspicion*, 1991), Roland Gräf (*The Tango Player*, 1991), and Heiner Carow (*The Mistake*, 1992) all took their leave with painful political reminiscences of

Jutta Hoffmann in *The Third* (1972)

Jutta Hoffmann in *Der Dritte* (1972)

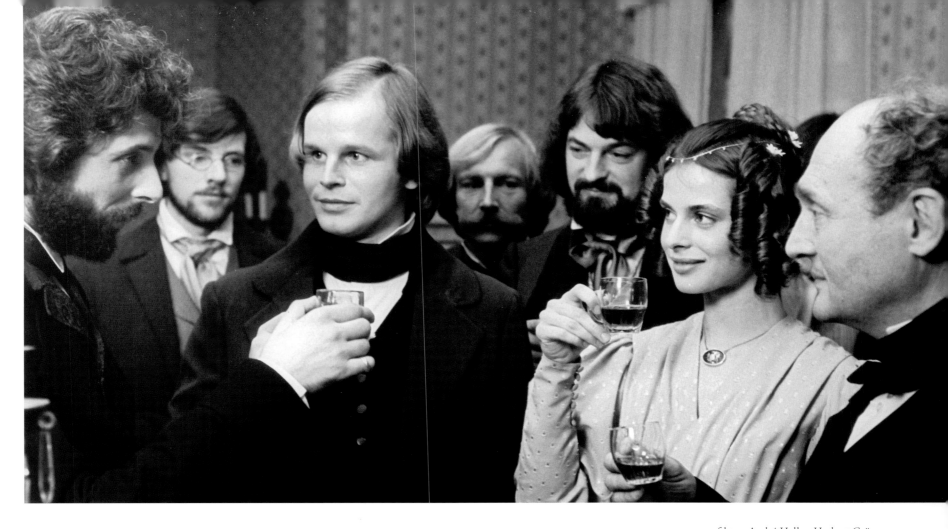

f.l.t.r.: André Heller, Herbert Grönemeyer,
Nastassja Kinski, and Rolf Hoppe
in *Spring Symphony* (1983, Director: Peter Schamoni)

v.l.n.r.: André Heller, Herbert Grönemeyer,
Nastassja Kinski und Rolf Hoppe
in *Frühlingssinfonie* (1983, Regie: Peter Schamoni)

Kinos erhöhen – nicht zuletzt deswegen, weil viele frühere Kinobesucher inzwischen zum heimischen Fernsehapparat abgewandert waren. Auch das DEFA-Studio selbst konnte sich dem Fernsehen nicht verschließen: Seit den frühen 60er Jahren wurden, um die Ateliers auszulasten und Geld einzunehmen, jährlich rund 15 bis 20 Fernsehfilme als Auftragsproduktionen realisiert, darunter die bedeutenden Opernadaptionen Walter Felsensteins, *Hoffmanns Erzählungen* (1970) und *Ritter Blaubart* (1973), die in der DDR auch im Kino liefen. Hin und wieder öffnete sich das Studio Devisen bringenden Auftragsarbeiten aus der Bundesrepublik: Den *Heiden von Kummerow* (1966, Werner Jacobs) folgten unter anderem *Frühlingssinfonie* (1983, Peter Schamoni) und *Die Grünstein-Variante* (1985, Bernhard Wicki), die in Babelsberg inszeniert wurden.

Ende 1989, nach dem Fall der Mauer, lehnte sich das technische und ökonomische Personal des DEFA-Studios für Spielfilme erstmals in den über 40 Jahren seiner Geschichte gegen Filmvorhaben auf, die angeblich nicht mehr in die Zeit passten. Bühnenarbeiter, Dekorateure und Tischler forderten eine „unabhängige Kommission, deren Mitglieder von der Belegschaft demokratisch gewählt werden sollen" und die die geplanten Filme beschließt. Zunehmend war davon die Rede, Projekte nach marktwirtschaftlichen Maßstäben zu beurteilen: Viele Belegschaftsmitglieder hatten, angesichts westdeutscher Konkurrenz bei offenen Grenzen, die berechtigte Befürchtung, arbeitslos zu werden. Im Frühjahr 1990 wurde deutlich, dass eine staatliche Alimentierung der Studios künftig nicht mehr infrage käme. Als einer der letzten DDR-Filme hatte *Die Architekten* (1990, Peter Kahane) Premiere, eine schonungslose Abrechnung der damals 40-jährigen, die in jenem Land, in das sie hineingeboren worden waren, nie eine echte Chance erhalten hatten, sich zu verwirklichen. *Die Architekten*, verfasst von Thomas Knauf, war der Schlüsselfilm der vierten und letzten Generation von DEFA-Regisseuren, die nach dem Studium angetreten war, „etwas Säure auf das polierte Gruppenbild des ‚real existierenden Sozialismus' zu spritzen",[7] aber viel zu selten zum Zuge kam.

Mit Beginn der Wirtschafts- und Währungsunion erhielt die von der DDR-Regierung installierte Treuhandanstalt die Aufgabe, auch das DEFA-Spielfilmstudio vom Volkseigenen Betrieb in die Marktwirtschaft zu überführen. Die DEFA-GmbH, seit dem 1. Juli 1990 eine Kapitalgesellschaft, entließ zunächst große Teile des künstlerischen Personals, darunter rund 40 fest angestellte Regisseure sowie zahlreiche Dramaturgen und Autoren. Zugleich erhielt die GmbH rund 18 Millionen DM Zuschuss vom letzten DDR-Kulturministerium, um mehrere

Steffen Mensching and Hans-Eckardt Wenzel in
Latest from the Da-Da-R (1990, Director: Jörg Foth)

Steffen Mensching und Hans-Eckardt Wenzel in
Letztes aus der DaDaeR (1990, Regie: Jörg Foth)

the GDR. And Evelyn Schmidt, who, along with Iris Gusner and Hannelore Unterberg, was one of the few female DEFA directors and who was seen as an ideologically unreliable colleague, gave feminist comedy a try with *Der Hut* (*The Hat*, 1991). Together with Rolf Losansky's *The Cloud Sheep* (1993), these were the last of the approximately 750 DEFA feature films.

None of these films would succeed with the public. Only little by little did awareness develop for their value as contemporary documents and key texts of a societal upheaval of unimagined proportions. This process has by no means ended today, and is also apt in describing all the DEFA productions that—both directly and indirectly—were always a mirror of the politics, moral values, forces, and ambivalences of their times.

1 Cf. Heinz Kersten: *Das Filmwesen in der Sowjetischen Besatzungszone Deutschlands*. Bonn / Berlin (West): Bundesministerium für Gesamtdeutsche Fragen 1963, Vol. 1, p. 8.
2 Ibid.
3 Richard Groschopp: Faszination Film. Ein Gespräch. Aufgezeichnet von Ralf Schenk. In: *Aus Theorie und Praxis des Films*, Volume 3/1987, p. 28.
4 Hereafter, films without an official English-language title will be credited by their original German title, followed by a literal translation in brackets.
5 Attempts by the DEFA to recruit other remigrants such as Max Ophüls, who was to direct the German-German coproduction *Die Buddenbrooks* in 1955, failed due to various reasons.
6 During the XX. Congress of the Communist Party of the Soviet Union in February 1956, Khrushchev disclosed some of the crimes of the Stalin era and denounced the personality cult around the despot. Subsequently, an attempt at de-Stalinization began in the Eastern bloc.
7 Hubert Vater: Expectations of a Reader from DEFA and Television. What I Would Like to See from Our Filmmakers. In: *Neues Deutschland*, Berlin / DDR, 17 November 1981.
8 Thomas Knauf: Babelsberg-Storys. Erlebnisse eines Drehbuchautors in Ost und West. Berlin / Köln: Alexander Verlag 2011, p. 45.

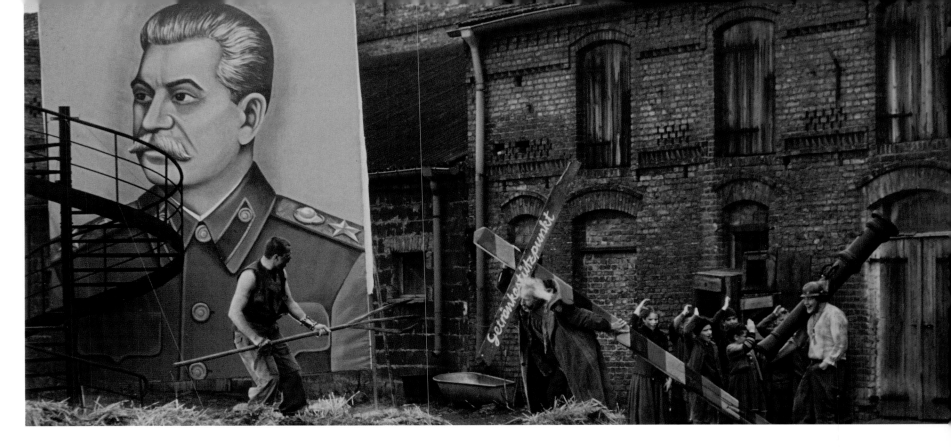

A scene featuring Franciszek Pieczka (middle) from
The Land Beyond the Rainbow
(1992, Director: Herwig Kipping)

Szene mit Franciszek Pieczka (Mitte) aus
Das Land hinter dem Regenbogen
(1992, Regie: Herwig Kipping)

Filmprojekte auf den Weg zu bringen und sich so auf die Marktwirtschaft vorzubereiten. Die neue DEFA-Leitung, mit dem bisherigen Chefdramaturgen Rudolf Jürschik als Künstlerischem Direktor, entschied, einige Projekte junger Regisseure zu unterstützen, darunter Jörg Foth mit dem Clownsspiel *Letztes aus der DaDaeR* (1990) und Herwig Kipping mit der bitteren Farce *Das Land hinter dem Regenbogen* (1992). Außerdem wurden einige ältere Filmemacher gefördert, denen sich die DEFA moralisch verpflichtet fühlte. Egon Günther, der mit *Lotte in Weimar* (1975, Hauptrolle: Lilli Palmer) und *Die Leiden des jungen Werthers* (1976) noch zwei veritable Literaturadaptionen inszeniert und die DDR Ende der 70er Jahre verlassen hatte, kehrte mit der Tragikomödie *Stein* (1991) ins Studio zurück. Ulrich Weiß, dem lange Jahre keine Arbeit ermöglicht worden war, drehte die Endzeitparabel *Miraculi* (1992). Frank Beyer (*Der Verdacht*, 1991), Roland Gräf (*Der Tangospieler*, 1991) und Heiner Carow (*Verfehlung*, 1992) verabschiedeten sich mit schmerzhaften politischen Reminiszenzen von der DDR. Und Evelyn Schmidt, neben Iris Gusner und Hannelore Unterberg eine der wenigen Regisseurinnen der DEFA und seit ihrer sozialkritischen Studie *Das Fahrrad* (1982) als ideologisch unsichere Kantonistin betrachtet, probierte sich an der feministischen Komödie *Der Hut* (1991) aus. Zusammen mit Rolf Losanskys Kinderfilm *Zirri – das Wolkenschaf* (1993) waren dies die letzten von insgesamt rund 750 DEFA-Spielfilmen.

Keiner dieser Filme wurde ein Publikumserfolg. Erst nach und nach entwickelte sich ein Bewusstsein für ihren Wert als Zeitdokumente und Schlüsselwerke eines gesellschaftlichen Umbruchs ungeahnten Ausmaßes. Dieser Prozess ist bis heute keineswegs abgeschlossen – was im Übrigen auf die gesamte DEFA-Produktion zutrifft, deren Œuvre, direkt und indirekt, immer auch ein Spiegel der Politik und Moral, der Zwänge und Ambivalenzen ihrer Zeit gewesen ist.

1 Vgl. Heinz Kersten: *Das Filmwesen in der Sowjetischen Besatzungszone Deutschlands.* Bonn / Berlin (West): Bundesministerium für Gesamtdeutsche Fragen 1963, Bd. 1, S. 8.

2 Ebd.

3 Richard Groschopp: Faszination Film. Ein Gespräch. Aufgezeichnet von Ralf Schenk. In: *Aus Theorie und Praxis des Films*, Heft 3/1987, S. 28.

4 Versuche, auch andere Remigranten zur DEFA zu holen, so wie Max Ophüls, der in Babelsberg 1955 die deutsch-deutsche Koproduktion *Die Buddenbrooks* realisieren sollte, scheiterten aus verschiedenen Gründen.

5 Auf dem XX. Parteitag der KPdSU im Februar 1956 enthüllte Chruschtschow einige Verbrechen der Stalin-Ära und prangerte den Personenkult um den Despoten an. In der Folge begann der Versuch einer Entstalinisierung im Ostblock.

6 Hubert Vater: Erwartungen eines Lesers an DEFA und Fernsehen. Was ich mir mehr von unseren Filmemachern wünsche. In: *Neues Deutschland*, Berlin / DDR, 17.11.1981.

7 Thomas Knauf: *Babelsberg-Storys.* Erlebnisse eines Drehbuchautors in Ost und West. Berlin / Köln: Alexander Verlag 2011, p. 45.

1946
-
1992

Rolf Ludwig in *Stone*
(1992, Director: Egon Günther)

Rolf Ludwig in *Stein*
(1992, Regie: Egon Günther)

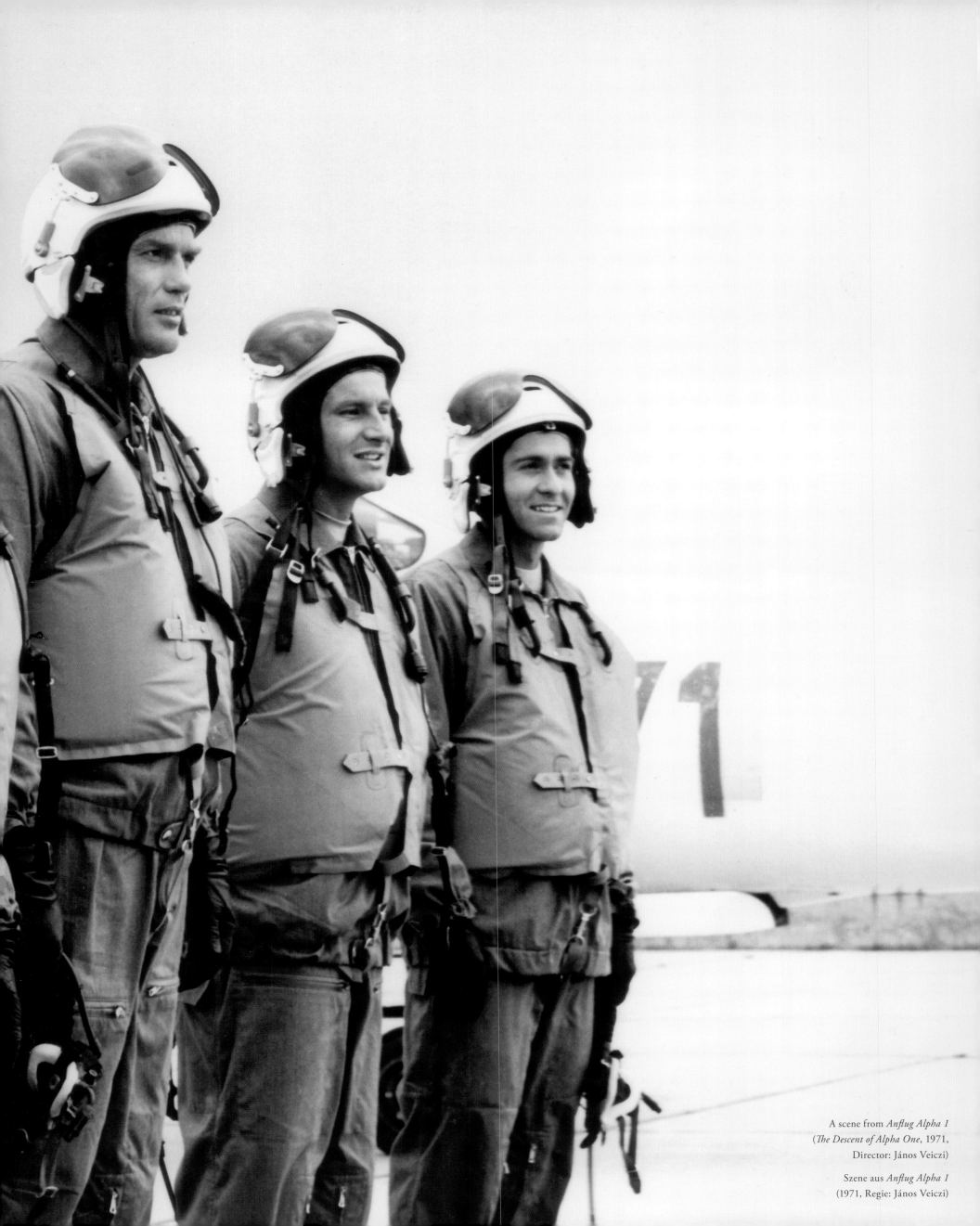

A scene from *Anflug Alpha 1*
(*The Descent of Alpha One*, 1971,
Director: János Veiczi)

Szene aus *Anflug Alpha 1*
(1971, Regie: János Veiczi)

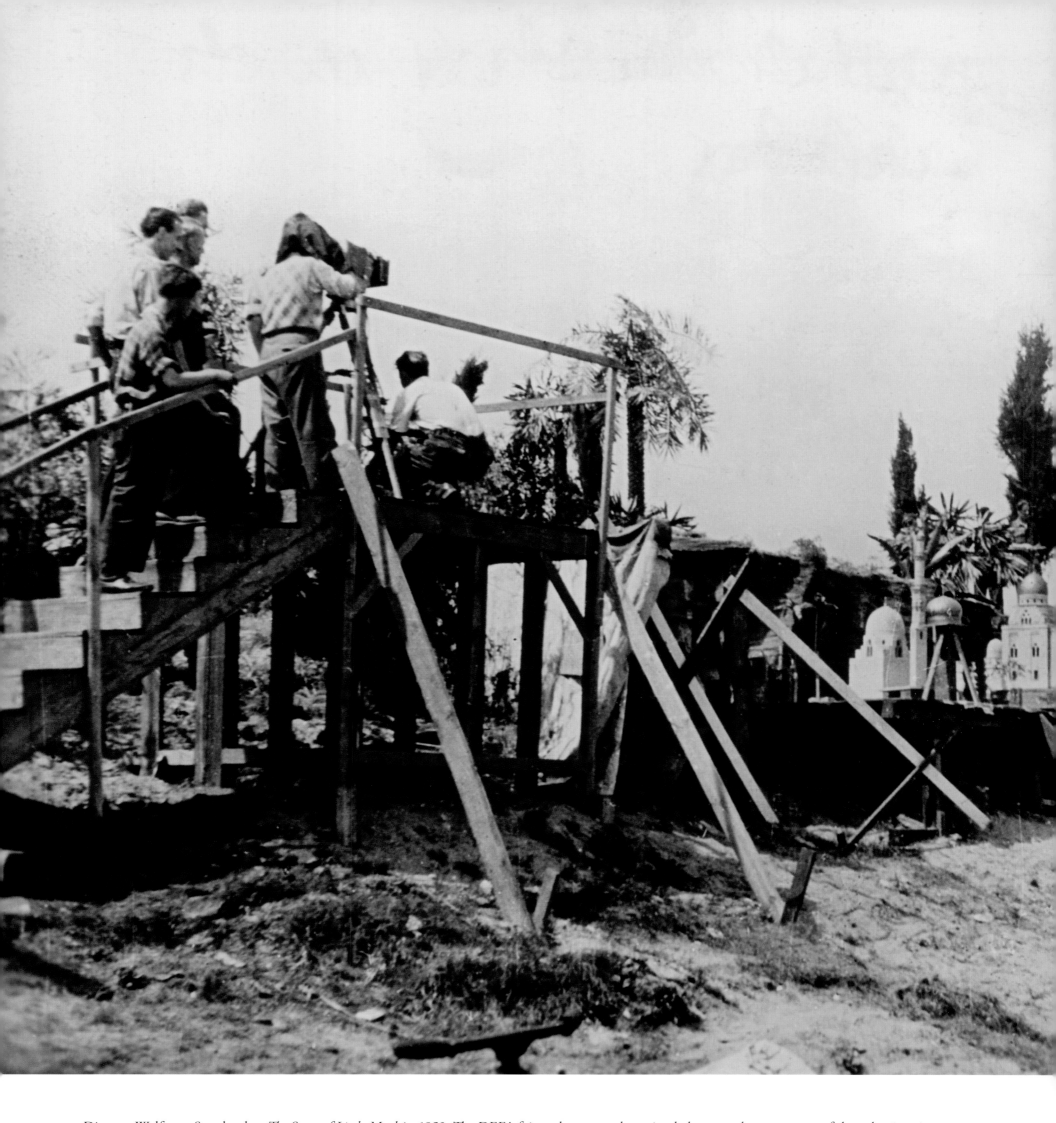

Director Wolfgang Staudte shot *The Story of Little Mook* in 1953. The DEFA fairy tale screen adaptation belongs to the most successful productions in DEFA history. Top: Photos from the set constructions, and a film still (on the bottom, right) with Thomas Schmidt as Mook and Trude Hesterberg as Ahavzi.

1953 dreht Regisseur Wolfgang Staudte *Die Geschichte vom kleinen Muck*. Die DEFA-Märchenverfilmung zählt zu den erfolgreichsten Produktionen der DEFA-Filmgeschichte. Oben: Fotos vom Kulissenbau sowie Szenenfoto (rechts unten) mit Thomas Schmidt als Muck und Trude Hesterberg als Ahavzi.

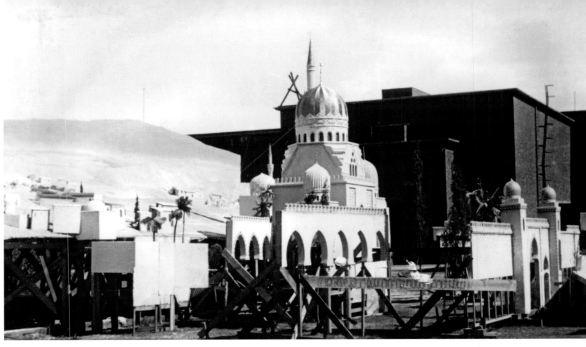

Gojko Mitic in
The Sons of Great Bear
(1966, Director: Josef Mach)

Gojko Mitic in
Die Söhne der großen Bärin
(1966, Regie: Josef Mach)

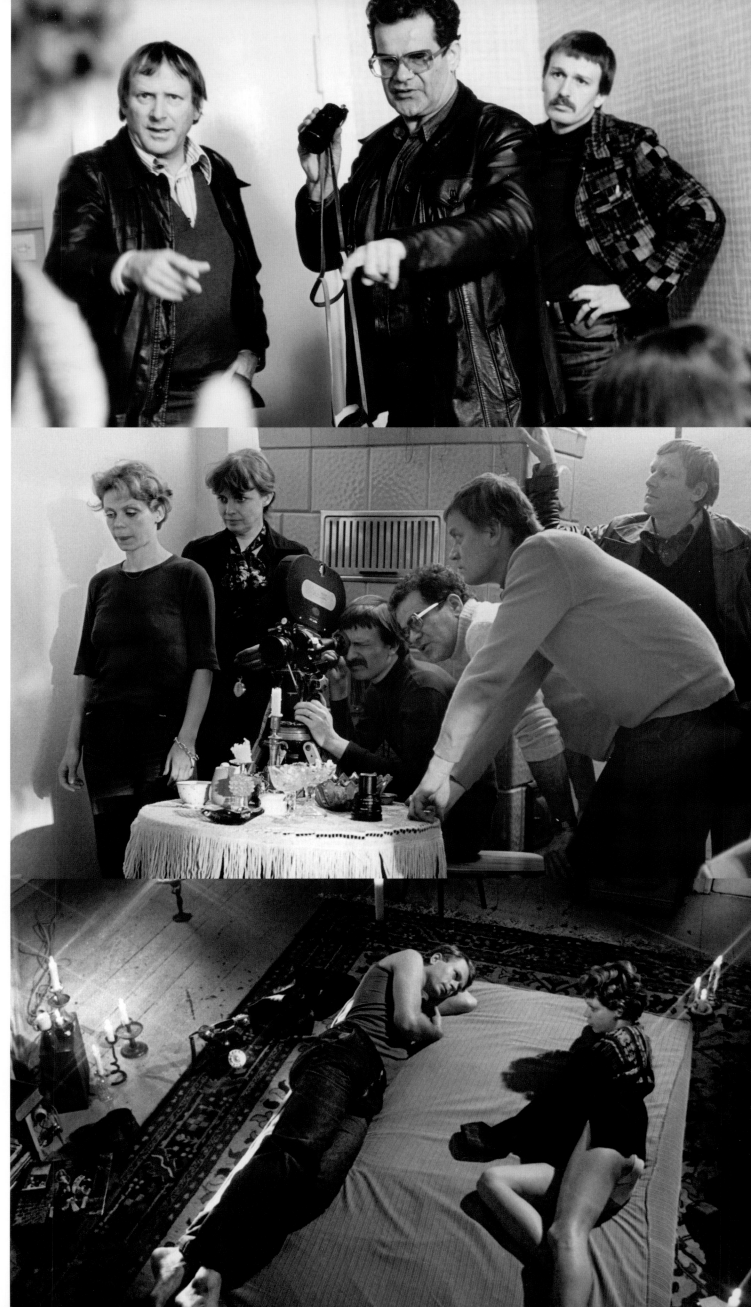

top, f.l.t.r.: Screenwriter and codirector Wolfgang Kohlhaase, director Konrad Wolf, and cinematographer Eberhard Geick during the making of *Solo Sunny* (1980)

oben, v.l.n.r.: Drehbuchautor und Koregisseur Wolfgang Kohlhaase, Regisseur Konrad Wolf und Kameramann Eberhard Geick während der Dreharbeiten zu *Solo Sunny* (1980)

middle: Renate Krößner (left), Eberhard Geick, Konrad Wolf (middle), and Wolfgang Kohlhaase (at the back, right)

Mitte: Renate Krößner (links), Eberhard Geick, Konrad Wolf (Mitte) und Wolfgang Kohlhaase (hinten rechts)

bottom: Alexander Lang and Renate Krößner

unten: Alexander Lang und Renate Krößner

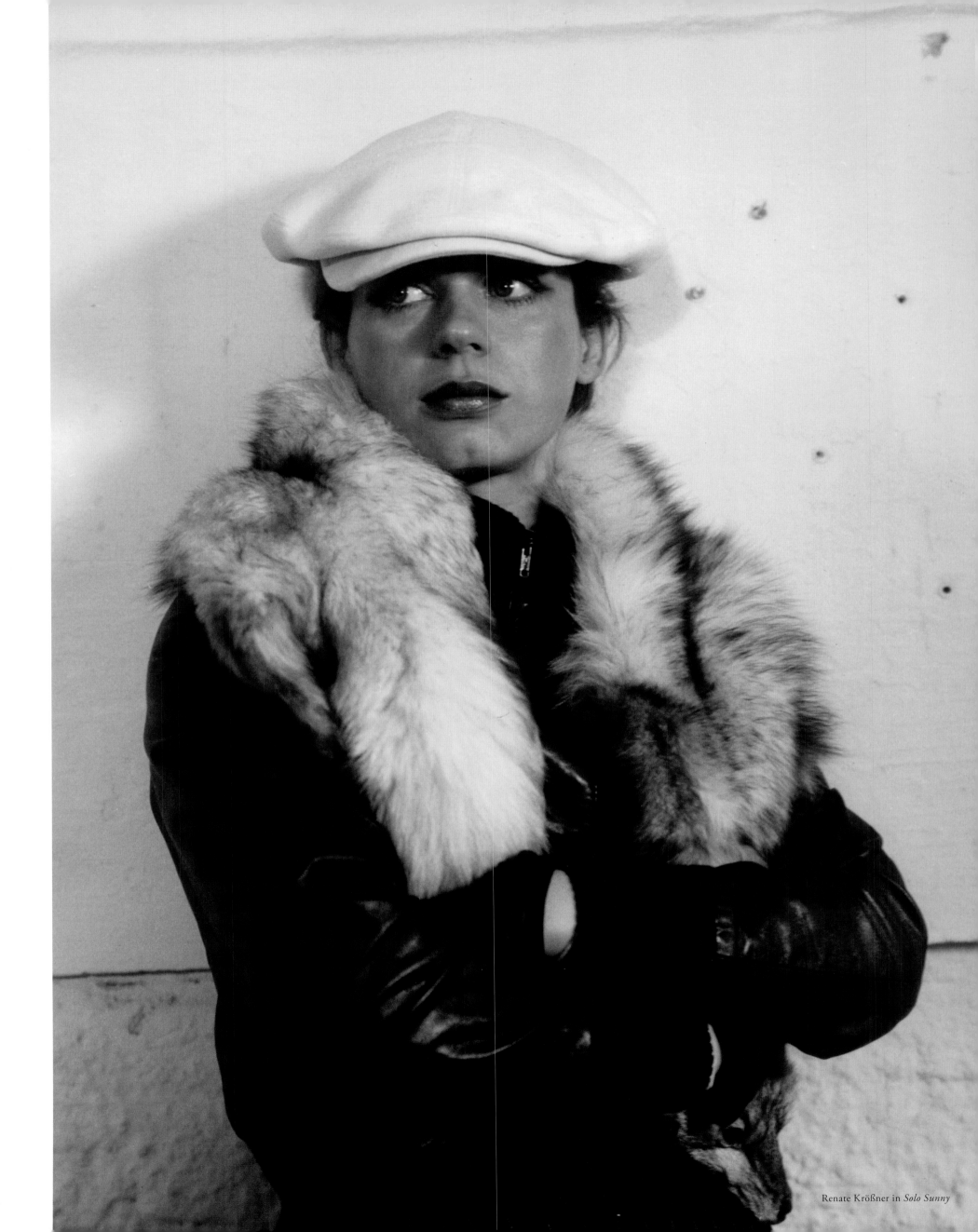

Renate Krößner in *Solo Sunny*

Stephan Jahnke in
When You Grow Up, Dear Adam
(1965/1990, Director: Egon Günther)

Stephan Jahnke in
Wenn Du groß bist, lieber Adam
(1965/1990, Regie: Egon Günther)

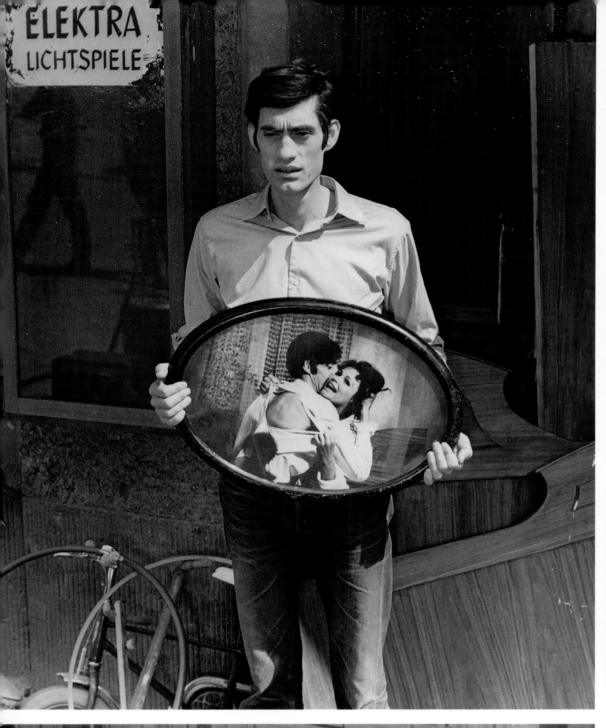

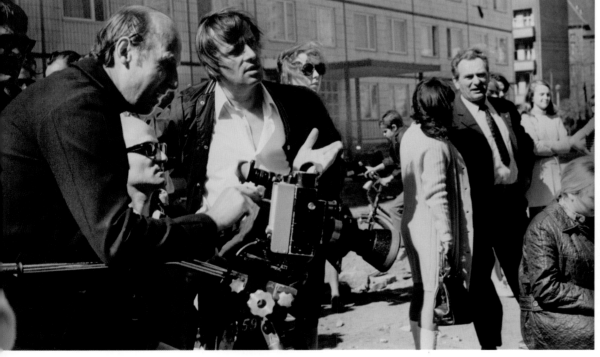

Heiner Carow shot *The Legend of Paul and Paula* with Angelica Domröse and Winfried Glatzeder (top left) in the leading roles, based on the screenplay by Ulrich Plenzdorf in 1973. The film belongs to the most successful feature films made in the GDR. The large picture shows a production design sketch by scene and set designer Harry Leupold.

1973 dreht Heiner Carow nach dem Drehbuch von Ulrich Plenzdorf *Die Legende von Paul und Paula* mit Angelica Domröse und Winfried Glatzeder
(oben links) in den Hauptrollen. Der Film zählt zu den erfolgreichsten in der DDR gedrehten Spielfilmen. Das große Foto zeigt einen Szenenbildentwurf von
Szenen- und Bühnenbildner Harry Leupold.

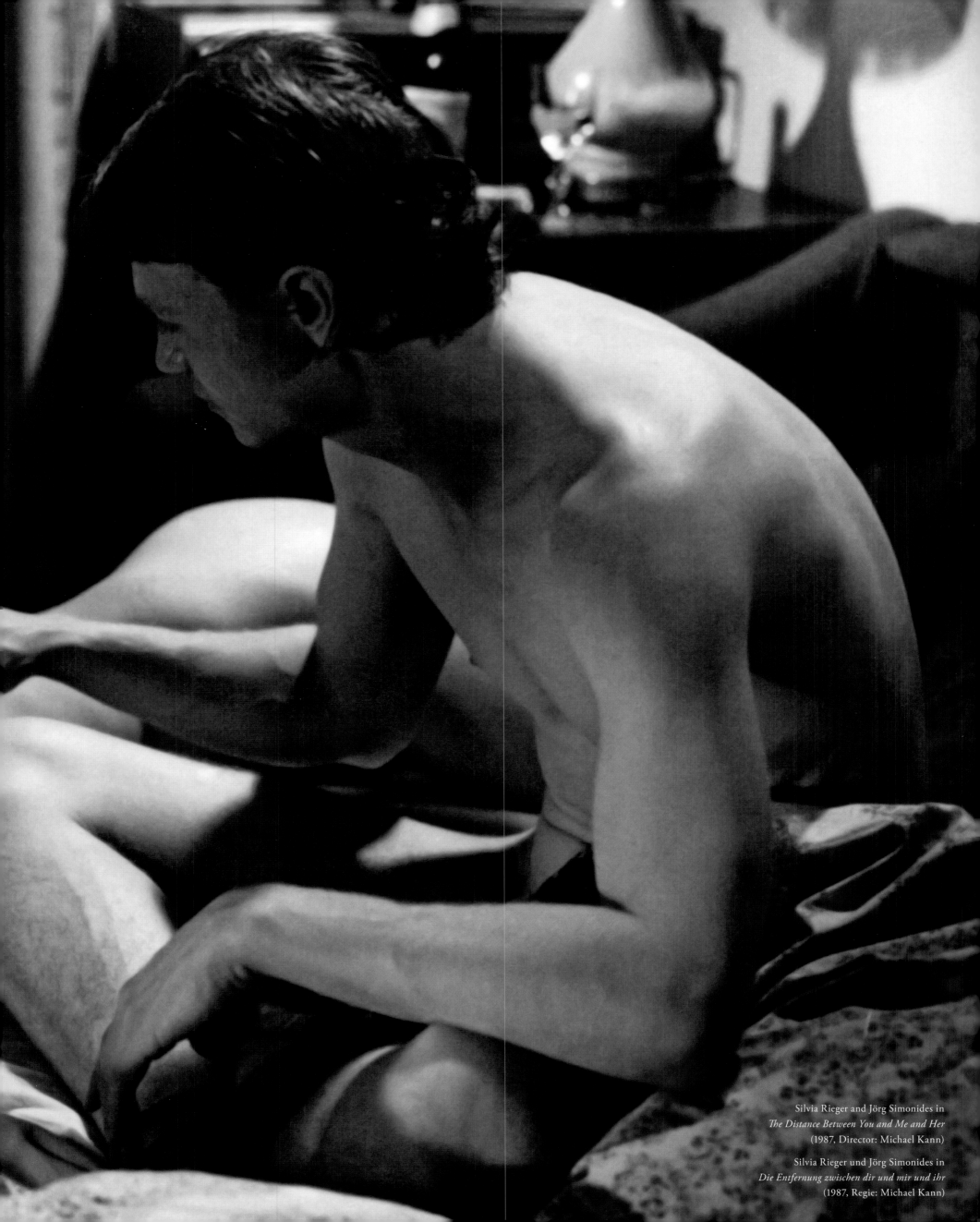

Silvia Rieger and Jörg Simonides in
The Distance Between You and Me and Her
(1987, Director: Michael Kann)

Silvia Rieger und Jörg Simonides in
Die Entfernung zwischen dir und mir und ihr
(1987, Regie: Michael Kann)

Klaus-Peter Thiele in
The Adventures of Werner Holt
(1965. Director: Hans-Joachim Kunert)

Klaus-Peter Thiele in
Die Abenteuer des Werner Holt
(1965. Regie: Hans-Joachim Kunert)

Heidemarie Schneider in *The Bicycle*
(1982, Director: Evelyn Schmidt)

Heidemarie Schneider in *Das Fahrrad*
(1982, Regie: Evelyn Schmidt)

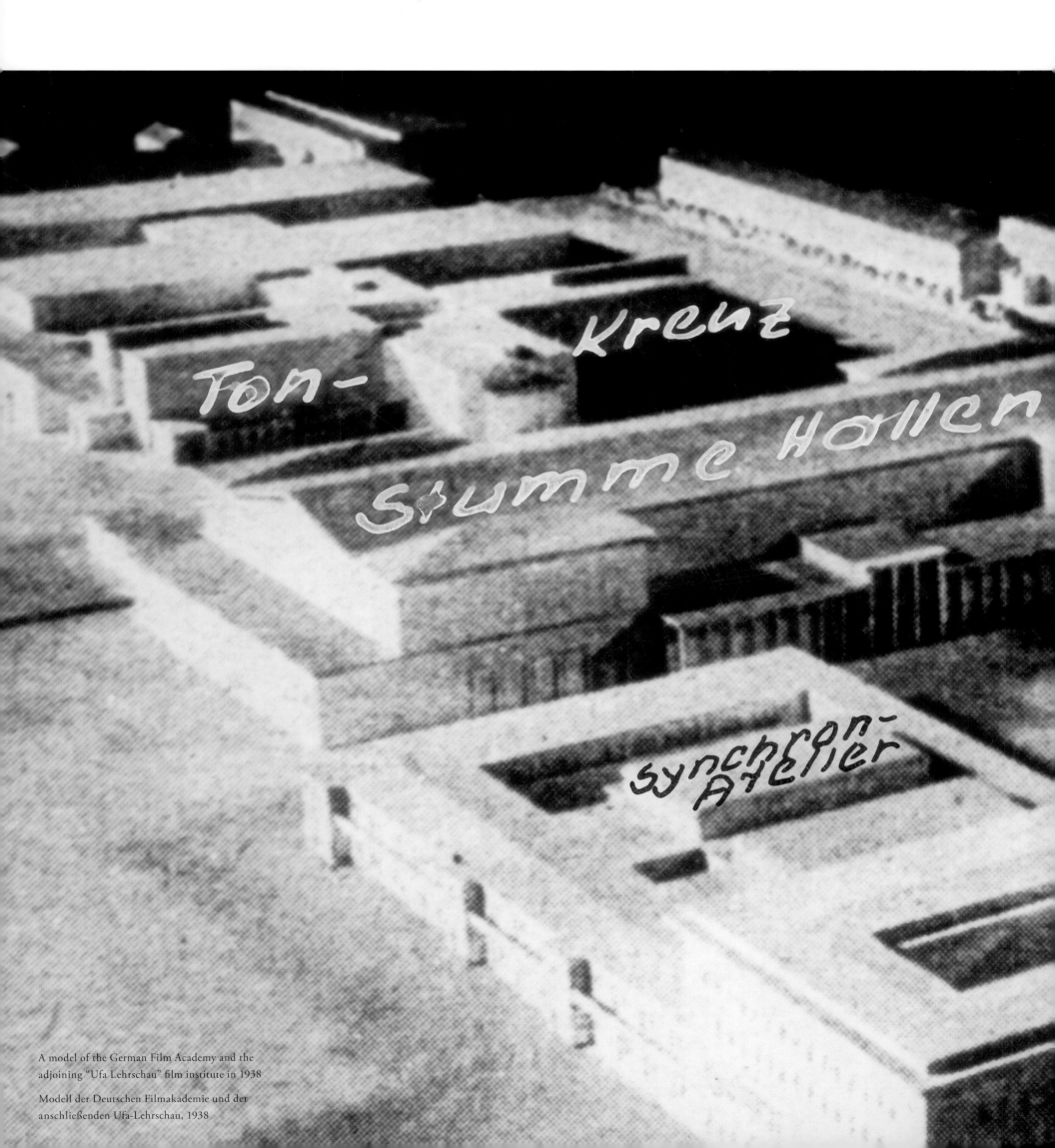

Ton-

Kreuz

Stumme Hallen

synchron- Atelier

A model of the German Film Academy and the
adjoining "Ufa Lehrschau" film institute in 1938

Modell der Deutschen Filmakademie und der
anschließenden Ufa-Lehrschau, 1938

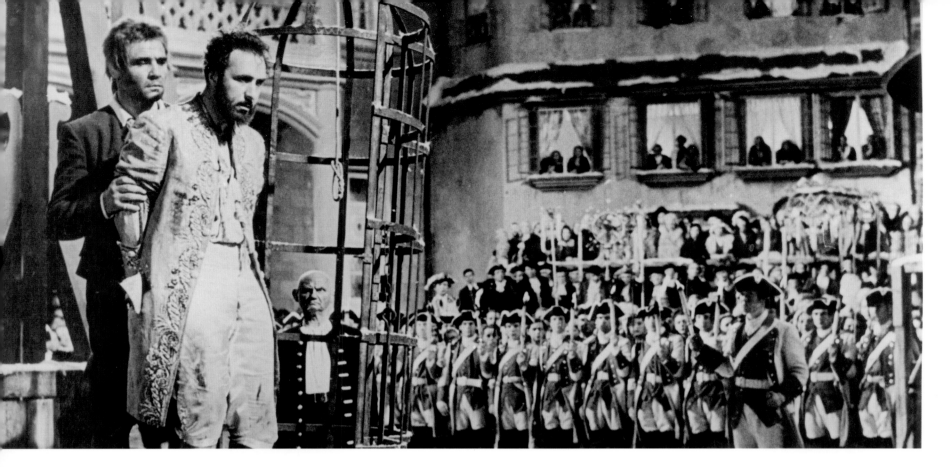

Ferdinand Marian in the title role of
Jew Süss (1940, Director: Veit Harlan)

Ferdinand Marian in der Titelrolle von
Jud Süß (1940, Regie: Veit Harlan)

"DRITTES REICH" (1933-1945)

by Chris Wahl

The Ufa came into being in 1917 during World War I. With several former military officers at the top, it was a kind of semigovernmental propaganda machine designed to continue the war "by other means."[1] Even 25 years later, foreign observers such as future director Robert Stevenson (*Mary Poppins*, 1964), who was "stationed" as a supervisor for English-language versions in Neubabelsberg in 1932, attributed the frictionless daily functions of the Ufa organism to the soldierly principles employed there, and the general military atmosphere that dominated the Neubabelsberg studios.[2] His observations from Ufa's inner workings corroborate with the outside view a British reporter gained that same year:

> Should Herr Hitler ever conquer Germany, he will probably transform the Ufa film metropolis near Berlin into a fortress. It almost looks like one already. When you approach the main studios, you expect to be shot from the battlements or disintegrated with an invisible beam from the windowless walls of this robot castle.[3]

On the one hand, this writer's powerful imagination was absolutely shrewd, but on the other hand, it did not quite hit the mark. For one thing, it was less Hitler himself than his Minister of Propaganda Joseph Goebbels who sought to transform Ufa into a kind of national-cultural fortress. For another, they shot the "invisible," but nevertheless effective, beams (of excommunication) inside the robot castle first. Next to Erich Pommer, whole ranks of accomplished employees who were responsible for the great success of Ufa-style, multiple-language-version sound operettas like *Melody of the Heart* (1929), *Three Good Friends* (1930), or *The Congress Dances* (1931) had to leave the studio (and Germany): composers like Werner Richard Heymann and Friedrich Hollaender, song lyricists like Robert Gilbert, scriptwriters like Robert Liebmann and István Székely, and directors like Ludwig Berger, Eric Charell, Anatole Litvak, Hanns Schwarz, Curt Siodmak, and Wilhelm Thiele, to name but a few. In a few cases—particularly as far as actors were concerned—the Ufa board fought for the possibility of at least temporarily extended employment. Members of the board came from the traditional, national-conservative sphere, but were not necessarily entrenched in the Nazi Party. Yet their strategy, based on strictly business concerns, would

„DRITTES REICH" (1933-1945)

Chris Wahl

Die Ufa war 1917 dem Ersten Weltkrieg „entsprungen", um – mit einer Reihe Ex-Militärs an der Spitze – als eine Art halbstaatliche Propagandamaschine den Krieg „mit anderen Mitteln" fortzusetzen.[1] Noch 25 Jahre später führten ausländische Beobachter wie der spätere Regisseur Robert Stevenson (*Mary Poppins*, 1964), der 1932 als Supervisor für die englischen Sprachversionen in Neubabelsberg „stationiert" war, das reibungslose Funktionieren des Ufa-Organismus nicht zuletzt auf die soldatischen Prinzipien zurück, die hier zur Anwendung kämen, ja auf die militärische Atmosphäre, die generell in den Neubabelsberger Studios herrsche.[2] Seine Beobachtungen aus der Innenwelt der Ufa decken sich mit dem äußeren Eindruck, den ein britischer Reporter im selben Jahr gewann:

> Sollte Herr Hitler jemals Deutschland erobern, wird er wahrscheinlich die Ufa-Filmstadt bei Berlin in eine Festung umwandeln. Sie sieht bereits ganz wie eine solche aus. Wenn man sich den Hauptstudios nähert, erwartet man, von den Zinnen aus beschossen oder von einem unsichtbaren Strahl aus den fensterlosen Mauern dieser Roboterburg ausgelöscht zu werden.[3]

Diese Imaginationskraft war einerseits durchaus hellsichtig, traf andererseits nicht wirklich ins Schwarze. Denn zum einen sollte es weniger Adolf Hitler persönlich als vielmehr sein Propagandaminister Joseph Goebbels sein, der die Ufa in eine Art national-kulturelle Festung zu verwandeln suchte, und zum anderen schossen die „unsichtbaren", aber umso wirkungsvolleren (Bann-)Strahlen zunächst einmal ins Innere der Roboterburg. Das Studio (und Deutschland) verlassen mussten neben Erich Pommer eine ganze Reihe von verdienstvollen Mitarbeitern, die bis dahin für den großen Erfolg der Ufa-typischen, teils in mehreren Sprachen gedrehten Tonfilmoperetten wie *Melodie des Herzens* (1929), *Die Drei von der Tankstelle* (1939) oder *Der Kongreß tanzt* (1931) gesorgt hatten: Komponisten wie Werner Richard Heymann und Friedrich Hollaender, Liedtexter wie Robert Gilbert, Drehbuchautoren wie Robert Liebmann und István Székely, Regisseure wie Ludwig Berger, Eric Charell, Anatole Litvak, Hanns Schwarz, Curt Siodmak und Wilhelm Thiele, um nur ein paar Namen zu nennen. In einigen Fällen, vor allem von Schauspielern, kämpfte der Ufa-Vorstand allerdings um die Möglichkeit der zumindest zeitweiligen Weiterbeschäftigung.

f.l.t.r.: Veit Harlan, Joseph Goebbels, NN, Emil Jannings, and Adolf Hitler, around 1937

v.l.n.r.: Veit Harlan, Joseph Goebbels, NN, Emil Jannings und Adolf Hitler, um 1937

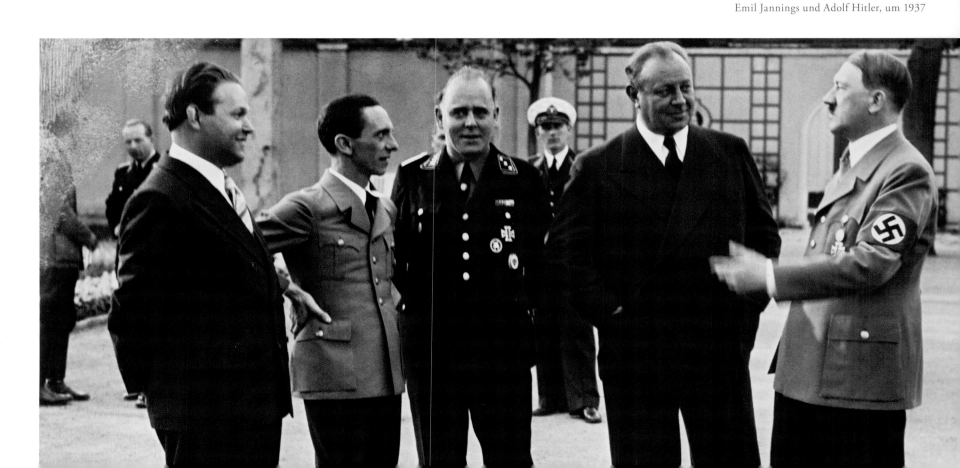

top and bottom: Scenes from *Refugees*
(1933, Director: Gustav Ucicky)

oben und unten: *Szenen aus* Flüchtlinge
(1933, Regie: Gustav Ucicky)

become increasingly sabotaged by ideologically and personally motivated directives from the Ministry of Propaganda. It was also because of this, that foreign sales continued to decline over the course of the '30s, and the studio would only become profitable again through the expansion of a cornered market as a result of World War II.

One example of the conflict between the government and Ufa is the fate of long-time production head Ernst Hugo Correll, who was finally removed from the company in 1939. He was probably considered "an irritating obstructionist who had resolutely represented the interests of the production side over the ponderousness of the political apparatus."[4] In his place, people such as Karl Ritter, a hard-line Nazi, and producer and director of war-glorifying fighter-pilot films like *Legion Condor* (1939) and *Stukas* (1941), or the "loathsome fellow"[5] Alfred Greven now had careers at Ufa. The latter, who was hired as Correll's successor production head in April 1939, was removed just a few months later due to his misguided program politics, "having fulfilled his duties as head of Continental Films" after the occupation of Paris, but "to the full satisfaction of the Minister of Propaganda."[6] Even his appearance as a representative of the German Reich in the occupied French territories remained politically correct, since "when the Nazis marched down the Champs-Elysées, he gave the Hitler salute from his window."[7]

Directly following Goebbels' speech about the film industry some days earlier at the Hotel Kaiserhof in Berlin, his March 29, 1933 resolution not only attacks Jewish directors, but also demands more "*völkisch*" (i.e. national) contours for the German film.[8] Ufa immediately reacted to the second point. All material currently in production was immediately investigated once again for its readiness for censorship boards and external review. Naturally, any changes in the production plan were initially kept within very narrow limits. There could be no talk of a complete conversion to "völkisch" productions. In the six and a half years before the war, subtly anarchist or at least contradictory works could be made in Neubabelsberg next to more or less nationally inclined films that often profiled a superior "Führer" figure—such as *Refugees* with Hans Albers (1933, Gustav Ucicky). For example, the role of the woman in national socialism as a "baby factory" and housewife is not really reflected at all in Reinhold Schünzel's *Viktor and Viktoria* (1933), the story of an androgynous young girl who dresses as a man to perform as a female impersonator. Schünzel, who eventually left Germany in 1937, is considered today to be the king of musical comedy. His apprentice at the time—Kurt Hoffmann, son of Ufa cinematographer Carl Hoffmann—later attempted to continue that tradition in post-war West Germany.

Hans Albers in *Refugees* (1933)

Hans Albers in *Flüchtlinge* (1933)

Die Mitglieder dieses Gremiums kamen zwar traditionell aus einem national-konservativen Umfeld, waren aber nicht unbedingt in der Nazi-Partei verwurzelt. Doch ihre streng auf geschäftlichen Überlegungen basierende Strategie wurde in der Folge immer wieder von ideologisch und persönlich motivierten Anweisungen aus dem Propagandaministerium torpediert. Auch aus diesem Grund fiel das Auslandsgeschäft im Verlauf der 30er Jahre kontinuierlich ab und konnte nur durch die Ausdehnung des gesicherten Absatzmarktes im Zuge des Zweiten Weltkriegs wieder rentabel gemacht werden.

Exemplarisch für die Auseinandersetzung zwischen Regierung und Ufa ist das Schicksal des langjährigen Produktionschefs Ernst Hugo Correll, der 1939 schließlich aus dem Konzern entfernt wurde. Wahrscheinlich galt er, „der mit Entschiedenheit die Interessen der Produktionsseite gegenüber den Schwerfälligkeiten des politischen Apparats vertreten hatte, im Propaganda-ministerium als störender Querulant".[4] Stattdessen machten nun Leute wie der stramme Nazi Karl Ritter, Produzent und Regisseur von kriegsverherrlichenden Fliegerfilmen wie *Legion Condor* (1939) und *Stukas* (1941), oder der „abscheuliche Kerl"[5] Alfred Greven Karriere bei der Ufa. Letzterer, im April 1939 als Nachfolger von Correll zum Produktionsleiter berufen, wurde schon nach wenigen Monaten wegen seiner verfehlten Programmpolitik wieder abgelöst, „erledigte seinen Auftrag als Chef der Continental Films" nach der Okkupation von Paris aber „zur vollen Zufriedenheit des Propagandaministers".[6] Auch sein Auftreten als Repräsentant des Deutschen Reichs in den besetzten französischen Gebieten war überaus korrekt, denn „wenn die Nazis die Champs-Elysées hinuntermarschierten, entrichtete er aus seinem Fenster den Hitlergruß".[7]

Die Beschlussfassung am 29. März 1933 folgte direkt auf Goebbels' tags zuvor gehaltene Rede an die Filmindustrie im Hotel Kaiserhof zu Berlin, in der er nicht nur jüdische Regisseure attackiert, sondern auch völkische Konturen für den deutschen Film gefordert hatte.[8] Auch auf den zweiten Punkt reagierte man bei der Ufa umgehend. Alle Stoffe der aktuellen Produktion wurden nochmals auf ihre Zensurfähigkeit und Auswertungsmöglichkeit durchleuchtet. Aller-dings hielten sich die Änderungen im Produktionsplan zunächst in sehr engen Grenzen. Von einer Umstellung auf „völkische" Produktion konnte nicht die Rede sein. In den sechseinhalb Jahren bis Kriegsbeginn entstanden in Neubabelsberg neben mehr oder weniger nationalistisch argumentierenden Filmen, die oftmals eine fast übermenschliche Führerfigur als Protagonisten exponierten – wie beispielsweise *Flüchtlinge* (1933, Gustav Ucicky) mit Hans Albers –, auch subtil-

Director Karl Ritter, Albert Hehn, and Georg Thomalla during the making of *Stukas* (1941)

Regisseur Karl Ritter, Albert Hehn und Georg Thomalla während der Dreharbeiten zu *Stukas* (1941)

Fita Benkhoff in *Amphitryon*
(1935, Director: Reinhold Schünzel)

Fita Benkhoff in *Amphitryon*
(1935, Regie: Reinhold Schünzel)

The Schünzel film *Amphitryon* (1935) is seen today as a film that mocks the regime in certain passages, sometimes even openly:

> For the German audience in 1935, good fortune coming from the clouds was unequivocally associated with the divine Adolf Hitler, who swooped down in an airplane from the cloud-bedecked heavens into the expectant arms of the people at the Nürnberg party convention, as in the famous opening sequence of Leni Riefenstahl's *Triumph of the Will* [which premiered on March 28, while *Amphitryon* was in production]. Down in Franconian Thebes, the patriotic women of Greece parody the lofty attitudes of a German soldier's wife: "Be brave during difficult times / The men are amidst bloody conflict / And he among them who falls out there / He dies for the Fatherland as a hero!"[9]

Another deeply contradictory film was *Black Roses* (1935, Paul Martin). And it was not merely because it presented Lilian Harvey and Willy Fritsch, the dream couple of the earlier sound-film operettas, playing serious roles and proceeded to see through the implied melancholy of the title itself to its very unhappy end: suicide and exile. The story, set in Finland, contains no thoroughly positive and/or superior male figure that would offer identification with the powers-that-be. Instead, Fritsch plays a determined but tragically unsuccessful Finnish freedom fighter, and Willy Birgel a rational but openly unscrupulous Russian-occupation officer with a dangerous weakness for the freedom fighter's dancer-bride, played by Harvey. On the one hand, the Russian commander is not portrayed sympathetically, but on the other hand he represents exactly the same ideals that the national socialists would adopt as occupation forces a few years after the film's premiere. And if the Finnish freedom fighters are supposed to represent the early years of the Party—when it was just a "movement" itself—why are they routinely unsuccessful in the film?

Black Roses and *Refugees* belonged to the increasing number of films produced with "luxurious film sets" during the '30s, which was also inversely proportional to the sinking export profits.[10] Exotic and/or distant locales, which were completely foreign to the majority of the audience, such as China (*Prinzessin Turandot—Princess Turandot*, 1934, Gerhard Lamprecht), Brazil (*Donogoo Tonka. Die geheimnisvolle Stadt—The Mysterious City*, 1936, Reinhold Schünzel), New York (*Lucky Kids*, 1936, Paul Martin), Turkey (*Stadt Anatol—The City of Anatol*, 1936, Viktor Tourjansky) or the South Pacific (*Love, Death and the Devil*, 1934, Heinz Hilpert and Reinhart Steinbicker) were completely staged on either the studio lot itself or at least in its vicinity. *To New Shores* (1937) is also one of these films, as its presumably Australian environment was staged on an open lot at Neubabelsberg. Director Detlef Sierck made Zarah Leander a star with that

Willy Fritsch and Paul Kemp in *Amphitryon*

Willy Fritsch und Paul Kemp in *Amphitryon*

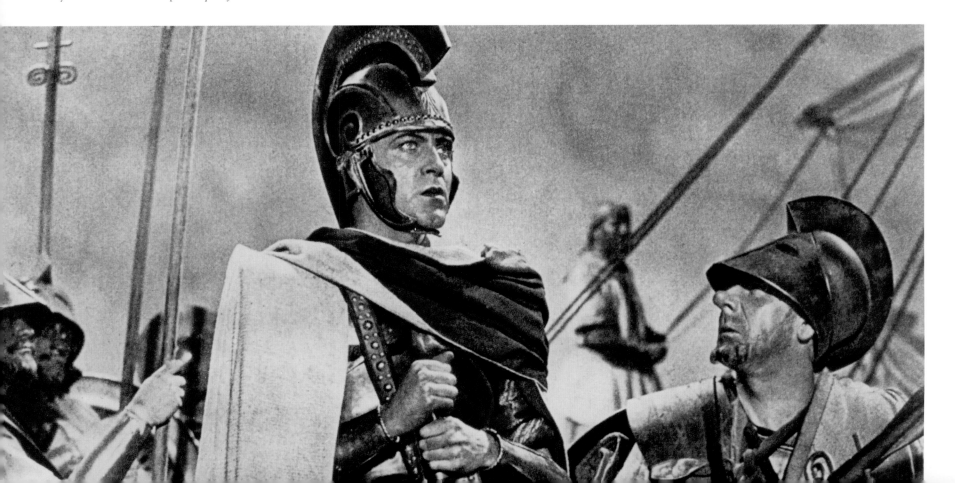

anarchische oder zumindest widersprüchliche Werke. Die der Frau im Nationalsozialismus zugedachte Rolle als Gebärmaschine und Heimchen spiegelt sich so gar nicht in Reinhold Schünzels *Viktor und Viktoria* (1933), der Geschichte eines androgynen Fräuleins, das sich als Mann verkleidet, um auf der Bühne als Damenimitator auftreten zu können. Schünzel, der erst 1937 Deutschland verließ, gilt bis heute als König der musikalischen Komödie, die sein damaliger Lehrling Kurt Hoffmann, Sohn des Ufa-Kameramanns Carl Hoffmann, später in der Bundesrepublik fortzuführen versuchte. Der in den Neubabelsberger Ufa-Ateliers entstandene Schünzel-Film *Amphitryon. Aus den Wolken kommt das Glück* (1936) wird heute als ein Film verstanden, der sich passagenweise – mehr oder weniger versteckt – über das Regime mokierte:

> Das Glück, das aus den Wolken kommt, war für den Volksgenossen von 1935 ganz eindeutig der göttliche Adolf Hitler, wie er in der berühmten ersten Sequenz von Riefenstahls [am 28. März, also während der Dreharbeiten zu *Amphitryon* uraufgeführten] *Triumph des Willens* aus den Nebelfetzen des Himmels über Nürnberg auf das seiner harrende Parteitags-Volk mit dem Flugzeug herniederschwebt. Unten im fränkischen Theben parodieren die vaterländischen Frauen Griechenlands die hehre Gesinnung der deutschen Kämpfers-Gattin: „Seid mutig in der schweren Zeit / die Männer stehn in blut'gem Streit / und wer von ihnen draußen fällt, / der stirbt fürs Vaterland als Held!"[9]

Ein zutiefst widersprüchlicher Film war *Schwarze Rosen* (1935, Paul Martin): Nicht nur, dass er das Traumpaar der frühen Ufa-Tonfilmoperettenzeit Lilian Harvey und Willy Fritsch in ernsten Rollen präsentierte und die schon im Titel angelegte Melancholie bis ans Ende durchhielt, das keineswegs *happy* war – am Schluss standen Selbstmord und Verbannung. Es gibt in dieser in Finnland angesiedelten Geschichte keine durchgehend positiv bzw. überlegen besetzte männliche Figur, die zu einer Identifikation im Sinne der Machthaber eingeladen hätte; stattdessen einen entschlossenen, aber tragisch erfolglosen finnischen Freiheitskämpfer (Fritsch) und einen zwar konsequenten, aber offensichtlich skrupellosen russischen Besatzer (Willy Birgel) mit einer gefährlichen Schwäche für die von Harvey gespielte Tänzerin und Braut des Freiheitskämpfers. Einerseits wird dieser russische Kommandant nicht gerade als Sympathieträger dargestellt, andererseits vertritt er genau dieselben Ideale, mit denen wenige Jahre nach der Filmpremiere die Nationalsozialisten zu Besatzern werden würden. Und wenn die finnischen Freiheitskämpfer für die Frühzeit der Partei stehen sollen, als man selbst noch „Bewegung" war, warum sind sie dann notorisch erfolglos?

Sowohl *Schwarze Rosen* als auch *Flüchtlinge* gehörten zu den im Laufe der 30er Jahre in steigender Zahl produzierten Filmen, bei denen die „luxuriöse Filmausstattung" sich umgekehrt proportional zum Sinken der Exporterlöse verhielt.[10] Exotische oder zumindest weit entfernte und dem Großteil des Publikums völlig fremde Schauplätze wie China (*Prinzessin Turandot*, 1934, Gerhard Lamprecht), Brasilien (*Donogoo Tonka. Die geheimnisvolle Stadt*, 1936, Reinhold Schünzel), New York (*Glückskinder*, 1936, Paul Martin), die Türkei (*Stadt Anatol*, 1936, Viktor Tourjansky)

Renate Müller in *Viktor and Viktoria*
(1933, Director: Reinhold Schünzel)

Renate Müller in *Viktor und Viktoria*
(1933, Regie: Reinhold Schünzel)

To New Shores (1937, Director: Detlef Sierck),
starring Zarah Leander

Zu neuen Ufern (1937, Regie: Detlef Sierck)
mit Zarah Leander

Boxing match between Dutch forced laborers

Boxkampf niederländischer Zwangsarbeiter

film and his later film *La Habanera* (1937), partially shot on Tenerife in the Canary Islands, but then he also went into exile. Later, under the name Douglas Sirk, he became a top director of the Hollywood melodrama and a role model for Rainer Werner Fassbinder.

For most of its 28-year history, Ufa had wanted to measure itself against the American film industry. The National Socialists' megalomania intended the construction of a film metropolis at Neubabelsberg that would overshadow even that of Hollywood. The renaming of the train station at Neubabelsberg "Ufa-Stadt" in 1938 was one sign of this plan. Since 1949, however, the S-Bahn station there has been called "Griebnitzsee." Most Ufa employees, including actors and extras, commuted from Berlin via public transportation every day. During the war, about 2,000 people still worked on the lot with its (back then) eight sound stages (today 16).[11] Only a few stars, like Heinz Rühmann, drove their cars from their nearby Berlin residences or walked across the street from the gated community south of Griebnitzsee, as did Brigitte Horney and Marika Rökk, whose houses previously belonged to Jews now forced into emigration. In any case, this noble Neubabelsberg residential area was united with the neighboring industrial and workers' district Nowawes in 1938, which brought with it the new name of "Babelsberg." A year later, this new district was incorporated into Potsdam.[12] On the way from the station to the studio lot during the war, Ufa employees passed one of over 70 camps for forced laborers that existed in Potsdam. One need only make a slight detour along Hermann-Göring-Straße (today Stahnsdorferstraße) to the athletic field, in order to discover Ufa's own personal forced-labor barracks. In the fall of 1942, the studio acquired from the city two plots of land bordering the athletic field to house foreign slave workers,[13] whose presence no one could ignore. A photo from the time shows a boxing match between two Dutch forced laborers on the Ufa lot, and an audience of well-dressed spectators who came to watch despite the rain.[14]

Forced laborers were not only present behind the scenes, but also often served as film extras. In this respect, Leni Riefenstahl attracts the most attention, as her epic film *Lowlands* (1954), which she spent

oder die Südsee (*Liebe, Tod und Teufel*, 1934, Heinz Hilpert und Reinhart Steinbicker) wurden komplett auf dem Studiogelände oder zumindest in dessen näherer Umgebung nachgestellt. Zu diesen Filmen könnte man auch *Zu neuen Ufern* (1937) hinzuzählen, dessen angeblich australisches Ambiente auf dem Neubabelsberger Freigelände erschaffen wurde. Nachdem Regisseur Detlef Sierck mit diesem und dem folgenden, teilweise auf Teneriffa gedrehten Film *La Habanera* (1937) Zarah Leander zum Star gemacht hatte, ging auch er ins Exil und wurde später als Douglas Sirk zum Inbegriff des Hollywood-Melodramas und Vorbild von Rainer Werner Fassbinder.

In den meisten Abschnitten ihrer 28-jährigen Geschichte wollte sich die Ufa mit der amerikanischen Filmindustrie messen. Die Megalomanie der Nationalsozialisten sah vor, Neubabelsberg zu einer Filmstadt auszubauen, die selbst Hollywood in den Schatten stellen sollte. Ein Zeichen dieses Vorhabens war die Umbenennung des 1931 errichteten Bahnhofs Neubabelsberg in „Ufa-Stadt" im Jahr 1938. Seit 1949 heißt die S-Bahn-Station „Griebnitzsee". Mit öffentlichen Verkehrsmitteln aus Berlin reisten täglich die meisten Ufa-Mitarbeiter einschließlich Schauspieler und Statisten an. In der Kriegszeit arbeiteten auf dem Gelände mit seinen damals acht (heute 16) Tonfilmateliers immerhin rund 2 000 Menschen.[11] Nur wenige Stars wie Heinz Rühmann kamen aus ihren nahegelegenen Berliner Residenzen mit dem Auto oder wohnten direkt vor Ort in der Villenkolonie südlich des Griebnitzsees, darunter Brigitte Horney und Marika Rökk, deren Häuser vormals jüdische Besitzer gehabt hatten, die in die Emigration gezwungen worden waren. Ebenfalls 1938 wurde dieses noble Neubabelsberger Wohngebiet mit dem benachbarten Industrie- und Arbeiterstadtteil Nowawes vereinigt, was eine Namensänderung in „Babelsberg" mit sich brachte, und ein Jahr später, am 1. April 1939, als Ortsteil von Potsdam eingemeindet.[12] Auf dem Weg vom Bahnhof zum Studiogelände kamen die Ufa-Mitarbeiter in der Kriegszeit an einem von über 70 Zwangsarbeitslagern vorbei, die es in Potsdam gab. Es bedurfte nur eines kleinen Schlenkers entlang der Hermann-Göring-Straße (heute Stahnsdorferstraße) bis zum Sportplatz, um das dort gelegene Ufa-eigene Barackenlager zu entdecken. Im Herbst 1942 erwarb das Studio zwei weitere direkt an den Sportplatz angrenzende Flächen von der Stadt für die Unterbringung von ausländischen Arbeitssklaven,[13] deren Präsenz niemand ignorieren konnte: Ein erhaltenes Foto zeigt den Boxkampf zweier niederländischer Zwangsarbeiter auf dem Ufa-Gelände und ein Publikum aus gut gekleideten Zuschauern, die für dieses Spektakel dem Regen trotzen.[14]

Zwangsarbeiter waren allerdings nicht nur hinter den Kulissen präsent, sondern dienten oftmals als Filmstatisten. Zwar hat Leni Riefenstahl mit ihrem fast über die gesamte Kriegszeit hinweg für die Tobis gedrehten Epos *Tiefland* (1954), bei dem gefangene Sinti aus dem „Zigeunerlager"

Zarah Leander in *La Habanera*
(1937, Director: Detlef Sierck)

Zarah Leander in *La Habanera*
(1937, Regie: Detlef Sierck)

Barracks on the Ufa grounds for the
accommodation of forced laborers

Baracken auf dem Ufa-Gelände zur
Unterbringung der Zwangsarbeiter

nearly the entire war shooting, uses captured Sinti from the "gypsy camp" Maxglan in Salzburg. But also an Ufa film like *Germanin* (*The Germanic Woman*, 1943, Max W. Kimmich), set in German East Africa (Tanzania) and partially shot near Rome, shows dark-skinned French prisoners of war from a camp in Luckenwalde (Brandenburg) in the roles of native tribesmen.[15] Even though it may be cynical to argue that the work in the film studios was surely more pleasant for the slaves than some conceivable alternatives, in many respects, the Babelsberg lot certainly proved for *German* Ufa employees to be less a "desert in an oasis," as Kracauer expressed it in 1926, than an oasis in the desert. Not only did employment on a film often protect men from being sent off to the front, it also offered a welcome distraction from the steadily increasing "bombing terror" of Berlin. It was relatively quiet there compared to the capital until the end of the war, when Potsdam also became a target of Allied bombing raids. This was also good because the bomb shelter erected on the studio lot in 1939 was only meant for 418 people, or a quarter of the staff at any given time.[16] Thankfully, war was just staged in Babelsberg, such as when battle scenes had to be reenacted out of a lack of original material for the newsreel. This meant that

> there [was] a miniature wooden fleet on the studio lake. An electrical device could simulate shell fire and explosions on the water. Even camera nose-dives (with the lenses looking over part of a fake airplane) toward the model ships were possible.[17]

Many eyewitnesses report that Ufa was an oasis in the desert also because there were few swastikas to be seen there and the "Heil Hitler" greeting was not customary. That seems like a miracle, considering the company's origins within a military spirit that dominated the studios for so long.

When World War II begins, the film *Rote Mühle* (*Red Mill*, 1940, Jürgen von Alten) is created just outside of Ufa in a tourist café refitted as a stage at the edge of the Babelsberg city

Peter Petersen and Lotte Koch in *Germanin*
(*The Germanic Woman*, 1943, Director: Max W. Kimmich)

Peter Petersen und Lotte Koch in *Germanin*
(1943, Regie: Max W. Kimmich)

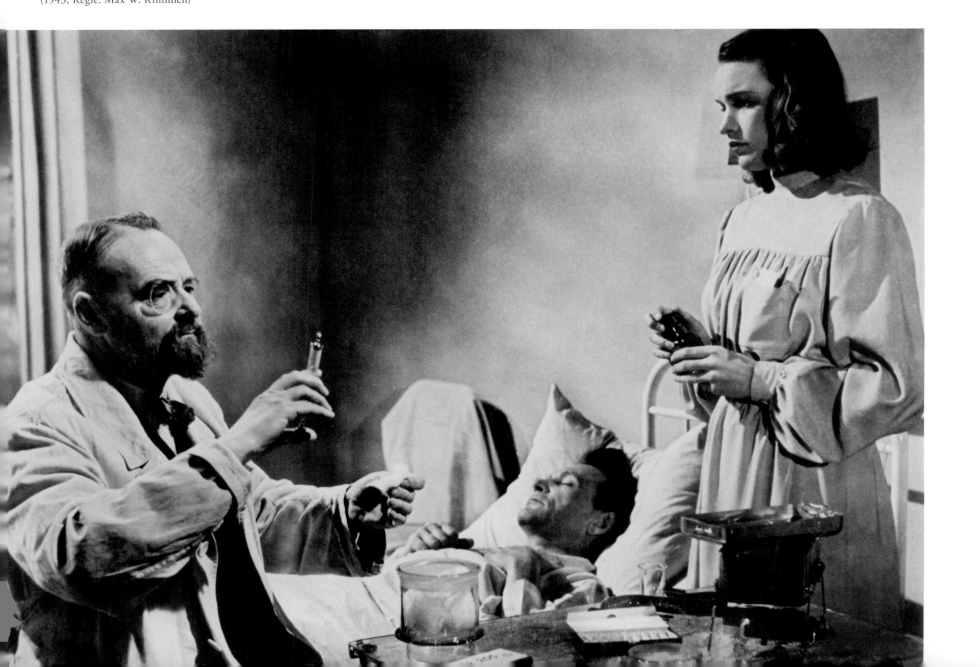

Lotte Koch in *Germanin* (*The Germanic Woman*)
Lotte Koch in *Germanin*

Maxglan in Salzburg zum Einsatz kamen, in dieser Hinsicht sicherlich am meisten Aufmerksamkeit erregt, doch auch ein Ufa-Film wie *Germanin* (1943, Max W. Kimmich), der in Deutsch-Ostafrika (Tansania) spielt und teilweise in der Gegend um Rom gedreht wurde, zeigt französische Kriegsgefangene dunkler Hautfarbe aus einem Lager in Luckenwalde (Brandenburg) in der Rolle der einheimischen Bevölkerung.[15] Auch wenn es zynisch sein mag zu behaupten, die Arbeit in den Filmstudios sei auch für Sklaven sicherlich angenehmer gewesen als manche denkbare Alternative, für die *deutschen* Angestellten der Ufa war das Gelände in Babelsberg während des Krieges mit Sicherheit weniger eine „Wüste in der Oase", wie es Kracauer noch 1926 ausgedrückt hatte, als eine Oase in der Wüste, und das gleich in mehrfacher Hinsicht. Nicht nur, dass das Engagement für einen Film die Männer nicht selten davor bewahrte, an die Front abkommandiert zu werden, es bot darüber hinaus eine willkommene Abwechslung zum stetig zunehmenden „Bombenterror" auf Berlin. Bis zum Ende des Krieges, als Potsdam doch noch zum Ziel der alliierten Flugzeugangriffe wurde, war es hier im Vergleich zur Hauptstadt relativ ruhig. Das war auch gut so, denn der 1939 auf dem Studiogelände erbaute Luftschutzbunker war nur für 418 Personen ausgelegt und damit gerade einmal für ein Viertel der Belegschaft.[16] Krieg wurde in Babelsberg meistens nur gespielt, wenn aus Mangel an Originalmaterial für die Wochenschau Kampfszenen nachgestellt werden mussten, wozu es

> auf dem Ateliersee eine hölzerne Miniaturflotte [gab]. Eine elektrische Anlage konnte Geschützfeuer und Explosionen auf dem Wasser simulieren. Sogar Kamerasturzflüge (deren Linsen über ein Stück Flugzeugtragfläche schielten) auf die Modellschiffe waren möglich.[17]

Eine Oase in der Wüste war die Ufa, so berichten viele Zeitzeugen, aber auch aufgrund der Tatsache, dass man hier kaum Hakenkreuze zu Gesicht bekam und das Begrüßen mit „Heil Hitler" nicht zu den Gepflogenheiten gehörte. Betrachtet man den militärischen Geist, aus dem der Konzern entstanden war und der ihn so nachhaltig geprägt hat, erscheint das fast wie ein Wunder.

Als der Zweite Weltkrieg beginnt, entsteht vor den Toren der Ufa, am Rande des Babelsberger Stadtparks, in einem zum Studio umgebauten Ausflugslokal der Film *Rote Mühle* (1940, Jürgen von Alten). Verantwortlich für diese Operation ist Gustav Althoffs Aco-Film, eine der 17 noch in Privatbesitz verbliebenen Berliner Produktionsfirmen, denen die Arbeit in den großen Ateliers verwehrt bleibt. Seit 1937, als er mithilfe der von ihm 1929 gegründeten Cautio Treuhandgesellschaft im Auftrag des Staates die Ufa gekauft hatte, arbeitete Max Winkler als Reichsbeauftragter für die Filmwirtschaft kontinuierlich an der restlosen Zentralisierung der deutschen Kinoindustrie. Bald hielt die Cautio auch alle anderen großen Firmen (z. B. Bavaria, Terra, Tobis) sowie die

Ilse Werner and Carl Raddatz in *Request Concert*
(1940, Director: Eduard von Borsody)

Ilse Werner und Carl Raddatz in
*Wunschkonzer*t (1940, Regie: Eduard von Borsody)

park. Gustav Althoff's Aco-Film is responsible for this operation, one of the 17 remaining Berlin production companies still in private hands who are nevertheless denied access to the large studios. Since 1937, Max Winkler worked continuously to centralize the German film industry as the Reich's film finance representative with the help of his own Cautio, Inc. holding company founded in 1929, a firm which bought Ufa on behalf of the state. Soon Cautio held ownership of all other large companies (e.g. Bavaria, Terra, Tobis) as well as the remaining private operations like Aco, which itself was eventually integrated into "Berlin-Film" on February 2, 1941. A year later, this conglomerate of numerous German film production companies was renamed "Ufa-Film," but then soon dubbed "Ufi" to distinguish it from the "old" Ufa. So the old Ufa now existed on the one hand as a single brand of "Ufa film art" inside the Ufi portfolio, and on the other hand as "Universum-Film AG," which served along with Ufi as umbrella for all other film activities that did not just belong to production:

> The name "Ufa" was now absolute and a synonym for the German film. Just as the swastika now stood for Hitler's Germany, so did the Ufa rhombus symbolize all that encompassed film and cinema in the Reich and in the conquered European countries.[18]

Even Bavaria, Terra, and Tobis were given the byname "Film Art" during their integration into the national-socialist film production cooperatives. After being taken over by Cautio in July 1937, Terra Film Art no longer produced in the Eiko studios in Berlin-Marienfelde, but in the Ufa studios. One of its main attractions was actor Heinz Rühmann, who led his own production group and debuted as a director in 1938 (*Many Lies*) with the support of Kurt Hoffmann. Shortly before the beginning of the war, *Bachelor's Paradise* (1939, Kurt Hoffmann) was made. It was a variation on *Three Good Friends*, only now Rühmann led the male cohort rather than Willy Fritsch, who, meanwhile, was trying to revitalize the old Ufa sound-film operettas at Lilian Harvey's side with *Frau am Steuer* (*Woman at the Wheel*, 1939, Paul Martin). Just as Fritsch, Rühmann, and Oskar Karlweis landed a giant hit in 1930 with the song "Ein Freund, ein guter Freund" ("A Friend, a Good Friend"), Rühmann and his film companions Josef Sieber and Hans Brausewetter were also successful with "Das kann doch einen Seemann nicht erschüttern" ("That Won't Faze a Sailor"). Thus the trio also performed their musical number a year later in a different Babelsberg production: *Request Concert* (1940, Eduard von Borsody). It was a film that attached a love story to the real existing musical institution and radio program "Wunschkonzert für die Wehrmacht" ("Request Concert for the Army"),

zunächst verbliebenen Privatunternehmen wie die Aco, die man am 2. Februar 1941 in die „Berlin-Film" integrierte. Ein Jahr später wurde dieses Konglomerat sämtlicher deutscher Filmproduktionsfirmen in „Ufa-Film" umbenannt, zur Unterscheidung von der „alten" Ufa aber bald „Ufi" genannt. Die alte Ufa existierte nun einerseits weiter als einzelne Marke „Ufa-Filmkunst" innerhalb des Ufi-Portfolios und andererseits als „Universum-Film AG", die neben der Ufi als Dach aller Filmaktivitäten fungierte, die nicht zur Produktion gehörten:

> Der Name „Ufa" war nun total und ein Synonym für den deutschen Film, und wie das Hakenkreuz als Signum für Hitler-Deutschland galt, so symbolisierte der Ufa-Rhombus alles, was mit Film und Kino im Reich und in den eroberten europäischen Ländern zusammenhing.[18]

Auch die Bavaria, Terra und Tobis erhielten im Zuge ihrer Integration in die nationalsozialistische Filmproduktionskooperative den Beinamen „Filmkunst". Die Terra-Filmkunst produzierte nach ihrer Übernahme durch die Cautio im Juli 1937 nicht mehr im Eiko-Atelier in Berlin-Marienfelde, sondern in den Studios der Ufa. Zu ihren Hauptattraktionen gehörte der Starschauspieler Heinz Rühmann, der eine eigene Herstellungsgruppe leitete und 1938 mit Unterstützung von Kurt Hoffmann auch als Regisseur debütierte (*Lauter Lügen*). Kurz vor Kriegsbeginn entstand dann in Babelsberg *Paradies der Junggesellen* (1939, Kurt Hoffmann), eine Variation von *Die Drei von der Tankstelle*, nur dass diesmal Rühmann die Männerfreundschaft anführte, und nicht Willy Fritsch, der stattdessen mit *Frau am Steuer* (1939, Paul Martin) an der Seite von Lilian Harvey versuchte, die alten Ufa-Tonfilmoperetten-Erfolge wieder aufzuwärmen. Genauso wie Fritsch, Rühmann und Oskar Karlweis 1930 mit dem Lied „Ein Freund, ein guter Freund" einen riesigen Hit gelandet hatten, waren 1939 Rühmann und seine Filmkompagnons Josef Sieber und Hans Brausewetter mit „Das kann doch einen Seemann nicht erschüttern" überaus erfolgreich. So trat das Trio mit seiner musikalischen Nummer ein Jahr später in einer weiteren Babelsberger Produktion auf: *Wunschkonzert* (1940, Eduard von Borsody) war ein Film, der die seit Kriegsbeginn real existierende Berliner Musikveranstaltung und Radiosendung „Wunschkonzert für die Wehrmacht" mit einer Liebesgeschichte verband und die Ideologie des Regimes geschickt

f.l.t.r.: Heinz Rühmann, Josef Sieber, and Hans Brausewetter in *Bachelor's Paradise* (1939, Director: Kurt Hoffmann)

v.l.n.r.: Heinz Rühmann, Josef Sieber und Hans Brausewetter in *Paradies der Junggesellen* (1939, Regie: Kurt Hoffmann)

which cleverly presented the ideology of the regime under the guise of an entertainment program. Next to Zarah Leander's film *The Great Love* (1942, Rolf Hansen), the hybrid film became the most commercially successful production of the Nazi era. The song from *Bachelor's Paradise* also became, with modified lyrics, one of the greatest anti-British hits of the war. When a German ship broke the English blockade in December 1939 and arrived in Hamburg, the German star actor sang with his boys in celebration over the radio:

> How Churchill would've liked to block us / You see, it looks now black! / The German submarine torpedoes / His breakfast bacon. / Every single shot hits the man himself, / Now no longer ruling the waves. / The Baltic Sea became German; / Now look out behind you! / That will make the First Lord of the Sea tremble, / And when he lies, he lies like a rug![19]

Bachelor's Paradise was primarily a comedy that, based on one's perspective, could be read either as a confirmation or a send-up of the Nazi dictatorship, much more so than today's well-known Babelsberg-Terra-Rühmann film *The Punch Bowl* (1944, Helmut Weiss). But Terra also produced less ambiguous films in Babelsberg, such as the most infamous Nazi piece of all time: *Jew Süss* (1940, Veit Harlan).

The name "Film Art" to describe Ufa's activities during the last three years of the war may seem to some like a cynical distortion of the facts. But it may come as a surprise that completely artistic or even sensitive films such as *Under the Bridges* (1945, Helmut Käutner) could be made, too. Incidentally the main bridge—Glienicker Brücke—in the film was discovered as a shooting location a few months before it would be destroyed, and later became known as the "bridge of spies" during the Cold War. But standing at the center of the company's interests during the war years was a completely different project: the color film. As in the case of the sound film a decade earlier, they limped far behind their American competition in this development. While Marlene Dietrich had already lit up the screen in Technicolor with the 1936 film *The Garden of Allah* (Richard Boleslawski),[20] Marika Rökk only flashed her dance legs for the first time in Agfacolor on October 31, 1941, when *Women Are Better Diplomats*, directed by her husband Georg Jacoby, celebrated its premiere. The Babelsberg film's production itself had taken over two years, as their lack of experience meant they had to constantly respond to new problems: "For example, there were also initial difficulties with the make-up: they had applied it as if it were in black-and-white. Willy Fritsch and the others were running around with brown faces at first."[21]

Marika Rökk in *Women Are Better Diplomats*
(1941, Director: Georg Jacoby)

Marika Rökk in *Frauen sind doch bessere Diplomaten*
(1941, Regie: Georg Jacoby)

Under the Bridges
(1945, Director: Helmut Käutner)

Unter den Brücken
(1945, Regie: Helmut Käutner)

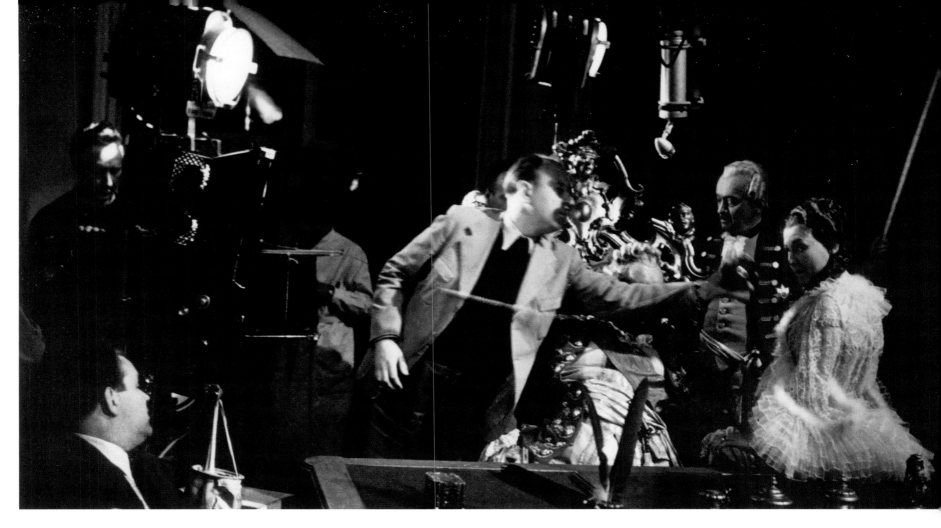

During the making of *Jew Süss*
(1940, Director: Veit Harlan)

Während der Dreharbeiten zu *Jud Süß*
(1940, Regie: Veit Harlan)

unter dem Mantel einer Unterhaltungssendung präsentierte. Mit dieser Melange wurde er neben dem Zarah-Leander-Film *Die große Liebe* (1942, Rolf Hansen) zum kommerziell einträglichsten Film der NS-Zeit. Das Lied aus *Paradies der Junggesellen* hingegen schaffte es mit einem umgewandelten Text zum größten antibritischen Schlager des Krieges. Als ein deutsches Schiff im Dezember 1939 die englische Blockade durchbrochen hatte und in Hamburg einlief, sang der Deutschen Lieblingsschauspieler mit seinen Jungs zur Feier des Tages im Radio:

> Wie gern hätt' Churchill uns blockiert! / You see, it looks now black! / Das deutsche U-Boot torpediert / Ihm seinen Frühstücksspeck. / Ihn selber trifft ein jeder Schuss, / Die waves zu rulen ist jetzt Schluss. / Die Nordsee ward ein deutsches Meer; / Nu kiekste hinterher! / Das wird den Ersten Seelord doch erschüttern, / Lügt er auch, lügt er auch wie gedruckt![19]

Wenn *Paradies der Junggesellen* – und zwar noch viel mehr als der heute wesentlich bekanntere Babelsberg-Terra-Rühmann-Film *Die Feuerzangenbowle* (1944, Helmut Weiss) – trotz allem eine Komödie war, die man entweder als eine Bestätigung oder aber als eine Verhohnepipelung der Nazi-Diktatur lesen konnte, je nach Perspektive, so produzierte die Terra in Babelsberg auch weniger zweideutige Filme, beispielsweise eines der berüchtigtsten NS-Machwerke überhaupt: *Jud Süß* (1940, Veit Harlan).

Der Name „Filmkunst" für die Aktivitäten der Ufa in den drei letzten Kriegsjahren mag zwar manchem wie eine zynische Verdrehung der Tatsachen vorkommen, andererseits ist es erstaunlich, dass unter diesem Label und vor allem unter diesen Umständen durchaus künstlerische, oder besser: feinfühlige Filme wie *Unter den Brücken* (1945, Helmut Käutner), der die später als „Brücke der Spione" bekannt gewordene Glienicker Brücke noch wenige Monate vor ihrer Zerstörung als Drehort entdeckte, entstehen konnten. Doch im Zentrum des Konzerninteresses stand in den Kriegsjahren ohnehin ein ganz anderes Projekt: der Farbfilm. Wie schon im Fall des Tonfilms ein Jahrzehnt zuvor hinkte man auch bei dieser Entwicklung den amerikanischen Gegnern zunächst weit hinterher. Während Marlene Dietrich schon 1936 in *The Garden of Allah* (Richard Boleslawski) in Technicolor erstrahlte,[20] schwang Marika Rökk ihre Tanzbeine erstmals am 31. Oktober 1941 in Agfacolor, als *Frauen sind doch bessere Diplomaten* in der Regie ihres Gatten Georg Jacoby Premiere feierte. Die Produktion dieses Babelsberger Films hatte sich über zwei Jahre hingezogen, da man ohne jegliche Erfahrungswerte ständig auf neue Probleme reagieren musste: „Es waren

Marika Rökk in *Women Are Better Diplomats*

Marika Rökk in *Frauen sind doch bessere Diplomaten*

Brown was also how the grass in front of the exterior location, Babelsberg Castle, appeared on Agfacolor stock, since the green of the grass optically blended together with the blue of the water droplets on it. Goebbels only approved the film when the already completed shoot of Ufa's second Agfacolor feature promised a considerable increase in quality.[22] The director responsible for that film, *The Golden City* (1942), was none other than infamous Nazi star director Veit Harlan, who would make two more color melodramas featuring his wife Kristina Söderbaum in starring roles: *Immensee* (*Immen Lake*, 1943) and *The Great Sacrifice* (1944).

But the real flagship of the Ufa color-film production was another film-set spectacle that—at the beginning of March 1943, somewhat delayed after two years of work—was finally completed to celebrate the 25th anniversary of the company: *The Adventures of Baron Munchausen* (Josef von Báky). At a cost of 6.5 million Reichsmark, the film was the Third Reich's most expensive entertainment film to date. Film architects Emil Hasler and Otto Gülstorff remember shooting the film in Babelsberg: "An idyllic small town sprang up on the sandy open lot: 18th-century Brunswick, Munchausen's family castle in Bodenwerder, Baltic landscapes, and Turkish war camps on the Crimea."[23]

Though the film architects from *Metropolis'* time turned up their noses at enlarging small models with the help of the Schüfftan effect, because it disallowed them from showing off their art, that was not the case with *The Adventures of Baron Munchausen*. Reich film commandant Fritz Hippler, creator of the anti-semitic propaganda film *The Eternal Jew* (1940), increased the usage of the mirror-trick photography with models to reduce the costs of studio sets.[24] Yet no trick in the world could obstruct the collapse of the Nazi leadership for very long, and Ufa's time in Babelsberg ended with it. The last scenes for the time being were shot in April 1945.

Hans Albers and Brigitte Horney in
The Adventures of Baron Munchausen
(1943, Director: Josef von Báky)

Hans Albers und Brigitte Horney in
Münchhausen (1943, Regie: Josef von Báky)

Kristina Söderbaum in *The Great Sacrifice*
(1944, Director: Veit Harlan)

Kristina Söderbaum in *Opfergang*
(1944, Regie: Veit Harlan)

Anfangsschwierigkeiten zum Beispiel auch bei der Maske: Die haben noch so geschminkt wie in schwarzweiß. Willy Fritsch und andere liefen erst mit braunen Gesichtern rum."[21]

Braun erschien auch der Rasen vor dem Schloss Babelsberg, wo einige Außenaufnahmen stattfanden, weil das Grün des Grases und das Blau der darauf sitzenden Wassertropfen optisch miteinander verschmolzen. Goebbels gab den Film erst frei, als die bereits angelaufenen Dreharbeiten zum zweiten Agfacolor-Spielfilm der Ufa eine erhebliche Steigerung der Qualität versprachen.[22] Verantwortlich für *Die goldene Stadt* (1942) war der heute berüchtigte Regiestar der Nazis, Veit Harlan, der darauf mit seiner Frau Kristina Söderbaum in der Hauptrolle noch zwei weitere Farb-Melodramen (teilweise) in Babelsberg inszenieren sollte: *Immensee* (1943) und *Opfergang* (1944).

Das eigentliche Flaggschiff der Ufa-Farbspielfilmproduktion war aber ein anderes Ausstattungs-Spektakel, das Anfang März 1943 nach ebenfalls zwei Jahren Arbeit – etwas verspätet – zum 25. Jubiläum des Konzerns fertiggestellt wurde: *Münchhausen* (Josef von Báky) ist mit über sechseinhalb Millionen Reichsmark der teuerste Unterhaltungsfilm des Dritten Reichs. Die Filmarchitekten Emil Hasler und Otto Gülstorff erinnern sich an die Dreharbeiten in Babelsberg: „Auf dem Freigelände war aus dem märkischen Sand eine ganze Kleinstadtidylle entstanden: Braunschweig im 18. Jahrhundert, das Stammschloß derer von Münchhausen in Bodenwerder, kurländische Landschaften und kriegerische Türkenlager auf der Krim."[23]

Während zu Zeiten von *Metropolis* die Filmarchitekten das Einspiegeln von kleinen Modellen mit Hilfe des Schüfftan-Effekts naserümpfend ablehnten, weil es sie um die Möglichkeit brachte, ihre Kunst zu zeigen, wurden sie im Fall von *Münchhausen* vom Reichsfilmintendanten Fritz Hippler, Schöpfer des antisemitischen Propagandafilms *Der ewige Jude* (1940), verstärkt zur Anwendung dieses Trickverfahrens gedrängt, um die Kosten für Atelierbauten zu senken.[24] Doch kein Trick der Welt konnte den Zusammenbruch der Nazi-Herrschaft auf Dauer verhindern, und mit ihm endete auch die Zeit der Ufa in Babelsberg, wo im April 1945 die vorerst letzten Aufnahmen stattfanden.

Carl Raddatz in *Under the Bridges*
(1945, Director: Helmut Käutner)

Carl Raddatz in *Unter den Brücken*
(1945, Regie: Helmut Käutner)

Hannelore Schroth in *Under the Bridges* (1945)

Hannelore Schroth in *Unter den Brücken* (1945)

1 Klaus Kreimeier: *Die Ufa-Story. Geschichte eines Filmkonzerns.* Frankfurt am Main: Fischer 2002, p. 42.

2 Cf. Robert Stevenson: A year in German studios. In: *Proceedings of the British Kinematograph Society* 20, 1933, pp. 3–12, here p. 6.

3 Quoted from Chris Wahl: *Sprachversionsfilme aus Babelsberg. Die internationale Strategie der Ufa 1929–1932.* München: edition text + kritik 2009, p. 179.

4 Kreimeier: *Die Ufa-Story*, p. 378.

5 Gerhard Midding / Robert Müller: "Aimez-vous Babelsberg?" A Conversation with Marcel Carné on December 3, 1991, in Berlin. In: Wolfgang Jacobsen (ed.): *Babelsberg. Ein Filmstudio 1912–1992.* Berlin: Argon 1992, pp. 223–228, here p. 227.

6 Jürgen Spiker: *Film und Kapital. Der Weg der deutschen Filmwirtschaft zum nationalsozialistischen Einheitskonzern.* Berlin: Verlag Volker Spiess 1975, p. 292.

7 Midding / Müller: "Aimez-vous Babelsberg? ", p. 227.

8 Cf. Dr. Goebbels' speech at the Kaiserhof March 28, 1933; reprinted in Gerd Albrecht: *Film im 3. Reich.* Karlsruhe: Schauburg 1979, pp. 26–31.

9 Christa Bandmann / Joe Hembus: *Klassiker des deutschen Tonfilms 1930–1960.* München: Goldmann 1980, p. 102.

10 Spiker: *Film und Kapital*, p. 143.

11 Cf. Oliver Ohmann: *Heinz Rühmann und* Die Feuerzangenbowle. *Die Geschichte eines Filmklassikers.* Leipzig: Lehmstedt 2010, p. 60.

12 Cf. Almuth Püschel: *Zwangsarbeit in Potsdam. Fremdarbeiter und Kriegsgefangene.* Wilhelmshorst: Märkischer Verlag 2002, p. 17.

13 Cf. ibid, pp. 49, 56.

14 Cf. ibid, p. 104.

15 Cf. ibid, p. 41. The film *The Girl of Your Dreams* (1998, Fernando Trueba) is about the shooting of an Ufa German-Spanish film commissioned by Goebbels, which employed forced laborers as extras. In its clever mix of facts and fantasy, the film was awarded seven Goyas in Spain along with achieving immense success at the box office. In Germany, the film had an unsuccessful run in competition at the 1999 Berlinale, and received no distribution there after German financiers respectfully declined it earlier as a potential coproduction.

16 Cf. Ohmann: *Heinz Rühmann und* Die Feuerzangenbowle, p. 66.

17 Ibid, p. 82.

18 Kreimeier: *Die Ufa-Story*, p. 376.

19 The text of the original is: "The wind is blowing with the force of ten, / The ship reels back and forth. / No stars to be seen in the heavens, / The wild sea rages. / O look at him, o look at him: / The hobgoblin shows his face! / Yet even when the last mast breaks, / We won't be afraid! / That won't faze a sailor, / Have no fear, no fear, Rosmarie!"

20 The first color feature film of all time was *Becky Sharp* (USA 1935, Rouben Mamoulian).

21 That was the account of Dr. Alfred Clever, former head of the Ufa copying facilities, in a 1992 television interview. Quoted in Friedemann Beyer / Gert Koshofer / Michael Krüger: *Ufa in Farbe. Technik, Politik und Starkult zwischen 1936 und 1945.* München: Collection Rolf Heyne 2010, p. 68.

22 Cf. ibid, p. 69.

23 Ibid, p. 104.

24 Cf. ibid, p. 107.

A scene from *Under the Bridges* (1945)

Szene aus *Unter den Brücken* (1945)

1 Klaus Kreimeier: *Die Ufa-Story. Geschichte eines Filmkonzerns.* Frankfurt am Main: Fischer 2002, S. 42f.

2 Vgl. Robert Stevenson: A year in German studios. In: *Proceedings of the British Kinematograph Society* 20, 1933, S. 3–12, hier S. 6.

3 Zitiert nach Chris Wahl: *Sprachversionsfilme aus Babelsberg. Die internationale Strategie der Ufa 1929–1932.* München: edition text + kritik 2009, S. 179.

4 Kreimeier: *Die Ufa-Story*, S. 378.

5 Gerhard Midding / Robert Müller: „Aimez-vous Babelsberg?" Ein Gespräch mit Marcel Carné am 3. Dezember 1991 in Berlin. In: Wolfgang Jacobsen (Hg.): *Babelsberg. Ein Filmstudio 1912–1992.* Berlin: Argon 1992, S. 223–228, hier S. 227.

6 Jürgen Spiker: *Film und Kapital. Der Weg der deutschen Filmwirtschaft zum nationalsozialistischen Einheitskonzern.* Berlin: Verlag Volker Spiess 1975, S. 292.

7 Midding / Müller: „Aimez-vous Babelsberg?", S. 227.

8 Vgl. Dr. Goebbels' Rede im Kaiserhof am 28.3.1933; abgedruckt bei Gerd Albrecht: *Film im 3. Reich.* Karlsruhe: Schauburg 1979, S. 26–31.

9 Christa Bandmann / Joe Hembus: *Klassiker des deutschen Tonfilms 1930–1960.* München: Goldmann 1980, S. 102.

10 Spiker: *Film und Kapital*, S. 143.

11 Vgl. Oliver Ohmann: *Heinz Rühmann und* Die Feuerzangenbowle. *Die Geschichte eines Filmklassikers.* Leipzig: Lehmstedt 2010, S. 60.

12 Vgl. Almuth Püschel: *Zwangsarbeit in Potsdam. Fremdarbeiter und Kriegsgefangene.* Wilhelmshorst: Märkischer Verlag 2002, S. 17.

13 Vgl. ebd., S. 49, 56.

14 Vgl. ebd., S. 104.

15 Vgl. ebd., S. 41. Der mit Penélope Cruz in der Hauptrolle entstandene *La niña de tus ojos* (*Das Mädchen deiner Träume*, 1998, Fernando Trueba) über die Dreharbeiten an einem im Auftrag der Ufa bzw. von Goebbels in deutscher und spanischer Version gedrehten Film, für den Zwangsarbeiter als Statisten verwendet werden, vermischt geschickt Fakten und Fantasie und wurde dafür in Spanien mit sieben Goyas und einem immensen Kassenerfolg belohnt. In Deutschland lief der Film 1999 erfolglos im Wettbewerb der Berlinale und bekam auch keinen Verleih, nachdem im Vorfeld schon deutsche Finanziers eine Koproduktion dankend abgelehnt hatten.

16 Vgl. Ohmann: *Heinz Rühmann und* Die Feuerzangenbowle, S. 66.

17 Ebd., S. 82.

18 Kreimeier: *Die Ufa-Story*, S. 376.

19 Der Originaltext lautet: „Es weht der Wind mit Stärke zehn, / Das Schiff schwankt hin und her. / Am Himmel ist kein Stern zu sehn, / Es tobt das wilde Meer. / O seht ihn an, o seht ihn an: / Dort zeigt sich der Klabautermann! / Doch wenn der letzte Mast auch bricht, / Wir fürchten uns nicht! / Das kann doch einen Seemann nicht erschüttern, / Keine Angst, keine Angst, Rosmarie!"

20 Als erster Farbspielfilm gilt allgemein *Becky Sharp* (USA 1935, Rouben Mamoulian).

21 So berichtete der ehemalige Leiter des Ufa-Kopierwerks Dr. Alfred Clever bei einem Fernsehinterview im Jahr 1992. Zitiert nach Friedemann Beyer / Gert Koshofer / Michael Krüger: *Ufa in Farbe. Technik, Politik und Starkult zwischen 1936 und 1945.* München: Collection Rolf Heyne 2010, S. 68.

22 Vgl. ebd., S. 69.

23 Ebd., S. 104.

24 Vgl. ebd., S. 107.

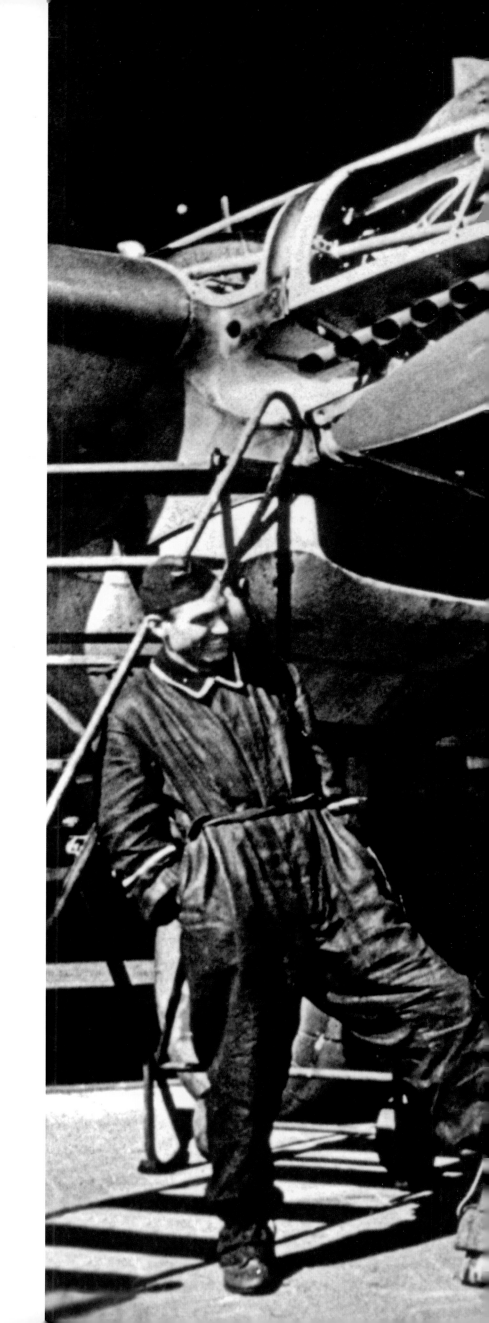

1933
–
1945

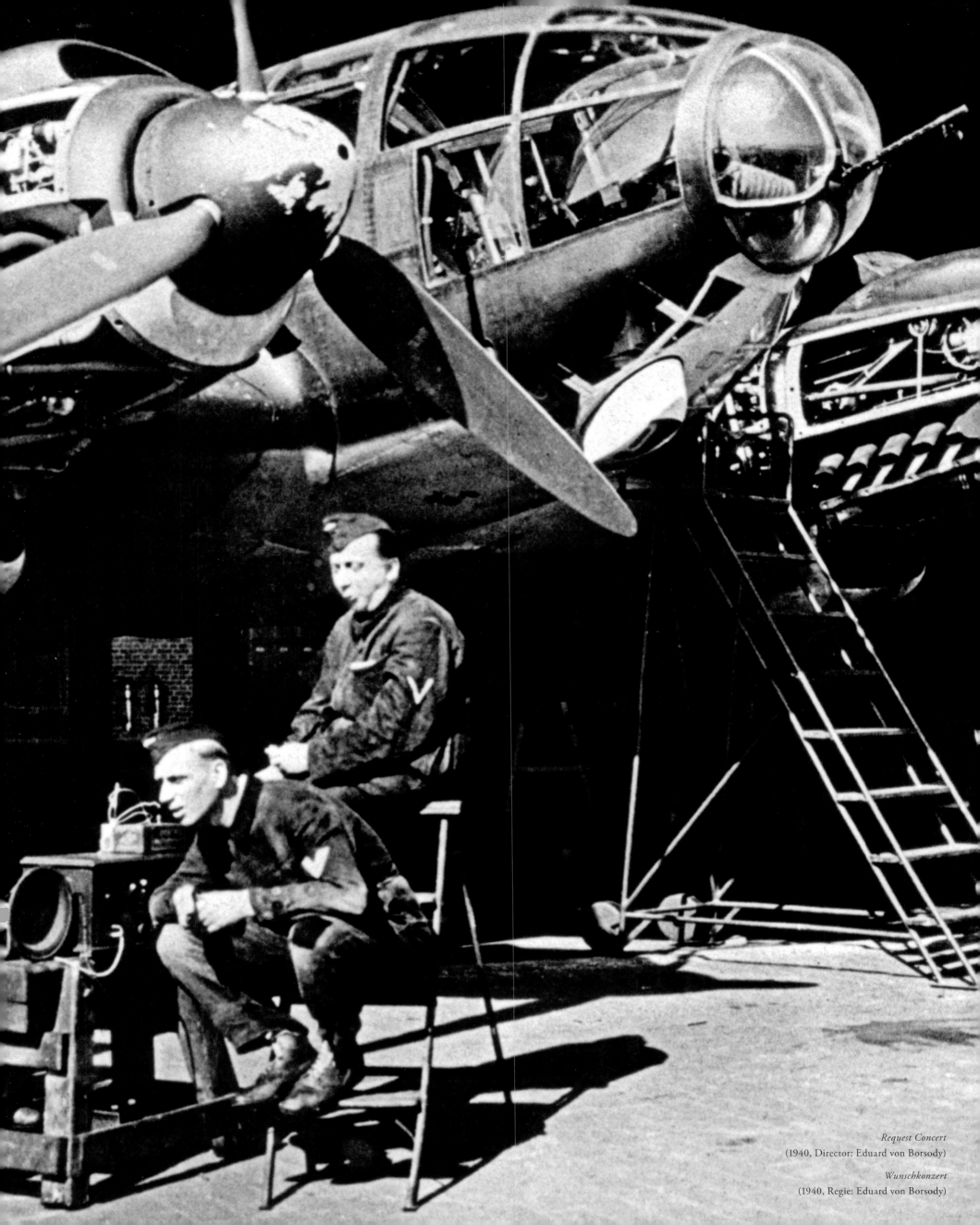

Request Concert
(1940, Director: Eduard von Borsody)

Wunschkonzert
(1940, Regie: Eduard von Borsody)

Dutch forced laborers of the Ufa
with portraits of their favorite
German film idols

Niederländische Zwangsarbeiter
der Ufa mit Porträts ihrer
deutschen Filmidole

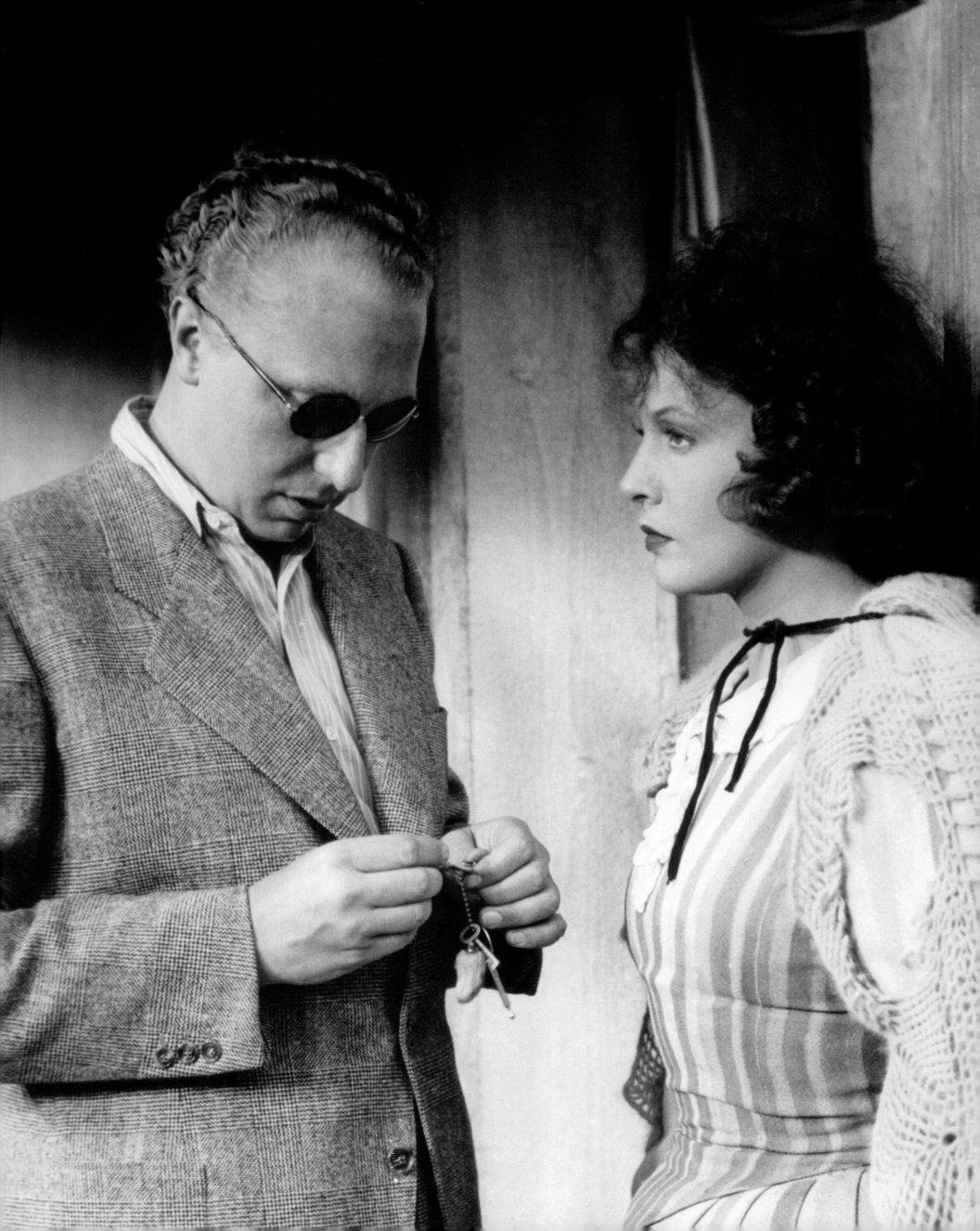

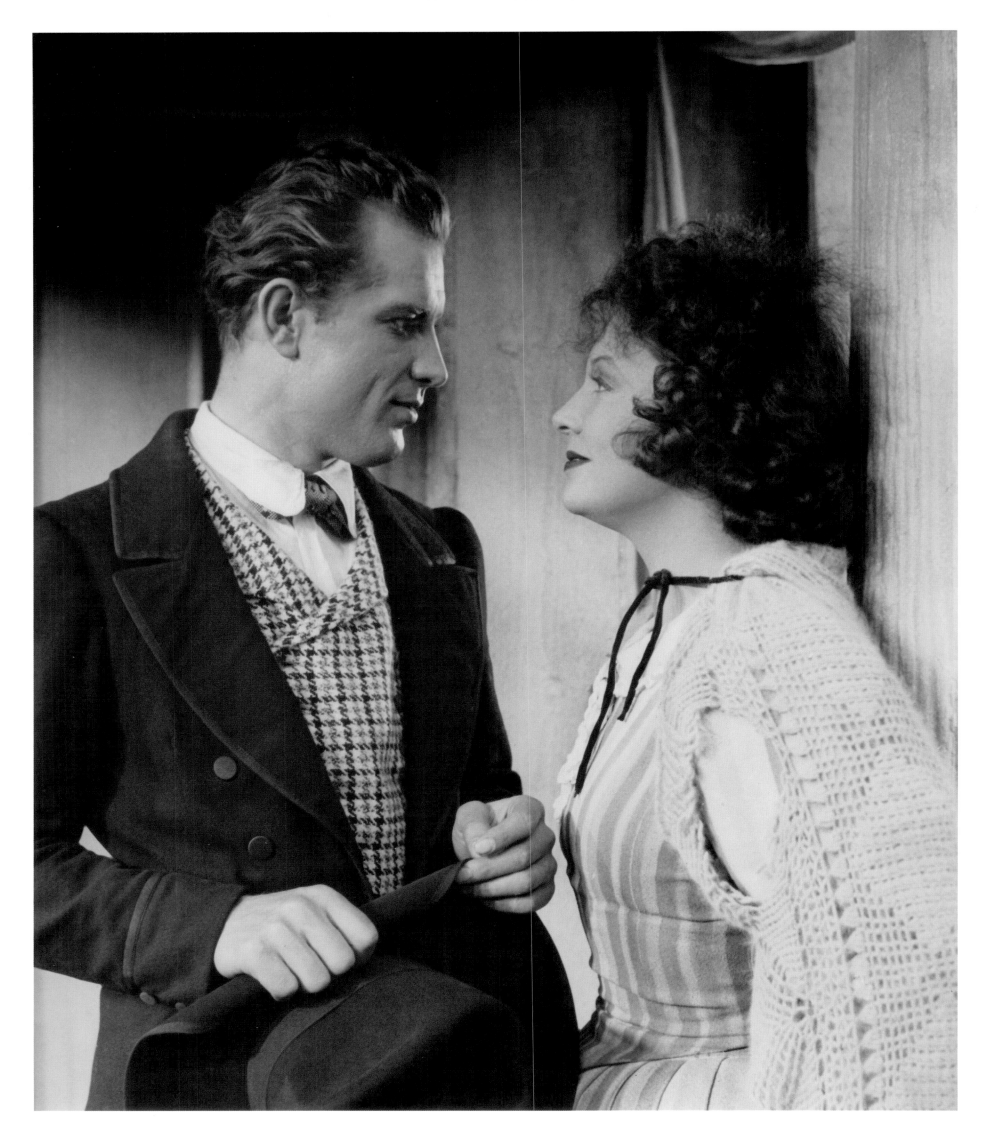

To New Shores (1937): Zarah Leander during rehearsal with director Detlef Sierck (left) and performing the scene with actor Viktor Staal (right)

Zu neuen Ufern (1937): Zarah Leander bei der Probe mit Regisseur Detlef Sierck (links) und die gespielte Szene mit Schauspieler Viktor Staal (rechts)

Hans Albers in *Gold*
(1934, Director: Karl Hartl)

Hans Albers in *Gold*
(1934, Regie: Karl Hartl)

UFA (1921–1933)

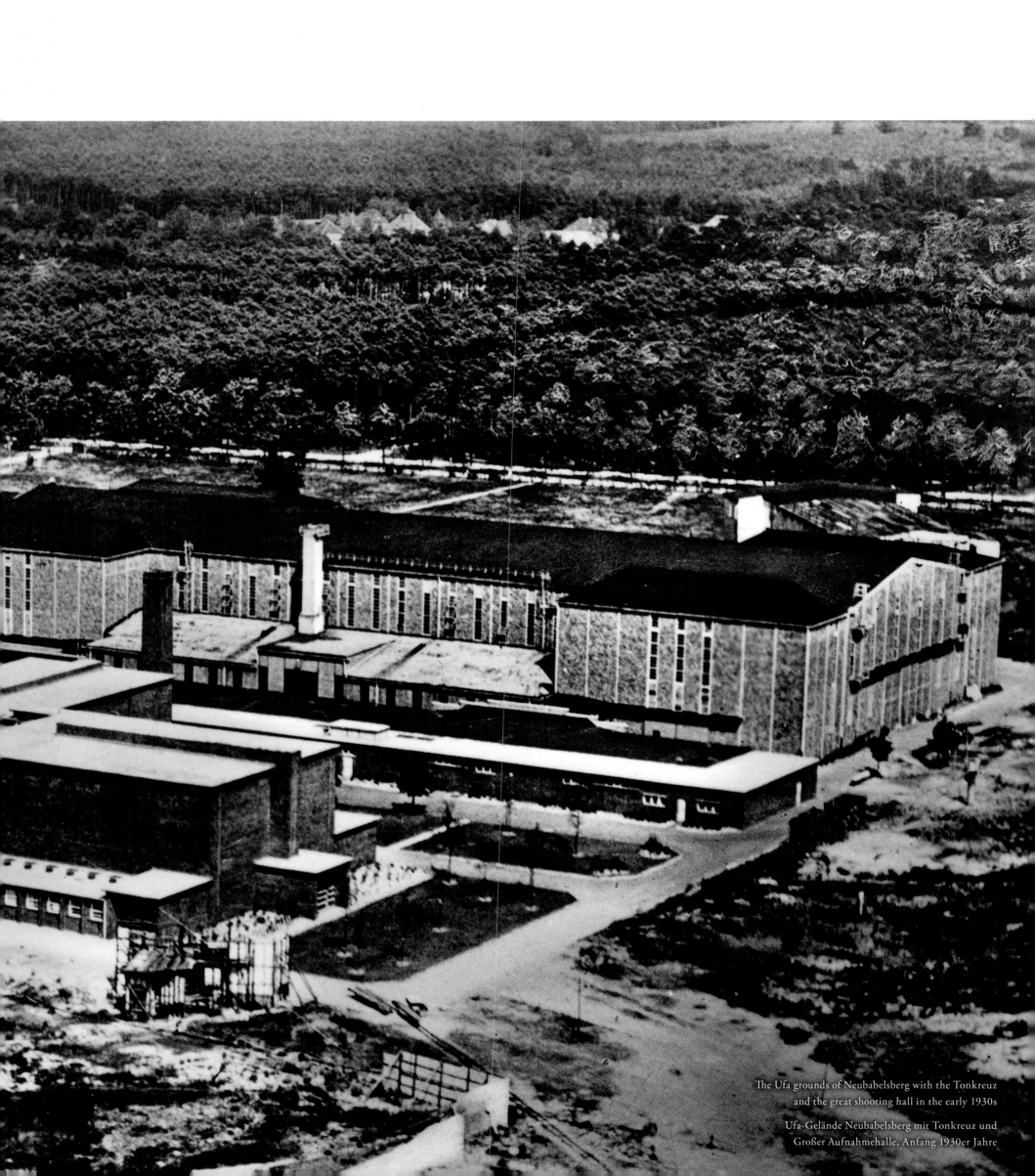

The Ufa grounds of Neubabelsberg with the Tonkreuz
and the great shooting hall in the early 1930s

Ufa-Gelände Neubabelsberg mit Tonkreuz und
Großer Aufnahmehalle, Anfang 1930er Jahre

left: Brigitte Helm in *Metropolis* (1927, Director: Fritz Lang)

links: Brigitte Helm in *Metropolis* (1927, Regie: Fritz Lang)

middle: Director Josef von Sternberg with Marlene Dietrich during the making of *The Blue Angel* (1930)

Mitte: Regisseur Josef von Sternberg mit Marlene Dietrich während der Dreharbeiten zu *Der blaue Engel* (1930)

right: Heinz Rühmann in *Three Good Friends* (1930, Director: Wilhelm Thiele)

rechts: Heinz Rühmann in *Die Drei von der Tankstelle* (1930, Regie: Wilhelm Thiele)

UFA (1921-1933)

by Chris Wahl

On October 11, 1921, Decla-Bioscop, the second largest German film company, decided to merge with the largest: Ufa. In this "marriage," the smaller partner primarily contributed three assets that would come to definitively dominate the face of Ufa in the coming years: the director Fritz Lang, the producer Erich Pommer, and the studio property at Neubabelsberg, where two glass studios stood at the time. In January 1926, Siegfried Kracauer gave an impression of the locale for the *Frankfurter Zeitung*, beginning his report with the following words:

> In the middle of the Grunewald is a fenced-in area that one can enter only after going through various checkpoints. It is a desert within an oasis. The natural things outside—trees made out of wood, lakes with water, villas that are inhabitable—have no place within its confines. But the world does reappear there—indeed, the entire macrocosm seems to be gathered in this new version of Noah's ark. But the things that rendezvous here do not belong to reality. They are copies and distortions that have been ripped out of time and jumbled together. [...] We find ourselves in the film city of the Ufa studios in Neubabelsberg, whose 350,000 square meters house a world made of papier-mâché. Everything guaranteed unnatural and everything exactly like nature.[1]

A few months after Kracauer's visit, in addition to the two glass buildings, the "great hall" was built in Neubabelsberg: a solid-walled studio that used artificial light, which could accommodate simultaneous work on different films through the clever use of sliding partitions. The new studio could be kept heated through the winter, in contrast to the former airship hangar in Staaken, which since 1923 had served as a film studio for sets requiring enormous amounts of space. At the end of 1927, Ufa could finally make the decision to relocate almost all of its film production from its home studio in Tempelhof to Neubabelsberg that up until that point, as the Ufa program catalog for 1925–26 explicitly noted, had been primarily a huge site where exterior shots took place.[2] The catalog includes as an example, among others, "an amusement park with carousels, swings and slides; one of the scenes from the film *Jealousy*."[3] This particular Ufa film by E.A. Dupont from 1925, with Emil Jannings in the starring role, became, after Ernst Lubitsch's production *Madame Du Barry* (1919) (also partially shot at the sprawling studio complex), "German cinema's greatest financial success in the U.S."[4]

UFA (1921-1933)

Chris Wahl

Am 11. Oktober 1921 beschloss die Decla-Bioscop, der zweitgrößte deutsche Filmkonzern, seine Fusion mit dem größten: der Ufa. Mit in diese „Ehe" brachte der kleinere Partner vor allem drei Werte, die in den kommenden Jahren das Gesicht der Ufa entscheidend prägen würden: den Regisseur Fritz Lang, den Produzenten Erich Pommer und das Studiogelände in Neubabelsberg, auf dem damals zwei Glasateliers standen. Im Januar 1926 verschaffte sich Siegfried Kracauer für die *Frankfurter Zeitung* einen Eindruck von der Örtlichkeit und begann seinen Bericht mit folgenden Worten:

> Mitten im Grunewald liegt ein abgeschlossener Bezirk, den man nur nach mancherlei Prüfungen betreten darf. Er ist eine Wüste in der Oase. Die Natürlichkeit draußen – Bäume aus Holz, Seen mit Wasser, Villen, die bewohnbar sind – haben innerhalb seiner Grenzen ihr Recht verloren. Zwar, die Welt kehrt wieder in ihm, ja, der ganze Makrokosmos scheint in dieser neuen Arche Noah eingesammelt: aber die Dinge, die sich hier ein Stelldichein geben, gehören nicht der Wirklichkeit an. Sie sind Abbilder und Fratzen, die man aus der Zeit gerissen und durcheinander gemischt hat. [...] Man befindet sich in der Filmstadt der Ufa zu Neubabelsberg. Sie enthält auf einer Fläche von 350 000 Quadratmetern die Welt aus Papiermaché. Alles garantiert Unnatur, alles genau wie die Natur.[1]

Wenige Monate nach Kracauers Besuch entstand in Neubabelsberg zusätzlich zu den beiden Glasgebäuden die „Große Halle", ein fest gemauertes Kunstlichtatelier, in dem durch den geschickten Einsatz von verschiebbaren Trennwänden gleichzeitig an verschiedenen Filmen gearbeitet werden konnte. Vor allem aber war das neue Atelier im Gegensatz zur ehemaligen Luftschiffhalle in Staaken, die seit Juli 1923 als Filmstudio für Sets mit enormem Platzanspruch diente, im Winter beheizbar. Ende 1927 konnte die Ufa schließlich den Beschluss fassen, die Filmproduktion fast gänzlich von ihren Stammateliers in Tempelhof nach Neubabelsberg zu verlagern, wo bis dahin vor allem Außenaufnahmen auf dem riesigen Gelände stattgefunden hatten,[2] wie der Ufa-Programmkatalog für die Saison 1925/26 noch ausdrücklich vermerkte. Als Beispiel angeführt wird darin unter anderem „ein Rummelplatz mit Karussels [sic], Schaukeln und Rutschbahnen, eines der Szenenbilder des Films *Varieté*".[3] Dieser Ufa-Film von E.A. Dupont aus dem Jahr 1925 mit Emil Jannings in der Hauptrolle galt nach Ernst Lubitschs ebenfalls zum Teil auf dem weitläufigen Studioareal entstandenem *Madame Dubarry* (1919) als „der größte finanzielle Erfolg des deutschen Films in den USA".[4]

A scene from *Madame Du Barry* (1919, Director: Ernst Lubitsch)

Szene aus *Madame Dubarry* (1919, Regie: Ernst Lubitsch)

Entrance to the Ufa studio lot in the mid-1920s

Eingang zum Ateliergelände der Ufa, Mitte 1920er Jahre

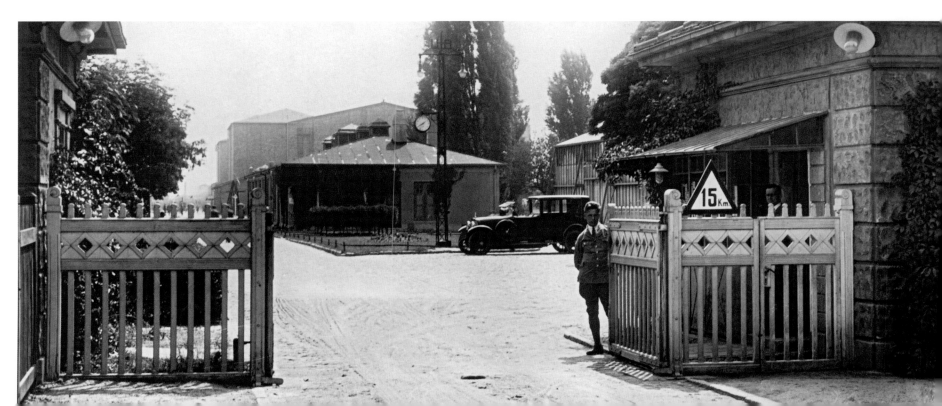

Destiny (1921, Director: Fritz Lang)

Der müde Tod (1921, Regie: Fritz Lang)

One of the most successful Neubabelsberg productions of 1921, *Destiny* still bore the trademark "Decla-Bioscop." That brand was not immediately removed from service, but was hidden and allowed to slowly fade, as Werner Sudendorf put it.[5] The next film from the Pommer-Lang duo *Die Nibelungen* (shot between 1922–24) was a production of Decla-Bioscop "on behalf of Ufa" and *Metropolis* (shot between 1924–26, premiered 1927) finally emerged as a purely Ufa production. On the last two large films, the inventive film architect Erich Kettelhut (together with Otto Hunte) played a decisive role. In his memoirs, he delivers an eloquent description of Erich Pommer, who had served as head of all Ufa production companies since February 1923. According to Kettelhut, Pommer had this "reputation of being experimental, daring and [...] ruthlessly severe against himself and his colleagues."[6] One immediately noticed when he was in a bad mood, because his cigarette was drooping in his mouth.[7] But Pommer's severity proved less impressive than his sovereignty. When, at one point, Kettelhut and his colleagues were in a legal dispute with him, Pommer unproblematically sided with himself on the proceedings, but—always the sportsman—respected the men's course of action and immediately presented them with new contracts to sign.[8] Based on such details, one begins to understand how he became such a significant producer.

Besides personal descriptions of this kind and some often highly technical details, Kettelhut's memoirs about his work contain some very interesting and vivid accounts of events that allow one to understand the extent to which the social realities of class struggle, political unrest, and inflation after World War I intruded on the dream world of the Ufa studios, as well. The studios tried to keep the number of permanent employees small and to employ stagehands from month to month. Strikers were fired immediately and union members excluded as much as possible.[9] Kettelhut writes about the shooting for *Die Nibelungen* in 1923: "Whoever didn't have daily work or didn't get paid his money was immediately screwed. When inflation reached its peak, the money would come to Babelsberg from Ufa's central offices in Berlin every morning." As a result, the pace slackened. People were hungry and thought of mutiny. "That's why the tenacious Thea von Harbou offered to cook for the personnel." The screenwriter and wife of director Fritz Lang "even managed to get Ufa to bear the costs of having the team's food given out for free."[10] Another aspect of the financially precarious situation is made clear by the fact that the profession of the "nail collector" existed well through the '20s: "The scarcity of materials made the acquisition of nails and screws of all kinds not only difficult, but also expensive. Film sets now had to be nailed together."[11] So, as beautiful as Kracauer's image of the "world of papier-mâché" may be, it is not altogether accurate:

Lil Dagover and Karl Platen in *Destiny*

Lil Dagover und Karl Platen in *Der müde Tod*

> Papier-mâché sets, as even serious critics have called the film decorations, neither exist today nor existed earlier. Just like with normal construction projects, the usual shortcuts are employed on a film set as well. But all our sets were and still are finished with common building materials. Papier-mâché was rarely ever used. Backdrops were never made of papier-mâché.[12]

Während *Der müde Tod*, eine der in Deutschland erfolgreichsten Neubabelsberger Produktionen des Jahres 1921, noch unter dem Markenzeichen „Decla-Bioscop" – das nicht sofort verschwinden sollte, sondern langsam verblasste, ausgeblendet wurde, wie Werner Sudendorf es formuliert hat – entstanden war,[5] firmierte der nächste Film des Duos Pommer-Lang, *Die Nibelungen* (gedreht 1922–24), als Produktion der Decla-Bioscop „im Auftrag der Ufa" und *Metropolis* (gedreht 1924–26, uraufgeführt 1927) schließlich als reine Ufa-Produktion. An den Bauten der beiden letzteren teuren Großfilme arbeitete, gemeinsam mit Otto Hunte, der erfinderische Filmarchitekt Erich Kettelhut entscheidend mit. In seinen Memoiren liefert er eine vielsagende Beschreibung von Erich Pommer, der ab Februar 1923 als Leiter aller Ufa-Produktionsbetriebe fungierte. Demnach hatte dieser „den Ruf, experimentierfreudig, waghalsig und [...] von unbarmherziger Härte gegen sich selbst und seine Mitarbeiter zu sein".[6] Wenn er schlechte Laune hatte, konnte man dies sofort bemerken, da seine Zigarette dann nach unten hing.[7] Beeindruckend war aber weniger Pommers Härte, denn seine Souveränität: Als Kettelhut einmal mit Kollegen gegen ihn juristisch vorgeht, entscheidet Pommer das Verfahren einerseits problemlos für sich, respektiert aber andererseits – ganz Sportsmann – das Handeln der Männer und legt ihnen umgehend neue Verträge zur Unterschrift vor.[8] Anhand solcher Details versteht man, wie er ein derart bedeutender Produzent hat werden können.

Neben Personenbeschreibungen dieser Art enthalten Kettelhuts oft recht technische Erinnerungen an seine Arbeit einige hochinteressante und sehr lebendige Schilderungen von Vorkommnissen, anhand derer man ansatzweise nachvollziehen kann, in welchem Maße die gesellschaftliche Realität, die nach dem Ersten Weltkrieg von Arbeitskämpfen, politischen Unruhen und der Inflation geprägt war, auch in die Traumwelt des Ufa-Studios Einzug hielt. Dort versuchte man die Zahl der Festangestellten klein zu halten und Bühnenarbeiter mit monatlicher Kündigungsfrist einzustellen. Streikende wurden sofort entlassen und Gewerkschaftsmitglieder möglichst ausgeschlossen.[9] Über die Dreharbeiten zu *Die Nibelungen* notiert Kettelhut 1923: „Wer nicht täglich Arbeit hatte oder sein Geld nicht gleich ausbezahlt bekam, war übel dran. Die Inflation ging ihrem Höhepunkt entgegen. Jeden Vormittag kam das Geld in Waschkörben von der Zentrale aus Berlin in die Ufa nach Babelsberg." Als Folge ließ das Arbeitstempo nach. Die Leute hatten Hunger und dachten an Meuterei. „Da erbot sich die resolute Thea von Harbou, für die Leute zu kochen." Die Drehbuchautorin und Gattin von Regisseur Fritz Lang „schaffte es sogar, dass die Ufa die Kosten übernahm, das Mannschaftsessen also gratis ausgegeben werden konnte".[10] Ein anderer Aspekt der wirtschaftlich prekären Lage wird dadurch verdeutlicht, dass es bis weit in die 20er Jahre hinein den Beruf des Nägelaufsammlers gab: „Die Materialknappheit machte die Beschaffung von Nägeln und Schrauben jeder Art nicht nur schwierig, sondern auch teuer. Filmbauten wurden nun mal zusammengenagelt."[11] So schön Kracauers Bild von der „Welt aus Papiermaché" auch sein mag, ganz korrekt ist es demnach nicht:

> Pappbauten, wie selbst ernsthafte Kritiker die Filmdekoration benennen, gibt und gab es weder heute noch früher. So wie an einem Filmbau alle auch im normalen Baugewerbe beschäftigten Handwerkersparten tätig sind, werden und wurden auch alle gebräuchlichen Baumaterialien verarbeitet. Pappen kamen dagegen kaum zum Einsatz. Kulissen waren eben nie aus Pappe.[12]

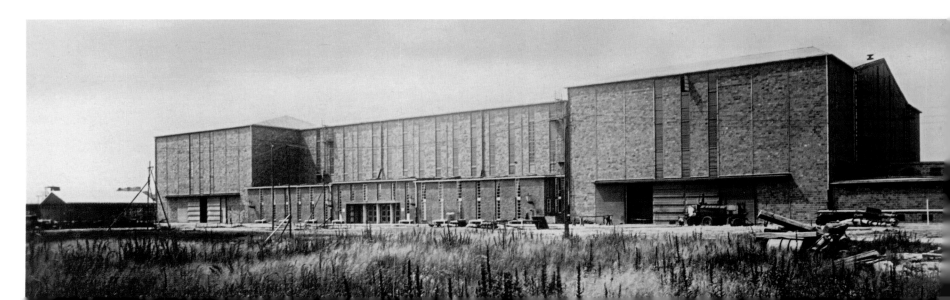

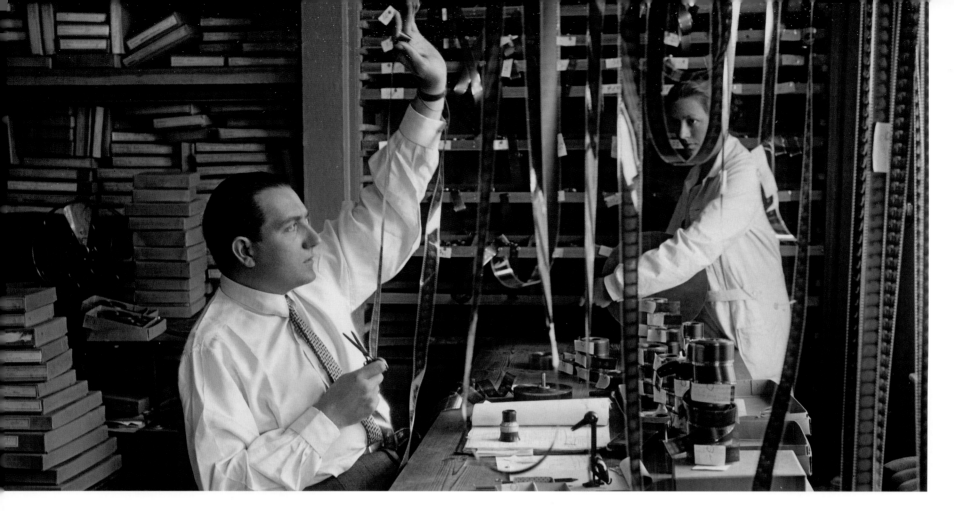

Director Fritz Lang in the editing suite

Regisseur Fritz Lang im Schneideraum

In the middle of the '20s, Ufa is the largest and most influential film studio in Europe, with dimensions that recall Hollywood. It seems as if every minute cinematographers like Karl Freund and Carl Hoffmann, together with film architects like Robert Herlth, Walter Röhrig, Otto Hunte, or even Erich Kettelhut, invent new film tricks for films from visionaries of the likes of Fritz Lang or Friedrich Wilhelm Murnau. The press regularly reports in *Film-Kurier*, *Kinematograph*, or *Lichtbild-Bühne* about the technical effects of the "unchained" camera (Karl Freund) or the expressive film lighting (Carl Hoffmann),[13] about breathtaking sets and, of course, about star performances. One of the most famous actors of this time up until the present is without a doubt Emil Jannings, who, with Murnau, shot *The Last Laugh* (1924), *Tartuffe* (1925), and *Faust* (1926) for Ufa (although largely in the Tempelhof studio) before going to Hollywood and winning the first ever Oscar for achievements in acting in 1929. Yet the stars are in the minority on the studio lot. Along with the technicians and craftsmen, extras and bit players cavort in the wings—sometimes literally—as Kettelhut impressively describes in his memories of working conditions on *Die Nibelungen*:

> Throughout the daily close-contact shooting process, a noticeably increasing lasciviousness began to develop. Most of the breasts bared for the camera now remained uncovered during rehearsals, and even during the breaks. The lighting technicians posted on the catwalks were assigned to watch the cavities between the set walls and the studio walls from above to identify potential fire hazards. But instead of seeing fire hazards, they saw various hot love plays of individual couples who had gotten themselves in the cavities by way of a narrow gap between the doorframe and the decoration at the main entrance.[14]

While such happily intimate encounters came to pass inside the stages, the actual, spacious studio lot itself, thanks to constantly moving operations, occasionally became witness to accidental collisions. Thus the well-planned exterior sets for *Die Nibelungen* from Erich Kettelhut (and Otto Hunte, who had recruited Kettelhut for the film) had to be revised at short notice because only once the construction commenced did they realize that another team was shooting the film *The Chronicles of the Gray House* (1923–25, Arthur von Gerlach) on that very part of the lot at the same time.[15] "That was a typical example of the confused planning that often happened back then. Improvisation was all the rage."[16] Herlth and Röhrig were responsible for the sets of the second film: two men who, along with Kettelhut, not only had to fight for their necessary space to work but who also could be considered his stylistic counterpart:

Mitte der 20er Jahre ist die Ufa das größte und einflussreichste Filmstudio Europas mit Dimensionen, die an Hollywood erinnern. Im Minutentakt, so scheint es, erfinden Kameramänner wie Karl Freund und Carl Hoffmann in Zusammenarbeit mit Filmarchitekten wie Robert Herlth, Walter Röhrig, Otto Hunte oder eben Erich Kettelhut für die Filme von Visionären vom Schlage eines Fritz Lang oder eines Friedrich Wilhelm Murnau neue Filmtricks. Presseorgane wie der *Film-Kurier*, der *Kinematograph* oder die *Lichtbild-Bühne* berichten regelmäßig über technische Effekte der „entfesselten" Kamera (Karl Freund) oder der expressiven Filmbeleuchtung (Carl Hoffmann),[13] über atemberaubende Kulissenbauten und natürlich über Starauftritte. Einer der bis heute berühmtesten Darsteller dieser Zeit ist ohne Zweifel Emil Jannings, der mit Murnau *Der letzte Mann* (1924), *Tartüff* (1925) und *Faust* (1926) für die Ufa dreht (allerdings größtenteils in den Tempelhofer Ateliers), bevor er nach Hollywood geht und dort 1929 als erster den neu geschaffenen Oscar für Schauspielleistungen gewinnt. Doch die Stars sind auf dem Studiogelände in der Minderheit. Neben all den Technikern und Handwerkern tummeln sich vor allem Statisten und Kleindarsteller in den Kulissen, und zwar im wahrsten Sinne des Wortes wie Kettelhut in seinen Erinnerungen an die Umstände der Dreharbeiten von *Die Nibelungen* eindrucksvoll schildert:

> Durch den täglichen hautnahen Umgang entwickelte sich eine spürbar zunehmende Laszivität. Die meisten der anfangs nur zu den Aufnahmen entblößten Brüste blieben jetzt auch bei den Proben, sogar während der Pausen unbedeckt. Die auf den Brücken postierten Beleuchter waren beauftragt, von oben auf die zwischen den Kulissenwänden und den Atelierwänden verbliebenen Hohlräume zu achten, um eventuelle Brandherde rechtzeitig zu erkennen. Sie sahen zwar keine Brandherde, dafür aber heiße, variationsreiche Liebesspiele einzelner Pärchen, die sich beim Haupteingang durch eine schmale Spalte zwischen Türrahmen und Dekoration gezwängt hatten.[14]

Karl Freund and the "unchained camera"

Karl Freund und die „entfesselte Kamera"

Während es innerhalb der Ateliers zu solch glücklich-intimen Begegnungen kam, wurde das eigentlich weitläufige Studioareal wegen des regen Betriebs gelegentlich Zeuge von ungewollten Zusammenstößen: So mussten die von Erich Kettelhut (und Otto Hunte, der Kettelhut zum Film geholt hatte) für *Die Nibelungen* geplanten Außenbauten kurzfristig abgeändert werden, weil erst bei der Bauausführung bemerkt worden war, dass gleichzeitig auf demselben Geländeabschnitt auch der von einem anderen Team hergestellte Film *Zur Chronik von Grieshuus*

Carpenter's workshop at the Ufa

Tischlerei der Ufa

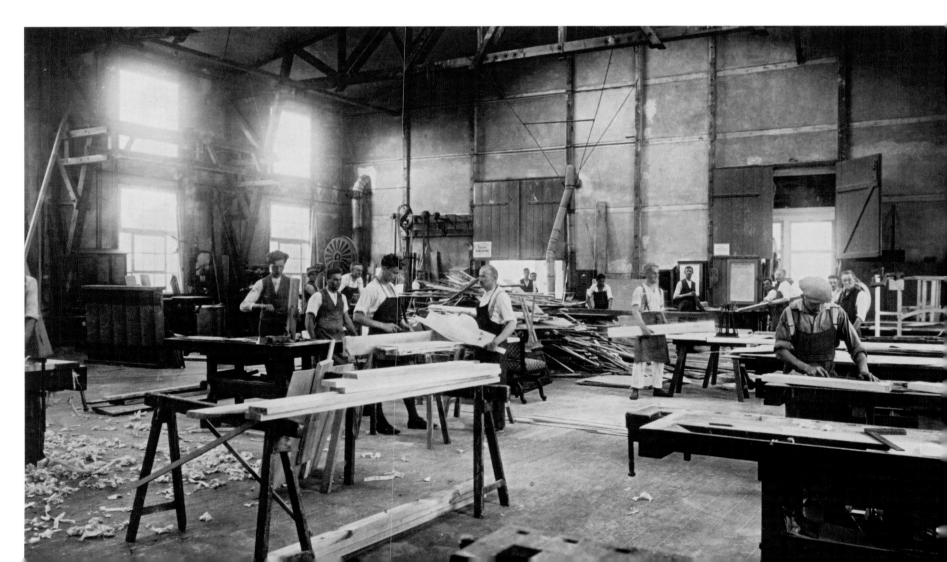

Fritz Lang's *Die Nibelungen* and *Metropolis* are dominated by Erich Kettelhut's static, monumental sets, meaning often he was drawing up filmic tombs and shrines. The spaces drawn by Robert Herlth and Walter Röhrig for Murnau's *The Last Laugh*, *Tartuffe*, and *Faust* appear by contrast to dissolve their surfaces and lines in light and movement. They seem animated by the heartbeat of the stories being told.[17]

Kettelhut was first and foremost an ingenious problem-solver. For *Asphalt* (1929, Joe May), he sketched the largest set ever to be built in a European studio: a lively street scene, for which Ufa's first camera crane was constructed.[18]

Fritz Lang's films made at this time were only possible due to Erich Pommer's "strange mixture of commercial spirit and artistic daring."[19] Though today their work may be treated as the highest form of German culture, Ufa only had one thing in mind after *Metropolis* was completed: to get rid of both of them. Already in October 1924, they had traveled to Hollywood to become familiar with the production methods there (as well as providing Lang in particular with a vision of the New York skyline which likely had an effect on the design of *Metropolis*). In January 1926, Pommer made his way back to the U.S. alone. Ufa had fired him, not least because the huge expenditures on the films that he produced amounted to about 50 million Reichsmark in liabilities during economically difficult times. *Metropolis* alone cost more than 5 million. By way of comparison: "The net hourly wage of a stagehand in 1927 is 1.23 RM, a master's salary 2.10 RM."[20] Just a few days before Pommer's departure, Ufa's negotiations with Paramount and MGM had begun, which led them to the devil's bargain that gave the studio 17 million Reichsmark in credit, but also condemned them to screening almost exclusively only films from both American studios in their cinemas. This deal was organized in the form of a joint loan with the pretty title "Parufamet."[21] In the view of film scholar Michael Töteberg, Ufa ruined *Metropolis* in revenge for this; they mutilated the film itself. Thus one might facetiously claim that America both inspired the work and then destroyed it again.[22]

Carpenter foremen on the set of *Die Nibelungen*
(1924, Director: Fritz Lang)

Kulissenbauer am Set von *Die Nibelungen*
(1924, Regie: Fritz Lang)

Exterior set for
The Chronicles of the Gray House
(1925, Director: Arthur von Gerlach)

Außenkulissen von
Zur Chronik von Grieshuus
(1925, Regie: Arthur von Gerlach)

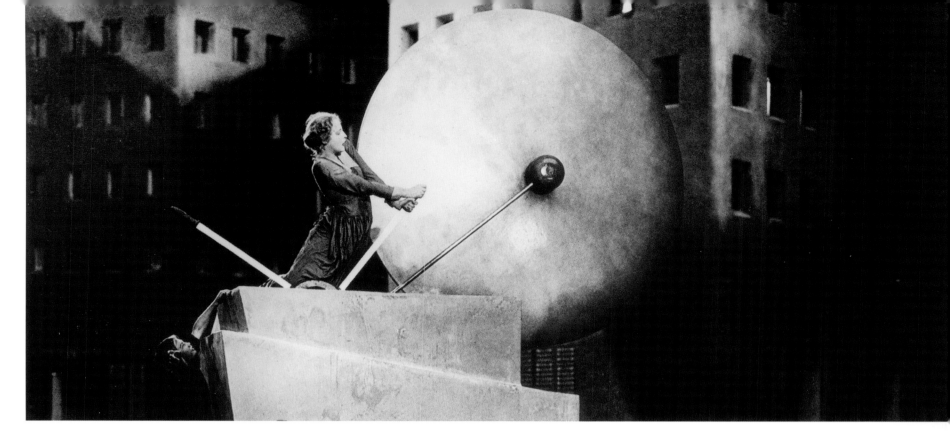

(1923–25, Arthur von Gerlach) gedreht werden sollte.[15] „Das war ein typisches Beispiel für ein damals häufig vorkommendes Planungswirrwarr. Das Improvisieren war große Mode."[16] Für die Bauten des zweiten Films zeichneten Herlth und Röhrig verantwortlich, die sich mit Kettelhut nicht nur um den nötigen Platz zanken mussten, sondern auch so etwas wie ein stilistisches Gegenstück zu ihm bildeten:

> Fritz Langs *Die Nibelungen* und *Metropolis* sind geprägt von den statisch-monumentalen Bauten Erich Kettelhuts, nicht selten entwirft er filmische Grabmäler und Weihestätten; die von Robert Herlth und Walter Röhrig gezeichneten Räume für Murnaus *Der letzte Mann*, *Tartüff* und *Faust* scheinen dagegen ihre Flächen und Linien in Licht und Bewegung aufzulösen, scheinen belebt vom Herzschlag der erzählten Geschichten.[17]

Kettelhut war vor allem ein ingeniöser Problemlöser. Für *Asphalt* (1929, Joe May) entwarf er die damals größte je in einem europäischen Atelier gebaute Dekoration: eine Straßenszene, zu deren lebendiger Filmgestaltung der erste Kamerakran der Ufa konstruiert wurde.[18]

Werden Fritz Langs Filme dieser Zeit, die Erich Pommer durch seine „seltsame Mischung aus kommerziellem Geist und künstlerischem Wagemut" erst ermöglicht hat,[19] heute als höchstes deutsches Kulturgut gehandelt, so hatte die Ufa nach der Fertigstellung von *Metropolis* nur noch eines im Sinn: die beiden loszuwerden. Noch im Oktober 1924 waren sie zusammen nach Hollywood gereist, um die dortigen Produktionsmethoden kennenzulernen (wobei sich besonders die Ansicht der Skyline von New York auf die Gestaltung von *Metropolis* ausgewirkt haben dürfte). Im Januar 1926 machte Pommer sich dann alleine auf den Weg dorthin. Die Ufa hatte ihn gefeuert. Nicht zuletzt aufgrund der immensen Ausgaben für die von ihm produzierten Filme in wirtschaftlich schwierigen Zeiten betrugen die Verbindlichkeiten des Studios circa 50 Millionen Reichsmark. Allein *Metropolis* hatte mehr als 5 Millionen gekostet. Zum Vergleich: „Der Nettostundenlohn eines Bühnenarbeiters liegt 1927 bei 1,23 RM, der Lohn eines Meisters bei 2,10 RM."[20] Nur wenige Tage vor Pommers Abgang hatten die Verhandlungen der Ufa mit Paramount und MGM begonnen, die schließlich zu einem Knebelvertrag führten, der der Ufa einen Kredit von 17 Millionen Reichsmark einbrachte, sie gleichzeitig aber dazu verdammte, in ihren Kinos fast nur noch Filme der beiden amerikanischen Studios abzuspielen. Organisiert wurde dieser Deal in Form eines gemeinsamen Verleihs mit dem schönen Namen „Parufamet".[21] Aus Rache dafür, so sieht es jedenfalls der Filmwissenschaftler Michael Töteberg, ruinierte die Ufa *Metropolis*, indem sie den Film verstümmelte. Angeregt wurden die Kürzungen und Umstellungen von der amerikanischen Verleihfassung. So kann man überspitzt feststellen, dass Amerika dieses Werk gleichzeitig inspiriert und dann wieder zerstört hat.[22]

Fritz Lang shot two more films for Ufa in Neubabelsberg—*Spies* (1928) and *Woman in the Moon* (1929)—before the studios finally separated from him, not only because of his persistent act of exceeding the budgets, but also because of his alleged refusal to produce sound films.[23] This seems quite an irony of fate, considering Ufa had long and steadfastly also refused to make sound films. Furthermore, they could have been the first studios to have sound, even preceding Warner Brothers, which began publicly experimenting on needle sound processes in August 1926, surprising and astonishing the world with *The Jazz Singer* in October 1927. Already in 1925, Joseph Massolle was named chief technician of the first Ufa sound film department.[24] Together with Hans Vogt and Jo Engl, he invented the first optical sound process by the name of "Tri-Ergon" (Work of Three), which was eventually to prove superior to needle and/or record sound. Guido Bagier was the artistic director of the newly created department, who also directed the first Ufa short sound-film *The Little Match Girl*. In his working notes, the entry from July 16, 1925, reads:

> Everything is proceeding very slowly in Babelsberg, as we are encountering the most stubborn resistance from the silent film people. People don't want to hear anything about our "useless experiments" and they are so busy anyway with shooting the monumental film *Metropolis* in the American style, that we had to unload the delivery truck with our devices on our own and temporarily store them in a remote shed.

And four days later:

> We cannot find a single spot in Babelsberg that is suitable for acoustic recording. In addition, the so-called "silent film" has the peculiar trait of being the loudest thing in the world. So we'll have to look elsewhere for a quieter place [...].[25]

This place was found in Berlin-Weißensee, where Ufa built a brand-new makeshift studio just for its sound film experiments. Yet the premiere on December 17, 1925, in Mozart Hall "was a total disaster in terms of sound quality, and given the developing economic crisis, Ufa's management decided to abandon further experimentation for the time being."[26]

Lien Deyers in *Spies*
(1928, Director: Fritz Lang)

Lien Deyers in *Spione*
(1928, Regie: Fritz Lang)

Fritz Lang drehte noch zwei weitere Filme für die Ufa in Neubabelsberg – *Spione* (1928) und *Frau im Mond* (1929) –, bevor man sich endgültig von ihm trennte, und zwar nicht nur wegen der anhaltenden Überschreitung der Budgets, sondern auch aufgrund seiner angeblichen Weigerung, Tonfilme herzustellen.[23] Das ist insofern eine Ironie des Schicksals, als gerade die Ufa sich lange standhaft geweigert hatte, Tonfilme herzustellen. Dabei hätte sie das erste Studio sein können, noch vor den Warner Brothers, die ab August 1926 öffentlich mit einem Nadelton-Verfahren experimentierten und im Oktober 1927 die Welt mit *The Jazz Singer* überraschten und begeisterten. Schon 1925 war Joseph Massolle zum technischen Leiter der ersten Ufa-Tonfilmabteilung ernannt worden.[24] Zusammen mit Hans Vogt und Jo Engl hatte er unter dem Namen „Tri-Ergon" (= Werk der Drei) das erste Lichtton-Verfahren erfunden, das sich letztendlich als dem Nadel- bzw. Schallplattenton überlegen herausstellen sollte. Künstlerischer Leiter der neu geschaffenen Abteilung war Guido Bagier, der als Regisseur des ersten Ufa-Ton-Kurzspielfilms *Das Mädchen mit den Schwefelhölzern* fungierte. In seinen Arbeitsnotizen heißt es unter dem 16. Juli 1925:

> In Babelsberg geht alles sehr langsam vorwärts, denn wir stoßen bei den Leuten des stummen Films auf den hartnäckigsten Widerstand. Man will von unseren „nutzlosen Experimenten" nichts wissen und ist derart mit den Aufnahmen eines im amerikanischen Stil gehaltenen Monumental-Films *Metropolis* beschäftigt, daß wir den Lieferwagen mit unseren Apparaten selbst ausladen und in einem entlegenen Schuppen provisorisch unterbringen mußten.

Und vier Tage später:

> Wir konnten nicht einen Platz in Babelsberg finden, der für akustische Aufnahmen geeignet ist. Außerdem hat der sogenannte stumme Film die Eigentümlichkeit, die lauteste Angelegenheit der Welt zu sein. So werden wir uns anderwärts einen ruhigeren Ort suchen müssen [...].[25]

Actress Gerda Maurus

Schauspielerin Gerda Maurus

Dieser wurde in Berlin-Weißensee gefunden, wo die Ufa kurzerhand ein nagelneues Behelfs- atelier für ihre Tonfilmexperimente aufbaute. Doch die Premiere am 17. Dezember 1925 im Mozartsaal endete „in einem tontechnischen Debakel, und angesichts der heraufziehenden wirt- schaftlichen Krise schien es der Direktion ratsam, alle weiteren Experimente auf diesem Gebiet vorerst einzustellen".[26]

Im März 1927 übernahm dann als weitere Folge der finanziellen Krise der Medienzar Alfred Hugenberg (Scherl-Gruppe) den Konzern und setzte Ludwig Klitzsch als Generaldirektor ein. Wenige Monate später startete dieser zu einer Amerika-Reise, auf der er nicht nur eine erste Lockerung des Parufamet-Vertrags erreichen konnte (der mit der Zeit an Bedeutung verlor und 1932 endgültig aufgelöst wurde),[27] sondern von der er auch einen neuen Produktionsleiter mitbrachte: Erich Pommer. Dieser hatte in den USA nicht nur den Durchbruch des Tonfilms erlebt, sondern auch Einsichten in die straffe Organisation der Hollywoodstudios mit ihren verbindlichen Drehplänen gewonnen. Anstelle gewichtiger nationaler Mythen wollte er nun stilvolle, aber leichte internationale Unterhaltung produzieren.[28] Pommers fantastischer Ruf innerhalb der Branche und seine Kompetenz in allen Bereichen des Filmemachens,[29] die im Ausland manchmal dazu führten, dass ihm die Regie an einem Film unterstellt wurde, obwohl er „nur" der Produzent war,[30] bildeten in Kombination mit seiner betriebswirtschaftlichen „Läuterung" einen Teil der neuen, aggressiven Ufa-Strategie. Der strikte Sparkurs sah neben einer Beendigung des Starwesens (die nicht zu bewerkstelligen war) die Zentralisierung der Produktion und die minutiöse Über- wachung von deren Kalkulation vor.[31] Zu diesem Ziel wurden Herstellungsgruppen eingerichtet, deren Leiter nur dem Produktionschef Ernst Hugo Correll verantwortlich waren. Als mächtigsten Herstellungsleiter für die teuren Produktionen setzte man Pommer ein. Pommers aus den USA importierte Drehpläne hatten allerdings zunächst einen schweren Stand: Sie seien „unzumutbar und unkünstlerisch", kurz: „Fließbandarbeit und mit sensiblen Schauspielern einfach nicht durchführbar".[32]

Makeup room of the Ufa

Schminkraum der Ufa

As a further consequence of the financial crisis, media czar Alfred Hugenberg (Scherl Group) took over the company in March 1927 and installed Ludwig Klitzsch as general director. A few months later, he took his own trip to America, where he not only reached an initial agreement easing the statutes of the Parufamet contract (which gradually lost meaning over time and was finally dissolved in 1932),[27] but where he also found a new production manager: Erich Pommer. He had experienced the breakthrough of sound film in the U.S., but also gained insights into the tight-fitting organization of the Hollywood studios with its mandatory shooting schedules. Instead of heavy, national myths, he now wanted to produce stylish, but light international entertainment.[28] Pommer's business "purification" along with his fantastic reputation inside the industry and his competence in all areas of filmmaking,[29] which had sometimes led him to directing a film or two while he was abroad—even when he was "only" the producer[30]—, formed a part of the new, aggressive Ufa strategy. The strict austerity program was intended to centralize production and painstakingly monitor cost calculations, in addition to terminating the star system (a goal which turned out to be unachievable).[31] To reach this goal, production groups were assembled which answered exclusively to production head Ernst Hugo Correll. As the most powerful production manager, Pommer was assigned to the most expensive productions. His imported shooting schedules from the U.S. were not, however, readily accepted: they were deemed "unreasonable and unartistic"; in short: "assembly line work with sensitive actors is simply unworkable."[32]

Pommer's residence in Hollywood had made it clear to him that sound film would prevail in the long run. The European variants should be set to the beloved operetta structure, music becoming "esperanto for the talkies."[33] In this respect, the Ufa board of directors was extremely cautious due to the nearly incalculable technical, financial, and patent-related problems involved. That's why Pommer's urging to begin to work again with the Tri-Ergon process was rejected in the spring of 1928. A year later, however, things moved very fast. At the beginning of 1929, Klitzsch traveled to America again and came back convinced that they should not become dependent on Hollywood. Already at the end of September, the "Tonkreuz" was completed: four new sound film halls grouped around one technical core building.[34] This was built over the so-called "Metropolis pool," where Lang had shot a few scenes of that film. Klitzsch described this approach as a "gamble,"[35] in that it represented a kind of revolution from above, since Ufa was in effect acting against the interests of the theater owners and also contrary to the ideas of the press. Yet, the late but determined switchover to sound film—which was in conjunction with the Ufa sound film contract of April 1929, and which sealed the cooperation between the largest

Pommers Aufenthalt in Hollywood hatte ihm klargemacht, dass der Tonfilm sich mittelfristig durchsetzen würde. Die europäische Variante sollte auf die beliebte Operettenstruktur setzen, die Musik zum „Esperanto für den Tonfilm" werden.[33] In dieser Beziehung war der Ufa-Vorstand aber aufgrund der nahezu unkalkulierbaren technischen, finanziellen und patentrechtlichen Probleme äußerst zurückhaltend. So wurde noch im Frühjahr 1928 Pommers Drängen, wieder mit dem Tri-Ergon-Verfahren zu arbeiten, zurückgewiesen. Ein Jahr später ging es dann aber ganz schnell: Klitzsch war Anfang 1929 noch einmal in die USA gereist und mit der Überzeugung zurückgekommen, dass man sich nicht von Hollywood abhängen lassen dürfe. Schon Ende September wurde in Neubabelsberg – genau über dem sogenannten „Metropolis-Becken", wo Lang einige Szenen seines gleichnamigen Films gedreht hatte – das „Tonkreuz" fertiggestellt: vier neue Tonfilmhallen gruppiert um ein technisches Herzgebäude.[34] Klitzsch bezeichnete dieses Vorgehen als „Wagnis",[35] da es sich um eine Art Revolution von oben handelte, bei der die Ufa zunächst gegen die Interessen der Theaterbesitzer und zum Teil auch entgegen der Vorstellungen der Presse agierte. Doch die späte, aber dann entschlossene Umstellung auf Tonfilm bewirkte – in Verbindung mit dem Ufa-Klangfilm-Vertrag vom April 1929, der die Zusammenarbeit des größten Filmproduzenten mit dem wichtigsten Hersteller für Kinotechnik besiegelte[36] – einen Sog, dem sich kein Unternehmen der Branche entziehen konnte. Bereits Anfang 1931 war der Kern der täglich spielenden Kinos in Deutschland zur Projektion von Tonfilmen ausgerüstet.[37]

Das Tonkreuz war noch im Bau, da entstand bereits der erste abendfüllende Tonspielfilm der Ufa in den behelfsmäßig umgerüsteten Ateliers (sowie *on location* in Ungarn): *Melodie des Herzens* (1929, Hanns Schwarz). Für die noch nicht auf Ton umgestellten Filmtheater wurde auch eine stumme Variante hergestellt; die Tonfassung hingegen gab es gleich in drei Sprach-versionen: deutsch, englisch und ungarisch. Auf diese Weise wollte die Ufa zunächst vor allem den amerikanischen Markt erobern, holte deshalb Emil Jannings aus Hollywood zurück und drehte mit ihm auch *Der blaue Engel* (1930, Josef von Sternberg) in einer englischen Version. Als sich aber bald abzeichnete, dass die Strategie in den USA nicht aufgehen würde, nahm man zwei wesentliche Änderungen vor: Anstatt deutsche Schauspieler die fremdsprachigen Mundbewegungen

Tonkreuz, built in 1929

Tonkreuz, erbaut 1929

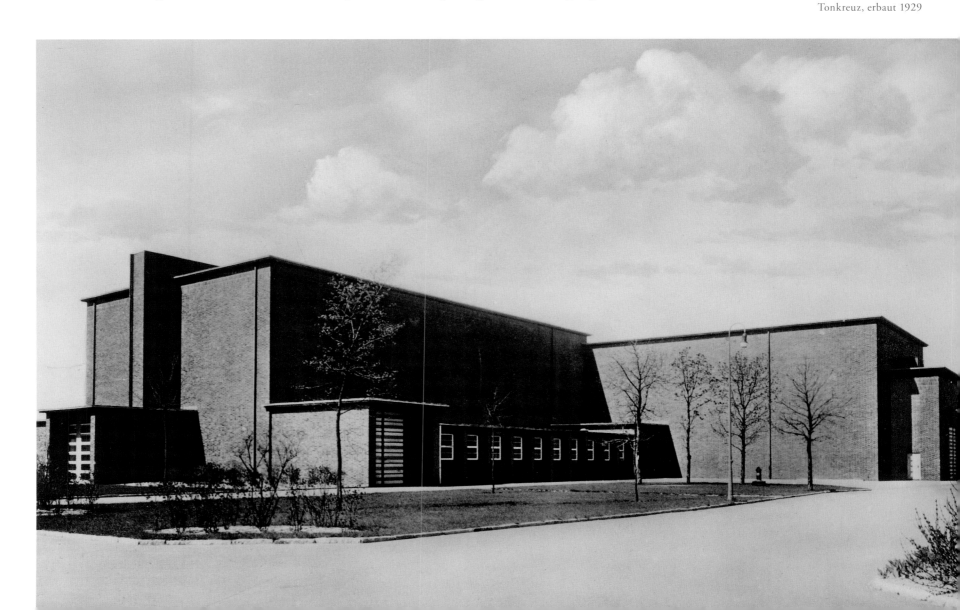

Lilian Harvey

Shooting break during *Three Good Friends* and
the French version *Le chemin du paradis*
(1930, Director: Wilhelm Thiele), f.l.t.r.: Heinz Rühmann,
Eberhard Klagemann (in the front, middle), René Lefèvre
(with glasses), Lilian Harvey, and Erich Pommer (dark suit)

Drehpause bei *Die Drei von der Tankstelle* und der
französischen Version *Le chemin du paradis*
(1930, Regie: Wilhelm Thiele), v.l.n.r.: Heinz Rühmann,
Eberhard Klagemann (vorne Mitte), René Lefèvre (mit Brille),
Lilian Harvey und Erich Pommer (im dunklen Anzug)

film producers and the most important manufacturers of film technology[36]—brought about an undertow that no firm in the industry could escape. By the beginning of 1931, the majority of cinemas in daily use in Germany were equipped to project sound films.[37]

Though the Tonkreuz was under construction, Ufa's first full-length sound film was made in a makeshift converted studio (as well as on location in Hungary): *Melody of the Heart* (1929, Hanns Schwarz). A silent version was produced for those cinemas not yet converted to sound, whereas the sound version itself was also available in three languages: German, English, and Hungarian. In this fashion, Ufa wanted first and foremost to conquer the American market. Therefore, they brought back Emil Jannings from Hollywood and shot *The Blue Angel* (1930, Josef von Sternberg) in an English version. But as soon as it became apparent that their strategy would never take off in the U.S., they undertook two major changes: instead of German actors trying to merely imitate foreigners' mouth movements in order to synchronize them after the fact (as in *Melody of the Heart*) and/or to simply speak the English lines themselves despite their strong accent (such as for *The Blue Angel*), they now employed entire acting troupes from abroad. Once a shot was done in German, then the next group would come onto the set. The artistic and technical composition of the shots remained more or less identical.

The second change related to the eventual goal of this operation. Instead of focusing on the U.S., they concentrated on England, and interest shifted to English and French versions, since France was by far the most important export market for German films. Indeed, the fundamentally revanchist Ufa board had long been reluctant to employ staff from their "arch-enemy" country. The film *Three Good Friends* (1930, Wilhelm Thiele) proved the turning point in this regard, as the French version *Le chemin du paradis* was as successful as the original was in Germany, and it established Henri Garat as an ideal counterpart to Willy Fritsch. With this film, the native Englishwoman Lilian Harvey also got her breakthrough as a European star. A year later, she would set a milestone with her role as Viennese glove merchant Christel in *The Congress Dances* (1931, Erik Charell), in which she played the main role in the German, English, and French versions. The person responsible for the very expensive and demanding method of producing different language films was, of course, Erich Pommer, whose film group produced 17 talkies, of which 15 were shot in different language versions. His final dismissal was decided at the board meeting of March 29, 1933, and was a direct consequence of Hitler's coming to power on January 30.

Dita Parlo and
Willy Fritsch in
Melody of the Heart
(1929, Director:
Hanns Schwarz)

Dita Parlo und
Willy Fritsch in
Melodie des Herzens
(1929, Regie:
Hanns Schwarz)

nur imitieren zu lassen, um sie im Nachhinein zu synchronisieren (wie für *Melody of the Heart*),
bzw. anstatt sie den englischen Text trotz ihres starken Akzents selbst sprechen zu lassen
(wie für *The Blue Angel*), engagierte man nun ganze Schauspielensembles aus dem Ausland:
War eine Einstellung auf Deutsch abgedreht, kam die nächste Gruppe auf den Set. Die künstlerische
und technische Ausgestaltung der Aufnahmen blieb dabei weitgehend identisch.

Die zweite Änderung betraf das hauptsächliche Ziel dieser Operation: Statt auf die USA
konzentrierte man sich nun auf England, vor allem aber wurde das Interesse von englischsprachigen
auf französischsprachige Versionen verlagert, da Frankreich ohnehin der wichtigste Auslands-
markt für deutsche Filme war. Allerdings hatte der grundsätzlich revanchistisch eingestellte
Ufa-Vorstand lange gezögert, Mitarbeiter aus dem Land des „Erbfeindes" zu verpflichten. Den
diesbezüglichen Wendepunkt stellte *Die Drei von der Tankstelle* (1930, Wilhelm Thiele) dar,
dessen französische Version *Le chemin du paradis* in Frankreich genauso erfolgreich war wie das
Original in Deutschland und mit Henri Garat einen idealen Widerpart zu Willy Fritsch etablierte.
Ihren Durchbruch als europäischer Star hatte mit diesem Film auch die gebürtige Britin Lilian
Harvey, die sich ein Jahr später durch ihre Rolle der Wiener Handschuhverkäuferin Christel in
Der Kongreß tanzt (1931, Erik Charell), in dem sie die Hauptrolle in der deutschen, englischen
und französischen Version spielte, ein Denkmal setzte. Verantwortlich für die sehr aufwendige
und von allen Beteiligten eine unglaubliche Disziplin verlangende Methode der Sprachversions-
filme war natürlich Erich Pommer, dessen Herstellungsgruppe bis zu seiner Entlassung
17 Tonspielfilme produzierte, von denen 15 in Sprachversionen gedreht wurden. Seine endgültige
Entlassung wurde in der Vorstandssitzung vom 29. März 1933 beschlossen und war eine direkte
Folge von Hitlers Machtantritt am 30. Januar.

Emil Jannings

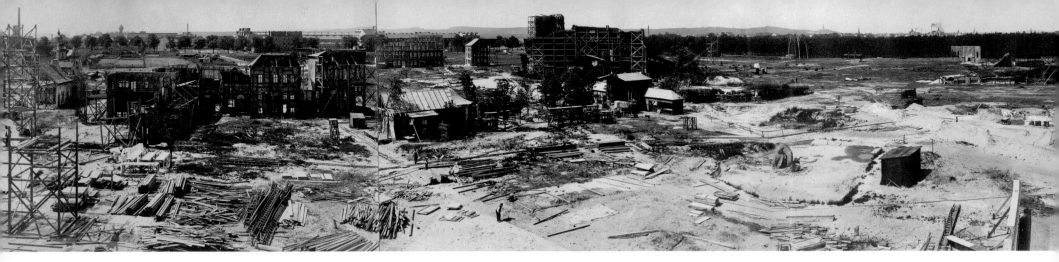

The studio lot of the Ufa during the construction of the "Great Hall" in 1926

Studiogelände der Ufa während des Baus der „Großen Halle", 1926

1 Siegfried Kracauer, Calico-World: The Ufa City in Neubabelsberg [1926]. In: Siegfried Kracauer, *The Mass Ornament: Weimar Essays*, transl., edited and with an introduction by Thomas Y. Levin, Cambridge, Mass. / London: Harvard University Press 1995, pp. 281–288, here p. 281.

2 Cf. Werner Sudendorf: Kunstwelten und Lichtkünste. In: Wolfgang Jacobsen (ed.): *Babelsberg. Ein Filmstudio 1912–1992*. Berlin: Argon 1992, pp. 45–72, here p. 58.

3 Quoted in Karl Prümm: Empfindsame Reisen in die Filmstadt. In: Jacobsen (ed.): *Babelsberg*, p. 117–134, here p. 117.

4 Sudendorf: Kunstwelten und Lichtkünste, p. 62.

5 Cf. ibid, p. 54. Other films shot under the Decla-Bioscop label on Erich Pommer's watch are, for example, *The Haunted Castle* (1921) and *The Phantom* (1922) by F.W. Murnau, as well as *One Glass of Water* and *The Lost Shoe* (both 1923) by Ludwig Berger.

6 Cf. Werner Sudendorf (ed.): *Erich Kettelhut – Der Schatten des Architekten*. München: belleville 2009, p. 41.

7 Cf. ibid, p. 121.

8 Cf. ibid, p. 50.

9 Cf. Sudendorf: Kunstwelten und Lichtkünste, p. 57.

10 Sudendorf (ed.): *Erich Kettelhut*, p. 76.

11 Ibid, p. 139.

12 Ibid, p. 135.

13 Cf. Thomas Brandlmeier: Deutsche Bilderwelten. Karl Freund, Carl Hoffmann und die Kamerakunst. In: Hans-Michael Bock / Michael Töteberg (ed.): *Das Ufa-Buch*. Frankfurt am Main: Zweitausendeins 1992, pp. 126–133.

14 Sudendorf (ed.): *Erich Kettelhut*, p. 104.

15 Cf. Michael Esser: Poeten der Filmarchitektur: Robert Herlth und Walter Röhrig. In: Bock / Töteberg (ed.): *Das Ufa-Buch*, pp. 118–123, here p. 118.

16 Sudendorf (ed.): *Erich Kettelhut*, p. 73.

17 Esser: Poeten der Filmarchitektur, p. 119.

18 Cf. Sudendorf (ed.): *Erich Kettelhut*, p. 225.

19 Brandlmeier: Deutsche Bilderwelten, p. 127.

20 Sudendorf: Kunstwelten und Lichtkünste, p. 57.

21 Cf. Klaus Kreimeier: *Die Ufa-Story. Geschichte eines Filmkonzerns*. Frankfurt am Main: Fischer 2002, p. 153.

22 Cf. Michael Töteberg: Der Turmbau zu Babelsberg. Fritz Langs *Metropolis*. In: Bock / Töteberg (ed.): *Das Ufa-Buch*, pp. 180–183, here p. 180. Thanks to the 2008 rediscovery of material in Buenos Aires, the film is nearly complete again today. See also the Deutsche Kinemathek's edited volume *Fritz Langs* Metropolis. München: belleville 2010.

23 Cf. Michael Töteberg: Nie wieder Fritz Lang! Ein schwieriges Verhältnis und sein Ende. In: Bock / Töteberg (ed.): *Das Ufa-Buch*, pp. 218–223. Lang's epoch-making sound film *M* (1931) was then produced by Nero Film, a small independent company in Staaken.

24 Cf. Kreimeier: *Die Ufa-Story*, p. 211.

25 Quoted in Bock / Töteberg (ed.): *Das Ufa-Buch*, p. 245.

26 Klaus Kreimeier, The Ufa-Story: A History of Germany's Greatest Film Company 1918–1945. Translated by Robert and Rita Kimber. New York: Hill and Wang, 1996, p. 178.

27 Cf. ibid, p. 217.

28 Cf. Wolfgang Jacobsen: *Erich Pommer. Ein Produzent macht Filmgeschichte*. Berlin 1989.

29 Cf. Sudendorf (ed.): *Erich Kettelhut*, p. 212.

30 Cf. Chris Wahl: *Sprachversionsfilme aus Babelsberg. Die internationale Strategie der Ufa 1929–1932*. München: edition text + kritik 2009, p. 142, FN 228.

31 Cf. Sudendorf: Kunstwelten und Lichtkünste, p. 58.

32 Sudendorf (ed.): *Erich Kettelhut*, p. 194.

33 Erich Pommer: Tonfilm und Internationalität. In: Frank Arnau (ed.): *Universal Filmlexikon 1932*. Berlin / London 1932, p. 14.

34 Cf. Wolfgang Jacobsen: Die Tonfilmmaschine. In: Jacobsen (ed.): *Babelsberg*, pp. 145–164, here p. 147.

35 "Deutschland das kommende Produktionszentrum Europas". Klitzsch's program speech. In: *Licht-Bild-Bühne*, 29.7.1930.

36 Cf. Wolfgang Mühl-Benninghaus: *Das Ringen um den Tonfilm. Strategien der Elektro- und der Filmindustrie in den 20er und 30er Jahren*. Düsseldorf: Droste 1999, pp. 109–128.

37 Cf. Corinna Müller: *Vom Stummfilm zum Tonfilm*. München: Fink 2003, p. 26.

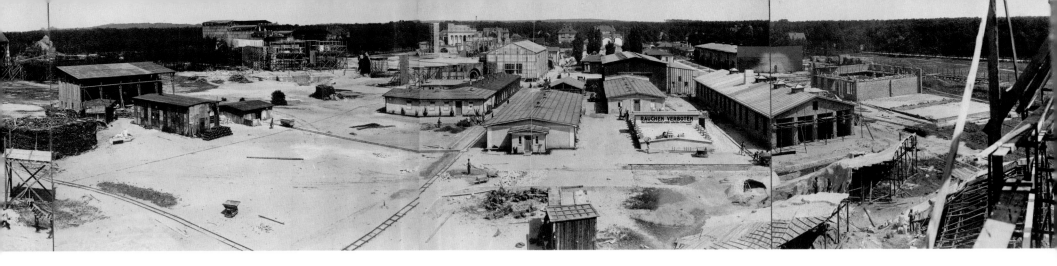

1 Siegfried Kracauer: Kaliko-Welt. In: *Frankfurter Zeitung*, Nr. 72, 28.1.1926.

2 Vgl. Werner Sudendorf: Kunstwelten und Lichtkünste. In: Wolfgang Jacobsen (Hg.): *Babelsberg. Ein Filmstudio 1912–1992*. Berlin: Argon 1992, S. 45–72, hier S. 58.

3 Zitiert nach Karl Prümm: Empfindsame Reisen in die Filmstadt. In: Jacobsen (Hg.): *Babelsberg*, S. 117–134, hier S. 117.

4 Sudendorf: Kunstwelten und Lichtkünste, S. 62.

5 Vgl. ebd., S. 54. Weitere in Neubabelsberg unter der Leitung von Erich Pommer und unter dem Label der Decla-Bioscop gedrehte Filme sind beispielsweise *Schloß Vogelöd* (1921) und *Phantom* (1922) von F.W. Murnau sowie *Ein Glas Wasser* und *Der verlorene Schuh* (beide 1923) von Ludwig Berger.

6 Vgl. Werner Sudendorf (Hg): *Erich Kettelhut – Der Schatten des Architekten*. München: belleville 2009, S. 41.

7 Vgl. ebd., S. 121.

8 Vgl. ebd., S. 50f.

9 Vgl. Sudendorf: Kunstwelten und Lichtkünste, S. 57.

10 Sudendorf (Hg.): *Erich Kettelhut*, S. 76.

11 Ebd., S. 139.

12 Ebd., S. 135.

13 Vgl. Thomas Brandlmeier: Deutsche Bilderwelten. Karl Freund, Carl Hoffmann und die Kamerakunst. In: Hans-Michael Bock / Michael Töteberg (Hg.): *Das Ufa-Buch*. Frankfurt am Main: Zweitausendeins 1992, S. 126–133.

14 Sudendorf (Hg.): *Erich Kettelhut*, S. 104.

15 Vgl. Michael Esser: Poeten der Filmarchitektur: Robert Herlth und Walter Röhrig. In: Bock / Töteberg (Hg.): *Das Ufa-Buch*, S. 118–123, hier S. 118.

16 Sudendorf (Hg.): *Erich Kettelhut*, S. 73.

17 Esser: Poeten der Filmarchitektur, S. 119f.

18 Vgl. Sudendorf (Hg.): *Erich Kettelhut*, S. 225.

19 Brandlmeier: Deutsche Bilderwelten, S. 127.

20 Sudendorf: Kunstwelten und Lichtkünste, S. 57.

21 Vgl. Klaus Kreimeier: *Die Ufa-Story. Geschichte eines Filmkonzerns*. Frankfurt am Main: Fischer 2002, S. 153.

22 Vgl. Michael Töteberg: Der Turmbau zu Babelsberg. Fritz Langs *Metropolis*. In: Bock / Töteberg (Hg.): *Das Ufa-Buch*, S. 180–183, hier S. 180. Dank der Materialfunde in Buenos Aires aus dem Jahr 2008 ist der Film heute wieder annährend komplett. Vgl. hierzu auch den von der Deutschen Kinemathek herausgegebenen Band *Fritz Langs* Metropolis. München: belleville 2010.

23 Vgl. Michael Töteberg: Nie wieder Fritz Lang! Ein schwieriges Verhältnis und sein Ende. In: Bock / Töteberg (Hg.): *Das Ufa-Buch*, S. 218–223. Langs epochemachender Tonfilm *M* (1931) wurde daraufhin von der Nero-Film – einer kleinen, unabhängigen Firma – in Staaken hergestellt.

24 Vgl. Kreimeier: *Die Ufa-Story*, S. 211.

25 Zitiert nach Bock / Töteberg (Hg.): *Das Ufa-Buch*, S. 245.

26 Kreimeier: *Die Ufa-Story*, S. 211.

27 Vgl. ebd., S. 217.

28 Vgl. Wolfgang Jacobsen: *Erich Pommer. Ein Produzent macht Filmgeschichte*. Berlin 1989.

29 Vgl. Sudendorf (Hg.): *Erich Kettelhut*, S. 212.

30 Vgl. Chris Wahl: *Sprachversionsfilme aus Babelsberg. Die internationale Strategie der Ufa 1929–1932*. München: edition text + kritik 2009, S. 142, FN 228.

31 Vgl. Sudendorf: Kunstwelten und Lichtkünste, S. 58.

32 Sudendorf (Hg.): *Erich Kettelhut*, S. 194.

33 Erich Pommer: Tonfilm und Internationalität. In: Frank Arnau (Hg.): *Universal Filmlexikon 1932*. Berlin / London 1932, S. 14.

34 Vgl. Wolfgang Jacobsen: Die Tonfilmmaschine. In: Jacobsen (Hg.): *Babelsberg*, S. 145–164, hier S. 147.

35 „Deutschland das kommende Produktionszentrum Europas". Klitzschs Programmrede. In: *Licht-Bild-Bühne*, 29.7.1930.

36 Vgl. Wolfgang Mühl-Benninghaus: *Das Ringen um den Tonfilm. Strategien der Elektro- und der Filmindustrie in den 20er und 30er Jahren*. Düsseldorf: Droste 1999, S. 109–128.

37 Vgl. Corinna Müller: *Vom Stummfilm zum Tonfilm*. München: Fink 2003, S. 26.1 Siegfried Kracauer: Kaliko-Welt. In: *Frankfurter Zeitung,* Nr. 72, 28.1.1926.

1921
-
1933

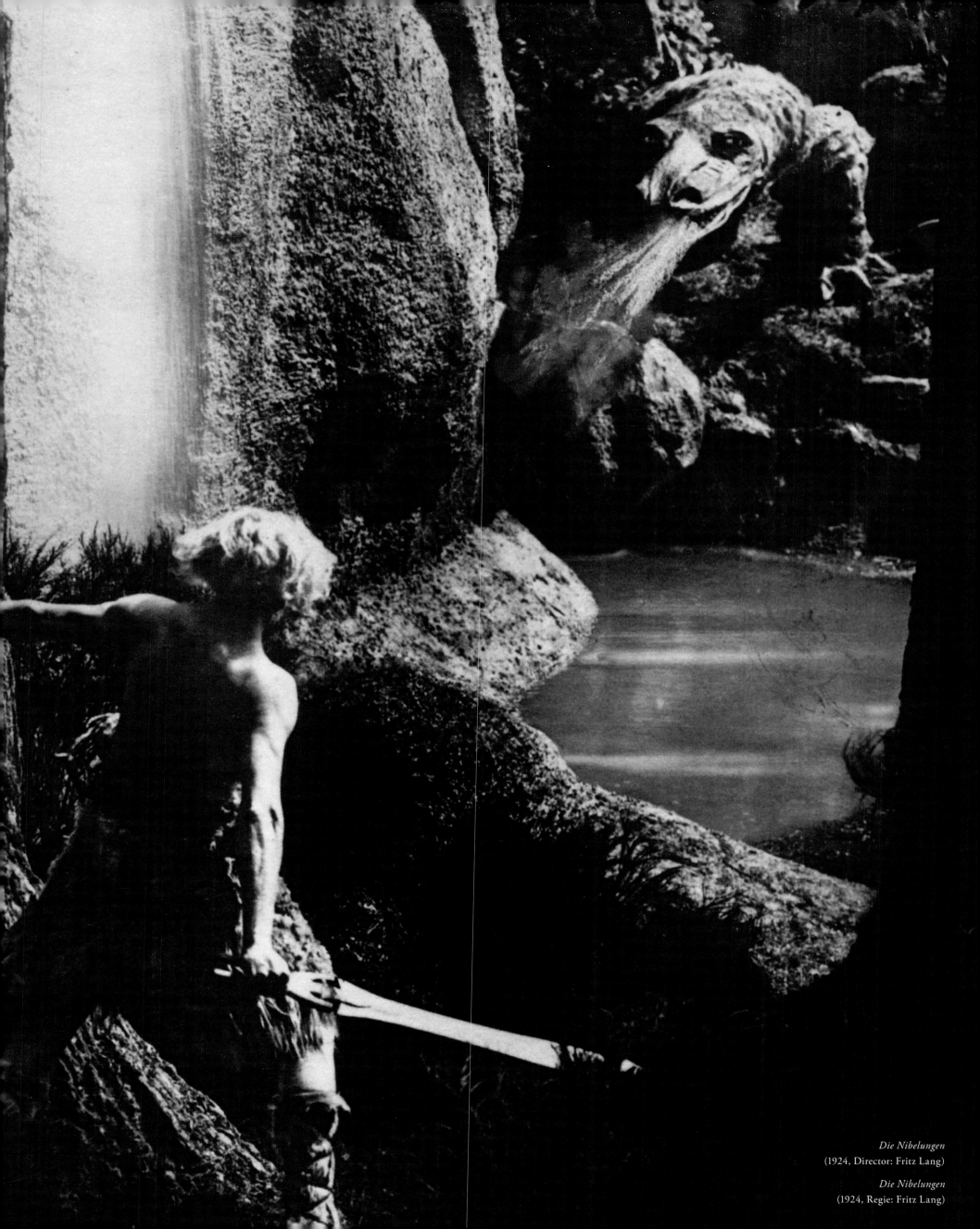

Die Nibelungen
(1924, Director: Fritz Lang)

Die Nibelungen
(1924, Regie: Fritz Lang)

Scenes from the silent film *Spies* starring Rudolf Klein-Rogge. Fritz Lang directed the film based on the screenplay by Thea von Harbou (1928).

Szenen aus dem Stummfilm *Spione* mit Rudolf Klein-Rogge. Regie führte Fritz Lang nach dem Drehbuch von Thea von Harbou (1928).

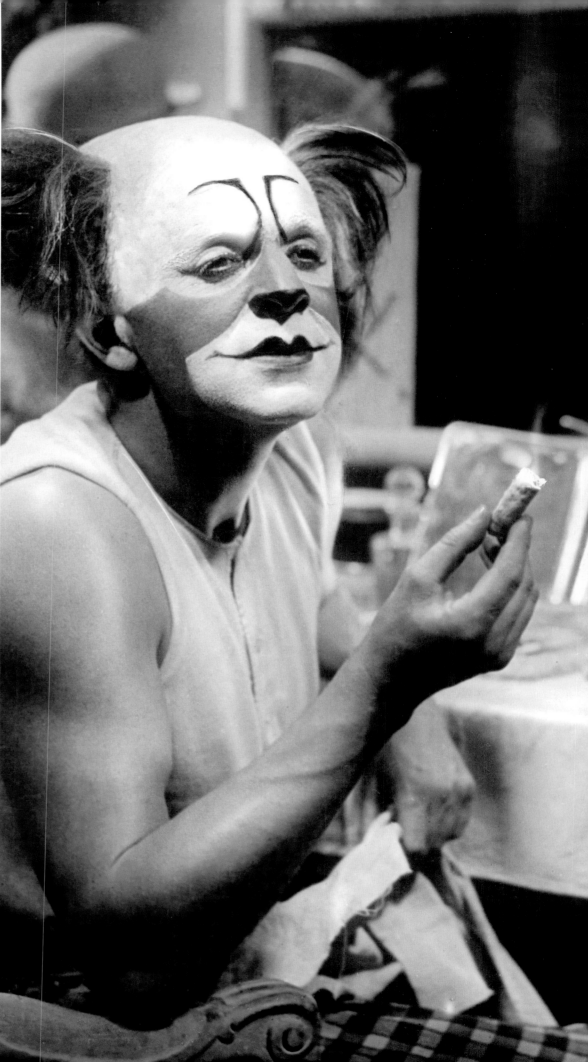

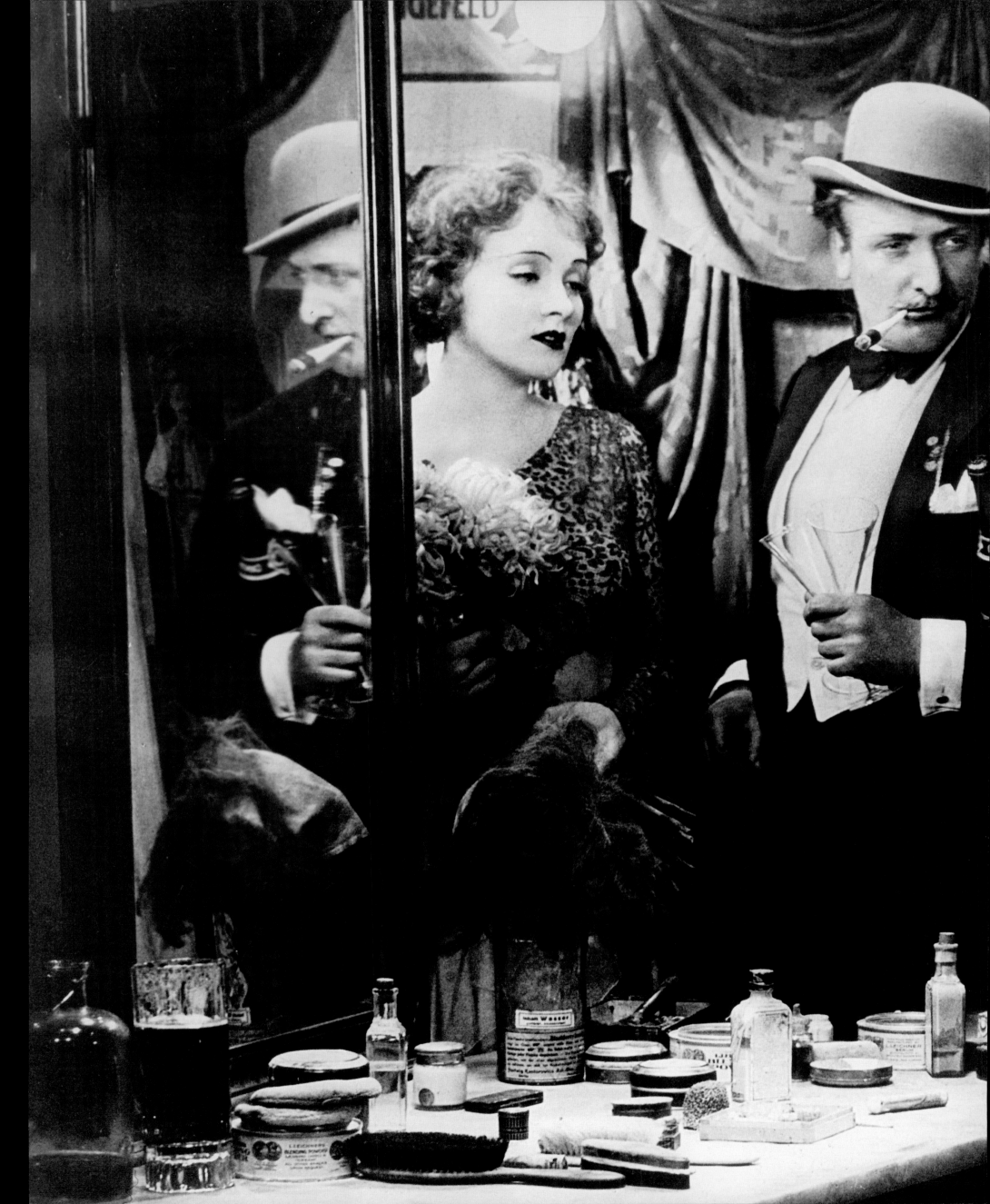

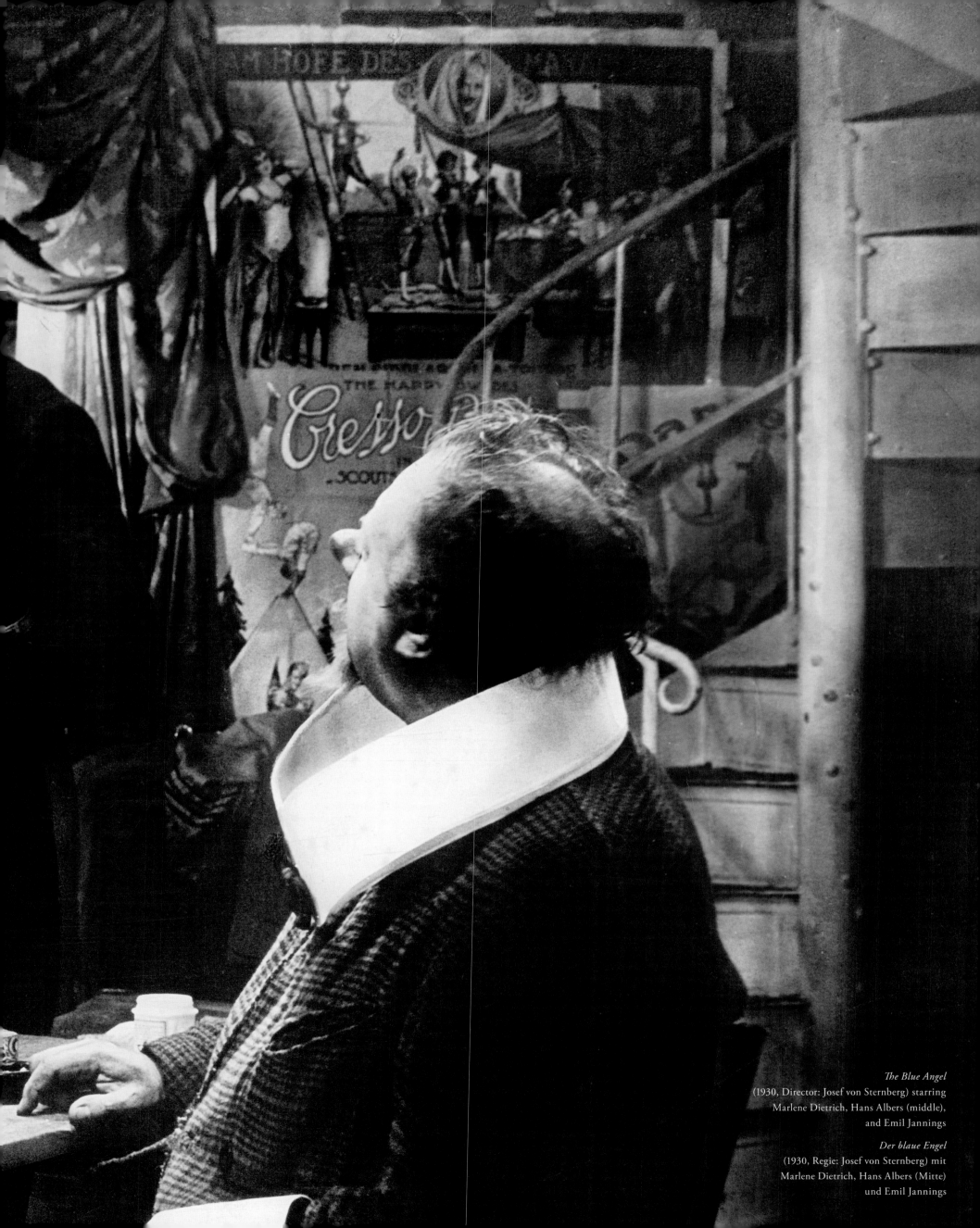

The Blue Angel
(1930, Director: Josef von Sternberg) starring
Marlene Dietrich, Hans Albers (middle),
and Emil Jannings

Der blaue Engel
(1930, Regie: Josef von Sternberg) mit
Marlene Dietrich, Hans Albers (Mitte)
und Emil Jannings

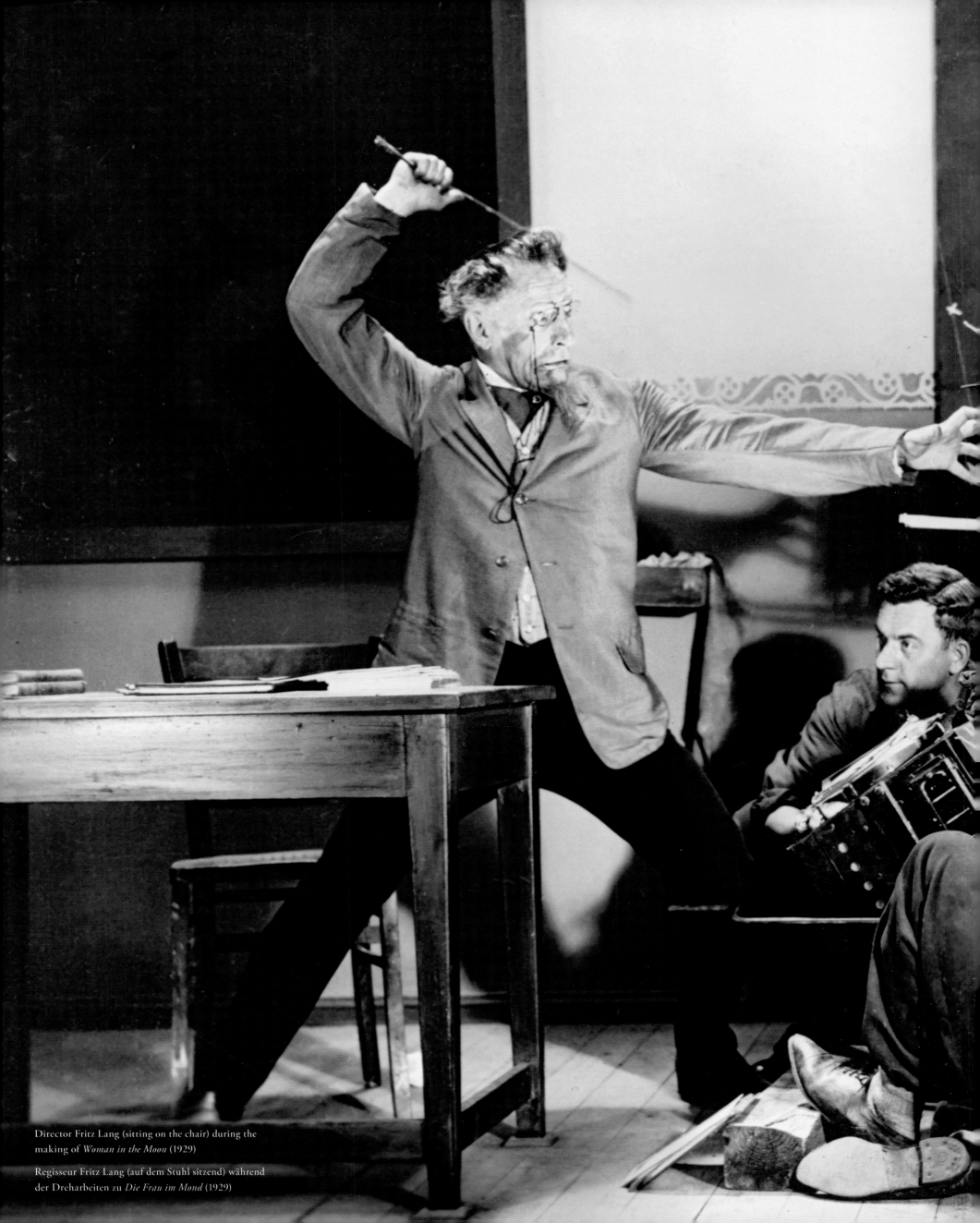

Director Fritz Lang (sitting on the chair) during the
making of *Woman in the Moon* (1929)

Regisseur Fritz Lang (auf dem Stuhl sitzend) während
der Dreharbeiten zu *Die Frau im Mond* (1929)

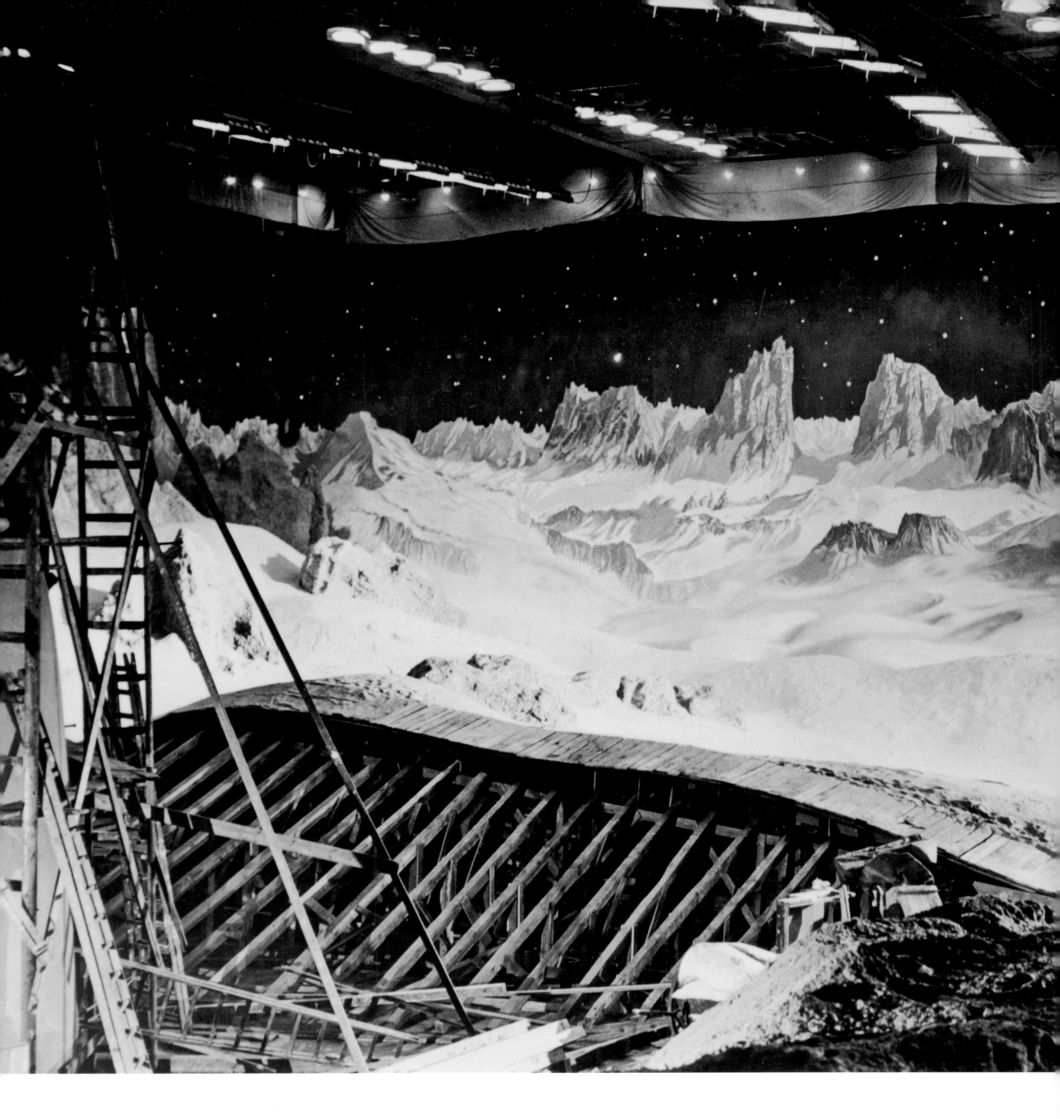

Shooting *Woman in the Moon* (1929) in today's Marlene Dietrich Stage. The science fiction film based on the screenplay by Thea von Harbou was the last silent film of director Fritz Lang and one of the last German silent films ever.

Dreharbeiten zu *Die Frau im Mond* (1929) in der heutigen Marlene-Dietrich-Halle. Der Science-Fiction-Film nach dem Drehbuch von Thea von Harbou war der letzte Stummfilm des Regisseurs Fritz Lang und einer der letzten deutschen Stummfilme überhaupt.

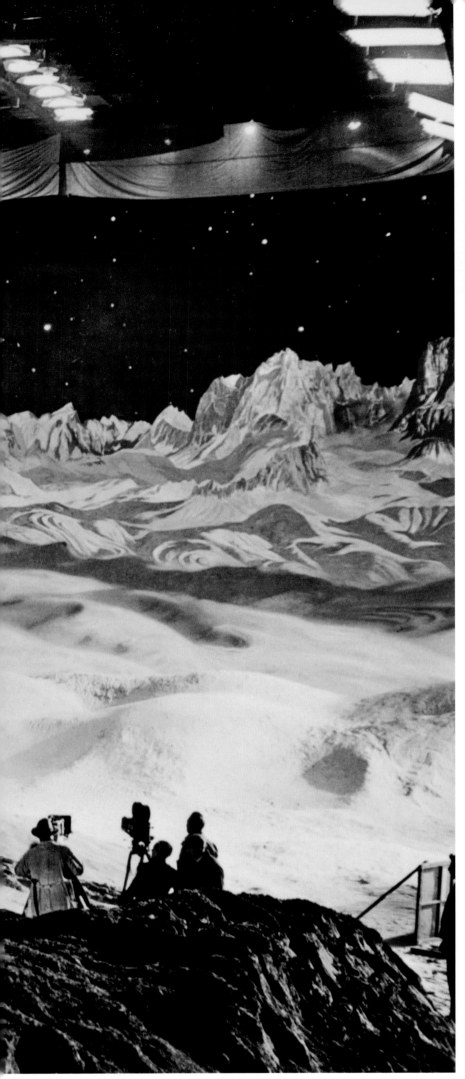
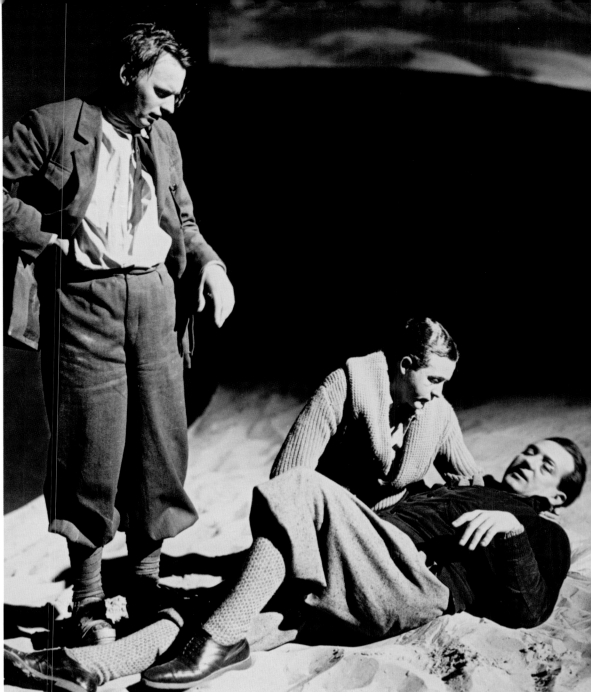
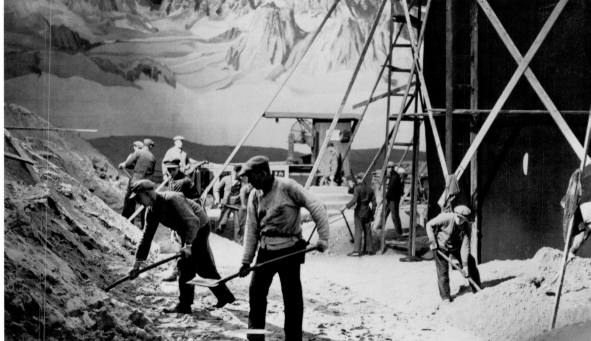

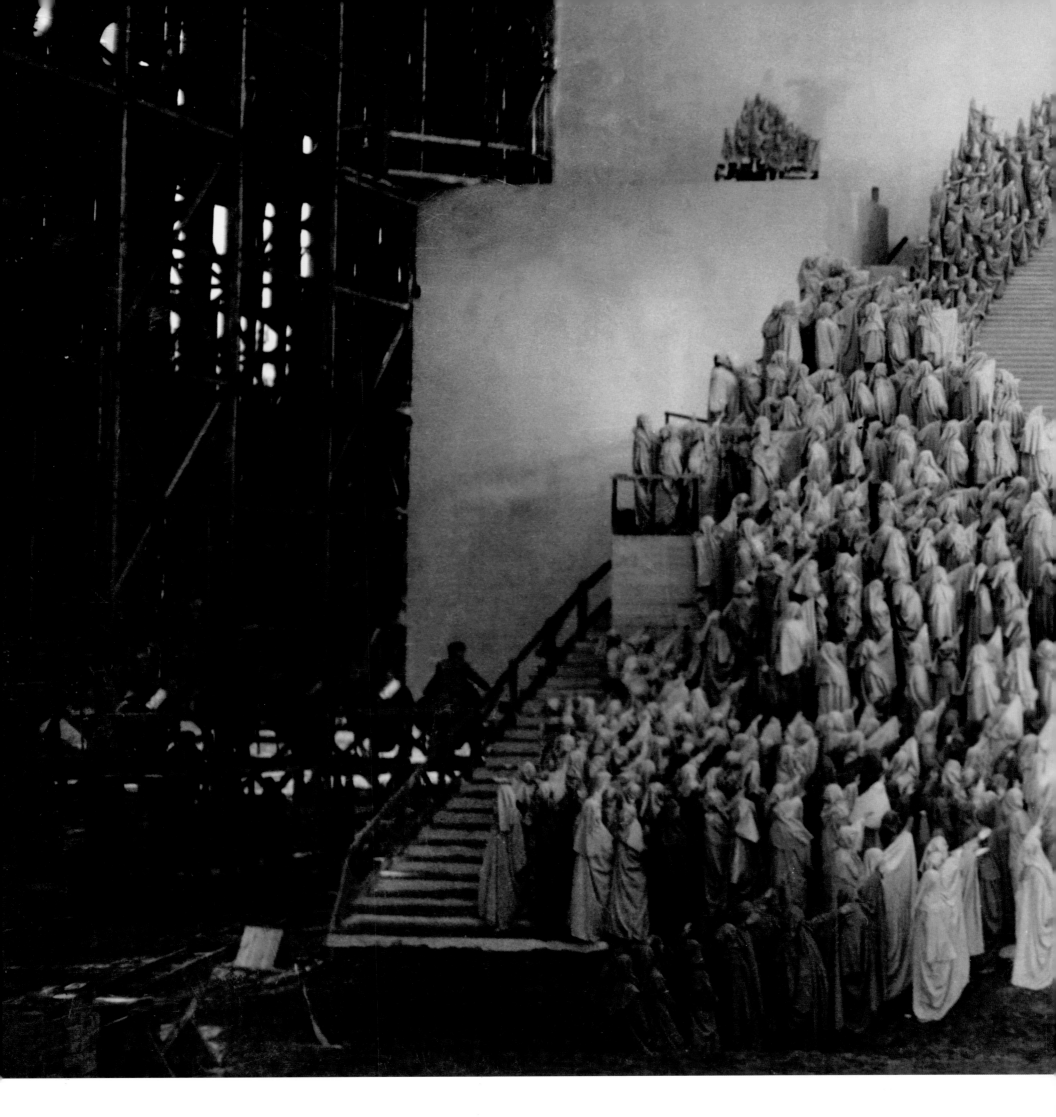

Production photograph from *The Blackguard* (1925, Director: Graham Cutts). Alfred Hitchcock was involved, among other things, as an assistant director and witnessed other shoots at the same time. Everything he had to know about filmmaking he claimed to have learned in Babelsberg.

Szenenfoto aus Die Prinzessin und der Geiger *(1925, Regie: Graham Cutts). Alfred Hitchcock arbeitete hier u. a. als Regieassistent und beobachtete nebenher andere Dreharbeiten. Alles, was er über das Filmemachen wissen musste, habe er in Babelsberg gelernt.*

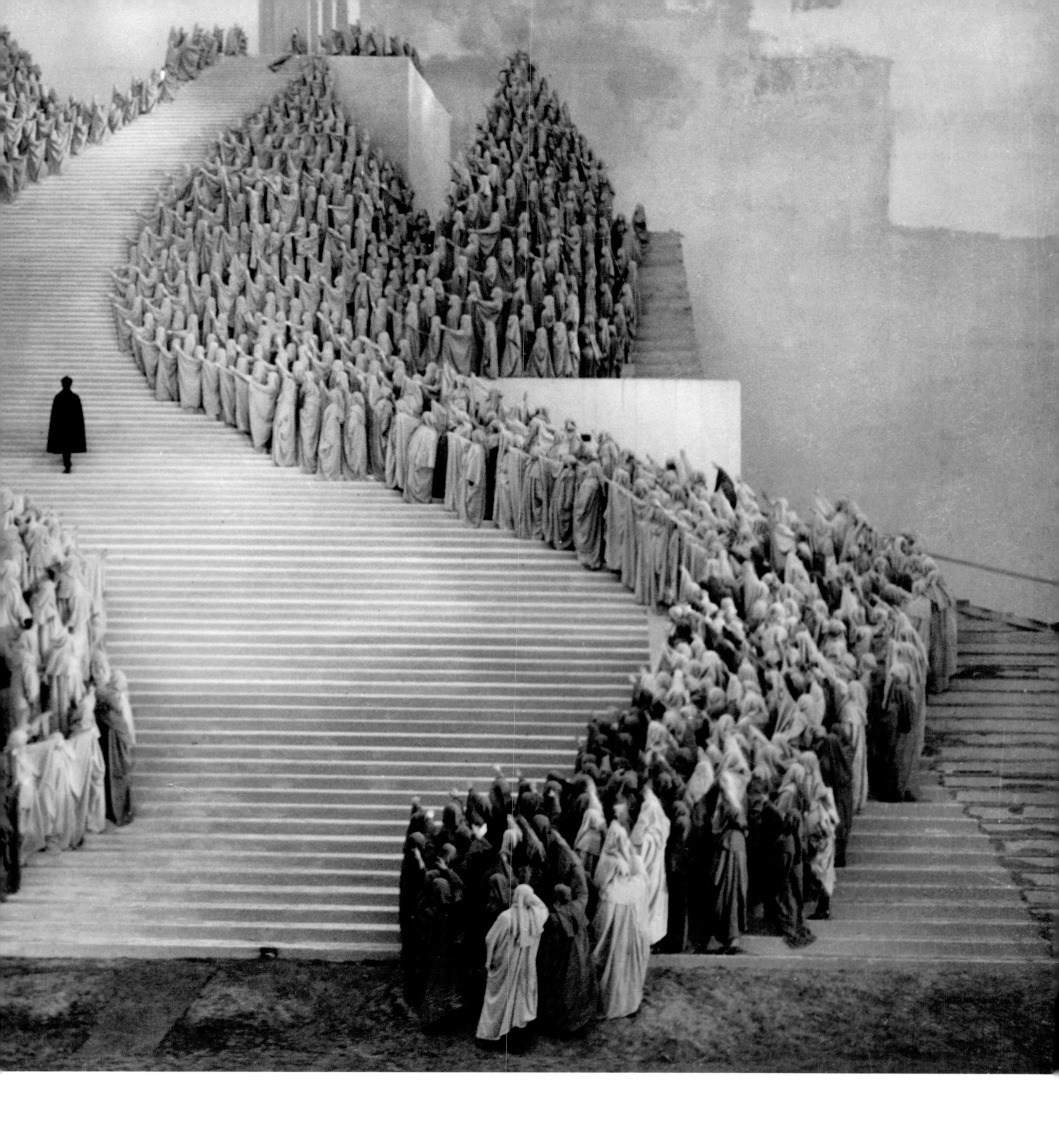

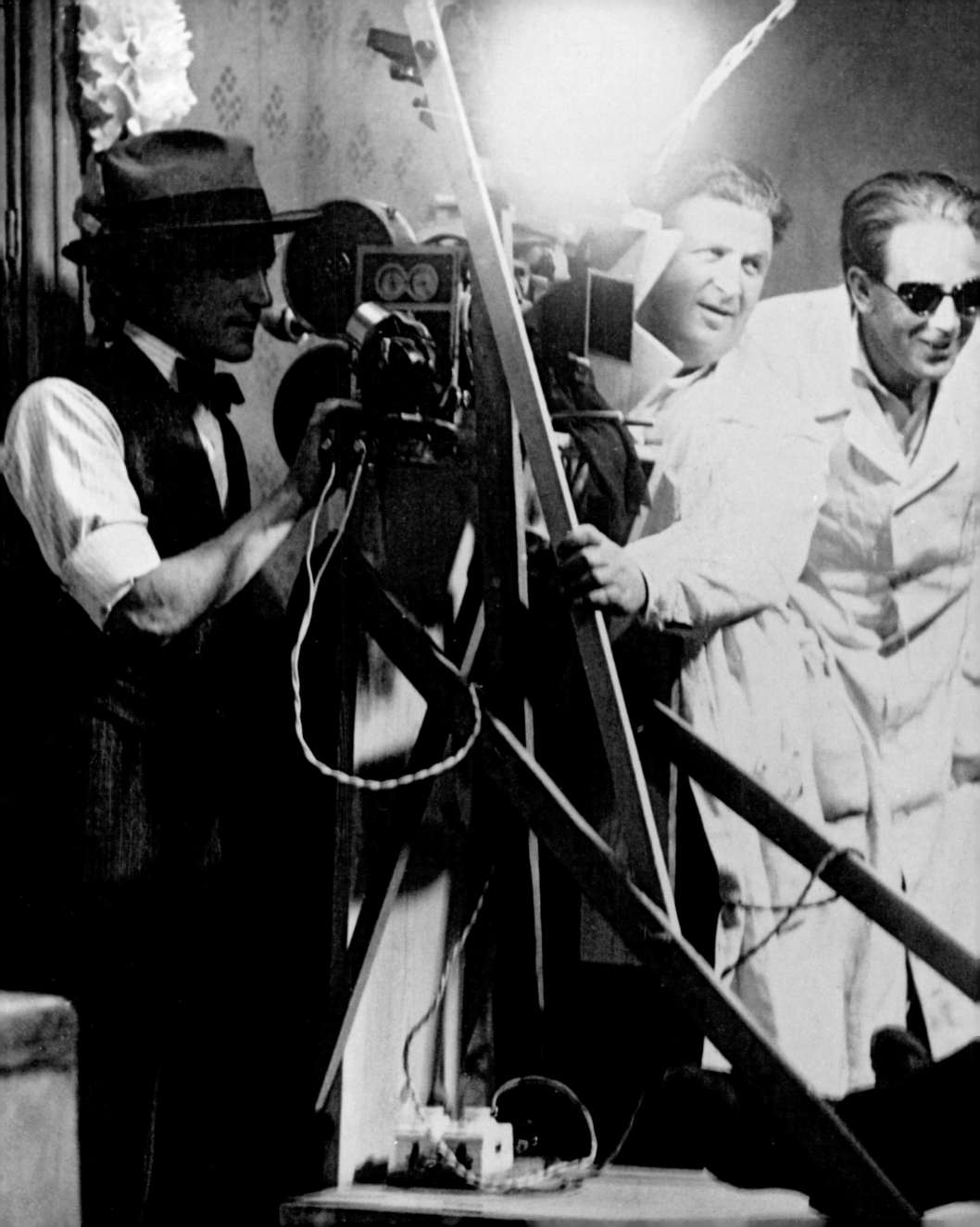

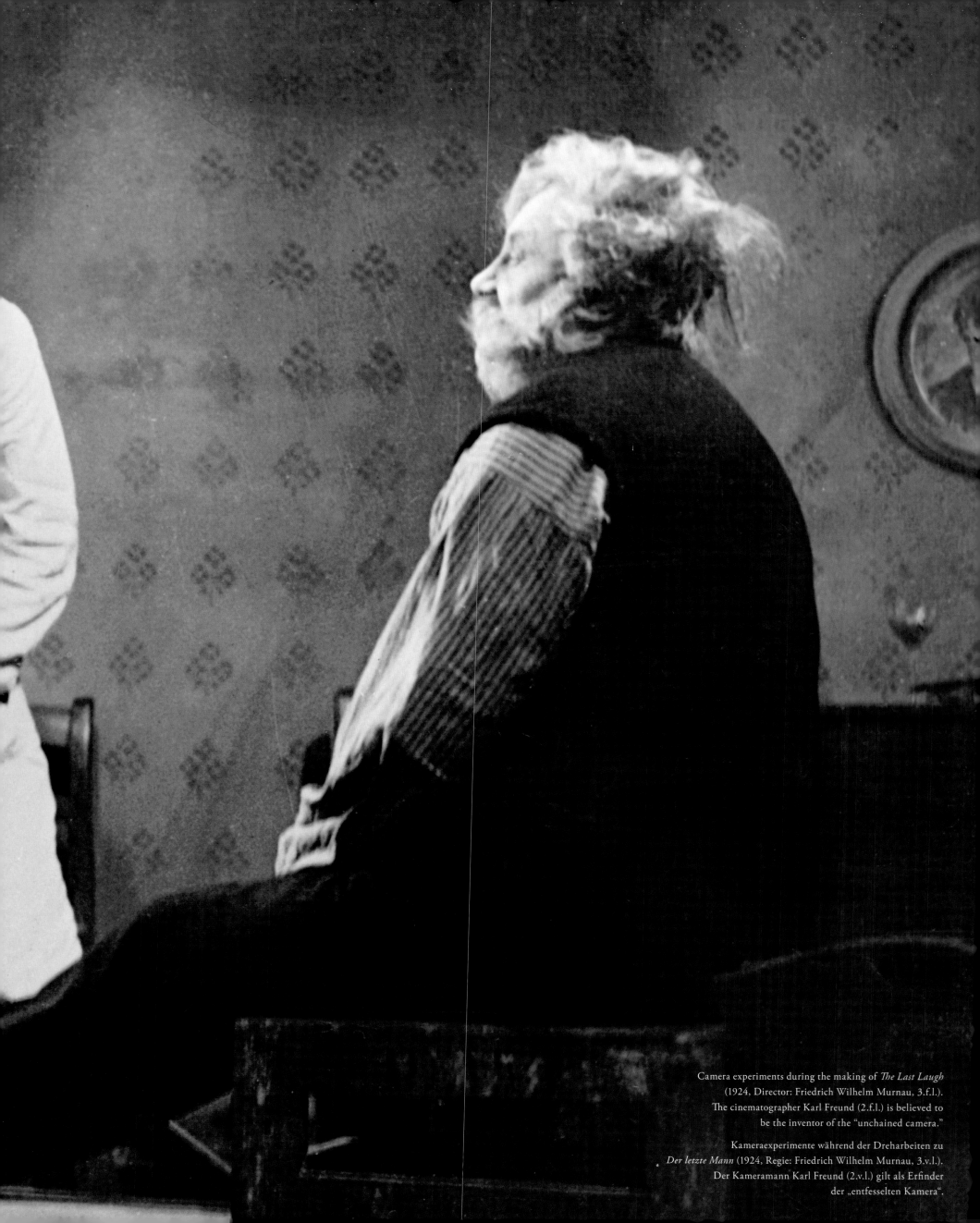

Camera experiments during the making of *The Last Laugh*
(1924, Director: Friedrich Wilhelm Murnau, 3.f.l.).
The cinematographer Karl Freund (2.f.l.) is believed to
be the inventor of the "unchained camera."

Kameraexperimente während der Dreharbeiten zu
Der letzte Mann (1924, Regie: Friedrich Wilhelm Murnau, 3.v.l.).
Der Kameramann Karl Freund (2.v.l.) gilt als Erfinder
der „entfesselten Kamera".

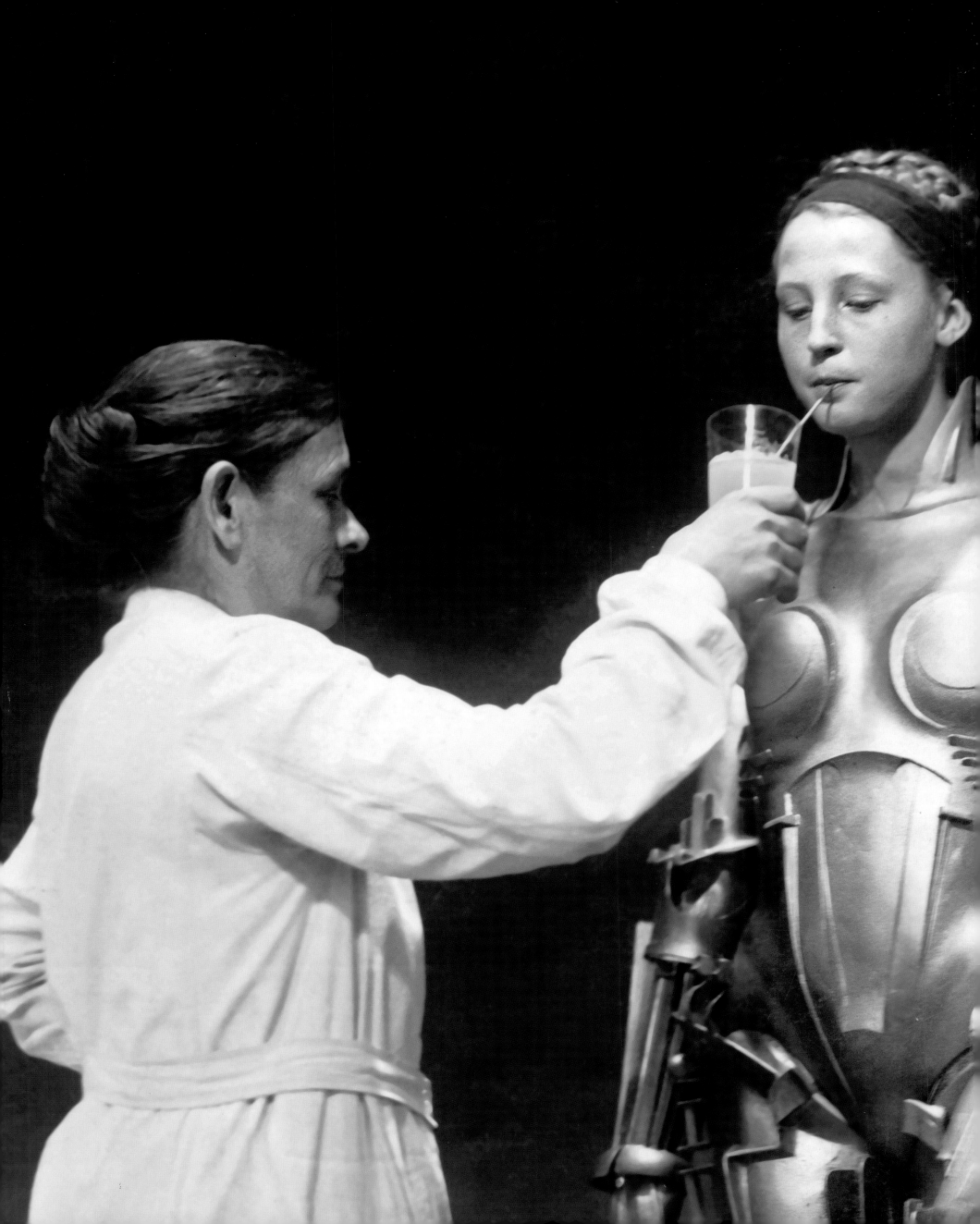

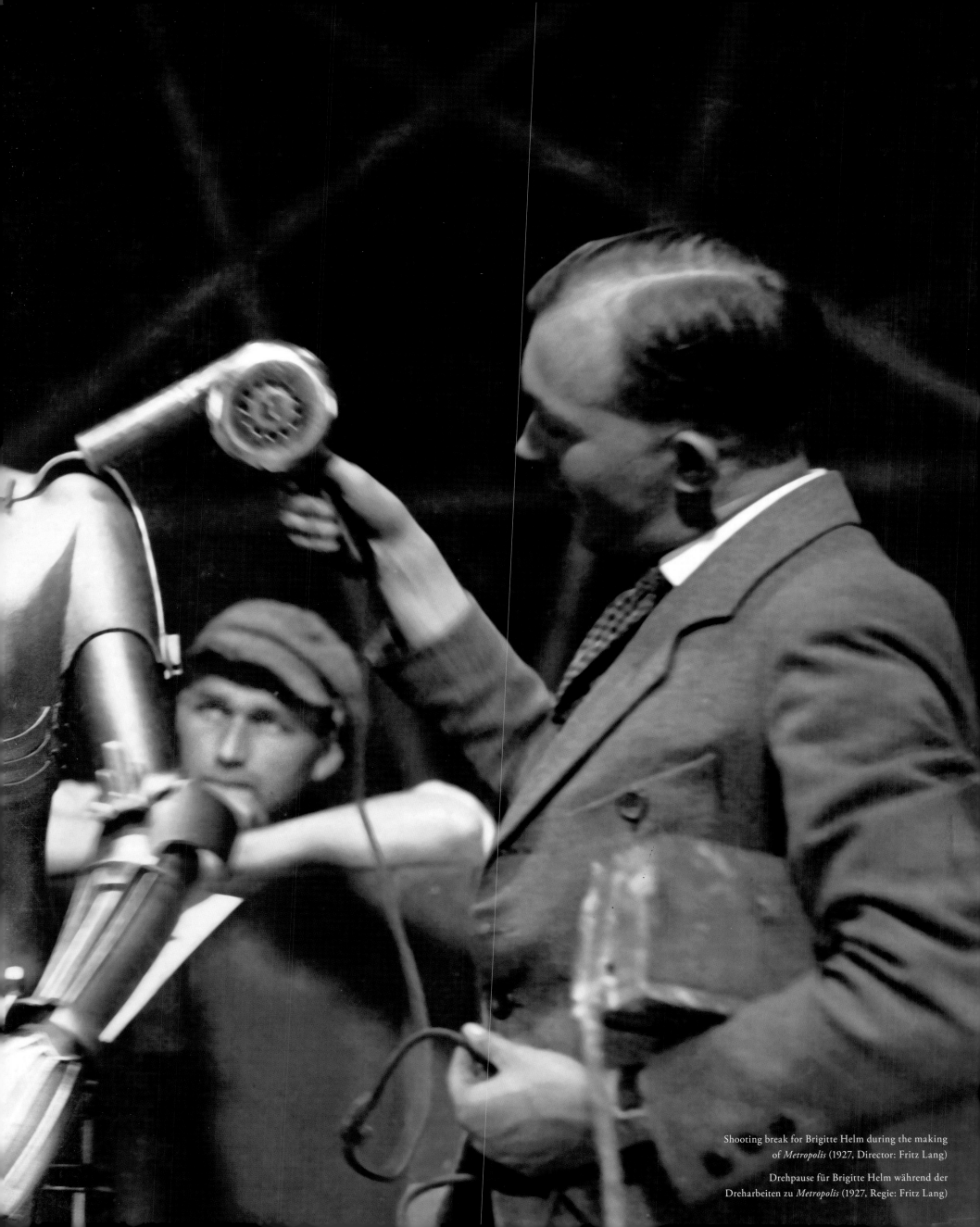

Shooting break for Brigitte Helm during the making
of *Metropolis* (1927, Director: Fritz Lang)

Drehpause für Brigitte Helm während der
Dreharbeiten zu *Metropolis* (1927, Regie: Fritz Lang)

Image mashup by Volker Noth, using a production
photograph from *Asphalt* (1929, Director: Joe May)

Bildcollage von Volker Noth unter Verwendung eines
Werkfotos aus *Asphalt* (1929, Regie: Joe May)

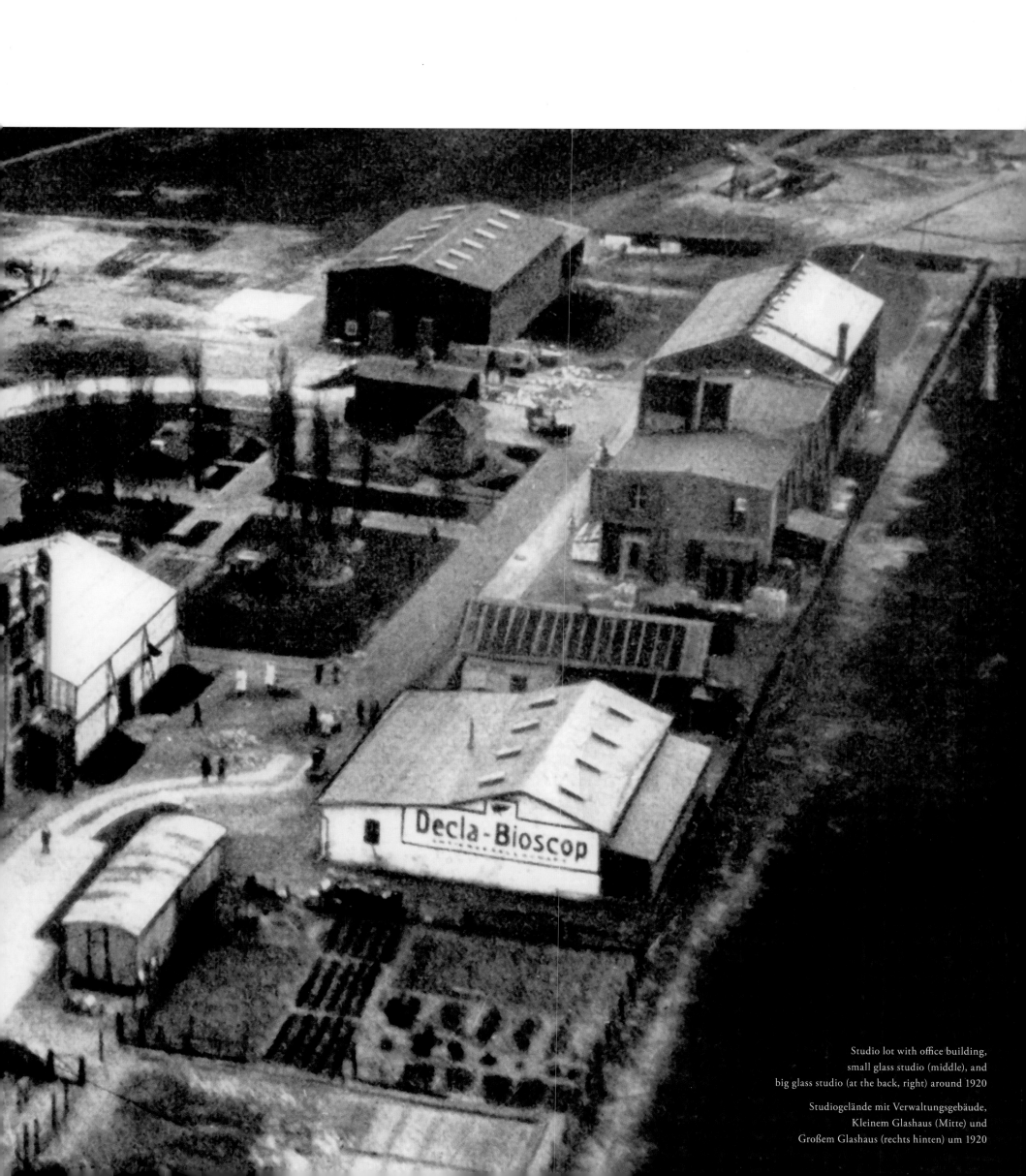

Studio lot with office building,
small glass studio (middle), and
big glass studio (at the back, right) around 1920

Studiogelände mit Verwaltungsgebäude,
Kleinem Glashaus (Mitte) und
Großem Glashaus (rechts hinten) um 1920

THE BEGINNINGS (1912–1921)

by Michael Wedel

The heart of the German film industry beats in Babelsberg—Neubabelsberg, as it was called then—during the mid-1920s and the Ufa studios are the Mecca of European film art. Filmmakers from Hollywood and Europe alike pilgrimage to Berlin's outskirts in order to learn about production processes under the aegis of legendary producer Erich Pommer (*Metropolis, The Blue Angel*) and to update their knowledge of film technology and design. Methods and visions of famous directors like Friedrich Wilhelm Murnau or Fritz Lang, leading cinematographers like Carl Hoffmann or Karl Freund, scenographers like Robert Herlth or Otto Hunte, and special effects artists like Eugen Schüfftan or Erich Kettelhut all attract worldwide attention—and with it, the international film scene. Alfred Hitchcock shoots in Babelsberg in 1925, watching Murnau at work in the next studio. A year later, Sergei Eisenstein is given a tour of the sets for *The Last Laugh* (1924) and *Metropolis* (1927).

The press reports almost daily about shoots and star performances, spectacular effects and breathtaking backdrops. Authors and artists are inspired by "the magic of film"[1] and contribute to its glow. In 1926, cultural theorist Siegfried Kracauer details his impressions of the "Filmstadt zu Neubabelsberg:"

> The ruins of the universe are stored in warehouses for sets, representative samples of all periods, peoples, and styles. Near Japanese cherry trees, which shine through the corridors of dark scenery, arches the monstrous dragon from *Die Nibelungen*, devoid of the diluvial terror it exudes on the screen. [...] The world's elements are produced on the spot in immense laboratories. The process is rapid: the pieces are prepared individually and delivered to their locations, where they remain patiently until they are torn down. They are not organisms that can develop on their own. Wood-working shops, glassmaking shops, and sculpture studios provide what is necessary. There is nothing false about the materials: wood, metal, glass, clay. One could also make real things out of them, but as objects in front of the lens [*Objektiv*] the deceptive ones work just as well. After all, the lens is objective [*objektiv*].[2]

A short time later, Alfred Polgar goes on an exploratory tour of the "romantic site" surrounded by sandy soil and meadows at the "farthest end of the city, where it is actually city no longer," and which gives off the impression of a "wondrous children's playground" with its "various fantasy backdrops." And no less precisely than Kracauer does his colleague Polgar, recently arrived from Vienna, perceive the calculus underlying this romanticism: "It all looks so great … and

Director Fritz Lang

Regisseur Fritz Lang

Guido Seeber behind the camera with the film crew in 1911

Guido Seeber hinter der Kamera mit Filmteam, 1911

DIE ANFÄNGE (1912–1921)

Michael Wedel

Das Herz der deutschen Filmindustrie schlägt Mitte der 20er Jahre in Babelsberg, das damals noch Neubabelsberg hieß, die Ufa-Studios sind das Mekka der europäischen Filmkunst. Filmschaffende aus Hollywood, aber auch aus europäischen Ländern pilgern in das Umland Berlins, um sich über Herstellungsabläufe unter der Ägide des legendären Produzenten Erich Pommer (*Metropolis, Der blaue Engel*) zu informieren und in Sachen Filmtechnik und -architektur auf den neuesten Stand zu bringen. Arbeitsweisen und Visionen berühmter Regisseure wie Friedrich Wilhelm Murnau oder Fritz Lang, führender Kameraleute wie Carl Hoffmann oder Karl Freund, Szenografen wie Robert Herlth oder Otto Hunte, Trickspezialisten wie Eugen Schüfftan oder Erich Kettelhut ziehen weltweite Aufmerksamkeit auf sich und die internationale Filmszene scharenweise an. Alfred Hitchcock dreht 1925 in Babelsberg und schaut Murnau im Atelier nebenan bei der Arbeit zu, im Jahr darauf lässt sich Sergej Eisenstein durch die Kulissen von *Der letzte Mann* (1924) und *Metropolis* (1927) führen.

 Fast täglich berichtet die Presse über Dreharbeiten und Starauftritte, spektakuläre Filmtricks und atemberaubende Kulissenbauten. Literaten und Künstler lassen sich vom „Filmzauber"[1] inspirieren und tragen zu seinem Glanz bei. Der Kulturtheoretiker Siegfried Kracauer beschreibt 1926 seine Eindrücke aus der „Filmstadt zu Neubabelsberg":

> Trümmer des Universums lagern in den Requisitenhäusern, Belegexemplare sämtlicher Zeiten, Völker und Stile. Nahe bei japanischen Kirschenbäumen, die durch dunkle Kulissengänge leuchten, wölbt sich der Monstredrache aus den *Nibelungen*, seiner diluvialen Schrecken bar, die er auf der Leinwand entfaltet. [...] Die Weltelemente werden in umfänglichen Laboratorien an Ort und Stelle erzeugt. Das Verfahren ist prompt. Man richtet die Stücke einzeln her und schafft sie an ihren Platz, wo sie geduldig stehen bleiben, bis man sie wieder abreißt; Organismen, die sich auf eigene Faust entwickeln wollen, sind sie nicht. Tischlereien, Glasereien, Bildhauer-Werkstätten besorgen das Nötige. Die Stoffe: Holz, Metall, Glas, Ton, sind ohne Falsch. Auch richtige Dinge wären aus ihnen zu machen, aber vor dem Antlitz des Objektivs gelten die trügerischen eben so viel. Es ist objektiv.[2]

Von Sand- und Wiesenflächen umgeben, am „äußersten Ende der Stadt, wo sie das schon eigentlich gar nicht mehr ist", begibt sich Alfred Polgar wenig später auf Erkundungstour in ein „romantisches Gelände", das mit seiner „vielgestaltigen Phantasiekulisse" einen „wundervollen Kinderspielplatz" abgäbe. Nicht weniger präzise als Kracauer erfasst der aus Wien zugezogene Kritikerkollege das Kalkül, dem sich diese Romantik verdankt: „Großartig sieht das alles aus; und gering. Bezwingend; und kläglich. Kaum erschaffen; und längst gewesen. Fossiles Heute! Geister von Millionen Rentenmark umschweben es klagend."[3] Die Blauen Blumen, die zu Beginn

Poster for *Die Nibelungen* (1924, Director: Fritz Lang)

Plakat *Die Nibelungen* (1924, Regie: Fritz Lang)

small. Compelling … and feeble. Newly created … and long in existence. A fossilized present! The ghosts of millions of Rentenmark hover around it, wailing."[3] The Blue Flowers planted in the Brandenburg sand at the beginning of the 20th century still promised an artificial paradise—but only for a limited time. At least millions would see it.

Despite German film's heyday, the rather familiar, seemingly middle-class beginnings of the production facilities in Babelsberg are occasionally remembered, particularly by two of the most prominent figures of German cinema in the '20s: cinematographer Guido Seeber and Danish actress Asta Nielsen. As a creative duo, the two played a significant part in the foundation of Babelsberg as a film production site.

On the occasion of their collaboration on *Tragedy of the Street* (1927, Bruno Rahn), which was to be their last, Seeber recalls their first films made together at the beginning of the '10s. In contrast to that earlier time, a filmgoer now "no longer wants to see how the wall or the background was acquired. No, they want to be moved into the *milieu*, the atmosphere of the narrative."[4] But just as Seeber at that moment is also celebrating the great progress compared with the early days of narrative cinema, especially with regard to film narration and technology, in the 1930 retrospective honoring the completion of the brand-new Ufa sound film studio he cannot help but mention that, dating back to 1912, "sound-pictures" (Tonbilder) had already been filmed in Babelsberg, "as any audience could see in every major cinema about 20 years ago."[5]

In an article series in the *B.Z. am Mittag* at the end of the '20s, Asta Nielsen also sees her "path through film" pass by in review.[6] Under the direction of Urban Gad, to whom she was also married from 1912 to 1918, she suddenly became one of the most popular female film stars. It was not only film critic Rudolf Kurtz who knew the reason for the feverish popularity surrounding Asta Nielsen after 1910, which was that something resembling *film art* only became really apparent when she made an appearance on screen: "Films up to that point might have succeeded at shocking or entertaining the audience—but her films succeed at making the audience *tremble*."[7] In 1928, the silent film diva herself rather dryly noted, that the success of her first films was "so strong" that the Bioscop production company extended the contract with her and Gad for eight more films. But not only that: "For my films back then, Bioscop had the first large film studio in Germany created in Neubabelsberg."[8]

Decla-Bioscop editing room around 1920

Kleberei der Decla-Bioscop, um 1920

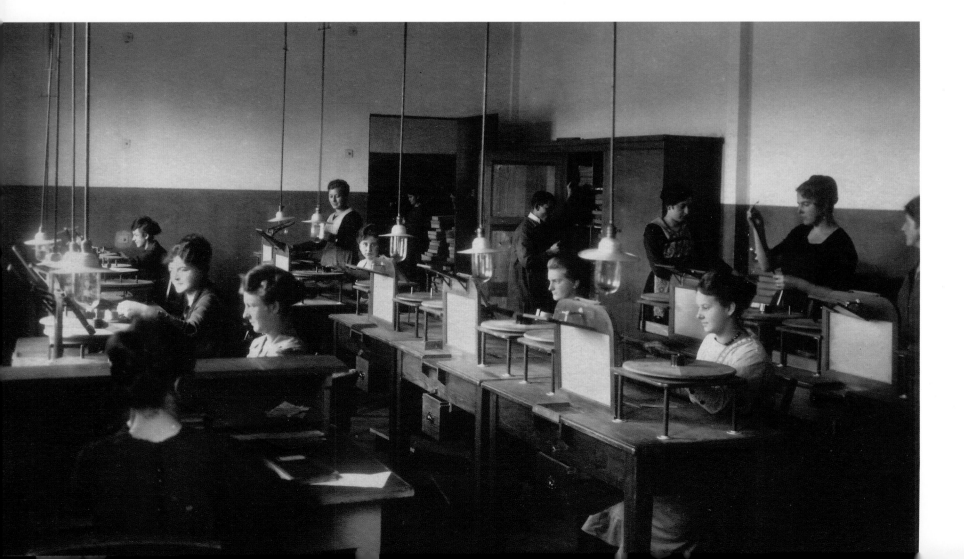

des 20. Jahrhunderts in den märkischen Sand gepflanzt werden, verheißen künstliche Paradiese –
doch nur noch auf begrenzte Zeit. Das aber immerhin für Millionen.

Gelegentlich wird zu dieser Glanzzeit des Films an die noch eher mittelständisch-familiär
anmutenden Anfänge des Produktionsbetriebs in Babelsberg erinnert, unter anderem von
zwei noch in den 20er Jahren prägenden Gestalten des deutschen Films: dem Kameramann
Guido Seeber und der dänischen Schauspielerin Asta Nielsen. Als kreatives Doppelgestirn hatten sie
seinerzeit entscheidenden Anteil an der Begründung von Babelsberg als Filmproduktionsstandort.

Anlässlich ihrer jüngsten Zusammenarbeit an *Dirnentragödie* (1927, Bruno Rahn), die
zugleich ihre letzte bleiben sollte, bringt Seeber die ersten gemeinsamen Filme vom Anfang der
10er Jahre in Erinnerung. Im Unterschied zu damals wolle man nun „nicht mehr sehen, wie die
Wand oder der Hintergrund beschaffen ist, nein, man will in das Milieu, die Atmosphäre der
Spielhandlung versetzt werden".[4] Feiert Seeber an gleicher Stelle noch die grandiosen Fortschritte,
die im Vergleich zur Frühzeit des Erzählfilms vor allem auf den Gebieten der Filmdramaturgie
und Filmtechnik zu beobachten seien, so kann er sich in einem 1930 veröffentlichten Rück-
blick angesichts der Fertigstellung der brandneuen Ufa-Tonfilmateliers doch den Hinweis nicht
verkneifen, schon 1912 seien in Babelsberg „Tonbilder" gedreht worden, „wie sie vor etwa
20 Jahren in jedem größeren Lichtbildtheater das Publikum sehen konnte".[5]

In einer Artikel-Serie in der *B.Z. am Mittag* lässt Ende der 20er Jahre auch Asta Nielsen
ihren „Weg im Film" Revue passieren.[6] Unter der Regie Urban Gads, mit dem sie von 1912 bis
1918 auch verheiratet war, wurde sie schlagartig zu einem der beliebtesten weiblichen Filmstars
überhaupt. Nicht nur der Filmkritiker Rudolf Kurtz erkannte den Grund für Asta Nielsens ab
1910 fieberhaft um sich greifende Popularität darin, dass mit dem Erscheinen ihrer Persönlichkeit
auf der Leinwand so etwas wie Filmkunst erstmals wirklich sichtbar geworden sei: „Wenn es
bisher gelungen war, mit dem Film ein Publikum zu spannen oder zu erheitern – mit ihren Filmen
gelang es, das Publikum zu *erschüttern*".[7] Die Stummfilm-Diva selbst stellt 1928 eher nüchtern
fest, der Erfolg ihrer ersten Filme sei „dermaßen stark" gewesen, dass die Produktionsfirma
Bioscop den Vertrag mit ihr und Gad um acht weitere Filme verlängert habe. Jedoch nicht nur das:

Small glass studio around 1912

Kleines Glashaus, um 1912

In reality, it was indeed the profits from the first Asta Nielsen films *Burning Blood* and *The Moth* already shot in the Berlin studio at Chausseestraße 123 as well as the option to extend their contract with the Danish star and her director that put the Deutsche Bioscop GmbH in the position to look for a new studio site outside the city limits in the fall of 1911. The task of finding the right location on the outskirts of Berlin fell on the shoulders of Guido Seeber. Seeber, who had been employed as a photo technician in the family business of the future owner of Bioscop, Carl Schleussner, functioned since 1908 as the first cinematographer and technical director of the film company. With Schleussner's complete takeover of Bioscop in August 1909, the office of studio director was transferred from the firm's founder Jules Greenbaum, who let his shares pay out, to Erich Zeiske, who was responsible for Asta Nielsen's later employment.[9] In the summer of 1911, the signs pointed toward expansion and Seeber, as technical director of the company and permanent cinematographer of the Asta Nielsen films, was the man to actually carry it out.

In Babelsberg—part of the town of Nowawes at the time—Seeber found an open field containing an empty factory where artificial flowers and decorative items had once been manufactured, and which had also temporarily served as a feed depot. The convenient train connection to Berlin, a power plant nearby, but, most importantly, the lack of any neighboring building, which offered optimal lighting conditions and great possibilities for expansion, were in the site's favor. The existing building was renovated under Seeber's leadership and, on October 14, 1911, he applied for permission to build a glass studio onto the available factory building. The permission was granted on November 3, 1911.

The plans for the first glass film studio on German soil came from the C.H. Ulrich Company, which specialized in photo studios. Over a surface area of 3,200 square feet, a studio building was erected measuring 45 x 60 feet and cut to certain specifications for filmmaking. Not only was a special cement-less glazing developed for the glass but even the supporting beams of the infrastructure had to be installed outside of the studio, so as not to spoil the sunlight when it fell; it was still the preferred light source at the time. Since Bioscop was only renting the property at the time, the building's beams were only screwed in rather than riveted, so that it could be

„Damals ließ die ‚Bioscop' für meine Filme das erste große Filmatelier in Deutschland herstellen, und zwar in Neubabelsberg."[8]

Tatsächlich waren es die Einnahmen aus den ersten, 1911 noch im Berliner Atelier in der Chausseestraße 123 gedrehten Asta-Nielsen-Filmen *Heißes Blut* und *Nachtfalter* sowie die Option auf eine Vertragsverlängerung mit dem dänischen Star und seinem Regisseur, wodurch die Deutsche Bioscop Gesellschaft m.b.H. in die Lage versetzt war, sich im Herbst 1911 nach einem neuen Studiogelände außerhalb der Stadtgrenzen umzusehen. Die Aufgabe, einen geeigneten Standort im Umland Berlins zu finden, fiel Guido Seeber zu. Seeber, der bereits seit 1907 als Fototechniker im Familienunternehmen des späteren Eigentümers der Bioscop, Carl Schleussner, beschäftigt war, fungierte seit 1908 als erster Kameramann und technischer Leiter der Filmfirma. Mit der vollständigen Übernahme der Bioscop durch Schleussner im August 1909 ging die Funktion des Studiodirektors von Firmengründer Jules Greenbaum, der sich seine Anteile auszahlen ließ, auf Erich Zeiske über, der für das spätere Engagement Asta Nielsens verantwortlich war.[9] Im Sommer 1911 standen die Zeichen auf Expansion, und Seeber war der Mann, der sie in seinen Funktionen als technischer Leiter der Firma und als fester Kameramann der Asta-Nielsen-Filme praktisch umzusetzen hatte.

In Babelsberg – zu dieser Zeit Teil der Ortschaft Nowawes – fand Seeber ein auf freiem Gelände leerstehendes Fabrikgebäude, das früher einmal zur Herstellung von Kunstblumen und Dekorationsartikeln sowie kurzzeitig als Futtermitteldepot gedient hatte. Die verkehrsgünstige Bahnanbindung nach Berlin, ein in der Nähe gelegenes Elektrizitätswerk, vor allem aber der Umstand einer fehlenden Nachbarbebauung, wodurch sich optimale Lichtverhältnisse und großzügige Expansionsmöglichkeiten boten, sprachen für das Gelände. Unter Leitung Seebers wurde das bestehende Gebäude hergerichtet und am 14. Oktober 1911 die Bauerlaubnis für ein Glashaus als Anbau an das vorhandene Fabrikgebäude durch die Bioscop beantragt. Die Genehmigung wurde am 3. November 1911 erteilt.

Die Pläne für den Bau des ersten zu ebener Erde gelegenen Glashaus-Filmstudios Deutschlands stammten von der bis dahin auf Fotoateliers spezialisierten Firma C.H. Ulrich. Auf einer Grundfläche von 300 m² entstand ein Studiobau mit den Abmessungen 15 m x 20 m, der auf die speziellen Bedürfnisse der Filmarbeit zugeschnitten war: Es wurde nicht nur eine kittlose Spezialverglasung entwickelt, auch die Stützverstrebungen der Trägerkonstruktion brachte man extra außerhalb des Ateliers an, um den Einfall des Tageslichts – zu dieser Zeit noch immer die für Filmaufnahmen bevorzugte Lichtquelle – nicht zu beeinträchtigen. Da Grund und Boden von der Bioscop zu diesem Zeitpunkt nur gepachtet waren, wurden die Träger des Gebäudes nicht vernietet, sondern verschraubt, damit es gegebenenfalls ohne größere Umstände wieder abgebaut werden konnte. Im Unterschied zu bereits existierenden Glashaus-Ateliers, die etwa in Berlin und München auf mehrgeschossige Miets- und Bürohäuser „aufgesetzt" worden waren, bot die ebenerdige Lage des Babelsberger Neubaus der Bioscop den Vorzug, dass Lastwagen mit Requisiten

Bioscop drying room in 1919

Bioscop Trockenraum, 1919

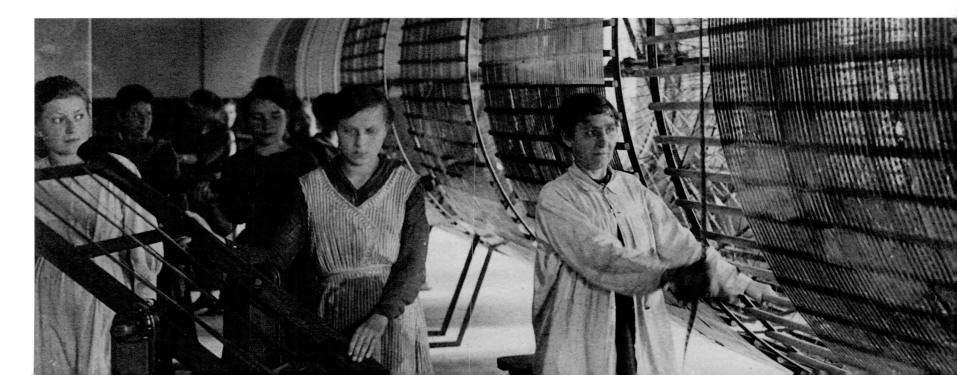

easily taken down should the situation arise. In contrast to already existing glasshouse studios that had been "set up" in Berlin and Munich in multi-level apartment blocks and office buildings, the ground level location of the new Bioscop building at Babelsberg had the advantage of trucks with props and sets being able to be driven through a sliding door directly into the glass studio with its average height of 20 feet.[10]

The ground floor of the immediately adjacent factory building accommodated wardrobe and prop rooms, a woodshop, art studio, and a canteen. On the first floor, the production company's office, as well as the laboratory for developing negatives and positives, were set up. On the floor above was where one found the dry drums for developed film material, the room in which the films were edited, and the rooms where intertitles were prepared. Except for the costume department, which would be built systematically a few years later, Bioscop oversaw a completely integrated film studio, which made it possible to perform most stages of film production on-site.

The glasshouse studio, built throughout the cold winter, was inaugurated on February 12, 1912, with the shooting of *Der Totentanz (The Dance to Death)*, the first film in the Asta Nielsen series 1912–13. It was followed that year with *Die Kinder des Generals (The General's Children)*, *Wenn die Maske fällt (When the Mask Drops)*, *Das Mädchen ohne Vaterland (The Girl Without a Homeland)*, *Jugend und Tollheit (Youth and Madness)*, *Komödianten (Comedians)*, and *Die Sünden der Väter (Sins of the Fathers)*: six more titles of the series, all directed by Urban Gad in Bioscop's glasshouse studio.[11]

Malwine Rennert, the only female German film critic at the time, gives an impression of the melodrama of *The Dance to Death*, typical for the Asta Nielsen films of this period:

> An unlucky engineer loses his good health when a boiler explodes; his wife (played by Asta Nielsen) claims she must go sing on stage to earn money for his care. She chooses the cabaret stage, where art is known to say less than frivolity. [...] She travels with a composer who loves her, and whom she begins to love, city after city. Adultery is in her heart; but she keeps her oath of fidelity, which she made to her husband upon leaving, locked away in a cabinet. The scenes in which the composer tries to break into this cabinet are of such brutality that I ask myself how she can stand to let the man see her again who robs her like a mugger and … what the censors thought when they approved this. But she, ever virtuous, not only sees him again, she does more: she dances a kind of snake dance, a bellydance. Movements like a panther's calculated to whip up sensuality. That's how easy women dance in oriental cities. [...] The composer goes into a frenzy, there's a brief struggle, she stabs him and kisses his corpse. That's the way she keeps her oath of fidelity [...].[12]

The Golem: How He Came into the World
(1920, Directors: Paul Wegener, Carl Boese)

Der Golem, wie er in die Welt kam
(1920, Regie: Paul Wegener, Carl Boese)

During the making of
The Dance to Death (1912, Director: Urban Gad)

Während der Dreharbeiten zu
Der Totentanz (1912, Regie: Urban Gad)

und Kulissenmaterial durch eine Schiebetür direkt in das verglaste Studio mit einer mittleren Höhe von sechseinhalb Metern hineinfahren konnten.[10]

Im Erdgeschoss des unmittelbar angrenzenden Fabrikgebäudes brachte man Garderoben und Requisitenräume, Tischlerei und Malerei sowie eine Kantine unter. In der ersten Etage wurden das Büro der Produktionsgesellschaft sowie Negativ- und Positiventwicklungslabors eingerichtet. Im zweiten Stock befanden sich die Trockentrommeln für das entwickelte Filmmaterial, die Kleberei, in der die Filme geschnitten wurden, sowie die Räume, in denen die Zwischentitel angefertigt wurden. Mit Ausnahme des Kostümfundus, der erst einige Jahre später systematisch aufgebaut wurde, verfügte die Bioscop damit über ein vollständig integriertes Filmstudio, das sämtliche Arbeitsschritte der Filmproduktion vor Ort ermöglichte.

Eingeweiht wurde das den kalten Winter hindurch errichtete Glashaus-Studio am 12. Februar 1912 mit Dreharbeiten zu *Der Totentanz*, dem ersten Film der Asta-Nielsen-Serie 1912/13. Ihm folgten noch im gleichen Jahr mit *Die Kinder des Generals*, *Wenn die Maske fällt*, *Das Mädchen ohne Vaterland*, *Jugend und Tollheit*, *Komödianten* und *Die Sünden der Väter* sechs weitere Titel der Serie, die sämtlich Urban Gad im ersten Glashaus-Studio der Bioscop inszeniert hatte.[11]

Malwine Rennert, die einzige deutsche Filmkritikerin jener Zeit, vermittelt anhand des Plots von *Der Totentanz* einen Eindruck der für die Asta-Nielsen-Filme dieser Jahre typischen Melodramatik:

> Ein unglücklicher Ingenieur verliert bei einer Kesselexplosion seine Gesundheit; seine Frau (gespielt von Asta Nielsen) behauptet, sie müßte zur Bühne gehen, um Geld für ihn, für seine Pflege zu ersingen. Sie wählt die Kabarettbühne, wo bekanntlich die Kunst wenig, die Frivolität sehr viel zu sagen hat. [...] Sie reist mit einem Komponisten, der sie liebt, und den sie auch liebt von Stadt zu Stadt. Der Ehebruch ist schon im Herzen; aber der Treueschwur, den sie ihrem Gatten beim Abschiede geleistet, hält sie äußerlich in Schranken. Die Szenen, in denen der Komponist versucht, diese Schranken zu durchbrechen, sind von einer Brutalität, daß man sich verwundert fragt, wie sie den Menschen je wieder vor sich lassen kann, der sie wie ein Straßenräuber überfällt, und – was die Zensoren dachten, als sie das genehmigten. Aber sie, die Tugendhafte, empfängt ihn nicht nur wieder; sie tut mehr: Sie tanzt eine Art Schlangentanz, einen Bauchtanz. Bewegungen wie die eines Panthers darauf berechnet, die Sinnlichkeit aufzupeitschen; so tanzen die verkäuflichen Frauen in den orientalischen Städten. [...] Der Komponist verfällt in Raserei, ein kurzes brutales Ringen, sie ersticht ihn und küsst den Toten. Damit vermeint sie den Treueschwur zu wahren [...].[12]

Schon im Herbst 1912 begann man mit dem Bau einer weiteren Produktionsanlage, die ursprünglich ausschließlich für Filme mit Asta Nielsen genutzt werden sollte. Der Erfolg ihrer Filme war weiterhin die wirtschaftliche Voraussetzung für die Expansion der Filmfirma auf dem Gelände in Babelsberg.

The Danish silent film diva Asta Nielsen

Die dänische Stummfilm-Diva Asta Nielsen

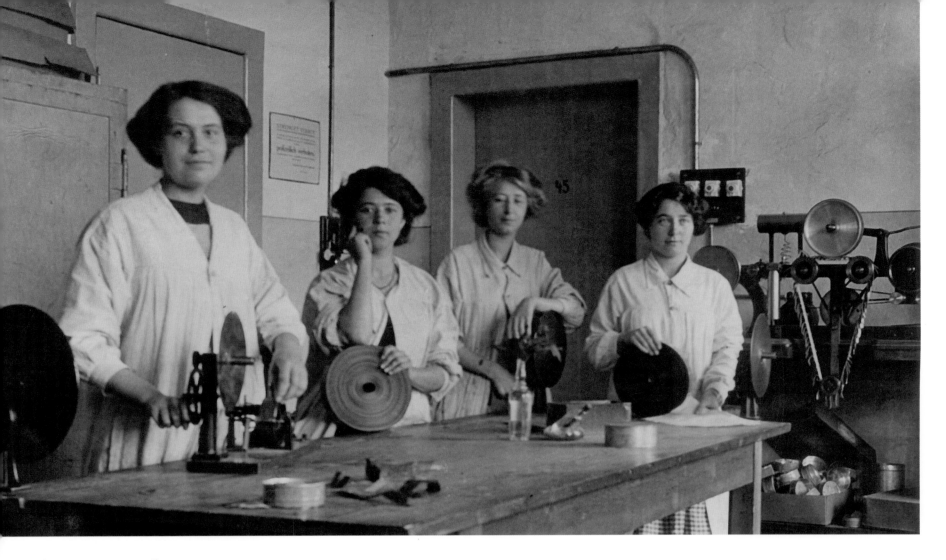

The Bioscop printing staff
around 1914

Mitarbeiterinnen der Bioscop
Kopieranstalt, um 1914

In the fall of 1912, construction had already begun on another production facility, which initially was to be used exclusively for films with Asta Nielsen. The success of her films continued to be the economic condition for the expansion of the film company on the Babelsberg property.

The expansion itself was made possible by the purchase of an adjacent 10-acre lot, a deal which Seeber was only able to conclude with difficulty, and only "indirectly."[13] Another glasshouse studio with a surface area of 4,800 square feet was built to the south at a sufficient distance from the existing studio building, which could not be shaded, as well as a two-story duplication facility whose exterior was designed so that it could also serve as a backdrop for outdoor shots. The exterior façade was built in two different styles: modern windows to the left of the door, gothic windows to the right. "Even the rooftop was covered with different types of tiles," Seeber recalls, "so we could have German, Italian, or Spanish tiles available at any time for recording purposes."[14]

On February 15, 1913, one year after the first film was shot in Babelsberg, another complete production facility on the studio property could be put into operation. From then on, the older studio was named the "small glasshouse," and the new one the "large glasshouse." But in this "large glasshouse," Asta Nielsen was contracted for only one more film before Seeber's camera: the retakes of *Der Tod in Sevilla (Death in Seville,* 1913), which had mostly been shot near Granada and Seville. Seeber's fellow cameraman Karl Hasselmann remembers how these retakes proceeded:

> I still remember how the new studio was used for the first time by Asta Nielsen. They tried for weeks to get sharp images out of it. [...] That was our gold mine back then, the Nielsen films, and they [Asta Nielsen and Urban Gad] had to be obeyed. They sat directly in front of the screen during the test screenings and as soon as a small, unclear movement came up: "Halt! Stop! Unclear. Do it again!" The scene would then be repeated another day, shot yet again, and it went on like that for a while. Good ol' Seeber was sweating bitterly in the meantime [...]."[15]

A little later, Paul Davidson's Projektions-AG "Union" (PAGU), in whose name Bioscop had manufactured the Nielsen-Gad films up until that point, reappropriated the lucrative Asta Nielsen films and withdrew the star, together with her director and now husband, from Babelsberg to the recently completed stage in Berlin-Tempelhof.

To handle the departure of Nielsen and Gad in the season of 1913–14, Bioscop tried to secure contracts with a whole cast of known theater stars. They proudly announced all of the big-name

Die Expansion selbst wurde durch den Ankauf eines angrenzenden Grundstücks von 40 000 m²
ermöglicht, den Seeber im Auftrag der Bioscop – nicht ohne Schwierigkeiten und nur „auf
Umwegen"¹³ – tätigen konnte. Südlich und in gebotener Entfernung zum bestehenden Studiobau,
der nicht beschattet werden durfte, entstand ein weiteres Glashaus-Atelier mit einer Grundfläche
von 450 m² sowie ein zweigeschossiges Kopierwerk, dessen Außenfassade so gestaltet war, dass
es gleichzeitig als Kulisse für Freiaufnahmen dienen konnte. Die Außenfront wurde in zwei
verschiedenen Stilarten ausgebaut, links der Haustür befanden sich moderne, rechts gotische
Fenster. „Selbst der Dachaufbau wurde mit verschiedenen Ziegelformen bedeckt", erinnerte
sich Seeber, „um sowohl deutsche wie auch italienische oder spanische Dachformen jederzeit für
Aufnahmezwecke zur Verfügung zu haben".¹⁴

Nur ein Jahr nachdem in Babelsberg die erste Klappe gefallen war, konnte am 15. Februar 1913
eine weitere komplette Produktionsanlage auf dem Studiogelände in Betrieb genommen werden.
Das ältere Atelier hieß seitdem „kleines Glashaus", das neue wurde „großes Glashaus" genannt.
Im „großen Glashaus" sollte Asta Nielsen jedoch nur für einen weiteren Film vor Seebers Kamera
stehen und dies lediglich noch im Rahmen von Nachaufnahmen zu *Der Tod in Sevilla* (1913), der
überwiegend in Spanien – in der Umgebung von Granada und in Sevilla – gedreht worden war.
An den Hergang dieser Nachaufnahmen erinnert sich Seebers Kamerakollege Karl Hasselmann:

> Ich weiß noch, wie anfangs das neue Atelier zum ersten Mal von Asta Nielsen benutzt wurde, da haben
> die wochenlang probiert, um scharfe Bilder rauszubekommen. [...] Das war damals sozusagen unsere
> Goldgrube, die Nielsen-Filme, und denen [gemeint sind Asta Nielsen und Urban Gad, M.W.] mußte
> gehorcht werden. Die haben sich bei den Probevorführungen direkt vor die Leinwand gesetzt, und sowie eine
> kleine unscharfe Bewegung kam: ‚Halt, aufhören, unscharf, noch mal!' Anderntags wurde die Szene
> wiederholt, noch mal gedreht, das ging 'ne ganze Weile so. Der gute Seeber hat dabei bitter geschwitzt [...].¹⁵

Alexander Moissi, known as a theater
actor, was under contract at the Bioscop
in 1913–14

Alexander Moissi, bekannt als
Bühnenschauspieler, bei der Bioscop
1913/14 unter Vertrag

Wenig später nahm Paul Davidsons Projektions-AG „Union" (kurz: PAGU), in deren Auftrag
die Bioscop die Nielsen-Gad-Filme bis dahin hergestellt hatte, die Produktion der lukrativen
Asta-Nielsen-Filme selbst in die Hand und zog den Star samt seines Regisseurs und frisch-
gebackenen Ehemanns aus Babelsberg in das eben fertiggestellte Atelier nach Berlin-Tempelhof ab.

Shooting in the big glass studio around 1914

Dreharbeiten im Großen Glashaus, um 1914

Tilla Durieux, a new star at the Bioscop as of 1913–14

Tilla Durieux, ab 1913/14 neuer Star bei der Bioscop

During the making of
The Golem: How He Came into the World (1920)

Während der Dreharbeiten zu
Der Golem, wie er in die Welt kam (1920)

actors under contract in one of their own advertising brochures: Alexander Moissi, Paul Wegener, Tilla Durieux, Lucie Höflich, Grete Wiesenthal, and Grete Berger. Among the writers and directors, author Hanns Heinz Ewers and Danish director Stellan Rye were emphasized, as they chalked up a great and noteworthy success with their 1913 "artist film," *The Student of Prague*. In retrospect, the film's star Paul Wegener formulates the credo of the fantasy doppelgänger story filmed primarily in Prague: "The real poet of the film has to be the *camera*."[16] This also applies for Wegener's follow-up fantasy films drawn from legend and fairytale, *The Golem* (1914) and *Old Nip's Wedding* (1916), which he wrote and directed without Stellan Rye, who fell fighting for Germany in the first months of World War I.[17] But Erich Zeiske had already pointed out that it would be "unfair" not to emphasize the accomplishments of cinematographer Guido Seeber as well. He was the one who had made the film implementation of the fantastic possible, with his multiple exposure technique and other groundbreaking camera tricks:

> Whereas theater has three factors—writer, director, and actor—that work together to create the whole, cinema has a fourth factor, and that's the camera operator. Similar demands are made on his artistic imagination as that of the director. And Guido Seeber is one who demonstrates a rich range of such capabilities, as well as a complete mastery of all that is technical. In this fashion, we believe we have done all that is humanly possible to create art for the cinema.[18]

Alongside artistically ambitious films and the occasional "patriotic" film, Bioscop continues to serve other popular genres during the war years. Comedies, melodramas, and crime and detective films define the program. That is how Emil Albes is able to direct no less than ten films between March and December 1915, with telling titles such as *Die Rache des Blutes* (*Revenge of the Blood*), *Fräulein Barbier* (*Miss Barbier*) or *Der überfahrene Hut* (*The Flattened Hat*). Other dramas and comedies come from directors Louis Ralph (*Wie ich ermordet wurde*—*The Way I Was Murdered,* 1915; *Das Opfer der Nacht*—*The Victim of the Night*, 1915) and Walter Schmidthässler (*Und das Wissen ist der Tod*—*And to Know Is to Die*, 1915). In the summer of 1915, Joseph Delmont shoots a spectacular adventure film *Der Silbertunnel* (*The Silver Tunnel*) on the open-air exhibition ground.

With the type of glasshouse in Babelsberg (the same as PAGU's glass hall in their multi-level Tempelhof subterranean studio), Bioscop relied on sunlight to illuminate scenes shot in the studio. As a consequence, one had to aim for certain times of year—March until September—and of

Den Weggang von Nielsen und Gad versuchte die Bioscop in der Saison 1913/14 mit der Verpflichtung einer ganzen Reihe zumeist von der Bühne her bekannter Stars aufzufangen. Stolz verkündet sie in einer eigens hergestellten Werbebroschüre die Namen der bei ihr unter Vertrag stehenden Schauspieler Alexander Moissi, Paul Wegener, Tilla Durieux, Lucie Höflich, Grete Wiesenthal und Grete Berger. Unter den Autoren und Regisseuren werden besonders der Schriftsteller Hanns Heinz Ewers und der dänische Regisseur Stellan Rye hervorgehoben, die mit dem „Künstlerfilm" *Der Student von Prag* 1913 den größten Achtungserfolg verbuchen konnten. Dessen Hauptdarsteller Paul Wegener formuliert im Nachhinein das Credo dieser überwiegend vor Ort in Prag gedrehten fantastischen Doppelgänger-Geschichte um den Studenten Balduin: „Der eigentliche Dichter des Films muß die *Kamera* sein."[16] Dies gilt gleichermaßen für Wegeners folgende, dem Legenden- und Märchenfundus entnommene Fantasien *Der Golem* (1914) und *Rübezahls Hochzeit* (1916), die er – ohne den in den ersten Monaten des Ersten Weltkriegs auf deutscher Seite gefallenen Stellan Rye[17] – in Personalunion auch geschrieben und inszeniert hat. Aber schon Erich Zeiske hatte in der Werbebroschüre der Bioscop darauf hingewiesen, dass es „ungerecht" wäre, nicht auch auf die Verdienste des Kameramanns Guido Seeber hinzuweisen, der mit Mehrfachbelichtungen und anderen bahnbrechenden Kameratricks die filmgemäße Umsetzung der fantastischen Stoffe erst ermöglicht hat:

> Während beim Theater drei Faktoren: Dichter, Regisseur und Darsteller, zusammenwirken, um ein Ganzes zu schaffen, tritt beim Kino noch ein vierter Faktor, nämlich der Aufnahme-Operateur hinzu, an dessen Kunstauffassung und künstlerisches Empfinden dieselben Ansprüche gestellt werden, wie an den Regisseur. Und diese Fähigkeiten zeigt, verbunden mit einer vollkommenen Beherrschung alles Technischen, in reichem Maße eben Guido Seeber. – Auf diese Weise glauben wir alles getan zu haben, was in Menschenkräften steht, um für das Kino Kunst zu schaffen.[18]

Neben künstlerisch anspruchsvollen und vereinzelten „patriotischen" Filmen werden in den Kriegsjahren bei der Bioscop weiterhin beliebte Genres bedient. Komödien, Melodramen, Kriminal- und Detektivfilme bestimmen das Programm. So inszeniert etwa Emil Albes zwischen März und Dezember 1915 nicht weniger als zehn Filme mit sprechenden Titeln wie *Die Rache des Blutes*, *Fräulein Barbier* oder *Der überfahrene Hut*. Andere Dramen und Komödien stammen von den Regisseuren Louis Ralph (*Wie ich ermordet wurde*, 1915; *Das Opfer der Nacht*, 1915) und Walter Schmidthässler (*Und das Wissen ist der Tod*, 1915). Joseph Delmont dreht mit *Der Silbertunnel* im Sommer 1915 auf dem Freigelände einen spektakulären Abenteuerfilm.

Mit dem Typus des Glashauses setzte die Bioscop in Babelsberg (ebenso wie die PAGU mit ihrer Glashalle auf einem mehrstöckigen Unterbau in Tempelhof) auf die Verwendung von Sonnenlicht zur Ausleuchtung der im Studio aufgenommenen Szenen. Für die Dreharbeiten hatte das zur Folge, dass man sich nach den lichtgünstigen Zeiten des Jahres – den Monaten von März bis September – sowie des Tages – von 10 bis 11 Uhr und von 15 bis 17 Uhr – zu richten hatte, um eine gleichmäßige Beleuchtung der Szenen zu gewährleisten. Reguliert wurde

day—from 10 to 11 am and from 3 to 5 pm—to achieve an even illumination of the scenes. Incidental sunlight was regulated in the Babelsberg glass studios using a sophisticated curtain system, which was attached to the studios' ceilings and which blocked shadows cast by the sun that were not fitting for interior scenes. It soon became clear that dependence on natural lighting conditions was too much of a restriction on the shooting times in both glass studios. Though they had access to artificial light in the form of an arc light from so-called "Jupiter lamps," these lamps were only sporadically used to supplement natural light due to financial reasons. During the summer months, the powerful arcs of the arc lights—which heated up to temperatures of up to 3,600 degrees Fahrenheit—contributed to the already hot glass house, the "greenhouse temperature" and "inhuman heat" which Asta Nielsen remembered decades later.[19] Only in 1915 would Seeber expand the lamp park at Babelsberg studios and use artificial light for subtle effects, such as for the films of the *Homunculus* series (1916–17, 6 parts, Otto Rippert). Today's film historians still portray cinematographer Carl Hoffmann's stylized pictorial compositions and chiaroscuro effects for the sensational, gothic romance-inspired serial as "one of the unquestionable artistic triumphs of the film," and as prefiguring similar processes in the Weimar art and *auteur* films.[20]

Though the artificially lit studio was also implemented in Babelsberg in 1926 with its first massive, walled studio built to be cost-effective and efficient to use, both glasshouses were in operation until the end of the silent period.

As suggested by the architectural design of the duplication facility's façade, the considerable expansion of the company's property was undertaken not least in order to erect large-scale exterior and/or interior decorations outside, so one could locally shoot outdoors or indoors without costly trips to suitable locations. In addition, there was now the opportunity to leave standing sets erected for one film and use them for multiple films about similar subjects, which Seeber points out in his memoirs:

> The first building built on the newly acquired property was a circus, of which only three-eighths was actually built. This circus, which might have gone down in history, stood for about ten years as it was rented out to other companies and fulfilled its purpose in the best possible way. Even the first real, large exterior set, an Oriental and/or Arabic street designed and created by architect [Robert A.] Dietrich, also had an extended afterlife, forming the background of a large number of films, including those with Paul Wegener, Grete Wiesenthal, Tilla Durieux, and Carl Clewing.[21]

The Student of Prague
(1913, Director: Stellan Rye)
with Paul Wegener in the lead

Der Student von Prag
(1913, Regie: Stellan Rye)
mit Paul Wegener in der Hauptrolle

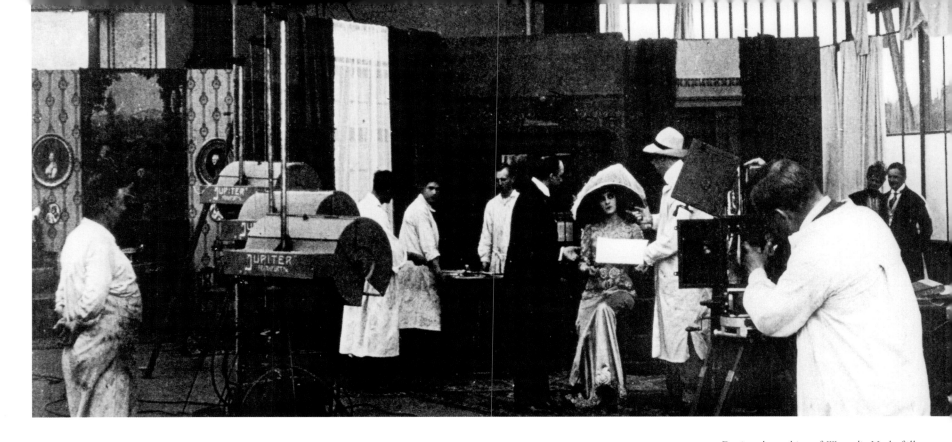

das einfallende Sonnenlicht in den Babelsberger Glasstudios mithilfe eines ausgeklügelten Vorhangsystems, das an den Glasdecken der Ateliers angebracht war und etwa einen für Innenszenen unpassenden, vom Stand der Sonne verursachten Schattenwurf verhinderte. Bald stellte sich jedoch heraus, dass die Abhängigkeit von natürlichen Lichtverhältnissen die Drehzeiten in beiden Glasateliers allzu sehr einschränkte. Obwohl von Anfang an Kunstlicht in Form des Bogenlichts von sogenannten Jupiter-Lampen vorhanden war, wurde es doch zunächst aus Kostengründen nur sporadisch zur Ergänzung des Naturlichts eingesetzt. Zur ohnehin schon großen Hitzeentwicklung im Glashaus während der Sommermonate trugen die mächtigen Lichtbögen der Bogenlampen – in denen Temperaturen von über 2 000 Grad Celsius herrschten – ihren Teil zu jener „Treibhaustemperatur" und „unmenschlichen Hitze" bei, an die sich Asta Nielsen noch im Alter erinnerte.[19] Erst um 1915 wurde der Lampenpark der Babelsberger Studios unter Seebers Federführung konsequent ausgebaut und das Kunstlicht zu subtilen Effekten genutzt, etwa für die Filme der *Homunculus*-Serie (1916/17, sechs Teile, Otto Rippert). Die von Kameramann Carl Hoffmann für die sensationelle, schauerromantisch inspirierte Fortsetzungsgeschichte bewerkstelligten stilisierten Bildlösungen und Hell-Dunkel-Wirkungen stellen heutigen Filmhistorikern zufolge „einen der fraglosen künstlerischen Triumphe des Films" dar und deuten auf ähnliche Verfahren des Weimarer Kunst- und Autorenfilms voraus.[20]

Obwohl sich in den 20er Jahren das Kunstlichtatelier aus Gründen der Wirtschaftlichkeit und effizienten Auslastung auch auf dem Studiogelände in Babelsberg durchsetzte, wo 1926 das erste massiv gemauerte Atelier gebaut wurde, blieben die beiden Glashäuser doch bis zum Ende der Stummfilmzeit in Betrieb.

Wie die architektonische Gestaltung der Fassade des 1913 erbauten Kopierwerkgebäudes nahelegt, war die beträchtliche Ausdehnung des Firmengeländes nicht zuletzt deshalb unternommen worden, um Dekorationen auch im Freien errichten zu können und auf diese Weise Außenaufnahmen bzw. Innenaufnahmen größeren Maßstabs direkt vor Ort und ohne kostspielige Reisen zu geeigneten Schauplätzen realisieren zu können. Zudem bot sich die Gelegenheit, einmal errichtete Kulissen auf dem Gelände stehen zu lassen und gleich für mehrere Filme mit ähnlichen Sujets zu nutzen, worauf auch Seeber in seinen Erinnerungen hinweist:

> Der erste Bau, der auf diesem neu erworbenen Gelände errichtet wurde, war ein Zirkus, von dem man allerdings nur drei Achtel des Umfangs aufbaute. Dieser fast historisch gewordene Zirkus, den man dann auch an andere Gesellschaften vermietete, hat fast zehn Jahre gestanden und seinen Zweck bestens erfüllt. Auch der erste wirklich große Freibau, eine orientalische bzw. arabische Straße, die von dem Architekten [Robert A.] Dietrich entworfen und ausgeführt wurde, hat ebenfalls die vorgenannte Lebensdauer überstanden und bildete den Hintergrund einer großen Reihe von Filmen, unter anderem mit Paul Wegener, Grete Wiesenthal, Tilla Durieux, Carl Clewing.[21]

With the circus set, which was first used in the summer of 1913 for the artist drama *The Master of Death* (Max Obal), Bioscop reacted to a wave of successful Danish films set in the circus milieu like *The Black Dream* (1911, Urban Gad) with Asta Nielsen and, especially, *The Four Devils* (1912, Alfred Lind). The cult of exoticism and fascination with the Orient are still quite visible in Kracauer's 1926 Babelsberg report. Testifying to this is the uninterrupted chain of Oriental exterior sets that likely graced the site over a decade. In the early years, not only was an Arabic street available, but also an "Indian temple court with a large pool," as director and cinematographer Rochus Gliese noticed on his first visit to Babelsberg in 1914. "Every corner of the property outside was different in style and time period," Gliese recalls and thereby hints at the quickly expanding dimensions of the plot.[22] By 1916, Bioscop's Babelsberg studio site had expanded to 18 acres, and the studio provided its own train line to quickly and comfortably reach individual exterior sets. At the end of the silent era, the total area of the site had grown to about 85 acres.

On April 29, 1920, Deutsche Bioscop merged with Decla-Filmgesellschaft Holz & Co. to form Decla-Bioscop AG, whose holdings were then completely taken over by Ufa in October 1921. Seeber had already left Bioscop and Babelsberg on March 31, 1920, prior to the acquisition of the property by the successor company headed by Erich Pommer. Only in the mid-'20s did Asta Nielsen stand once again in front of Seeber's camera: in 1924, for Paul Wegener's *Living Buddhas* in the Berlin Terra studio, and then for G.W. Pabst's *The Joyless Street* at the Staaken film facilities the following year. Asta Nielsen and Guido Seeber shot their last film together, *Tragedy of the Street*, not in Babelsberg, but in the Rexfilm studio in Berlin-Wedding. And yet the traces they have left behind on the history of Babelsberg studios can still be felt today.

The Seven Deadly Sins
(1920, Directors: Friedrich Zelnik, Heinrich Peer)

Die sieben Todsünden
(1920, Regie: Friedrich Zelnik, Heinrich Peer)

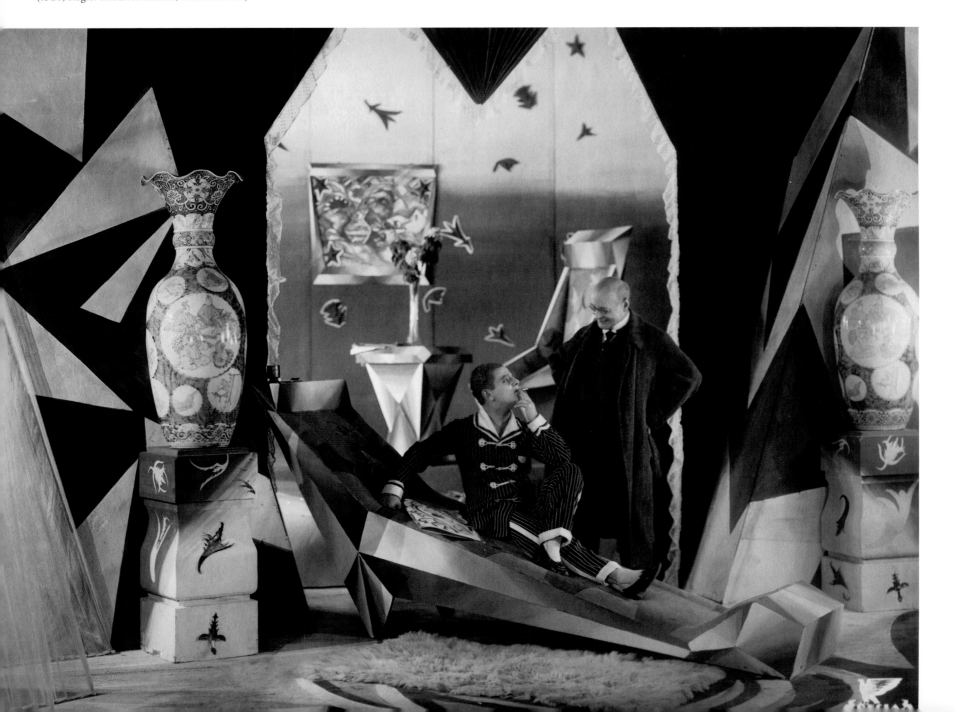

Mit dem Zirkusbau, der erstmals im Sommer 1913 für das Artistendrama *Der Herr des Todes*
(Regie: Max Obal) genutzt worden ist, reagierte die Bioscop auf eine Welle von im Zirkus-Milieu
angesiedelten dänischen Erfolgsfilmen wie *Der schwarze Traum* (1911, Urban Gad) mit Asta Nielsen
und vor allem *Die vier Teufel* (1912, Alfred Lind). Exotismus-Kult und Orient-Begeisterung sind
noch Kracauers Babelsberg-Bericht von 1926 abzulesen. Dies bezeugt, dass eine ununterbrochene
Kette von orientalischen Außenkulissen das Gelände über ein Jahrzehnt lang geziert haben
dürfte. Es gab in seiner Frühzeit nicht nur eine arabische Straße, sondern auch ein „indischer
Tempelhof mit einem großen Schwimmbecken darin" war vorhanden, wie der Regisseur und
Kameramann Rochus Gliese 1914 bei seinem ersten Besuch in Babelsberg feststellte. „Jede Ecke
[des Freigeländes] war anders im Stil und in der Zeit", erinnert sich Gliese und weist damit auf
die schnell wachsenden Dimensionen des Areals hin.[22] Bis 1916 hatte sich das Babelsberger Frei-
gelände der Bioscop auf 75 000 m² ausgedehnt, zur schnelleren und bequemeren Erreichbarkeit
der einzelnen Außensets war es mit einer studioeigenen Bahnlinie versehen. Bis zum Ende der
Stummfilmzeit sollte die Gesamtfläche des Geländes noch auf rund 350 000 m² anwachsen.

Am 29. April 1920 fusioniert die Deutsche Bioscop mit der Decla-Filmgesellschaft Holz & Co.
zur Decla-Bioscop AG, deren Anteile wiederum im Oktober 1921 komplett von der Ufa über-
nommen werden. Seeber hatte die Bioscop und Babelsberg bereits zum 31. März 1920 im Vorfeld
der Übernahme des Geländes durch die von Erich Pommer geführte Nachfolgefirma verlassen.
Erst Mitte der 20er Jahre steht Asta Nielsen wieder vor einer Kamera, die von Seeber geführt
wird: 1924 für Paul Wegeners *Lebende Buddhas* im Berliner Terra-Atelier, im Jahr darauf für
G.W. Pabsts *Die freudlose Gasse* in den Filmwerken in Staaken. *Dirnentragödie*, ihren letzten
gemeinsamen Film, drehen Asta Nielsen und Guido Seeber 1927 nicht in Babelsberg, sondern im
Rexfilm-Atelier im Berliner Wedding. Und doch wirken die Spuren, die sie in der Babelsberger
Studiogeschichte hinterlassen haben, bis heute nach.

f.l.t.r.: Lucie Höflich, Emil Jannings, Asta Nielsen

v.l.n.r.: Lucie Höflich, Emil Jannings, Asta Nielsen

1 Walter Muschg: Filmzauber. In: *Neue Zürcher Zeitung*, No. 997, 30 July 1922; reprinted in: Wolfgang Jacobsen (ed.): *Babelsberg. Ein Filmstudio 1912–1992*. Berlin: Argon 1992, pp. 139–142.

2 Siegfried Kracauer: Calico-World: The Ufa City in Neubabelsberg [1926]. In: Siegfried Kracauer: *The Mass Ornament: Weimar Essays*, transl., edited and with an introduction by Thomas Y. Levin. Cambridge, Mass. / London: Harvard University Press 1995, pp. 281–288, quoted on pp. 282, 286.

3 Alfred Polgar: Im romantischen Gelände. In: *Berliner Tageblatt*, No. 112, 6 March 1928; reprinted in: Jacobsen (ed.): *Babelsberg*, p. 143f.

4 Guido Seeber: Mein erster und mein jüngster Nielsen-Film [1927]. Reprinted in: Stiftung Deutsche Kinemathek (ed.): *Das wandernde Bild. Der Filmpionier Guido Seeber*. Berlin: Elefanten Press 1979, p. 100.

5 Guido Seeber: Als Babelsberg entstand [1930]. Reprinted in: Stiftung Deutsche Kinemathek (ed.): *Das wandernde Bild*, pp. 58–63, quote p. 63.

6 Asta Nielsen: Mein Weg im Film. In: *B.Z. am Mittag*, 22 September–24 October 1928; reprinted in: Renate Seydel / Allan Hagedorff (ed.): *Asta Nielsen. Ihr Leben in Fotodokumenten, Selbstzeugnissen und zeitgenössischen Betrachtungen*. Berlin: Henschel Verlag 1984, pp. 36, 38, 54, 82, 102, 110, 118, 138, 140, 158, 180, 214.

7 Rudolf Kurtz: Die Geschichte des Filmmanuskripts. Die seelische Vertiefung. In: *Der Kinematograph*, No. 71, 6 April 1934.

8 Nielsen: Mein Weg im Film. 3. Aus der Frühzeit des deutschen Films. In: Seydel / Hagedorff (ed.): *Asta Nielsen*, p. 54.

9 Cf. Andreas Hansert: *Asta Nielsen und die Filmstadt Babelsberg. Das Engagement Carl Schleussners in der deutschen Filmindustrie*. Petersberg: Michael Imhof Verlag 2007.

10 Technical and architectural details refer to Seeber's own descriptions from "Als Babelsberg entstand," supplemented by details found in Corinna Müller: Licht – Spiel – Räume. In: Jacobsen (ed.): *Babelsberg*, pp. 9–28.

11 For more about the films named, see Heide Schlüpmann / Karola Gramann (ed.): *Nachtfalter. Asta Nielsen, ihre Filme*. 2nd edition. Wien: Filmarchiv Austria 2010, pp. 83–117.

12 Malwine Rennert: Vom Markt. In: *Bild und Film*, 2.1, 1913, p. 26.

13 Seeber: Als Babelsberg entstand, p. 62.

14 Ibid, p. 62f.

15 Quoted in Müller: Licht – Spiel – Räume, p. 15.

16 Paul Wegener: Von den künstlerischen Möglichkeiten des Wandelbildes. In: *Deutscher Wille (Der Kunstwart)*, No. 30, 1916/17, pp. 13–15; reprinted in: Jörg Schweinitz (ed.): *Prolog vor dem Film. Nachdenken über ein neues Medium 1909–1914*. Leipzig: Reclam-Verlag 1992, pp. 335–338, quoted on p. 336.

17 After war broke out, Rye immediately volunteered for duty and died at the age of 34 on November 11, 1914, in French captivity as the result of a bullet wound. Rye had directed no less than 15 films in total for Bioscop between 1913 and 1914.

18 Erich Zeiske: *Unsere Künstler*. Berlin: Deutsche Bioscop Gesellschaft m.b.H. [1913], p. 13ff.

19 Asta Nielsen: *Die schweigende Muse. Lebenserinnerungen*. Berlin: Henschel Verlag 1977, p. 131.

20 Leonardo Quaresima: *Homunculus*. Projekt für ein modernes Kino. In: Thomas Elsaesser / Michael Wedel (ed.): *Kino der Kaiserzeit. Zwischen Tradition und Moderne*. München: edition text + kritik 2002, pp. 401–412, quoted on p. 406.

21 Seeber: Als Babelsberg entstand, p. 62.

22 Quoted in Müller: Licht – Spiel – Räume, p. 21.

1 Walter Muschg: Filmzauber. In: *Neue Zürcher Zeitung*, Nr. 997, 30.7.1922; Wiederabdruck in: Wolfgang Jacobsen (Hg.): *Babelsberg. Ein Filmstudio 1912–1992*. Berlin: Argon 1992, S. 139–142.

2 Siegfried Kracauer: Kaliko-Welt. Die Ufa-Stadt zu Neubabelsberg. In: *Frankfurter Zeitung*, Nr. 72, 28.1.1926; Wiederabdruck in: Siegfried Kracauer: *Das Ornament der Masse. Essays*. Frankfurt am Main: Suhrkamp 1963, S. 271–278, Zitat S. 271f., 276.

3 Alfred Polgar: Im romantischen Gelände. In: *Berliner Tageblatt*, Nr. 112, 6.3.1928; Wiederabdruck in: Jacobsen (Hg.): *Babelsberg*, S. 143f.

4 Guido Seeber: Mein erster und mein jüngster Nielsen-Film [1927]. Wiederabdruck in: Stiftung Deutsche Kinemathek (Hg.): *Das wandernde Bild. Der Filmpionier Guido Seeber*. Berlin: Elefanten Press 1979, S. 100.

5 Guido Seeber: Als Babelsberg entstand [1930]. Wiederabdruck in: Stiftung Deutsche Kinemathek (Hg.): *Das wandernde Bild*, S. 58–63, Zitat S. 63.

6 Asta Nielsen: Mein Weg im Film. In: *B.Z. am Mittag*, 22.9.–24.10.1928; Wiederabdruck in: Renate Seydel / Allan Hagedorff (Hg.): *Asta Nielsen. Ihr Leben in Fotodokumenten, Selbstzeugnissen und zeitgenössischen Betrachtungen*. Berlin: Henschel Verlag 1984, S. 36, 38, 54f., 82, 102, 110, 118, 138, 140, 158, 180, 214.

7 Rudolf Kurtz: Die Geschichte des Filmmanuskripts. Die seelische Vertiefung. In: *Der Kinematograph*, Nr. 71, 6.4.1934.

8 Nielsen: Mein Weg im Film. 3. Aus der Frühzeit des deutschen Films. In: Seydel / Hagedorff (Hg.): *Asta Nielsen*, S. 54.

9 Vgl. Andreas Hansert: *Asta Nielsen und die Filmstadt Babelsberg. Das Engagement Carl Schleussners in der deutschen Filmindustrie*. Petersberg: Michael Imhof Verlag 2007.

10 Technische und architektonische Details gehen auf Seebers eigene Beschreibung („Als Babelsberg entstand") zurück, ergänzt durch Angaben bei Corinna Müller: Licht – Spiel – Räume. In: Jacobsen (Hg.): *Babelsberg*, S. 9–28.

11 Zu den genannten Filmen vgl. Heide Schlüpmann / Karola Gramann (Hg.): *Nachtfalter. Asta Nielsen, ihre Filme*. 2. Aufl., Wien: Filmarchiv Austria 2010, S. 83–117.

12 Malwine Rennert: Vom Markt. In: *Bild und Film*, 2. Jg., Nr. 1, 1913, S. 26.

13 Seeber: Als Babelsberg entstand, S. 62.

14 Ebd., S. 62f.

15 Zitiert nach Müller: Licht – Spiel – Räume, S. 15.

16 Paul Wegener: Von den künstlerischen Möglichkeiten des Wandelbildes. In: *Deutscher Wille (Der Kunstwart)*, Nr. 30, 1916/17, S. 13–15; Wiederabdruck in: Jörg Schweinitz (Hg.): *Prolog vor dem Film. Nachdenken über ein neues Medium 1909-1914*. Leipzig: Reclam-Verlag 1992, S. 335–338, Zitat S. 336.

17 Rye hatte sich unmittelbar nach Kriegsausbruch freiwillig gemeldet und starb im Alter von 34 Jahren am 14.11.1914 an den Folgen einer Schussverletzung in französischer Kriegsgefangenschaft. Für die Bioscop hat Rye in den Jahren 1913 und 1914 insgesamt nicht weniger als 15 Filme inszeniert.

18 Erich Zeiske: *Unsere Künstler*. Berlin: Deutsche Bioscop Gesellschaft m.b.H. o.J. [1913], S. 13ff.

19 Asta Nielsen: *Die schweigende Muse. Lebenserinnerungen*. Berlin: Henschel Verlag 1977, S. 131.

20 Leonardo Quaresima: *Homunculus*. Projekt für ein modernes Kino. In: Thomas Elsaesser / Michael Wedel (Hg.): *Kino der Kaiserzeit. Zwischen Tradition und Moderne*. München: edition text + kritik 2002, S. 401–412, Zitat S. 406.

21 Seeber: Als Babelsberg entstand, S. 62.

22 Zitiert nach Müller: Licht – Spiel – Räume, S. 21.

f.l.t.r.: Emil Albes, Ludwig Colani, Max Obal, Paul Wegener, John Gottowt, Hanns Heinz Ewers

v.l.n.r.: Emil Albes, Ludwig Colani, Max Obal, Paul Wegener, John Gottowt, Hanns Heinz Ewers

1912
–
1921

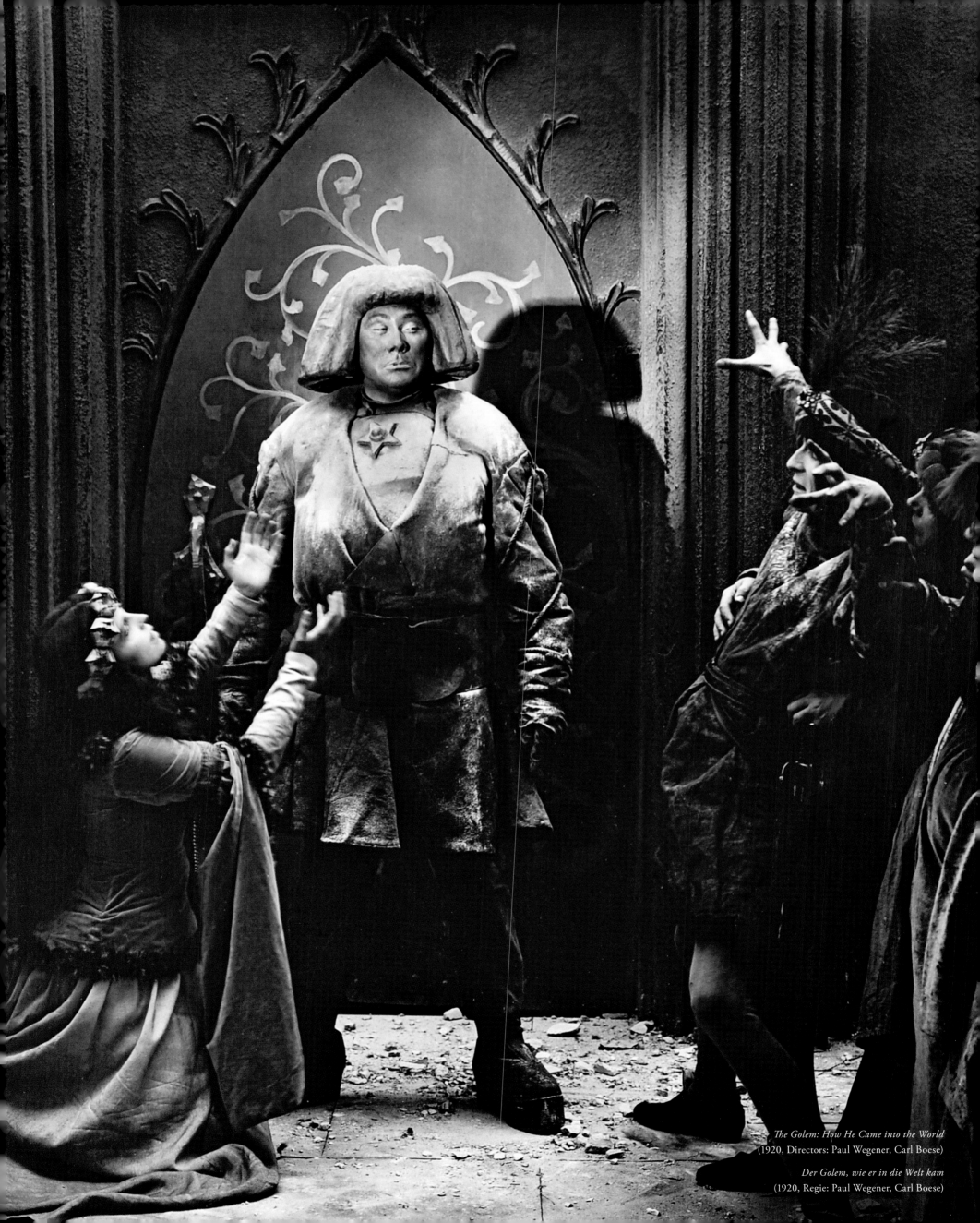

The Golem: How He Came into the World
(1920, Directors: Paul Wegener, Carl Boese)

Der Golem, wie er in die Welt kam
(1920, Regie: Paul Wegener, Carl Boese)

The Master of Death
(1913, Director: Max Obal)

Der Herr des Todes
(1913, Regie: Max Obal)

Scenes from *Genuine* (1920), directed by Robert Wiene. For the decorations and costumes, Wiene acquired the talents of expressionist painter, graphic artist, and set designer César Klein, who painted parts of the decorations directly onto the body of actress Fern Andra.

Szenen aus *Genuine* (1920). Regie führte Robert Wiene. Für die Dekorationen und Kostüme gewann Wiene den expressionistischen Maler, Grafiker und Bühnenbildner César Klein, welcher der Darstellerin Fern Andra einen Teil der Dekorationen direkt auf den Körper malte.

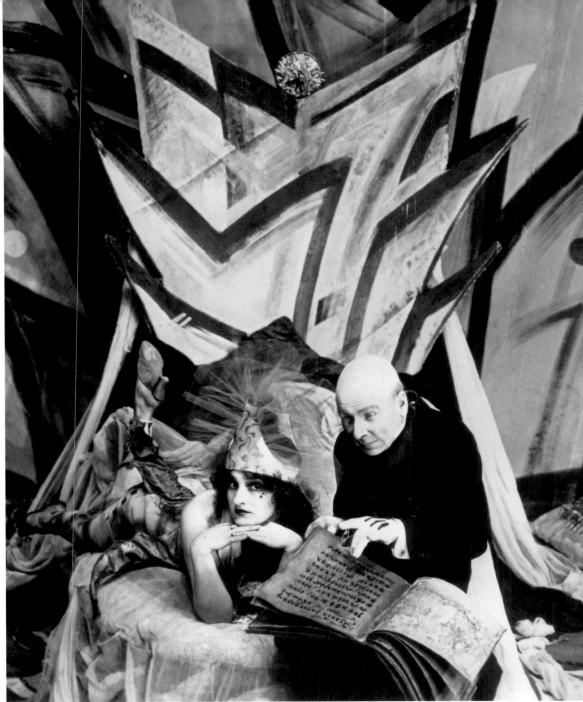

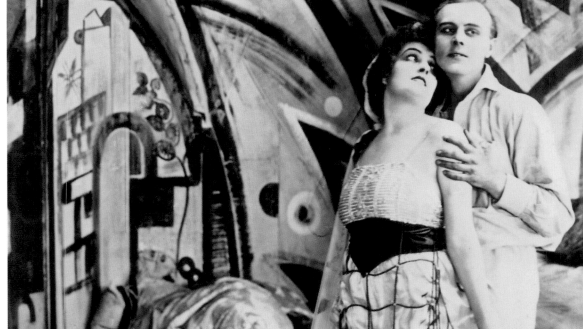

PHOTO CREDITS

Cover photo:
Studio Babelsberg AG/Michael Lüder

Back cover photos:
Deutsche Kinemathek; RP Productions/Guy Ferrandis;
action press/Everett Collection, Inc.;
DEFA-Stiftung, Filmmuseum Potsdam/Manfred Damm;
Universal Studios Licensing LLC;
Filmmuseum Potsdam;
von Harbou, Horst/Cinémathèque française;
Universal Studios Licensing LLC/François Duhamel;
2011, Columbia TriStar Marketing Group, Inc./Reiner Bajo;
DEFA-Stiftung, Filmmuseum Potsdam/Eberhard
Klagemann; Olczyk, Jürgen; Filmmuseum Potsdam

Babelsberg Today

action press/Everett Collection, Inc.: pp. 6, 72

action press/Rex Features Ltd.: p. 11 top

Bajo, Reiner: pp. 48–49, 101

Boje Buck Production: pp. 52 bottom, 53

2011 Celluloid Dreams: p. 20 top

2009 Columbia Pictures Industries,
Inc. and Beverly Blvd LLC, courtesy of
Columbia Pictures/Jay Maidment:
pp. 47 bottom, 70, 71

2011 Columbia TriStar Marketing Group,
Inc./Reiner Bajo: pp. 8, 98–99, 102–103, 104–105

2011 Constantin Film Verleih GmbH: p. 109

2011 Dark Castle Holdings, LLC/Jay Maidment:
pp. 90–91, 93

Deutsche Kinemathek/Marlene Dietrich Collection
Berlin: p. 2

Dieter Geissler Film GmbH: pp. 34, 35

Erhard, Stefan: p. 41

Film & Entertainment VIP Medienfonds 4 GmbH &
Co, 2006/Jaap Vrenegoor: p. 47 top

Getty Images: pp. 5, 27 (4)

Hannemann, Lutz: pp. 14–15

von Harbou, Horst/Cinémathèque française:
p. 18 middle

von Harbou, Horst/Deutsche Kinemathek: pp. 198
left, 205 top, 220–221, 228–229

MM by MP Film Management DOS Productions
GmbH & Co. KG: p. 39

MM by MP Film Management DOS Productions
GmbH & Co. KG/Alex Bailey: pp. 38, 54 middle
and bottom, 55

Olczyk, Jürgen: p. 26 (3)

Phillips, Lloyd: p. 11

RP Productions/Guy Ferrandis:
pp. 10, 50–51, 56–60, 84–85, 86, 89

Sammlung Volker Schlöndorff/Deutsches Filminstitut –
DIF e.V., Frankfurt/Main: pp. 9, 37

Sinkel, Bernhard: p. 30

2011 Sony Pictures/Reiner Bajo: p. 21

Studio Babelsberg AG: pp. 18 right, 19, 20 bottom, 22,
23 (2), 24 (2), 25 (4), 28, 29, 31, 33, 40, 43 top left and
middle, 44, 52 top and middle, 54 top, 82, 87, 88 (3),
96 top and bottom, 97, 108

Studio Babelsberg AG/Reiner Bajo: p. 45

Studio Babelsberg AG/Joachim Gern: p. 17 bottom

Studio Babelsberg AG/Ulrich Illing: pp. 16, 17 top,
43 top right

Studio Babelsberg AG/Michael Lüder: pp. 68–69, 92,
93 top, 106–107 (4), 110–111

2008 The Weinstein Co., Melinda Sue Gordon:
pp. 7, 73 (2)

Thomas, Manfred: pp. 43 bottom, 100

transfermedia gGmbH: pp. 32, 36

2008 United Artists Production Finance LLC/
Frank Connor: pp. 74–75, 76, 77

Universal Studios Licensing LLC:
pp. 62–63, 96 middle

Universal Studios Licensing LLC/Alex Bailey: p. 94

Universal Studios Licensing LLC/François Duhamel:
pp. 4, 78, 80–81, 83 (3)

Warner Bros. Entertainment Inc./David Appleby:
pp. 64–65, 67

Warner Bros. Entertainment Inc. Legendary Pictures
Funding, LLC Dark Castle Holdings,
LLC/David Appleby: p. 46 top

Warner Bros. Entertainment Inc. and Village
Roadshow Films (BVI) Limited: p. 46 bottom

WÜSTE Film/Nimbus Film/Erik Aavatsmark: p. 42

DEFA, "Drittes Reich," and Ufa

Bundesarchiv-Filmarchiv: pp. 178, 179, 180 middle,
240, 244 bottom, 245 bottom, 252–253, 256–267 (3)

Deutsche Kinemathek: pp. 170, 171, 183 top,
198 middle, 200 (2), 203 top, 205 bottom,
222–223 (3), 224–225, 226–227, p. 234 bottom,
235 bottom, 249, 251

Deutsche Kinemathek/Volker Noth (Collage):
pp. 230–231

Deutsches Filminstitut – DIF e.V., Frankfurt/Main:
p. 210 bottom

Filmmuseum Potsdam: pp. 116 bottom, 117, 119 top,
156–157, 168–169, 172 (2), 173 (2), 174 (2), 175 (4),
176 (2), 177 (2), 180 left and right, 181, 182 (2),
183 bottom, 184, 185, 186 (2), 187, 188–189, 190–191,
192, 193, 194–195, 196–197, 198 right, 199 (2),
201 (2), 202, 203 bottom, 204 (2), 206, 207, 208, 209,
210 top, 211 (2), 212–213, 214–215, 216–217 (2),
218–219, 232–233, 234 top, 235 top, 236, 237, 238,
239, 241 (2), 242, 243 (2), 244 top, 245 top, 246, 247,
248, 250 (3), 254–255

more by Filmmuseum Potsdam:

Bergmann, Werner: p. 120 top

Blasig, Karin: pp. 132 top, 133 top (3)

Casper, Franz: pp. 114–115

Kastler, Fred: p. 131 bottom

Koeppe, Barbara: p. 133 bottom

Thiele, E. u. H.: p. 118

by DEFA-Stiftung, Filmmuseum Potsdam:

Bergmann, Werner: p. 134 bottom

Corbeau, Roger: p. 126

Damm, Manfred: p. 158 top

Daßdorf, Eberhard: p. 132 bottom

Ebert, Wolfgang: pp. 120 bottom, 160–161

Erkens, Jörg: p. 135 top

Fritsche, Wolfgang: p. 140

Gehlen, Hermann: p. 122 top

Jäger, Dieter: p. 145

Kilian, Erich: pp. 116 top, 123, 124 (3)

Klagemann, Eberhard: p. 119 bottom

Kleist, Dietram: pp. 164–165

Köfer, Christa: pp. 121 bottom, 138, 142 top, 166–167

Kowalewsky, Gerhard: p. 128 bottom

Kroiss, Herbert: pp. 148–149, 158 bottom, 159

Kuhröber, Norbert: p. 139 bottom

Lück, Dieter: pp. 154–155 (4)

Michailowa, Lotte: p. 134 top

Neufeld, Eduard: pp. 122 bottom, 125, 129 bottom,
131 top, 150–151 (4)

Pathenheimer, Waltraut: pp. 128 top, 130 bottom,
139 top, 152–153, 162–163

Pelikan, Rüdiger: p. 144

Pufahl, Heinz: pp. 146–147

Schütt, Kurt: p. 121 top

Schwarz, Klaus D.: p. 137

Teschner, Max: p. 135 bottom

Wenzel, Hein: pp. 127 top, 129 top, 130 top, 136, 141,
142 bottom

Filmmuseum Potsdam/Allianz Film Produktion
GmbH (Berlin)/Sybille Werner: p. 143

Filmmuseum Potsdam/Sammlung Pietsch:
p. 127 bottom